Architectures
of Chance

Design Research in Architecture

Series Editors

Professor Murray Fraser
Bartlett School of Architecture, UCL, UK

Professor Jonathan Hill
Bartlett School of Architecture, UCL, UK

Professor Jane Rendell
Bartlett School of Architecture, UCL, UK

and

Professor Teddy Cruz
Department of Architecture, University of California at San Diego, USA

Bridging a range of positions between practice and academia, this Ashgate series seeks to present the best proponents of architectural design research from around the world. Each author combines innovative historical and theoretical research with creative propositions as a symbiotic interplay. In offering a variety of key exemplars, the book series situates itself at the forefront of design research investigation in architecture.

720.
108
MAN

Other titles in this series

Furniture, Structure, Infrastructure
Making and Using the Urban Environment
Nigel Bertram
ISBN 978 1 4094 4927 0

Design Research in Architecture
An Overview
Edited by Murray Fraser
ISBN 978 1 4094 6217 0

The Inhabitable Flesh of Architecture
Marcos Cruz
ISBN 978 1 4094 6934 6

Marcel Duchamp and the Architecture of Desire
Penelope Haralambidou
ISBN 978 1 4094 4345 2

Digital Poetics
An Open Theory of Design-Research in Architecture
Marjan Colletti
ISBN 978 1 4094 4523 4

Architectures
of Chance

Yeoryia Manolopoulou

Published by
Ashgate Publishing Limited
Wey Court East
Union Road
Farnham
Surrey, GU9 7PT
England

Ashgate Publishing Company
110 Cherry Street
Suite 3-1
Burlington, VT 05401-3818
USA

www.ashgate.com

British Library Cataloguing in Publication Data
A catalogue record for this book is available from the British Library

The Library of Congress has cataloged the printed edition as follows:
Manolopoulou, Yeoryia.
 Architectures of chance / by Yeoryia Manolopoulou.
 pages cm. -- (Design research in architecture)
 Includes bibliographical references and index.
 ISBN 978-1-4094-3536-5 (paperback) -- ISBN 978-1-4094-3537-2
 (ebook) -- ISBN 978-1-4724-0839-6 (epub) 1. Architecture--Philosophy. 2.
 Chance. I. Title.
 NA2500.M33 2013
 720.1'08--dc23
 2013003631

ISBN: 978-1-4094-3536-5 (pbk)

Printed in the United Kingdom by Henry Ling Limited,
at the Dorset Press, Dorchester, DT1 1HD

For Phaedra, Stephan, Thalia and Anthony

Contents

List of illustrations

Invention in Drawing Original Compositions of Landscape, Plate 9, 24 × 31.5 cm, aquatint on paper, c. 1785, © Tate, London 2011

2.3 Max Ernst, *Rasant les murs* (Shaving the walls), from *Histoire Naturelle*, introduction by Jean (Hans) Arp, 1926, Galerie Jeanne Bucher, Paris edition 306, 49.8 × 32.3 cm, one from a portfolio of thirty-four collotypes after frottage, 1925, © 2011 The Museum of Modern Art, New York (gift of James Thrall Soby) / Scala, Florence, © ADAGP, Paris and DACS London 2011

2.4 Andrea Pozzo, St Ignazio, Rome (1685), general view of ceiling, photograph courtesy of Ro Spankie, 2011 (layout 4 – pair with 2.5)

2.5 Andrea Pozzo, St Ignazio, Rome (1685), detail view, photograph courtesy of Blair Osmer, 2011

2.6 Wu Bin, *Ten Views of a Rock*, painted scroll, dated to 1610, sourced from Philip Ursprung, ed., *Herzog & de Meuron: Natural history*, Canadian Center for Architecture and Lars Müller, 2002

2.7 Herzog & de Meuron, Forum Building, Barcelona, completed 2004, exterior view, photograph courtesy of Ana Maria Ferreira, 2007

2.8 Jørn Utzon, Bagsværd Church, Copenhagen, 1976, interior and exterior views, photographs by the author, 2010

2.9 Jørn Utzon, Bagsværd Church, Copenhagen, 1976, central space photograph by the author, 2010

2.10 Jørn Utzon, Bagsværd Church, Copenhagen, 1976, detail view of rectilinear and curved ceilings, photograph by the author, 2010

3 Drawing as Event

3.1 and 3.2 Albrecht Durer, *Self-portrait Study of a Hand and a Pillow*, 1493, © 2011 Metropolitan Museum of Art, New York / Art Resource / Scala, Florence

3.3 Madelon Vriesendorp, *Flagrant délit*, 1975, © OMA 2011

3.4 Madelon Vriesendorp, *Apres l'amour*, 1975, © OMA 2011

3.5 André Breton, Drawing from *The Automatic Message; The Magnetic Fields; The Immaculate Conception* by André Breton, 1997, Atlas Press, © ADAGP, Paris and DACS, London 2011

3.6 Coop Himmelb(l)au, *Body Language*, study, 1986, © COOP HIMMELB(L)AU 2011

3.7 Coop Himmelb(l)au, *The Open House*, Malibu, California, USA, plan superimposed on original sketch, 1983 / 1988–89, © COOP HIMMELB(L)AU 2011

3.8 Coop Himmelb(l)au, *The Open House*, Malibu, California, USA, section and model photograph, 1983 / 1988–89, © COOP HIMMELB(L)AU 2011

7.12 and 7.13 Social Housing, Mulhouse, France, 2005, interior view of the 'surplus space' in a four-bedroom apartment, © 2011 Lacaton & Vassal

7.14 Francis Alÿs, *Zocalo* (collaboration with Rafael Ortega), Mexico City, film extract, 1999, photograph courtesy of Francis Alÿs, 2011.

7.15 Francis Alÿs, *Zocalo* (collaboration with Rafael Ortega), Mexico City, film extract, 1999, photograph courtesy of Francis Alÿs, 2011.

Chapters A, B, C, D and E

All visual material is by the author, except from:

B13 Diagram from R. L. *Gregory, Eye and Brain: The Psychology of Seeing* (Oxford University Press, 1998), p. 141, fig. 8.1, reproduced by permission from Oxford University Press.

B14 Diagram from R. L. *Gregory, Eye and Brain: The Psychology of Seeing* (Oxford University Press, 1998), p. 76, fig. 4.6, reproduced by permission from Oxford University Press.

Acknowledgements

My interest in the idea of chance can be traced back to the late 1990s when I was a student in the Bartlett's MArch Architectural Design programme at University College of London. I further explored this subject through a design-led PhD, and my most grateful thanks go to Philip Tabor, an extremely generous and insightful supervisor and an amazing mentor while I took my first steps in writing and teaching. During this time I tried out aleatoric ideas on design projects for public squares with Anthony Boulanger, Penelope Haralambidou and Eduardo Rosa through our collaborative practice Tessera. Since then my partnership with Anthony at AY Architects has been vital in helping me integrate research with situated practice.

As a design tutor in the MArch Architecture at the Bartlett, I have benefited from numerous stimulating exchanges with colleagues and students. My teaching partnership with Níall McLaughlin is invaluable and has given me insightful and positive critique all along since 1999. Michiko Sumi, who recently started teaching with us, has provided much inspiration, as have our students with their own projects in Unit 17.

The Bartlett's research environment is an enormous intellectual resource. I am thankful to Murray Fraser, Jonathan Hill, Barbara Penner, Peg Rawes and Jane Rendell, and to my doctoral students, particularly Popi Iacovou, Christiana Ioannou, Rosalie Kim, Guan Lee and Christos Papastergiou, for all the knowledge they have shared with me. Many more colleagues and friends have supported me either directly or indirectly whilst developing this piece of work, among them Ben Campkin, Nat Chard, Marjan Colletti, Marcos Cruz, Penny Florence, Christine Hawley, Izumi Kobayashi, Chris Leung, Luis Rego, Souli Spiropoulou and Iliana Theodoropoulou. I would also like to thank those who invited me to contribute to talks, exhibitions and publications related to design research and aleatoric practice, especially Brent Allpress, Anne Beim, Marc Belderbos, Claudia Carbone, Odile Decq, Peter Gibbs-Kennet, Klaske Havik, Deborah Hauptmann, Hilde Heynen, Brandon LaBelle, Barbara Penner, Mette Ramsgaard Thomsen, Jane Rendell, Charles Rice, Anne Elisabeth Toft, Renata Tyszczuk and Johan Verbeke.

I am indebted to Lorens Holm for his insightful advice on Lacan, Sharon Morris for her decisive discussion of *Film* in the early days of my research, and Barney and Astrid Rosset at the Evergreen Theatre for their help and remarks on Beckett. I am grateful to Victoria Watson for all her perceptive suggestions after reading my texts, and to Jonathan Hill and Ruth Allan who also read parts of this book and gave me constructive feedback. I thank Kate Ahl and Wendy Toole for copy-editing and proofreading, and Brent Pilkie who meticulously collected all image permissions.

Many institutions and individuals provided images for reproduction, and in particular I wish to acknowledge the courtesy of Francis Alÿs, Nat Chard, Coop Himmelb(l)au, Christoph Engel, Ana

Maria Ferreira, James B. Janzer, Hans Hollein, Tim Hursley, Perry Kulper, Nelson Kon, Lacaton & Vassal, Blair Osmer, Carme Pinós, Barney Rosset, SANAA, Ro Spankie, Michiko Sumi and OMA/ Madelon Vriesendorp.

The initial stages of my research were supported by the IKY Greek State Scholarships Foundation, the Foundation of Panayotis & Effie Michelis, the British Foundation of Women Graduates, and the Arts & Humanities Research Council. Recently UCL granted a sabbatical period for me to complete this book while the Bartlett Architecture Research Fund contributed to the publication costs.

Architectures of Chance would have not been made possible without the vision and encouragement of Murray Fraser, Jonathan Hill and Jane Rendell, the Series Editors, and without the continual care of Senior Commissioning Editor Val Rose and Production Editor Kevin Selmes. All together they have created an important platform for publishing design research in architecture and I feel extremely fortunate to be part of it.

I am grateful to my parents Vivi and Yiorgos, my sister Maria and my brother Panos, who have been an endless resource of support for me all along. Finally, my deepest thanks are to Anthony, Phaedra, Stephan and Thalia, for their extraordinary patience and the countless ways they make me happy every day.

Opening

In my experience of buildings, I see very little of pure design. Movement, temporality and circumstance complement and change my surroundings all the time. Immaterial and material architectures mix everywhere, and the role of chance is paramount in every single spatial situation and experience. The activity around the kitchen table at a specific moment in time, voices and the sound of a passing train, light reflections on the window, the sudden opening of the door and the scent of the garden—all these orchestrate a spatiality that is based on chance factors and relationships as much as on design. I experience architecture through chance because I inhabit it as an environment of relationships in time. Without the presence of chance I could not fully appreciate architecture.

To talk about chance is to talk about time, the simultaneity of different human activities and the fugitive intervention of the environment, all intertwined with the relative permanence of the building. While chance 'charges' the building, producing unique aesthetic experiences according to specific events and points of view, these experiences are so common that often we do not notice or remember. Only now and then they become more poignant, disturbing our sense of logic and undercutting our assumptions about the role of architecture in the world. Such different types of chance and their intricate relation to architecture, from the ambiguities of perception to the poetics of weather and the unpredictability of political events,

have triggered the making of this book.

The interactive coincidence of building, environment and social intercourse as a joined event has been discussed frequently in the history of architecture but rarely in ways that pay notable attention to chance. This interaction between building, environment and society is, however, explicitly associated with chance in Vitruvius' origins of the idea of architecture. Vitruvius' mythical story of the beginnings of the design awareness of buildings characteristically starts from the accidental discovery of fire in the woods:

> [men] drew near, and observing that they were very comfortable standing before the warm fire, they put on logs and, while thus keeping it alive, brought up other people to it, showing them by signs how much comfort they got from it. In that gathering of men, at a time when utterance of sound was purely individual, from daily habits they fixed upon articulate words just as these had happened to come; then, from indicating by name things in common use, the result was that *in this chance way* they began to talk, and thus originated conversation with one another.

> Therefore it was the discovery of fire that originally gave rise to the coming together of men, to the deliberative assembly, and to social intercourse. And so, as they kept coming together in greater numbers into one place ... they began in that first assembly to construct shelters. ... Next, by observing the shelters of others and adding new details to their own inceptions, they constructed better and better kinds of huts as time went on.[1]

This passage suggests that chance can initiate design. 'In this chance way', Vitruvius says, people began to gather, make and talk. From one assembly to the next, from one shelter to the other, social relations evolved, and so did architecture, and so did language. People gradually developed organized social forms, signs and buildings, partly in response to the indeterminate threats of nature. Making buildings as shelters helped them to act socially and to develop languages until buildings acquired also a public purpose and became structures of political and cultural representation. The role of chance in creating this mutual interdependence between building, environment and society is inevitable because chance is inherent in the making of events and of life itself in the broadest sense.

There are two parallel perspectives that underpin *Architectures of Chance*. First is the view that design is a *live event*. From the perspective of the designer design is an experienced reality in its own right. As an embodied activity happening in the present, designing is not separate from living and is therefore implicated in the realm of chance. Just as all live events are affected and partly directed by chance, so is the experience of designing and its outcome. Chance contributes to design because it participates in the making of the imagination and of the event of thought itself. Second is the view that the building *performs*: it alters perceptually and physically over time, being remade and co-made by architects, non-architects, social life and the environment. Its performative role is produced by the relational conflict of materials, processes, atmospheres and emotions, all simultaneously interacting. Chance is a complementary agency continuously affecting architectural space, for all

that architects may try to choreograph and dictate its experience.

The interplay of chance and necessity, like the necessity for logic or order for example, is a fundamental aspect of the creative consciousness of the world and a principal enquiry in art, philosophy and science. It is extraordinary that architecture, which directly exposes its artefacts to the unpredictability and indeterminacy and the environment, has had so little to say about its relation to chance. I aim to address this gap by developing a conversation about chance between the spatial disciplines and by proposing chance as a new area of research in architecture. Chance has a long history as an interdisciplinary idea but it was in the nineteenth century that its probabilistic aspects started becoming critically influential for both the sciences and the creative fields. It was then that C. S. Peirce argued that probability permeates all aspects of life and that 'tychism', which derives from the Greek *tyche*, meaning 'absolute chance', is *real*. Peirce reasoned for an evolutionary cosmology in which all law and order develops out of chance. Following Peirce, and tracing the history of thought around the idea of chance, Ian Hacking has shown that since the nineteenth century our conception of indeterminism about the world has created an opposite effect in wanting us to calculate, regulate and control.[2] The more we are aware of the chance universe, the more we want to remove uncertainty, to predict and 'design' chance. The greater the level of indeterminism in our understanding of the world, the more we expect control and the less we expect freedom. In this context architecture's improved knowledge of the indeterminacies of nature is combined with an increasing and excessive

tendency to want to control the environment through technological means.

Many spatial disciplines related to architecture have acknowledged chance as both subject and method, particularly since the early 1900s. In philosophy, indeterminism has been systematically debated in relation to time, whereas in psychoanalysis mistakes and accidents are seen as meaningful signs for uncovering the unconscious. Dada, Surrealism, abstract expressionism and action painting used different kinds of automatism and assemblage to counter-balance causality and expand the limits of representation. Situational and performative urban practices, which flourished in the 1960s and 1970s, are currently being re-energized, welcoming participation and activism, mixing therefore the planned with the unpredictable in the dynamic realization of public events.[3] Later twentieth and twenty-first century aleatoric processes in dance, theatre, music and writing incorporate chance by encouraging improvisation and interaction, while at the same time developments in science and digital technologies study complexity and employ probability in order to predict patterns of behaviour and change.[4] In this context, it is disappointing that architecture, which overlaps with many of these disciplines, has avoided any serious consideration of chance.

The architectural profession persistently resists chance. Statistical probability is used today as a positivist tool in order to find 'optimal' solutions for structures, materials and energy flows, while the use of computation in architectural design continues to do the same old thing: to seek the optimal and attempt to control real chance. Inter-subjectivity and the more poetic and ideological possibilities of contiguity radically centred on place, people and history are rarely pursued. But the relentless tension between buildings and temporality, and the contingencies of inhabitation and weather, are available to be observed anytime by anyone interested: architects, non-architects and often those who occupy the boundaries between architecture and art. Consider for example the effect of abandoned buildings on artists—such as Robert Smithson's exploration of entropy—or how the complex simultaneities of urban experience inspired writers like James Joyce. While many more poets, artists and philosophers, from Stéphane Mallarmé, Henri Poincaré and Henri Bergson to John Cage and Gerhard Richter, have openly interrogated chance, architects have discussed it obliquely. The architects Aldo van Eyck, Lina Bo Bardi, Bernard Tschumi, Robert Venturi, Charles Jencks and Nathan Silver, Cedric Price, and Lacaton & Vassal have explored related concepts such as 'occasion', the 'in-between', 'event', 'contradiction', 'adhocism', 'anticipation' and 'surplus space'. These concepts allude to chance by critiquing authorial control and the functionalist tenets of modernism. In this book I acknowledge them but also attempt to expand them further to redefine architecture's preoccupation with programme, form and occupation through a more radical consideration of chance as a central area of concern in architectural theory *and* practice. What will the new histories of architecture be if chance consolidates its status as a valid concept for architectural thought, particularly strengthened by its open interrogation in design practice?

Architectures of Chance is a collection of differences: projects and texts intentionally converge and deviate from each other to explore a range of

creative possibilities of chance in architecture. The book unpacks two portfolios exploring two corresponding themes: 'Chance in Perception' and 'Chance in Design'. Portfolio I explores the perceptual and psychological instability between subject, image and object. It studies the function of chance in the structuring of spatial experience and how perception and visual representation are creatively charged by the interference of accidents. Portfolio II presents an interdisciplinary selection of chance-related works and gradually uncovers an array of thematics and techniques of chance that can be useful for architecture. I define these as *impulsive, systematic, fabricated, active* and *resistant* varieties of chance.

Each Portfolio is led by projects of my own, originally developed between 1999 and 2006, and presented now in this book as a series of notebook extracts. The projects generate questions for the historical analysis and theoretical argumentation that follow. Their original purpose was to better understand the possibilities of chance from an interdisciplinary perspective while using drawing as a thinking tool. I have decided to keep their sketch-like character untouched for this publication because I am interested in the open-ended quality of this material and in the ability of the *unformed drawing* to be interpreted in many different ways by the readers. As I have noted elsewhere, 'because of their minimal and incomplete form, notes, sketches and diagrams are open to variable interpretations. They can be ambivalent but trap a dense residue of intentions and meanings difficult to express in more elaborate modes of representation.'[5] I have also decided to exclude any relevant and more recent projects from my practice AY Architects because,

although these are based on a keen awareness of the importance of chance in architecture, they interact with it implicitly rather than directly.

In architectural practice drawing is typically used for design production but in *Architectures of Chance* I am drawing in a different way: I am drawing as a way of visualizing thought in action in order to advance levels of understanding for spatial problems I am preoccupied with. This mode of drawing is a form of questioning, confronting the propositional drives of design with elements of criticism. I am also drawing speculatively, asking 'what if?', and allowing the imagination to lead the making of experimental objects and proposals.

The different theoretical and historical positions presented in *Architectures of Chance* complement each other and are not intended to form any generalized or total knowledge about the subject. Through association and intentional opposition I hope to capture something of the nature of chance and something of the sense that architecture is an evolutionary and complex device for continuous conversation and disagreement. Dialogues with other authors are incorporated in the creation of the projects and texts, and in the making of the book as a whole. I have engaged with the works of others not as a historian but as an architect being interested in specific other architects, artists and writers. I am deliberately bringing together contrary perspectives because I think that it is exactly this diversity in the range of sensibilities towards chance that can benefit architecture. Architecture is more complex than art because it involves an unpredictable social reality beyond the author, and is largely experienced outside of the protective frame of institutions. I am therefore interested in how some of the more

introvert and spontaneous techniques in art can be critically attuned by architecture to become inter-subjective. Although for the purposes of this book I have more or less arranged these techniques from the individual to the social, the different qualities and categories of chance are in reality much more mixed and intertwined.

The summary below is a guide to the different parts of the book:

PORTFOLIO I: CHANCE IN PERCEPTION

A. *Eyes and Objects* is conceived as a dialogue between Samuel Beckett and Jacques Lacan. The dialogue is metaphorically located in the shooting room of Beckett's *Film* in New York where Lacan's renowned 'mirror stage' is understood to be unravelled. A series of diagrams is used in order to analyse the filmic and psychoanalytic sequences and introduce the topic of chance in perception.

B. *Crossings* responds to *Film* with a portable viewing instrument, made as an experimental object to test the limits of visual perception. The project critiques the monocular and frontal perspectival model of vision and stresses that spatial experience is based on a surrounding model of perception. Accidents always come from behind to interrupt our images.

1. *Behind the Image* is the first theoretical chapter of the book and has developed as a response to the project *Eyes and Objects*. I focus on the perceptual and psychological instability between subject, image and object, and discuss the role of chance in the structuring of spatial experience where perception and representation are creatively charged by the interference of accidents. I re-examine Beckett's *Film* and Lacan's dialectic of the eye and the gaze in order to explain how the images that we think we see function as masks that we construct in order to protect ourselves from the complexities of reality. With reference to Roland Barthes's 'punctum' I also discuss how images can capture traces of the spatial unconscious as 'slips of the eye', similarly to 'slips of the tongue'. If accidents are powerful interruptions that constructively upset our systems of representation to reveal meaningful gaps that otherwise would have been invisible, what is their role in the process of design?

PORTFOLIO II: CHANCE IN DESIGN

C. *Projections* is a series of drawings that interrogates Marcel Duchamp's thought on projection, 'the infra-thin' and 'the art-coefficient'. Duchamp studied the creative and critical possibilities of chance as a life-long experiment and this section of the book explores some of his work speculatively through drawing.

D. *Shutters* is a reconfigurable object, made and used as a design tool for the construction of a set of domestic shutters. The work explores variation as a design strategy and acts as a theoretical object that can be used for other works. It also incorporates techniques of play.

E. *Fields* is a series of drawings making a speculative design proposal for Pier 40 in New York. The project is partly an architectural adaptation of John Cage's *Fontana Mix*, motivated by Cage's 'chance operations' and seeking to test the role of polyphony and performativity in architecture.

2. *The Practice of Observation* defines observation as an associative and imaginative design activity that requires practice to become skilled. A brief history of the appreciation of *chance images* in art from classical antiquity until today explains how chance in art is associated with nature and with the artist's function of *fantasia* rather than *mimesis*. Sources range from Alexander Cozens's blotscapes to Aldo Rossi's texts on observation, Hubert Damisch's theory of /cloud/ and Robert Venturi's concept of ambiguity as a poetic architectural device. Buildings and landscapes which encourage a prolonged and creative mode of seeing as an aesthetic process in itself are particularly open to the poetics of fantasia and chance.

3. *Drawing as Event* argues that drawing is an experienced reality in its own right, inseparable from living, and therefore from chance. Concepts and techniques examined include 'automatism', 'gesture', 'enaction', 'trap picture' and 'the paranoid critical method'. Works by Coop Himmelb(l)au, Enric Miralles, Francis Bacon, Daniel Spoerri and Constant Nieuwenhuys are discussed alongside urban theories and practices by Guy Debord, Francis Alÿs and Rem Koolhaas. The book gradually moves from the *monologic* (the self and the unconscious) to the *dialogic* (the self in dialogue with external realities, found objects and social occasions).

4. *Encounter and Assemblage* focuses on the architect's desire to draw on encountered objects and situations and to synthesize these encounters in new propositions that can take the form of assemblage. Displacement, contiguity and non-finality are qualities found in Dadaist and surrealist modes of collage. While many architects have used similar kinds of collage, here I focus on *non-reconciliation* and *expansion* as two architectural ideas of assemblage embodied in certain buildings by Jørn Utzon and Lina Bo Bardi.

5. *Fragment, Part, Whole* argues that the urge to break totalities is persistent in the history of buildings of the twentieth century—a theme discussed also by Robin Evans. I expand Evans's discussion towards the topic of disorder found in the writings of Rossi, the type forms of Miralles and Pinós, and selected texts by Henri Bergson and Jeff Wall, among others. The tension between complete and broken form relates to simultaneity and the fracturing of pictorial space but also manifests the hidden drive in architecture to use chance in order to upset architecture's own stability and wholeness. Some contemporary architects are eager to produce in their buildings a Dadaist image of randomness but what prevails in computational design processes is an affection towards 'smooth geometries' which see less distinction between the part and the whole. The interest in making analogies between buildings and biological systems brings us back to the tension between *mimesis* and *fantasia*, where a new kind of digitally determined *mimesis* tends to prevail.

6. *Ironic Fabrication* has developed from the project *Projections* and is entirely devoted to Duchamp, possibly the artist-researcher who experimented with the tension between intention and chance the most. His invention of the readymade, 'canned chance' and 'the idea of fabrication' are supported by his greater inquiry into the invisible, pataphysics, the limits of science and of representation. The

Large Glass is a fabricated construction of chance which is also deliberately open to the consequences of real chance. It is an emblem of Lacan's theory of the eye and the gaze, and perhaps the artwork of the modern world that has mostly trapped the real.

7. Aleatoric Form can be linked with *Fields*. An aleatoric work (from *alea*, Latin for 'dice') is a piece that does not completely specify its end results. The chapter examines Lefebvre's definition of the aleatory as the essential characteristic of modernity and as *a form of questioning*. While deterministic applications of chance result in fixed forms because they are fully defined by the actions of the author, indeterminate applications of chance are open to the actions of the performers-users who invent ever-changing scores and spaces. This radical and unpredictable condition of chance is critical and deeply social, placing emphasis on how buildings *perform* rather than how they appear as finished objects. Cage's chance operations and the working modes used by the Situationist International, Van Eyck, Tschumi, Price and Lacaton & Vassal are among the approaches examined. Architecture tends to define itself against chance but chance, in turn, disturbs architecture's ideal image by generating *counter-tactics* to design and *counter-arrangements* to buildings. The negation of formalist chance in the course of design dialectically emphasizes the aesthetically and socially felt conditions of chance in spatial experience.

Throughout the Chapters of Portfolio 2 I discuss five different modes of engaging with chance, concluding in **Double Passage** that these are permeable categories, complementing each other

and favouring collaboration with other working modes:

Impulsive chance is driven by intuition, subjectivity and the imagination. It is associated with unconscious drives but can transcend the self to reach the collective for the making of architecture and the city. *Systematic chance* is methodical and aims for generative variability within a set of parameters. From the flexibility and adaptability of buildings, associated with industrial standardization and modularity since the early twentieth century, we have shifted to a more mathematical notion of chance through the use of the algorithm in computational design and technologies of making. *Fabricated chance* is used through play and humour to critique and ridicule rationalism, functionalism, statistics and all related doctrines. Postmodernism used this ironic notion of chance to question the pure principles of modernism. *Active chance*, on the other hand, accepts the aleatory as a critical part of *all* architecture, irrespective of author, period and style. It is underlined by social activity, non-finality and the possibilities of co-making. Finally I am suggesting that there is a fifth category of chance in architecture which is unspoken but pervasive: it is based on the actual negation of chance during design. *Resistant chance* conceives the building as an autonomous object, recognizing that it will inevitably be complemented by chance as its *other*. Showing a conscious disinterest towards chance as form is productive because it acknowledges the unavoidable interaction of the building with chance as agency and action.

What I try to convey with these definitions is not singular meanings or absolute methodologies as such but an overall curiosity about chance,

an openness and a letting go towards its many possibilities. I intend to show that architects need to develop a poetic and holistic attitude towards the study and practice of chance, and an awareness of its tireless role in influencing experiences and designs imaginatively and critically.

Buildings influence our perceptual and aesthetic habits, while our habits, in turn, describe the limits of architectural language in a continuous circle. Nonetheless, an accident may help us break out of this impasse: chance events may upset the routines of perception to call into question our assumptions about the world and stimulate the imagination. If chance is an inevitable but productive aspect of architecture, present in all its transformations—from conception, representation and building to inhabitation and interpretation—why have architects paid very little attention to it, or have they not? Can the broader architectural community—designers, theorists, users and readers—benefit from a more conscious and proactive engagement with chance, and how? Consider this book the beginning of a conversation.

Notes

1 Vitruvius, 'The Origin of the Dwelling House', *On Architecture*, trans. Morris Hicky Morgan (Dover, 1960). First published as *De architectura* in the first century BC.

2 Ian Hacking, *The Taming of Chance* (Cambridge University Press, 1990).

3 Several approaches are presented in Claire Doherty (ed.), *Situation* (MIT Press and Whitechapel Gallery, 2009).

4 The word 'aleatoric' comes from the Latin word *alea*, meaning 'dice'. In aleatoric art some element of the creative process is consciously left to chance. A characteristic example is John Cage's chance operations used for his music compositions, drawings, lectures and writings. See for example Cage, *A Year from Monday: New Lectures and Writings* (Marion Boyars, 1976).

5 For more on the definition of the 'unformed drawing', see Yeoryia Manolopoulou, 'Unformed Drawing: Notes, Sketches and Diagrams' (*The Journal of Architecture*, vol. 10, no. 5, 2005), pp. 517-25.

Chance in Perception

The considerate kindness of the Angel mollified me in no little measure; and, aided by the water with which he diluted my port more than once, I at length regained sufficient temper to listen to his very extraordinary discourse. I cannot pretend to recount all that he told me, but I gleaned from what he said that he was the genius who presided over the contretemps of mankind, and whose business it was to bring about the odd accidents which are continuously astonishing the sceptic.

Edgar Allan Poe, *The Angel of the Odd*, 1895

EYES AND OBJECTS
After Beckett

A01 An eye dissolves into a wall. An eyelid opens and the cornea appears. Then it closes, opens again and the cornea reappears. Gradually the blank surface of a brick wall emerges, on which the flare of the cornea seems to be reflected. The cornea, the eyelid and the wall merge into one image. They stand for the main thematic components of this project: the eye, the image and the object.

Samuel Beckett's *Film* 'is comic and unreal' in Beckett's own words, twenty-two minutes long, and despite having been produced at a time when audiences would expect full colour and sound effects, black and white and completely silent except one 'ssh!'. It unfolds in three parts—the street, the stairs and the room—and describes the story of a single man, played by Buster Keaton. In his script Beckett names Keaton, the protagonist of the film, Object (O) and the camera Eye (E):

> E = Eye (camera)
> O = Object (protagonist).[1]

A02 In the beginning of *Film* the Eye (E) searches for the Object (O) by panning from a fixed position until it finds O. E focuses on O and starts following him, constantly pursuing him, while he desperately tries to hide. O hastens along a sidewalk, rubbing the wall with his left arm and using the other hand to shield the right side of his face. His neurotic behaviour suggests he is scared, perhaps guilty of some terrible deed. He tries to escape capture but bumps into road works, and people moving in the opposite direction. People and things disrupt his hurried progress. At the same time O's face (which the audience cannot see) seems to alarm whoever encounters him, causing 'an expression only to be described as corresponding to an agony of perceivedness'.[2]

A03 The camera is not and cannot be an instrument of objective representation. It has different behaviours, and in *Film* Beckett uses it to create two distinct cinematic images, corresponding to two different visions: those of the perceiving Eye (E) and of the perceived Object (O). In the role of E the camera sees the world more impartially, presenting it crystal clear; in the role of O it sees it from a more subjective position, showing it blurred. E follows O from behind and films him from a 'hidden' angle not exceeding 45°. This angle, the 'angle of immunity' as Beckett puts it, defines O's blind field: an area of vision which allows E to see O without allowing O to notice the camera's gaze. Like E, we the audience never see O's face, only his back. Beckett imposes this technical convention of the 45° to represent the limitations of vision, whether cinematic or human. Each time E exceeds the 45° angle, an accident happens.

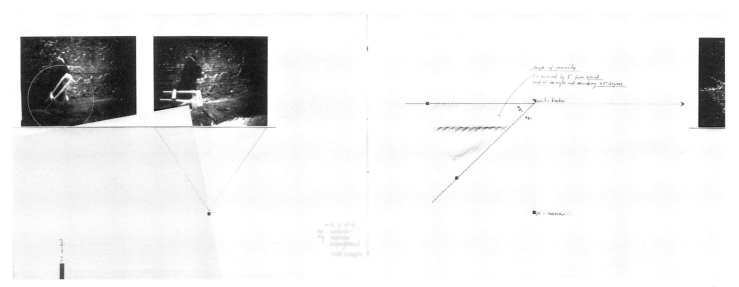

A02

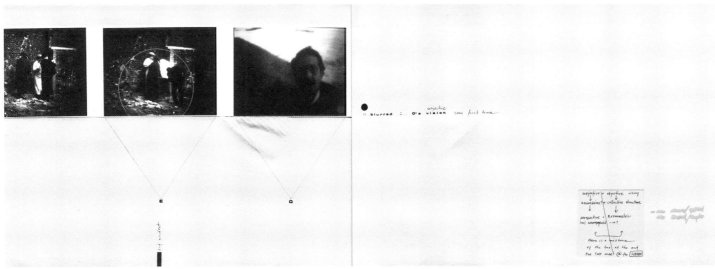

A03

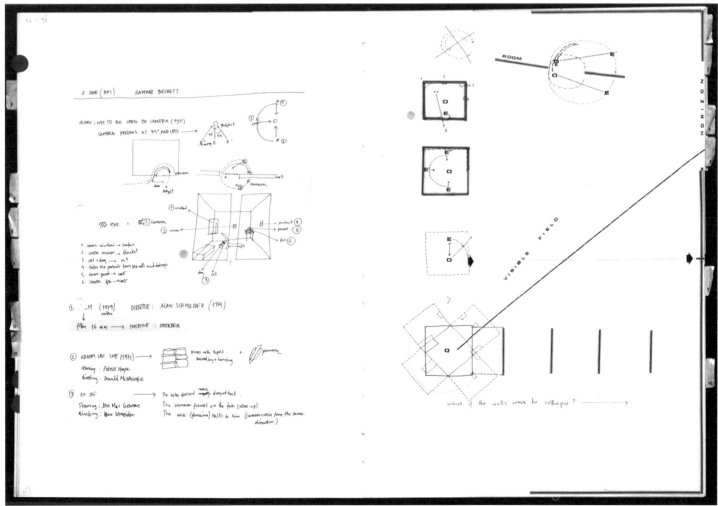

A04

A04 In the second part of *Film*, O enters a building, goes upstairs and reaches a door. E keeps following him within the angle of immunity. They enter the room together. O opens the door and E carefully tracks him in a 270° movement, constructing a continuous space between outside and inside, allowing the camera to follow the action without being seen. Now both E and O are locked in the room.

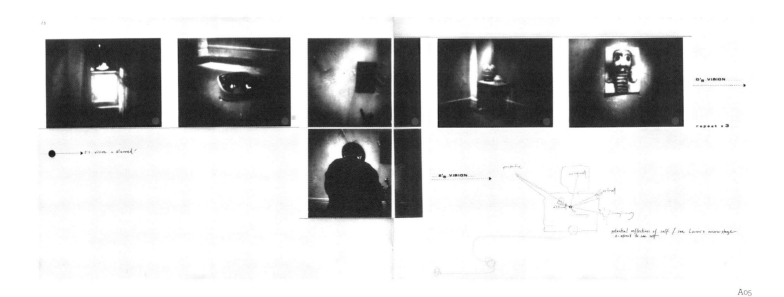

A05

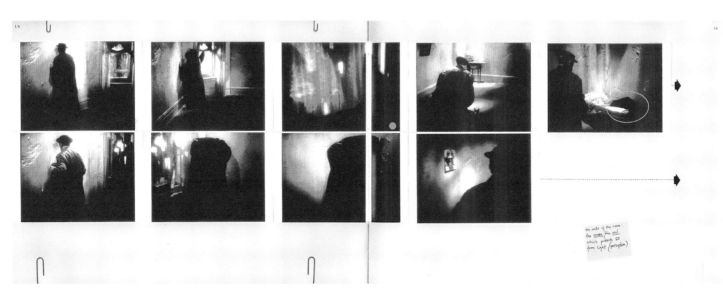

A06

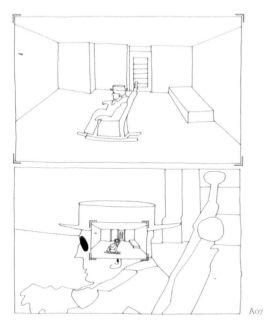

A07

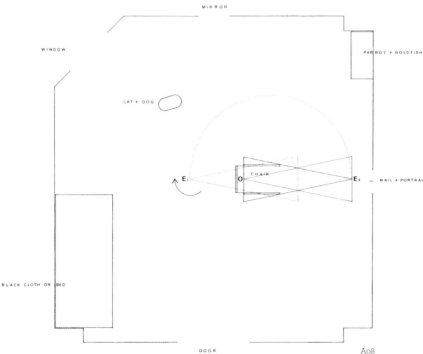

A08

A05 Inside the room E's angle of vision has doubled and follows O within a greater 90° angle. O still appears hunted. He sees 'eyes' everywhere around him. A dog and a cat are looking at him; a mirror, a window and a portrait are also looking at him; a parrot, a goldfish, and even the buttons of a folder and the holes on the headrest of a chair are staring at him.

A06 For O, objects and animals are all threatening perceivers. Anxious to escape visibility, he moves round the edge of the room and starts 'deleting' one by one its perceiving eyes. He draws the curtain of the window (the voyeur's eyes), covers the mirror (his own eyes), expels from the room the cat and the dog (the animals' eyes), takes down and destroys the portrait (the print's eyes), covers the parrot's cage (the bird's eyes), covers the goldfish bowl (the fish's eyes), turns his folder 90° (the folder's eye-like buttons), inspects seven photographic portraits one by one and immediately tears them up (the photographs' eyes). At this point O believes he has destroyed all perceivers.

A07 In O's mind each previous spatial experience is included in the present. All memory images are stored mentally in a Russian doll-like structure: the street is inside the stairs, the street and the stairs are inside the room, and all these are accumulated inside his mind. O perceives the room through perceiving his own self in the room. Self-perception is inevitable, constantly included in the routines of spatial perception and representation. Inside the room O has repeatedly followed the same steps, performed similar tasks again and again, moved in circles, traced and retraced the same viewing positions. He is not aware of E which, restricted by the 90° angle, is still unnoticed. Now, he finally rests in the rocking chair.

A08 It is only then, when he believes that he has destroyed all perceivers, that the camera E exceeds the 90° restriction. E gradually circles around O, now asleep. Its movement is reversed, looking away from O towards the periphery of the room, scanning the walls in a continuous close-up shot. O sleeps, unaware of E's movement, until the camera finally succeeds in facing him:

> E's gaze pierces the sleep, O starts awake, stares up at E. Patch over O's left eye now seen for first time ... O half starts from chair, then stiffens staring up at E. Gradually that look. Cut to E, of whom this very first image (face only, against ground of tattered wall). It is O's face (with patch) but with very different expression, impossible to describe,

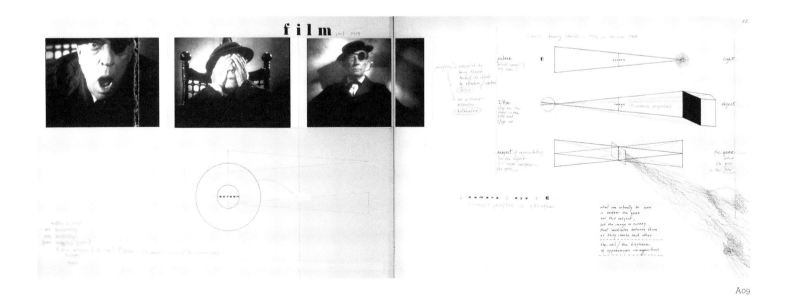

A09

neither severity nor benignity, but rather acute intentness. A big nail is visible near left temple (patch side). Long image of the unblinking gaze.[3]

A09 This is the first time that the Eye and the Object confront each other. To our surprise, the first image we see of E shows him to have the face of O. E is O's mirror-image. Beckett's paradox is revealed: the perceiver and the perceived are two aspects of the same person. The Eye is not other but the self. E (Eye) = O (Object).

A10 The sketch, reproduced from Beckett's manuscript notes, describes his thinking process for how to resolve the final sequence. The scene is funny as much as threatening. E and O are each wearing an eye-patch, and looking at each other intensely. Clearly this is a commentary on the camera lens and its functional analogy to monocular vision but is also a critique of those limited understandings of vision as only optical.

A11 The covered eye is metaphorically a *touching eye*: blind, it has to seek its way through contact. O moves on the edges of the spaces that surround him, rubbing and touching walls to orient himself. In the room each time he veils an object, he expressively places his hands over it, and during his ultimate confrontation with the camera he uses his hands to cover his eyes. The last encircling movement of the camera produces partially clear and partially blurred images, merging two qualities of vision in one: the eye looks while the gaze touches.

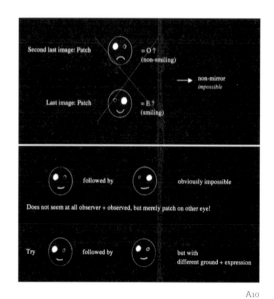

Second last image: Patch　　= O ?
(non-smiling)

→ non-mirror
impossible

Last image: Patch　　= E ?
(smiling)

followed by　　　　obviously impossible

Does not seem at all observer + observed, but merely patch on other eye!

Try　　followed by　　but with
different ground + expression

A10

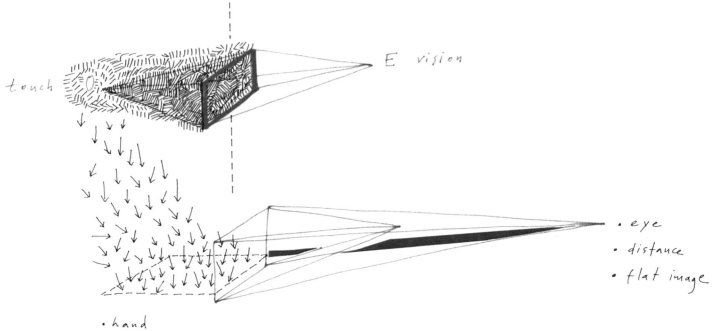

touch　　　　　　　　　　　　　　E vision

• hand
• immediacy
• plastic object

• eye
• distance
• flat image

A11

9

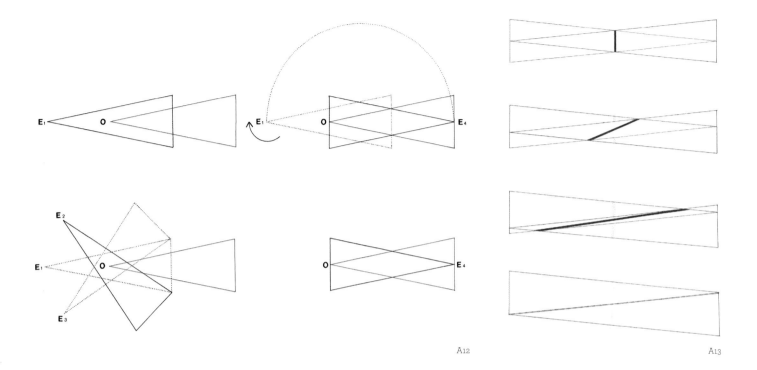

A12

A13

A12 The top left diagram describes the safest viewing relationship between E and O where E is totally hidden from O's view, and the bottom left outlines the double angle of immunity within which E can move unnoticed in the room. The top right shows E's final encircling of O and the bottom right outlines the relationship between E and O when they ultimately face each other. This last diagram describing E's and O's final encircling in the room is identical with Lacan's schema of the eye and the gaze. *Film* makes a cinematic allegory in which the protagonist stands for Lacan's eye and the camera for Lacan's gaze. The first is 'in flight', the second is 'in pursuit', and both are always intertwined.

A13 Lacan's schema of the two interchangeable cones suggests that the screen protects the eye from the gaze. Removing the cones from this fixed position problematizes this 'safe' relation. The slippage of the two cones produces a tilted screen which can capture anamorphic images. But the complete disconnection of the two cones totally abolishes the screen, the notion of perspective's picture plane and the assumption that observers and objects are uniquely positioned and motionless. The sliding of the two cones and their freedom to function independently suggests a different kind of visual construction where there are many viewing and vanishing points simultaneously.

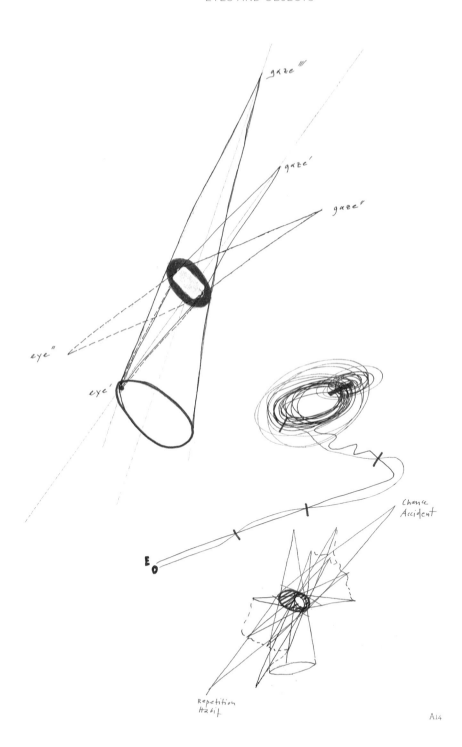

gaze‴

gaze′

gaze″

eye″

eye′

E O

Chance Accident

Repetition Habit

A14

A14 Just like Lacan, Beckett presents many eyes, as well as many *kinds* of eyes, within the self and outside it. There are all these inescapable eyes looking at O and most of all there is always the tyranny of self-perception. The gaze, linked with the self's desire, is everywhere and unstoppable. In everyday experience the gaze is suddenly sensed when it appears in the visual domain unexpectedly in the form of an accident. Accidents come obliquely or from behind to awake the routines of vision. If habits are linked with the automatic function of the eye, accidents relate with the unexpected psychological performance of the gaze, what Lacan calls 'the encounter with the real'. The cones of the eye and the gaze are interdependent but move freely. When they do not perfectly match each other, accidents and mistakes slip through the screen and rupture the safe representations of the self.

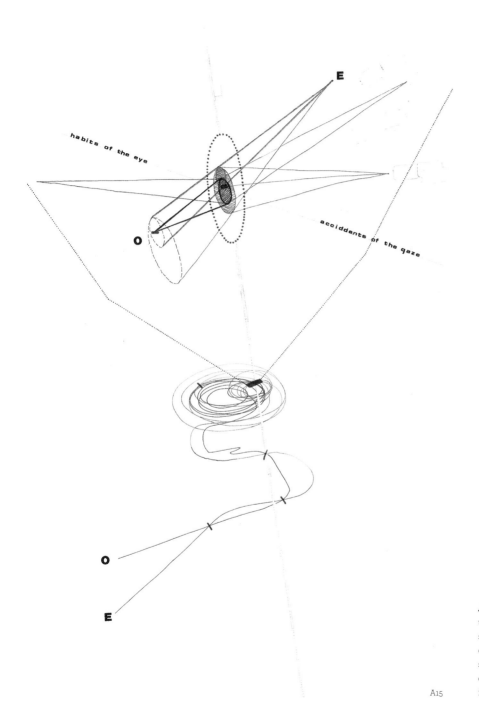

habits of the eye

acciddents of the gaze

E

O

O

E

A15 Like many of Beckett's works, *Film* is about the unspoken and unseen elements of experience. O's eyeless, soundless and emptied room is perhaps the equivalent of John Cage's silent work *4'33"*. When all languages and stories are told, when all intended images and sounds are eradicated, the self is still there, capable of creating complex imaginary structures, vulnerable to chance.

A15

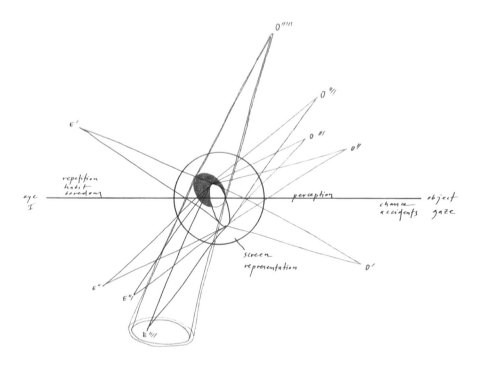

A16 The accident as the true 'encounter with the real' is inevitable even in the most controlled, well-framed and minimal environments of Beckett, Cage or Mies van der Rohe. But slips, unconscious deviations and chance events will happen in any case. Because architecture *belongs in the real* and is not something other than the real. And also because you, the self, participate in this real. Admitting the accident in the process of design, means admitting something of the indeterminacy that surrounds it to enter it. It means lessening the distance between architecture and life.

Notes

1 The British Film Institute holds a copy of *Film* (1964) in 16 mm. The actual 'Stencilled Typescript Shooting Scenario' by Beckett and many scholarly studies of *Film*, both published and unpublished, are housed in Beckett's archive at Reading University.

2 Samuel Beckett, *Film: Complete Scenario/Illustrations/ Production Shots* (Faber and Faber, 1972), p. 16.

A16

3 Beckett, *Film: Complete Scenario*, pp. 41–48.

CROSSINGS
Viewing Instrument I

B01 Photographing in regular intervals the space behind me means capturing snapshots of a space that I cannot normally see. These out-of-sight surroundings affect aesthetic experience, in other words the totality of my sense perceptions. The full causes of this sensorial totality, including what I perceive as 'accidents', are invisible. Metaphorically, therefore, chance comes from behind to astonish and enrich my habits of seeing and everyday experiences.

B02 Preliminary sketch plan, scale 1:40. I view the space that extends in front of me and behind me simultaneously. I keep the right eye naked, looking forward. I equip the left eye with two small mirrors at suitable angles so that they can bring the image of the space that extends behind me reflected into the mirror which is placed in front of my left eye.

B03 Preliminary sketch plan, scale 1:20. I calculate the angles of the mirrors and the exact shapes and sizes of each, so that the reflected image of the space that extends behind me matches the front left mirror exactly. The black areas indicate the shapes of the two mirrors: the left side mirror is shaped with an inverse perspectival distortion in order for the reflection to correspond to the rectangular front mirror and for the side mirror to not have any more surface than it needs.

B04 Preliminary plan, scale 1:40. I draw the plan of a controllable room with installed mirrors, assuming that I should look at them from a fixed position. Then I decide that I need this mirrored 'room' to move freely with me, so that I can test my surrounding perception in real, changeable environments.

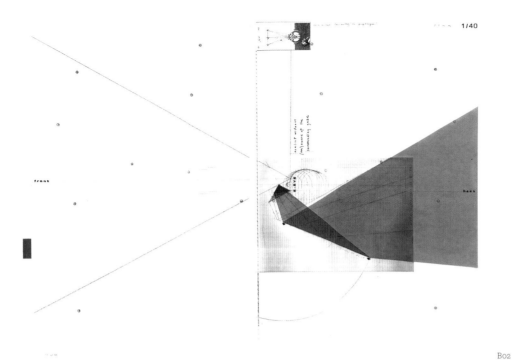

1/40

B02

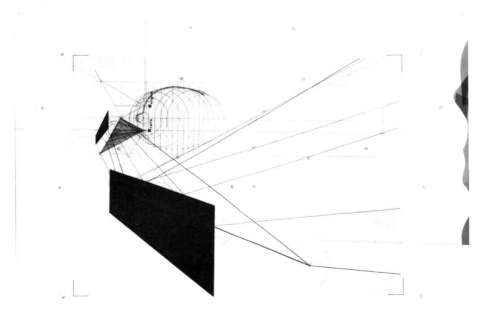

1/20 B03

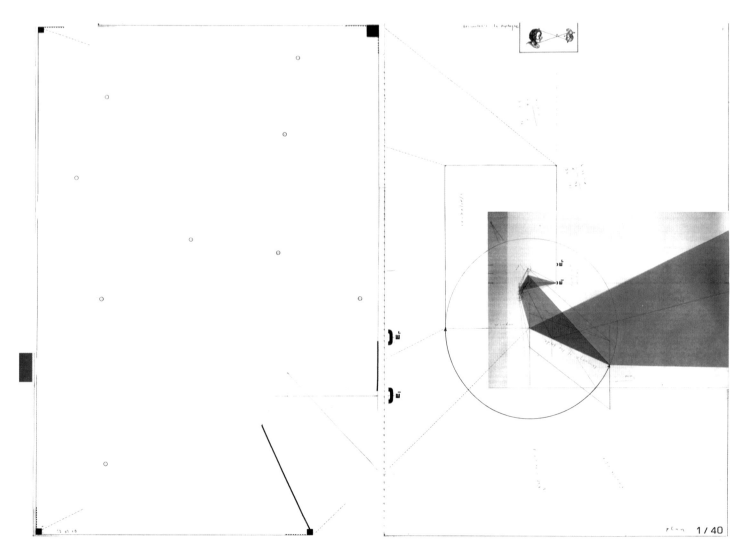

plan 1 / 40

B04

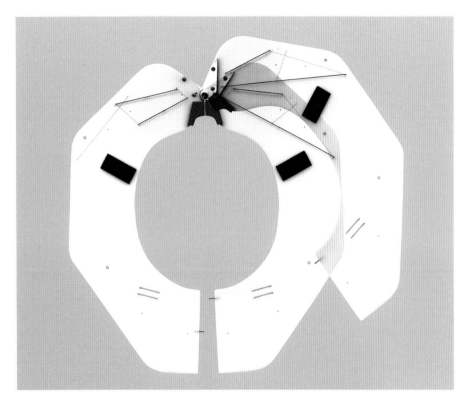

B05

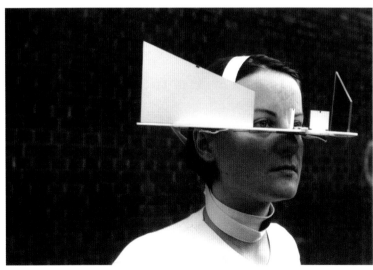

B06

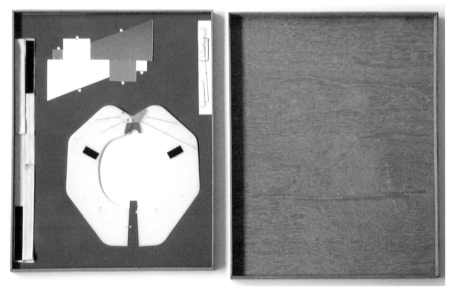

B07

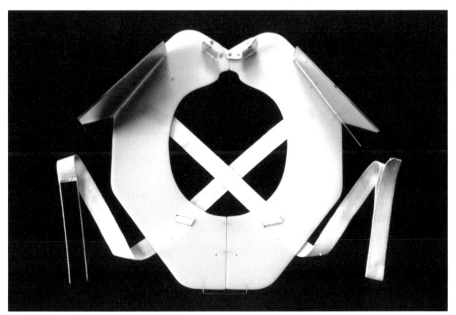

B05 B06 Negating the perspectival model of perception which assumes a frontal and fixed position and a singular flat picture plane, I make a portable full-scale model and wear it as a helmet. I use light materials to easily fasten it around my head. I open and close the rim with the aid of a central hinge, adaptable on the position of the nose. Using specific mirror arrangements, I capture images of the surrounding space stereoscopically in real time and while I move freely.

B07 B08 The case of *Viewing Instrument I* works as a toolbox. I include six different-size mirrors, wire fixings, spare velcro pieces and a pair of cloth straps to use when I want to alternate the viewing arrangements.

B08

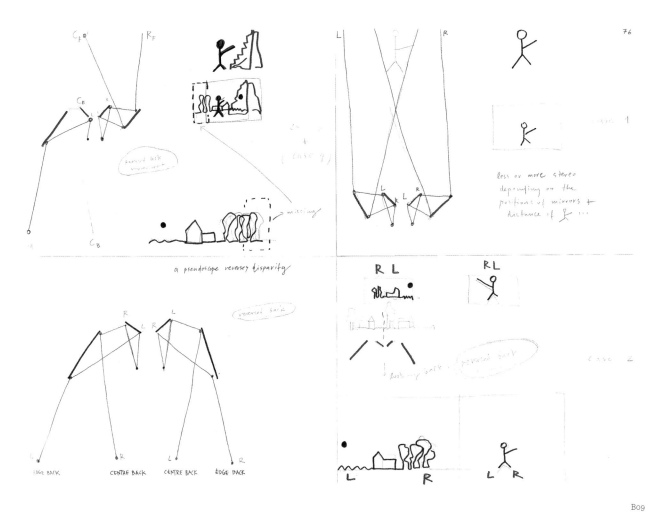

a pseudoscope reverses disparity

less or more stereo
depending on the
positions of mirrors +
distance of 웃 ...

EDGE BACK CENTRE BACK CENTRE BACK EDGE BACK

B10

B09 B10 At first wearing the instrument gives me an intense sense of visual confusion, causing dizziness. Familiar surroundings suddenly seem illusory and unreal since my memory images brought over from 'normal' vision are still my main criterion for interpreting reality. To keep concentrated on what I see in the mirrors is distressing. But strangely my body movement will help: by walking forward, for example, the animating back views make more sense. I keep moving. It is only through wearing the instrument for long periods of time and through repeated action that the views gradually become more comprehensible. I try to keep the same configuration on for about fifteen minutes until I nearly adapt to the new perceptual situation. It is by habit and action that we organize perceptions into a coherent spatial system in which expectation meets experience.

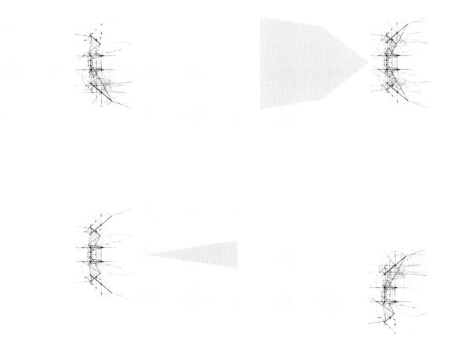

B11 The diagrams show:

a. Viewing the left-back and right-front parts of your surroundings stereoscopically. Both mirrors reflect the left part. The reflected images are discontinuous because of the flipped left-back image.

b. Viewing the left-front and right-front parts stereoscopically. The fused image created by the mirrors is a reproduction of what I would see in front of me with naked eyes.

c. Viewing the left-back and right-back parts of the space flipped horizontally. Each of the two mirrors reflects a horizontally flipped image of the space behind me. The two mirror images do not match stereoscopically: the left-back and right-back parts of the space merge in the central area of the new stereoscopic image and the central-back part splits in the outer edges of the new image.

d. Viewing the right-back and left-front parts of the space. The mirror images are discontinuous because of the flipped right-back image.

B12 The diagonally opposite -back and -front arrangements are the hardest to explain. They are unsettling: like a jumbled up sentence or a body that has lost its coherence. I get nearly panoptic views of the surroundings but the mirror images are disjointed and inversely related, making no visual sense. But while these views don't match my habits of seeing, they correspond to how my body feels its relationship to space. The views are confusing to begin with but gradually make more sense because I move and movement gives me relative clues about my surroundings. The surrounding space reflected in the mirrors is never seen as such but experienced in this way by my body in motion. We are surrounded by space as much as we surround space.

B12

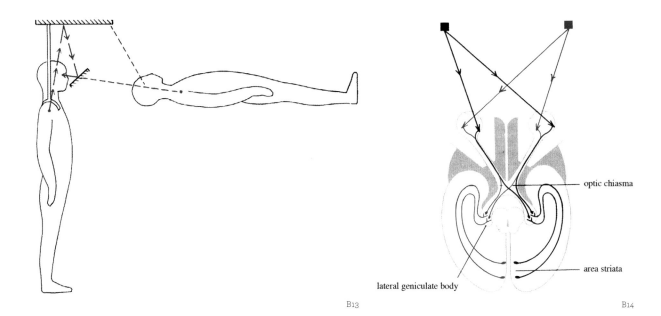

B13

B14

optic chiasma

area striata

lateral geniculate body

Notes

a. For an earlier discussion of *Viewing Instrument I* see Manolopoulou, 'The Interior of Vision: Beckett's *Film* and *Viewing Instrument I*' in *The Journal of Architecture* (vol. 9, no. 3, 2004), pp. 315-30.

b. We perceive in order to move and we move in order to perceive. Scientists have proven that space perception, habit and action are fundamentally interlinked, affecting the evolution of each other. Characteristically, James J. Gibson's theory of perception-in-action argues that depth perception developed in order to specifically help repetitive human endeavours to move through space. Many more theories of space perception have been discussed but there is one nineteenth century scientist who characteristically tested perception through prolonged and repetitive experiments with himself in ways not dissimilar to *Viewing Instrument I*. G. M. Stratton devised experimental optical devices to intentionally deviate from 'normal' vision. For example, he made a special mirror arrangement, mounted in a harness, that visually displayed his body in the air so that it appeared suspended before his eyes. He wore it for days going for country walks in order to get used to the new and strange images. Stratton,

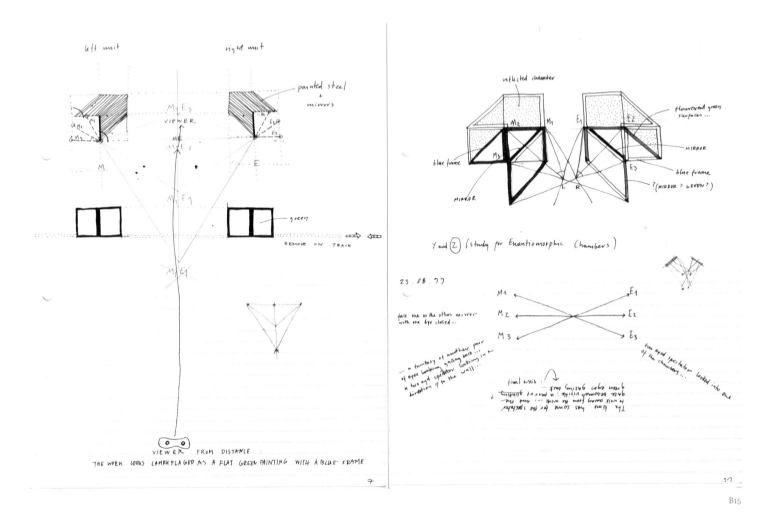

and later Richard L. Gregory, argued that adaptation to disturbed images is possible through repetition and perceptual processes of learning that are enforced by habit (see B13).

B13 Diagram from R. L. Gregory, *Eye and Brain: The Psychology of Seeing* (Oxford University Press, 1998), p. 141, fig. 8.1, reproduced by permission from Oxford University Press.

c. The visual effects of *Viewing Instrument I* may be related to the process of image forming inside the brain. Studies of the anatomy and physiology of vision show that the optic nerves inside the brain intersect at the 'optic chiasm'. Mapping from external visual fields to the cortex is completely crossed: all the information from the right visual field proceeds to the left half of the brain while all the information from the left visual field goes to the right half (see B14).

B14 Diagram from R. L. Gregory, *Eye and Brain: The Psychology of Seeing* (Oxford University Press, 1998), p. 76, fig. 4.6, reproduced by permission from Oxford University Press.

d. Robert Smithson's *Enantiomorphic Chambers* (1965) comprises two identical units hung on the wall like a split stereoscope with two mirrors instead of two pictures. Smithson aimed to 'exclude any fused image' and negate perspective by trying to position the viewer at the very location of the vanishing point. Being at this position 'is as though one is imprisoned by the actual structure of two alien eyes', he said. Smithson, 'Pointless Vanishing Points', in Jack Flam (ed.), *Robert Smithson: The Collected Writings* (University of California Press, 1996), p. 359. Timothy Martin believes that Smithson was interested in understanding vision as a desire mechanism and links his *Enantiomorphic Chambers* with Lacan's theory of the gaze. See Martin, 'De-architecturisation and the Architectural Unconscious: A Tour of Robert Smithson's Chambers and Hotels', in Alex Coles and Alexia Defert (eds), *The Anxiety of Interdisciplinarity: De-, Dis-, Ex-* (Backless Books and Black Dog Publishing, 1998, vol. 2), pp. 91–105 (see B15).

B15 Analysis of Smithson's *Enantiomorphic Chambers*.

BEHIND THE IMAGE

REPETITION

Film was written by Beckett in 1963 in Ussy, France, and filmed under Alan Schneider's direction and Beckett's close supervision in the summer of 1964 in New York.[1] The project was initiated by the producer Barney Rosset who invited eminent authors to write scripts for experimental films to be produced by his company Evergreen Theatre.[2] *Film* was the only one of these projects that Evergreen Theatre succeeded in realizing and the only cinematic piece ever scripted by Beckett.

Beckett's central idea for *Film* was to interrogate vision and the problem of self-perception. He tried to understand the role that repetition plays in the structuring of habits and the self. This is a 'foolish suggestion'—as he called it—for a scene to be repeated seventeen times in the production of *Film*:

(1) Cat and dog in. (2) O with dog to door; dog out. (3) O back for cat; dog back. (4) O with cat to door; cat out. (5) O back for dog; cat back. (6) O with dog to door; dog out. (7) O back for cat; dog back. (8) O with cat to door; cat out. (9) O back for dog; cat back. (10) O with dog to door; dog out. (11) O back for cat; dog back. (12) O with cat to door; cat out. (13) O back for dog; cat back. (14) O with dog to door; dog out. (15) O back for cat; dog back. (16) O with cat to door; cat out. (17) Cat and dog out.[3]

The protagonist Keaton strives to eject the cat and the dog from the room, but each time he puts one of the animals out, the other slips back in. This comic situation takes most of the duration of *Film*, which is only twenty-two minutes long. It comments not only on the repetitive nature of the cinematic medium and the shooting process, but also on the day-to-day repetition experienced within the home. Considering the extent to which Beckett insists on repetition for the whole making of *Film* through the recurring filming of all the objects in the room (window, mirror, fish bowl, wall, chair), it becomes apparent that there is something else at play. This is Beckett's interest in the process of *seeing* itself. Through presenting so many nearly identical scenes in *Film*, he is pointing to the value of repetition in the mechanics of perception and our visual systems of representation at large.

We construct visual representations all the time. We do this through routine modes of interpretation which are necessarily reductive because this is the only way we can make the complexities of reality bearable. The representations that we construct are nothing but *masks*, which simplify and sometimes idealize the world to protect us from the plethora of information that surrounds us. What we see is what we want to see, or what we think we see—and not what we actually see. From a psychoanalytic point of view we mask 'the real' because we can't function otherwise. In Beckett's *Film*, as in the processes of perception on the whole, the real has to do with *possibility*: it appears in our systems of representation as if by chance.

A crucial purpose of perception is to identify objects and attach meaning to them. In this process it is largely through repetition and mimicry that individuals adapt to things, learn how to see and act, and create order and significance in their environment. This role of repetition in perception

is so fundamentally constructive that without it we would be unable to categorize our surroundings and create hierarchies of visual information. Through assisting the functions of memory and spatial knowledge, repetition makes perception partly an automatic mechanism. As a result everyday buildings, if seen again and again, tend to go unnoticed. This lack of attention towards one's familiar surroundings, this lack of energized and active perception, is to a large extent the consequence of habit.

HABIT

The lack of attention associated with habit is discussed extensively by Henri Bergson who was an important philosophical influence on Beckett.[4] For Bergson habit determines an 'inattentive' kind of perception: involved in many similar daily actions, we become 'conscious automata' and respond to our environment with 'reflex acts'. This kind of perception, blended with memory, is based on motor mechanisms of seeing and is not specifically motivated, just automatic. It depends on resemblance, familiarity and the recollection of memories. For instance, we descend a staircase without consciously thinking about each step because we have memories of doing this many times before. We are likely to notice any deviation from the norm of this daily activity quite quickly. A chance occurrence can provoke a more voluntary function of seeing, closer to what Bergson calls 'attentive recognition'. Attentive recognition is intense, emerging from the perception of difference.[5] Buildings encourage different degrees of attentive and inattentive seeing, but in their more ordinary everyday function they are primarily appropriated

mechanistically by habit.

Habits help us form some kind of practical knowledge about the world and create a sense of stability and continuity in it. Buildings we visit frequently or inhabit continuously encourage the formation of habits on account of their familiar and enduring character. As Walter Benjamin remarks, when buildings are appropriated by use they are mastered by habit and 'tactile appropriation':

> Buildings are appropriated in a twofold manner: by use and by perception—or rather, by touch and by sight. Such appropriation cannot be understood in terms of the attentive concentration of a tourist before a famous building. On the tactile side there is no counterpart to contemplation on the optical side. Tactile appropriation is accomplished not so much by attention as by habit. As regards to architecture, habit determines to a large extent even optical reception. … For the tasks which face the human apparatus of perception … cannot be solved by optical means. … They are mastered gradually by habit, under the guidance of tactile appropriation.[6]

When we occupy a building repeatedly we gradually lose our sense of visual attention but this is balanced out by our routine tactile actions which are bodily lived. This may be less the case with public buildings which we use less often and which tend to provoke attentive recognition, usually by highlighting themselves more symbolically. The frequency of visiting a building affects the ways in which we see it and remember it. The first encounter is crucial: we are likely to be attentive and curious about the new space. We want to explore it and understand it. We will appreciate its function as shelter but also its capacity to represent meaning.

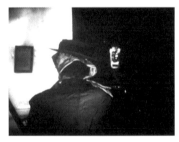

1.1

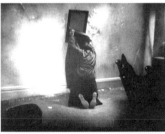

1.2

Thereafter, the more we use the building, the more we get to know it and overlook it. The less attentive we are, the more we 'forget' its physical presence. In this degrading perceptual activity towards inattention and boredom chance events play a significant role: they reverse inattention and awake spatial consciousness unpredictably. Chance events make us take notice more, see, hear and feel more the space we occupy.

BOREDOM

To clarify the plethora of information that surrounds us, we need to forget. Paul Valéry explained this clearly when he wrote: 'to regain control of ourselves in the midst of the moving bodies, the circulation of their contours, the jumble of knots, the paths, the falls, the whirlpools, the confusion of velocities, we must have resource to our grand capacity of forgetting'.[7] At the extreme end of this capacity of forgetting as a necessary and constructive function of the human mind, there is the problem of boredom.

Boredom and the struggle against repetition are often associated with everyday domesticity. Georges Teyssot claims: 'ennui moves beyond the physical limits of the body, to reveal itself in the ... interior rooms of domesticity, where intimate space clocks the body with the uncanny shapes of familiarity'.[8] He calls boredom one of the 'diseases of the soul', characterized by idleness and a state of void bound to the repetitive perception of space.[9] Many authors have considered the advantages and disadvantages of boredom but it is mostly artists who have seen it as a threat. When everything becomes familiar, there is the threat of no attention, no perception, not seeing at all. On this basis a large component of twentieth and twenty-first century art has focused on awakening the viewer through 'defamiliarization': making things strange. Bertolt Brecht played a key role in this school of thought with the strategies of 'shock' and 'estrangement' but, as I will explain in the next section, it is Viktor Shklovsky who offered a clear taxonomy of defamiliarization techniques that can be more directly associated with *Film*.

According to Teyssot, windows and mirrors in the domestic interior play an alleviating but also threatening role for the person who is lonely, inactive, or bored. They symbolise the possibility of seeing beyond the self. At the same time, however, they are distressing because they symbolize the fear of self-reflection. *Film* expresses this exact tension between boredom and anxiety and particularly focuses on the role of the mirror which both escapes and traps the self.

ACCIDENT

The mirror is a central element in *Film*. It is positioned symmetrically opposite the door of the room. Let's remember: E = Eye is the watching camera, following O; O = Object is the protagonist Keaton, running away from E.

When O enters the room, he is threatened by the reflection of his own eyes. But he is careful to protect himself, to avoid seeing his mirror image. Later on in the room sequence he holds a blanket in front of his face, walks round the edge of the room, passes cautiously in front of the window, approaches the mirror from the side, and veils it:

What's important is the gesture of veiling. ... His behaviour when he draws the curtain across the window is similar to his behaviour when he veils the mirror. He is careful not to see himself in the mirror when he veils it, and he is careful also

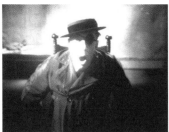

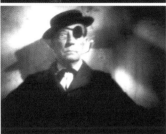

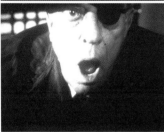

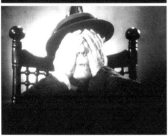

1.3

1.3 O encounters
his own self image.
Film, 1964, stills
reproduced by the
author and published
by permission from
Barney Rosset

not to expose himself before the window when he veils it, so that there is no profile of the window in his vision at all.[10]

O then turns and stares at the chair. The cat and the dog are still staring at him. He decides to eject them. He takes up his briefcase and moves towards the chair when suddenly the blanket falls from the mirror. Disturbed, he drops the briefcase, hastens closely to the wall, approaches the mirror from the side, picks up the blanket, stretches it in front of his face carefully so as not to be seen by the mirror, and veils it again. O suffers from the fear that he may be seen, even 'dismembered' in the reflections of all these surrounding eyes. Again and again he circles the room to screen the possibility of being perceived.

He finally rests. It is then that the most unexpected thing happens. O seems asleep. The gaze pierces him. The gaze is an ocean of possibilities, always there but often unacknowledged, just like time. When it suddenly appears, he sees in front of him his own self: O = E. We, the audience, feel, perhaps like O, the transition from boredom to threat. The scene feels entirely unpredictable. The fear of death is clearly implied but Beckett leaves us unsure as to whether the scene symbolizes the end of O.

It is easier now to detect Shklovsky's defamiliarization techniques in Beckett's work: 'retardation' found in the slowness and repetition used throughout the film; 'double plotting' evolving the E and O relationship; and the 'baring of the device', where illusionism is denied and art reveals its own technical structure—in this case this is demonstrated through E who takes the role of the camera itself.[11]

MIRROR IMAGE

Through *seeing oneself see oneself* Beckett constructs what Jacques Lacan calls the 'underside of consciousness'.[12] The 'memorable' room and 'memorable' chair that Beckett wanted for the last part of *Film* suggest that the setting could be a room that O knew quite well, perhaps his own or his mother's. Notably when O destroys his family photographs, he tries especially hard to tear apart the photograph showing him as a baby held by his mother. I would directly associate this scene with Lacan's thought about the infant's image of itself.

According to Lacan, an infant has not mastered its own body yet and has no conception of itself as a whole thing before the age of six months. But it knows it is separate from its mother and that things exist that are outside of itself. It understands what 'otherness' is but does not yet know what 'self' is. At some point between six and eighteen months, Lacan says, the baby eventually sees its own 'specular' image:

> The mirror stage describes the formation of the EGO via the process of identification: the ego is the result of identifying with one's OWN SPECULAR IMAGE. ... At six months, the baby still lacks coordination. However, its visual system is relatively advanced, which means that it can recognise itself in the mirror before attaining control over its bodily movements. The baby sees its image as whole ... and the synthesis of this image produces a sense of contrast with the uncoordination of the body, which is experienced as a FRAGMENTED BODY.[13]

The baby has not yet achieved full muscular coordination of its body until suddenly it sees a whole specular image of itself on the mirror which, paradoxically, makes it believe it has mastered it.

1.4

This sense of mastery is of course imaginary. The identification of the child with its 'ideal ego' as a whole completed self is a misrecognition. The child does not really see itself but an imaginary self, an 'other'. It can then imagine other seeing beings who see it as whole and ideal. It is important for the subject to imagine that it is seen, that it bathes in a vast illuminating medium of seeingness, because otherwise it cannot conceive itself as whole, or even as existing. This medium of seeingness is the gaze. It emanates from everywhere and the subject can never hide from it unless it ceases being: to not be perceived is to not be.

The child's mirror stage is obviously a metaphor. It represents a permanent condition of subjectivity where the self—fragmented, vulnerable and dependable on others—is continuously threatened by the image of a confident and autonomous identity of wholeness which it can not achieve. This is exactly the story that E enacts: a disjointed body, threatened by its ideal and whole image.

Lacan's theory of the mirror stage corresponds almost perfectly to *Film*'s final scene. Throughout the film Beckett prepares us for the E and O encounter and presents O entirely fragmented, reflected in the window, the cat, the dog, the mirror, the goldfish, the parrot, the buttons, the chair and the photographs. If, as Lacan tells us, the infant is partial to its objects—milk, its mother, teddy bears—so, too, O is partial to the objects and sources of seeingness that surround him. O sustains a contradictory state: an ideal ego of wholeness built on a primary reality that is piecemeal.

I am proposing to read the final sequence in *Film* as an enactment of the Lacanian story of the mirror stage. There is no evidence that

Beckett consciously aimed to tell this story but the commonalities described above, even if unintended, are too many to ignore. Beckett did not know Lacan personally, but they were contemporaries living in France, shared an interest in the unconscious, and were both influenced by Surrealism.[14] Beckett was more inspired by painting and philosophy than psychoanalysis. He characteristically said that he found in philosophical texts 'images' that he would try to reconstruct in his own work.[15] Film's philosophical 'image' came from George Berkeley who claimed that '*esse est percipi*', meaning 'to be is to be perceived'. Berkeley believed that physical objects exist only when they are perceived. Even though his theory of vision belongs to idealism, suggesting that objects depend on a mind for their existence, he points to inter-subjectivity as soon as the early 1700s, alluding to an associative way of thinking about the world in which objects and minds are interdependent and images are produced relationally to both. This approach is not far from Lacan's theory of vision published more than three centuries later.

ACTION PERCEPTION

The philosophical thought of Bergson is another important, if less obvious, link between Beckett and Lacan. It was Bergson who insisted that the human body is intertwined in a world of matter, where matter is 'an aggregate of images'. This matter can perhaps be understood as E's images or the Lacanian gaze. Perception, Bergson claimed, causes affection, and affection causes action.[16]

Very little has been published about *Film*, and nothing that focuses on its relation to architecture and the Lacanian notion of space. The few texts

1.4 Production shot from *Film*'s setting, 1964, © Evergreen Theatre

that discuss it contain diverse and controversial comments, some of which consider *Film* to be an aesthetic failure on the grounds of its minimal content.[17] However, Gilles Deleuze's interpretation of *Film* is positive. A staunch admirer of Bergson, Deleuze studied *Film* extensively, linking it with Bergson's work and consequently defining three types of cinematic images: 'perception-image', 'affection-image' and 'action-image'.[18] Deleuze, like Bergson, Beckett and Lacan, believed that perception is fundamentally affected by the body's *potential action* upon its surrounding objects. Perception depends on the individual's will to act, her potential action in space and her awareness of this potentiality.

Evolutionary psychologists argue that perception's primary purpose is not to provide knowledge but to direct action, to guide body movement through space. Buildings as objects that mark the environment play an important role in the development of this 'perception-in-action'. They guide body movement, influencing the ways in which we act and see and in which processes of acting and seeing evolve. James J. Gibson argued strongly for a direct perception of the world where we perceive material objects pretty much as they are (direct realism) rather as mind-dependent existences (idealism). This ecological understanding of perception might seem distant from Lacan but does not oppose his theory of vision. To the contrary: the psychological aspects of vision enrich the material object by adding to it an imagined response. This response is in actual fact the anticipation of movement, an action desired by the body. The gaze is performative and, as Lacan says, the emphasis should be not on the static notion of the gaze but on the *movement* of the *objet petit a* as it becomes absorbed into the subject.[19]

A THOUSAND VIEWS

Vision and *visuality*, as Hal Foster writes, involve complex physiological, emotional, historical and social factors, acting simultaneously:

> Although vision suggests sight as a physical operation, and visuality sight as a social fact, the two are not opposed as nature to culture: vision is social and historical too, and visuality involves the body and the psyche. Yet neither are they identical: here, the difference between the terms signals a difference within the visual—between the mechanism of sight and its historical techniques, between the datum of vision and its discursive determinations—a difference, many differences, among how we see, how we are able, allowed, or made to see and how we see this seeing or the unseen therein.[20]

The critical theorist Martin Jay describes the status of visuality similarly as 'a complex mix of natural and cultural phenomena' but questions the French antiocularcentric discourse which, he argues, leads at its most extreme to eliminating the optical, reinforcing non-vision and blindness. Jay is interested instead in encouraging the multiplication of 'a thousand eyes' because it 'suggests the openness of human possibilities'.[21] Jonathan Crary, another contemporary theorist and critic of modern culture, focuses on the complexities of vision and visuality, too, but in relation to the faculty of inattention. He states that our visual reflexes are 'such a jumble', that it is impossible to say 'where sight begins or where it ends, or, in some of the reflexes, to see what sight has to do with them at all'.[22]

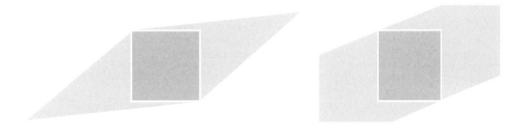

1.5

These divergent references to understandings of vision that I include here are only a small indication of the differences around this topic. My interest is not in arguing for one or the other position but in the dialogical interaction of all. Through association and opposition, I am placing different voices next to each other, hoping that readers might add their own. I see the argument for perception-in-action as ecological in the broadest sense of the word, which includes psychological reasons for movement. Vision is fundamentally a psychological mechanism. The subject's urge to act is not separable from desire and his own self-perception.

PARALLEL PROJECTION

How have the different approaches to visuality determined our representational systems? According to David Marr's computational theory of perception our perceptual system has two centres: the constantly changing, viewer-centred descriptions of the world and the object-centred descriptions which are independent of the incidental movements of the viewer or the viewed. 'These object-centred descriptions', Marr writes,

'play a vital biological role in the perceptual process, since descriptions based on a single viewpoint, or a single moment in time, would be almost useless for purposes of recognition.'[23] The schemata of visual representation mostly used in architecture and art describe these centres of perception through two analogous systems of projective geometry. We tend to use perspective projection to compose viewer-centred images and parallel projection to construct more object-centred descriptions.

Each system is defined by the distance of the viewpoint from the object. If this distance is finite, the projection has a vanishing point and is perspectival; if it is infinite, or almost infinite, the projection is parallel.[24] These two systems of projection not only construct two distinct types of images, but also suggest two fundamentally different understandings of space. Perspective projection assumes a one-eyed spectator at a fixed position. Parallel projection lacks the correspondence between spectator and position and defines no fixed viewpoint. Because the lines run parallel, this projection makes infinity thinkable. There is no suggestion of depth and the represented space can be extruded in front of the picture plane

1.5 The parallel projection shown on the right can be reversible without mimicking depth. Drawing by the author

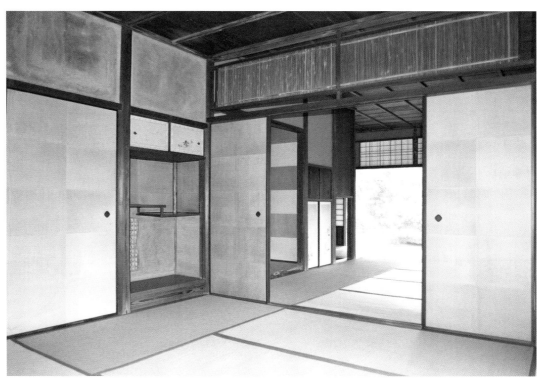

1.6

1.6 Shokin-Tei, one of the tea houses at Katsura Imperial Villa, Kyoto. Photograph by the author, 2011

as well as behind it. Theo van Doesburg's drawing *Architekturanalyse* (1923), for instance, shows how a projection can be reversible and free of the ground. It is easier to allude to indeterminacy with parallel projection than with perspective projection because parallel projection does not mimic depth.

Different systems of representation construct distinct notions of space, and accordingly influence architectural thought and attitudes to design. Pre-modern Chinese and Japanese paintings used parallel projection, showing lines slightly diverging rather than converging with increasing distance, therefore inverting the rules of perspective, and 'pushing' the viewer back towards infinity. Parallel axonometric projection originated in ancient China, where space is philosophically understood as infinite, and where the cultural significance of chance is paramount. Pre-modern buildings in Japan, like the Katsura complex in Kyoto, embody the logic of parallel projection in their composition too: there is no central hierarchy in the architecture, just an expansive spatial sequence of rooms, views and landscapes that emphasize the infinite and the temporal.

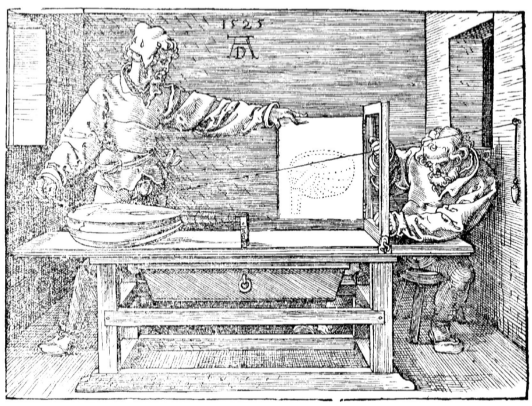

1.7

POINT-HORIZON

Let's return to *Film*'s encircling spatiality and the experience of space behind you when wearing *Viewing Instrument I* as shown in *Crossings*. Think about the notional pair of eyes at the back of your head. The gaze is everywhere, a surrounding watchfulness that constitutes you as the subject of a broader perception.[25]

In the series of seminars 'Of the Gaze as *Objet Petit a*' Lacan defies any clear explanation of the *objet petit a*, although he generally refers to it as the object of desire. Through both enticing and frustrating the reader about the complex meanings of the gaze, Lacan narrates the story of a sardine can which is 'looking' at young Lacan in the same way he is looking at it. The sardine can, Lacan says, is positioned 'at the level of the point of light'.[26] He draws a cone radiating from the subject's eye looking at an object and another cone radiating from the object looking back at the subject (see fig. 1.8).[27] The first cone represents the perspectival domain of what he calls 'geometral' vision. The subject positioned at a geometral point can reproduce a mapping of the image through touch. As Albrecht

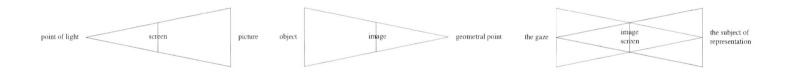

point of light — screen — picture object — image — geometral point the gaze — image screen — the subject of representation

1.8

Dürer pointed out centuries ago, a blind man can situate points in space and construct a perspectival image with the aid of a single thread.[28] In his 'window' of *A Draughtsman Drawing a Lute* (1525) the perspectival image of the lute is produced with the aid of strings (see fig. 1.7)..

But Lacan states: 'I am not simply that punctiform being located at the geometral point from which perspective is grasped. No doubt, in the depths of my eye, the picture is painted. The picture certainly is in my eye. But I, I am in the picture.'[29] The second cone describes the optical structuring of space. This cone starts from the point of light. The subject is positioned 'under the regard' of the object, photographed by its light, pictured by its gaze. The subject is *in* the picture.

In his seminar 'What is a Picture?' Lacan overlaps the two cones and says:

> In this matter of the visible, everything is a trap, and in a strange way ... entrelacs (interlacing, intertwining). There is not a single one of the divisions, a single one of the double sides that the function of vision presents, that is not manifested to us as a labyrinth. As we begin to distinguish its various fields, we always perceive more and more the extent to which they intersect.[30]

The relation of the subject with that which is strictly concerned with light seems ... somewhat ambiguous. Indeed, you see this on the schema of the two triangles, which are inverted at the same time as they must be placed one upon each other. What you have here is the first example of this functioning of interlacing, intersection, chiasma, which I pointed out above, and which structures the whole of this domain [the visual].[31]

In the visual domain the eye and the gaze create each other. Lacan uses Maurice Merleau-Ponty's metaphor of the glove to explain how this structure of vision functions 'like turning the finger of a glove inside out'. Each body moves with its 'point-horizon structure' which, according to Merleau-Ponty, is the foundation of the concept of space. The observer's body, its front and back, left and right, establishes an orientated experience that he calls 'lived bodily perspective'. Spatial experience is 'lived by me from a certain point of view; I am not the spectator, I am involved, and it is my involvement in a point of view which makes possible both the finiteness of my perception and its opening out upon the complete world as a horizon of every perception.'[32] I/Eye participate. I/Eye simultaneously function as an Eye that watches, and an Object being watched. From the participating point of view my body feels a tactile spatiality. From the spectatorial point of view my body observes its own image as an object among others in the world. The two perceptions, participatory and spectatorial, coexist. Merleau-Ponty continues: 'the world and I are within one another, and there is no anteriority of

1.8 Reproduction of Lacan's diagrams on the structuring of visual space. Drawing by the author

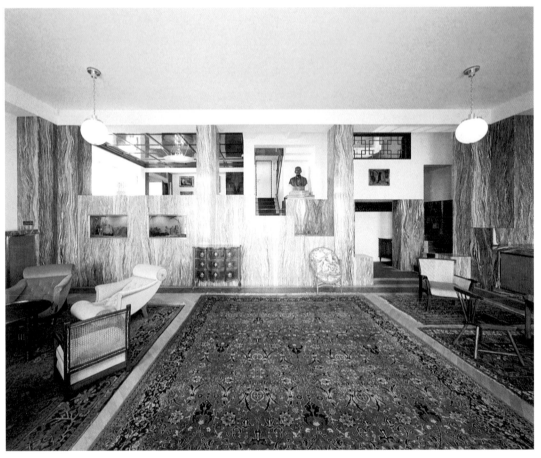

1.9 Adolf Loos,
Villa Müller, living
room, photograph
Radovan Boček and
Pavel Střecha (2000),
by permission from
Müllerova vila /
Muzeum hlavního
města Prahy

the percipere to the percipi, there is simultaneity or even retardation'.[33] And he adds: 'between my body looked at and my body looking, my body touched and my body touching, there is overlapping and encroachment ... the things pass into us as well as we into the things'.[34]

SEEING AND SEEN

Buildings play a significant role in this structuring of the subject's visual field as both participatory and spectatorial. They encourage and prevent seeingness in diverse ways: through the spatial and material positioning and composition of parts, they manipulate fields of vision; through determining qualities and levels of light and visibility, they influence experience.

The architecture historian Beatriz Colomina has critically discussed how architecture is essentially a viewing mechanism that *produces* the subject. She writes: 'architecture is not simply a platform

that accommodates the viewing subject. It is a viewing mechanism that produces the subject. It precedes and frames its occupant.'[35] Le Corbusier's Villa Savoye (1929), to use a famous example, is experienced through a sequence of viewing fields where the gaze tends to slip away. In contrast, Adolf Loos's Müller House, built almost at the same time in Prague (1930), Colomina argues, creates an entirely different viewing mechanism that aims to trap the gaze. Loos's windows aim to let the light in the interior rather than to let the gaze pass through them towards the exterior.

Loos designed the Müller House as a theatrical interior where multiple visual interactions are at play. The occupant, when standing against the windows' blinding light, appears as a mysterious silhouette. Rooms 'look' into other rooms everywhere. Being in the most social area of the house, the living room, does not give you enough privacy because there is another room, the 'theatre box', overlooking. This is the small lady's boudoir raised in the heart of the house.

Several other framed representations, paintings, mirrors, photographs and vitrines are carefully staged to intensify the feeling that someone else might be there looking at you (see fig. 1.9). Colomina writes that in such interiors you feel that you are 'an object for the gaze of others'. In support of this argument she carefully selects this passage from Lacan:

> I can feel myself under the gaze of someone whose eyes I do not even see, not even discern. All that is necessary is for something to signify to me that there may be others there. The window if it gets a bit dark and if I have reasons for thinking that there is someone behind it, is straightway a gaze. From the moment this gaze exists, I am already something other, in that I feel myself becoming an object for the gaze of others. But in this position, which is a reciprocal one, others know that I am an object who knows himself to be seen.[36]

Spatial perception is motivated by the desire to see and to act. It is a matter of possibility, not certainty, which includes involving the prospect of someone else appearing there to watch you. The gaze is found between you and that other location in space.

Lorens Holm, who has made a critical study of the associations between architecture and Lacanian psychoanalysis, proposes various ways in which architecture can determine subject positions. He acknowledges the highly specified interiors similar to Loos's houses, the perspectival streets of the Renaissance, squares and places which are heavily gridded, Le Corbusier's purist villas and the nineteenth century boulevards, among other spaces. Architectural space empowers multiple and simultaneous subject positions and movements, a great number of possibilities for the subject being either in stasis or in motion.[37]

THE PUNCTUM OF TYCHE

Beckett wanted *Film* to achieve an image which is neither about E nor about O but about the ambiguous screen that mediates between them as they produce each other's images. This screen is the locus of our visual representations where we tame the gaze into images. Images cannot possibly represent reality fully, nor accurately. They are reductive devices that make it easier to grasp the excess of information that surrounds us. In this sense images are *masks,* created by each of us in order to protect ourselves from the confusion that arises between us and the world. Foster explains:

Call it the conventions of art, the schemata of representation, the codes of visual culture, this screen mediates the object-gaze for the subject, but it also protects the subject from this object-gaze. That is, it captures the gaze, 'pulsatile, dazzling and spread out', and tames it in an image. ... for we have access to the symbolic—in this case to the screen as the site of picture making and viewing, where we can manipulate and moderate the gaze. ... the screen allows the subject, at the point of the picture, to behold the object, at the point of light. Otherwise it would be impossible, for to see without this screen would be to be blinded by the gaze or touched by the real.[38]

And he continues: 'behind the picture, for Lacan, is ... the real, which always remains, behind and beyond, to lure us. ... This is so because the real cannot be represented; indeed, it is defined as such, as ... a missed encounter, a lost object.'[39] But there is always the possibility of an unexpected accident or error which may 'touch' us by rupturing the protective screen where we construct our ideal images. The gaze is then interpreted as the traumatic point of reality which is felt as touch: it 'pierces' the subject.

In his book on photography, *Camera Lucida*, Roland Barthes defines a related term, the 'punctum'. Closer to the accident than the Lacanian gaze, the punctum of a photograph is 'this element which rises from the scene, shoots out of it like an arrow, and pierces me'.[40] The punctum is a 'sting, speck, cut, little hole—and also a cast of the dice. A photograph's punctum is that accident which pricks me (but also bruises me, is poignant to me).'[41] The source of the punctum is never clear, and its effect is like a cast of the dice. Moreover, the punctum is not a general condition but a 'partial' object,

usually a detail that disturbs and irritates the rest of the picture. It also has the potential to expand, affecting the meaning of the whole scene. Although causality might be able to explain the presence of the punctum, from the spectator's viewpoint the punctum is an accidental addition to the picture. As a result of chance rather than intentional design, the punctum nonetheless becomes part of the reality of the photograph.

I propose that Barthes's punctum is the effect of the Greek *tyche*, meaning chance. There is an intriguing similarity between *tyche* and the term *tuché* that Lacan uses to describe 'the encounter with the real'.[42] *Tuché* emerges unexpectedly to interrupt the norm of one's image. The word can be further associated with the French *taché*, meaning stain or accidental mark, and *touché* which denotes being touched. Characteristically *taché* has been used to define tachism, which is similar to action painting, and the European equivalent of abstract expressionism. There is a sonic and conceptual connection between Lacan's *tuché* and the words *tyche*, *touché* and *taché* which suggests that Lacan's subject is being surprised (*tyche*), touched (*touché*) and stained (*taché*) by the gaze simultaneously. These intertwining meanings make direct links between representation, accident and the real.

HIDDEN IMAGE

The accident interrupts the image. It brings to light a glimpse of something which was previously invisible from the subject's particular point of view. This disruption of the image has been explored in art through anamorphosis, a technique used to reveal a hidden or paradoxical aspect of the represented reality.

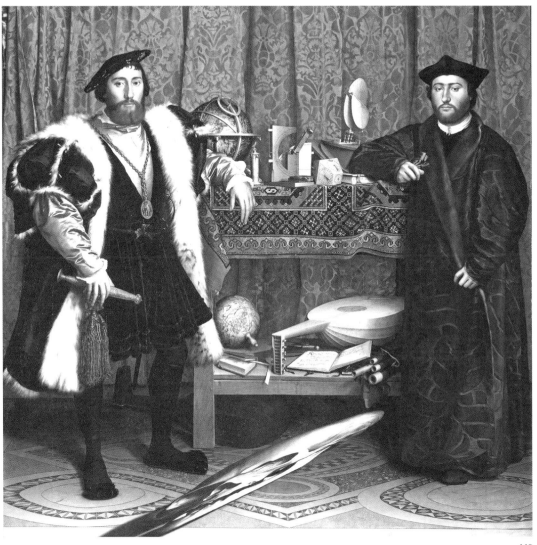

1.10 Hans Holbein the Younger, *Jean de Dinteville and Georges de Selve (The Ambassadors)*, 207 × 209.5 cm, oil on oak, 1533, © The National Gallery, London

Anamorphosis was of great interest to Lacan, who devoted a special seminar to it in which he explained how one can imagine the gaze in the visual domain.[43] He asked his audience to observe the mysterious, suspended, oblique object on the floor of Hans Holbein's famous painting *The Ambassadors* (1533). The object is a distorted image of a skull which can only be restored to normal proportions by standing very close and looking down on it from the right. Ideally the painting has to be hung low at

the base of a wall so that the gallery floor can appear to 'extend' into the picture. The gallery room should also have two doors corresponding to each of the two viewing points of the painting, a main door centrally opposite it and a side door next to it on the right. Jurgis Baltrušaitis writes:

> When the spectator enters by the main door ... He is amazed by their [the ambassadors'] stance, the display of luxury, the intense realism of the picture. He notes a single disturbing factor: the strange object at the ambassadors' feet. Our visitor advances in order to have a closer look. The scene becomes even more realistic as he approaches, but the strange object becomes increasingly enigmatic. Disconcerted, he withdraws by the right-hand door ... As he enters the next room, he turns his head to throw a final glance at the picture, and everything becomes clear: the visual contraction causes the rest of the scene to disappear completely and the hidden figure to be revealed. Instead of human splendour he sees a skull.[44]

When the hidden image of the skull is revealed, the rest of the picture vanishes as something incomprehensible. Lacan adds: *The Ambassadors* 'is simply what any picture is, a trap for the gaze. In any picture, it is precisely in seeking the gaze in each of its points that you will see it disappear.'[45]

Anamorphosis and optical correction as techniques of perspectival distortion have been used frequently in the history of art and architecture, particularly in the sixteenth and seventeenth centuries.[46] They were used as *trompe l'oeil*: a tricking of the eye, making depicted themes magically disappear or change for the pleasure of vision and for alluding to symbolic and hidden meanings. Whole rooms could be filled with large anamorphic murals and strange conical 'toys' that could produce anamorphic effects. Emmanuel Maignan's *St Francis of Paola* fresco in the cloister of Trinità dei Monti, Rome (original 1642), is an extraordinary example, following the same methodological principles as Dürer's 'window' of perspective (see figs. 1.11 and 1.12).

Anamorphosis is often used to imply a critique of conventional perspective. This is misleading because anamorphosis belongs in the same representational system. By mismatching viewer and view, it draws attention to perspective's unsatisfactory relation to reality:

> Perspective is as accidental a thing as lightning. ... [it] is the sign of an instant, of the instant when a certain man is at a certain point. ... in reality, we can change position: a step to the right and a step to the left complete our vision. The knowledge we have of an object is ... a complex sum of perceptions.[47]

At first sight, Lacan's perspectival cones of the eye and the gaze describe a rather dualistic and ocularcentric model of vision. But Lacan presumably used this schema deliberately because of its association with perspective, seen generally as a clear and familiar model for the communication of optics. To this he added a more intriguing diagram of a circle within a circle to describe how 'reality is marginal' and how the eye can 'relax' from the gaze (see fig 1.13). The first circle, representing the screen, partly masks a bigger circle, signifying reality. The role of the screen is to shield reality and 'protect' the individual, but the match is not always perfect. Eyes and objects shift continually in a probabilistic process of image-making that is vulnerable to chance.

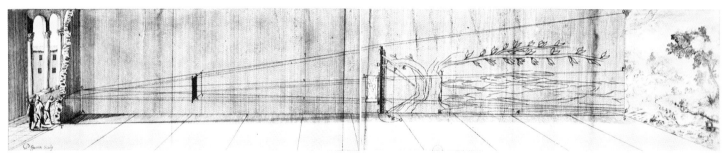

1.11

1.12

1.11 Emmanuel Maignan, apparatus and methods of execution for the large anamorphic composition in S. Trinità dei Monti, Rome, 1648, by permission from Bibliothèque nationale de France, 2011

1.12 Three views of the anamorphic fresco of St Francis of Paula, Trinità dei Monti Convent, Rome, photographs courtesy of Sian Bonnell, 2011

To summarize the main points made about the instability of perception:

a. We *perceive in action* and are surrounded by a larger and performative perception, the gaze. Buildings and objects sustain us in the position of a desiring subject striving to see and to be seen. Self-perception is inescapable and always implicated in the experience of architecture.

b. The gaze is blocked by our images. The image is a subjective interpretation, a 'mask' that we fabricate in order to defend ourselves against visual complexity. We cannot construct a representation of chance, but an aspect of it can spoil our image in the form of an accident, a punctum.

c. This function of chance challenges the dominant but limiting and unsatisfying definitions of architectural space as mainly visual, and interrupts architecture's 'ideal image' relentlessly. The real is behind the mask, *behind the image*.

UNINTENDED BEAUTY

Beckett's interest in the creative possibilities of chance is evident in his *Sans* (Lessness), a short story originally written in 1969, in which sentences

screen **reality is marginal**

1.13

1.13 Reproduction
of Lacan's diagram
on the structuring of
'reality'. Drawing by
the author

are ordered at random. *Film* is, on the other hand, an incredibly controlled piece which at first sight seems to have left very little to chance. But its minimal structure dialectically constructs an openness to chance. *Film*'s minimal content and Beckett's refusal to offer an exact meaning of the story opens the work to speculative extension. One can attach various stories on O's narrative, the emptiness of the room and the silence of the film. Like John Cage's 'Lecture on Nothing' or *4'33"*, *Film* is intentionally indeterminate with regard to its interpretation.[48]

What is more, a number of accidents and failures caused *Film* to deviate from its original scenario. Naturally the passage from one form of expression to the next (from scripting to shooting, for example) is exposed to factors that cannot be fully predictable. The street scene, unlike the other two scenes, was to be public and to involve several episodes of encountering people moving in an opposite direction to O. It ended up being very short, and O met one couple only. The cat and dog sequence, too, became shorter than prescribed because the dog declined further collaboration with Keaton. This situation would be almost impossible to foresee because of the animal's unpredictable behaviour.[49] Schneider did not succeed in materialising cinematically some of Beckett's other original ideas and, most importantly, failed to achieve a clear visual distinction between E's and O's images.[50] However, what looked like a failure in relation to the script became a success in terms of aesthetic outcome. I quote extensively from a letter that Beckett wrote to Schneider:

I have had two screenings here. … After the first I was not too happy, after the second I felt it was really something.

Not quite in the way intended, but as sheer beauty, power and strangeness of image. The problem of the double vision for example is not really solved, but the attempt to solve it has given the film a plastic value which it would not have otherwise. In other words and generally speaking, from having been troubled by a certain failure to communicate fully by purely visual means the basic intention, I now begin to feel that this is unimportant and that the images obtained probably gain in force what they lose as ideograms and that the whole idea behind the film, while sufficiently expressed for those so minded, has been chiefly of value on the formal and structural level. After the first screening I thought again a lot … about the possibility of reinforcing the E–O distinction by means of sound. Now I am definitely and finally opposed to any sound whatever apart from the 'hssh' which I think should be as brief and uninsistent as possible. … I described it [the film] … after the first screening as an 'interesting failure'. … It does I suppose in a sense fail with reference to a purely intellectual schema, that is in a sense which only you and I and a few others can discern, but in so doing has acquired a dimension and validity of its own that are worth far more than any merely efficient translation of intention.[51]

I am on the whole pleased with the film, having accepted its imperfections, for the most part perceptible only to insiders, and discern how in some strange way it gains by its deviations from the strict intention and develops something better.[52]

Film gained from its failures and imperfections because it accepted the deviations from its intentions as a constructive necessity for its making. What Beckett tells us—which is possible for art and for architecture—is that the work should admit to chance not through its intention but through its

actual becoming. In Beckett's words: 'What I am saying does not mean that there will ... be no form in art. It only means that there will be new form and that this form will be of such type that it admits the chaos and does not try to say that the chaos is really something else.'[53] This form of work does not represent chaos but is an integral part of chaos itself. Every designed artefact, be it film, painting or building, is in a way a material restriction of the chance universe. It incorporates chance even when it negates it. Buildings participate in the chaos more explicitly than art objects because they are directly affected by indeterminacy, continually mixing the boundaries between space proposed and space lived.

In her provocative essay 'Against Interpretation', Susan Sontag attacks the tradition of approaching works of art in order to interpret them. Trying to find out what art means is trying to make it manageable to bear, she argues. She calls for art and the experience of art to become more and more real.[54] Architecture is in a privileged position compared to art, where the topic of the real is concerned. Buildings are material objects, inhabited, viscerally and bodily lived, and are also exposed to environmental indeterminacies. If the unconscious of the mind is a reservoir of socially suppressed ideas, so the unconscious of the building is a repository of suppressed architectural possibilities which can emerge for the inhabitants as opportunities beyond the architect's intentions. An interesting other history of architecture could be written by looking at the gap between building intended and building lived and changed.

Architecture is a way of experiencing the building and this experiencing cannot be separated from chance.[55] The pleasure of the chance event, the concealed meaning of failed 'plans', and the curiosity for that which we cannot possible control, makes me wonder about the productive role of chance in the process of design. If chance is inescapable from experience, what are its creative, critical and experimental possibilities in the imagining, drawing, making and co-making of space?

Notes

1 This text can be read in conjunction with the notebook extracts presented in *Eyes and Objects.*

2 Other authors included Marguerite Duras, Günter Grass and Eugène Ionesco.

3 Extract from Samuel Beckett's 'Photocopy of Typescript of *Film* with Manuscript Corrections and Additions by S. B, Dated in Type May 1963', held in Beckett's archive at Reading University, MS 1525/1.

4 Anthony Uhlmann proves the links between Beckett and Bergson in Uhlmann, 'Image and Intuition in Beckett's *Film*', *Substance* (issue 104, vol. 33, no. 2, 2004).

5 For Henry Bergson's thought on the selection and recognition of images in the perception process see the first two chapters in his Bergson, *Matter and Memory*, trans. Nancy Margaret Paul and W. Scott Palmer (MIT Press, 1988), pp. 17–133.

6 Walter Benjamin, *Illuminations* (Fontana Press, 1992), p. 233.

7 Paul Valéry, quoted in Jonathan Crary, *Suspensions of Perception: Attention, Spectacle, and Modern Culture* (MIT Press, 1999), p. 299.

8 Georges Teyssot, 'Boredom and Bedroom: The Suppression of the Habitual', *Assemblage* (no. 30, 1996), p. 47.

9 Teyssot defines two categories of 'diseases' of the soul: spatial and temporal. Nostalgia, claustrophobia, claustrophilia, agoraphobia and boredom are spatial diseases; homesickness, melancholia, fatigue, jet lag and anxiety are temporal. See Teyssot, 'Boredom and Bedroom: The Suppression of the Habitual', pp. 46–48. The distinction in two categories is useful but also problematic because to different degrees most of these types of disorder depend on both space and duration and therefore should be understood as spatio-temporal.

10 Beckett, quoted in S. E. Gontarski, *The Intent of Undoing in Samuel Beckett's Dramatic Texts* (Indiana University Press, 1985), p. 190.

11 Viktor Shklovsky, 'Art as Technique', in Lee T. Lemon and Marion J. Reis (trans. and eds), *Russian Formalist Criticism: Four Essays* (University of Nebraska Press, 1965), pp. 3–24.

12 Jacques Lacan, *The Four Fundamental Concepts of Psycho-Analysis*, ed. Jacques-Alain Miller, trans. Alan Sheridan (Vintage, 1998), p. 83.

13 Dylan Evans, *An Introductory Dictionary of Lacanian Psychoanalysis* (Routledge, 1996), p. 115.

14 Beckett wrote *Film* in 1963. Lacan's first paper on the mirror stage was written and presented at a conference in Marienbad in 1936 and first published in 1949. His papers and articles were circulated in specialized professional journals which means that they were unlikely to have been read by Beckett. Moreover, although his discussion of the eye and the gaze evolved between 1953 and 1964, *The Four Fundamental Concepts of Psycho-Analysis*, a transcription of his seminar of 1964, was not published until 1973. It is worth noticing, however, that Beckett's relationship with the psychoanalyst Wilfred Bion between 1934 and 1935, the years when he undertook analysis at the Tavistock Clinic, London, might have influenced his thought on the 'splitting of the self'. For the effect of his experience of psychoanalysis on his work see Steven Connor, 'Beckett and Bion' (1998), www.bbk.ac.uk/eh/eng/skc/beckbion (visited 23 September 2011).

15 Uhlmann describes Beckett's interest in philosophical images and makes links between Berkeley, Bergson, Beckett and Deleuze in 'Image and Intuition in Beckett's *Film*', *Substance*, pp. 90–106.

16 I will come back to Bergson and the relevance of his thought on the definition of chance as 'impulse' and his influence on architects such as Mies van der Rohe in Chapter 7.

17 For example, Martin Dodsworth writes that *Film* is 'schematic' and 'dogmatic', and that the freedom it seems to give the audience is illusory. Dodsworth, 'Film and the Religion of Art', in Katharine Worth (ed.), *Beckett the Shape Changer* (Routledge and Kegan Paul, 1975), pp. 163–82.

18 Gilles Deleuze, *Cinema 1: The Movement-Image* (Athlone Press, 1992), p. 63. See also Deleuze, *Cinema 1: The Movement-Image*, pp. 56–70 and pp. 227–28.

19 In Lacan's words: 'the space of the *objet petit a* is not static, but rather performative'. Lacan, quoted in Carol Mavor, 'Odor di femina: Though You May Not See Her, You Can Certainly Smell Her', *Cultural Studies* (vol. 12, no. 1, 1998), p. 67. Mavor adds: 'Lacan's gaze is not only a seen gaze. ... Lacan's gaze is a sensate gaze that we can also smell or hear'. Mavor, 'Odor di femina', pp. 70–71.

20 Hal Foster (ed.), *Vision and Visuality* (Dia Art Foundation Discussions in Contemporary Culture, no. 2, New Press, 1988), p. ix.

21 He writes that 'ocular-eccentricity rather than blindness ... is the antidote to privileging any one visual order' and that 'it is better to encourage the multiplication of a thousand eyes, which, like Nietzsche's thousand suns, suggests the openness of human possibilities'. Martin Jay, *Downcast Eyes: The Denigration of Vision in Twentieth-Century French Thought* (University of California Press, 1994), p. 591.

22 Crary, *Suspensions of Perception*, p. 337.

23 David Marr in Fred Dubery and John Willats, *Perspective and Other Drawing Systems* (Van Nostrand Reinhold, 1983), p. 111.

24 A parallel projection is a perspectival image seen from a very great distance or from any distance but with an eye 'larger' from the view (a large flat retina, say, close to a small object).

25 For a related discussion on *Viewing Instrument I* and Beckett's *Film*, see also my paper 'The Interior of Vision: Beckett's *Film* and *Viewing Instrument I*', *The Journal of Architecture* (vol. 9, no. 3, 2004), pp. 315–30.

26 This series of seminars was held at the École Normale Supérieure in Paris in 1964. It belongs in Lacan's major series 'The Four Fundamental Concepts of Psycho-Analysis' which began at the École Normale Supérieure in 1953. Lacan, *The Four Fundamental Concepts*, pp. 65–119.

27 Lacan, *The Four Fundamental Concepts*, p. 91.

28 Dürer was the first to produce perspective by mechanical and tactile means. Jurgis Baltrušaitis, *Anamorphic Art* (Harry N. Abrams, 1977), p. 75 and pp. 87–90.

29 Lacan, *The Four Fundamental Concepts*, p. 96.

30 Lacan, *The Four Fundamental Concepts*, p. 93.

31 Lacan, *The Four Fundamental Concepts*, pp. 94–95.

32 Maurice Merleau-Ponty, *Phenomenology of Perception*, trans. Colin Smith (Routledge, 1962), p. 304.

33 Merleau-Ponty, *Visible and the Invisible; Followed by Working Notes*, ed. Claude Lefort, trans. Alphonso Lingis (Northwestern University Press, 1968), p. 123.

34 Merleau-Ponty, *Visible and the Invisible*, p. 123. There is something from the theory of Lacan's mirror stage implicated also in Hans Bellmer's *La Poupée* series (1933–38). The work involved assembling disjointed life-size doll parts in strange configurations and photographing them in everyday settings. See Sue Taylor, *Hans Bellmer: The Anatomy of Anxiety* (MIT Press, 2000). There are strong psychoanalytic aspects in the unnatural, incomplete and disordered dummies and their disorientation in relation to the photographic frame. The self is presented as a split and scattered object confronted by the reality of the world. It can easily be linked with Lacan's mirror stage, since both imply that the visual construction of the self's wholeness is unattainable.

35 Beatriz Colomina, *Privacy and Publicity: Modern Architecture as Mass Media* (MIT Press, 1994), p. 250.

36 In this passage Lacan is referring to Jean-Paul Sartre's *Being and Nothingness*. Lacan, quoted in Colomina, *Privacy and Publicity*, p. 250. For Colomina's discussion of Loos's interiors see pp. 232–81.

37 Naturally a building supports and encourages many more subject positions than a painting. See Lorens Holm, *Brunelleschi, Lacan, Le Corbusier: Architecture, Space and the Construction of Subjectivity* (Routledge, 2010), p. 168.

38 Hal Foster, *The Return of the Real: The Avant-garde at the End of the Century* (MIT Press, 1996), p. 140.

39 Lacan calls it *objet a*. Foster, *The Return of the Real*, p. 141.

40 Roland Barthes, *Camera Lucida: Reflections on Photography* (Vintage, 2000), p. 26.

41 Barthes, *Camera Lucida*, p. 27.

42 Lacan, *The Four Fundamental Concepts*, p. 53. Lacan links his seminar 'Tuché and Automaton' with Aristotle and the function of the cause. Lacan, *The Four Fundamental Concepts*, pp. 53–64.

43 Lacan, *The Four Fundamental Concepts*, pp. 79–90.

44 Baltrušaitis, *Anamorphic Art*, pp. 104–05.

45 Lacan, *The Four Fundamental Concepts*, p. 89.

46 For a discussion about optical correction in Greek architecture see Banister Fletcher, *A History of Architecture* (Athlone Press, 1975), pp. 193–94.

47 Jacques Rivière, quoted in Dubery and Willats, *Perspective and Other Drawing Systems*, p. 111. Merleau-Ponty also writes: 'the completed object is translucent, being shot through from all sides'. The house I see in front of me would be seen differently from inside, the back street, the balcony of the adjacent house or a helicopter. The house is 'the geometrized projection of these perspectives and of all possible perspectives, that is, the perspectiveless position from which all can be derived, the house seen from nowhere'. Merleau-Ponty, *Phenomenology of Perception*, p. 69. For an analysis of the 'point-horizon structure' and 'the synthesis of horizons' see also Merleau-Ponty, *Phenomenology of Perception*, pp. 98–147.

48 Dodsworth makes the opposite argument, supporting that Cage and Beckett do not under-determine their work but rather over-determine it. Dodsworth, '*Film* and the Religion of Art', pp. 163–82.

49 For more on these and other failures of *Film* see Dodsworth, '*Film* and the Religion of Art', pp. 163–82, and S. E. Gontarski, *The Intent of Undoing*, pp. 101–11.

50 In an attempt to restore *Film*'s 'failings' the director David Rayner Clark reinterpreted Beckett's script fifteen years later and shot a second version in London. Clark's *Film* (1979) uses unnatural colour and noise effects to distinguish more clearly between E's and O's viewpoints. He retains the extras in the street part and tries to stay as close as possible to Beckett's scenario. Yet he gives too many clues about what Beckett may have meant and over-specifies his intentions, losing the intense strangeness of the original production. For a critique see Nico J. Brederoo, 'Beckett's *Film*: An Essay', in Marius Buning, Danièle de Ruyter and Sjef Houppermans (eds), *Samuel Beckett 1970–1989* (Samuel Beckett Today/Aujourd'hui 1, Rodopi, 1992), pp. 168–69.

51 Extract from Beckett's letter dated 29.09.64. Beckett, quoted in Maurice Harmon (ed.), *No Author Better Served: The Correspondence of Samuel Beckett and Alan Schneider* (Harvard University Press, 1998), p. 166.

52 Extract from Beckett's letter dated 12.03.65. Beckett, quoted in Harmon (ed.), *No Author Better Served*, p. 188.

53 Deirdre Bair, *Samuel Beckett: A Biography* (Harcourt Brace Jovanovich, 1978), p. 523.

54 Susan Sontag, *Against Interpretation* (Vintage, 1994), pp. 3–14. 'Against Interpretation' was originally written in 1964.

55 This follows Shklovsky's argument that 'art is a way of experiencing the artfulness of an object'. Shklovsky, 'Art as Technique', pp. 3–24.

Chance in Design

The confusion is not my invention. ... It is all around us and our only chance now is to let it in. The only chance of renovation is to open our eyes and see the mess. ... What I am saying does not mean that there will henceforth be no form in art. It only means that there will be new form, and that his form will be of such type that it admits the chaos and does not try to say that the chaos is really something else. The form and the chaos remain separate. The latter is not reduced to the former. ... To find a form that accommodates the mess, that is the task of the artist now.

Samuel Beckett, Interview with Tom Driver, 1961

PROJECTIONS[1]
After
Duchamp

C01 *The Bride Stripped Bare by her Bachelors, Even* (1915–23), also called the *Large Glass*, permanently installed in the Philadelphia Museum and photographed in two shots from the back, 1999.

C02 C03 Duchamp stood at three different locations and from each one he shot the upper part of the work three times with a toy cannon. And so, with the aid of chance, he depicted the most minimal element of visual representation, *the point*, associating it also with the vanishing point of linear perspective. The diagram is for the making of an adjustable three-dimensional object with colour-coded elastic wires and rings. This object would represent Duchamp's nine hypothetical bullet trajectories and would stand metaphorically for vision as being spatial, fluid and in motion.

C04 When the gas touches the Bride as an amorphous splash, an 'electrical stripping' occurs. The Bachelors' domain is drawn in a rectilinear manner based on Euclidean rules. The volume of gas in the Bride's domain is drawn in a haptic way, guided by the punctured holes.

C05 Drawing of the possibility of contact between the Bachelors and the Bride. This momentary contact is imagined through the 'demultiplied' body of vision, a trajectory of vision which is spatial, multiple and in constant motion, as it originates from the eye, the Oculist Witnesses on the Bachelors' panel (red dot), and projects itself onto the Bride's panel (blue cloud). Measurable and geometrical organization for the Bachelors panel; impulsive and indeterminable configuration for the Bride's panel.

C06 Nine points (one point for each Bachelor), each one multiplied nine times. Each network of nine points is outlined with a different color. The dotted lines indicate the combined trajectory of the Bachelors while they traverse through different configurations in search for their final position close to the Bride.

C07 The trajectory of the demultiplied body of vision happens through rotation as the Bachelors' domain hinges to meet the Bride's territory. The gaze of the nine Bachelors explodes to perforate the plane of the Bride. All eighty-one (nine by nine) points pierce the paper as holes to allow the 'illuminating gas' to reach the Bride on the back side of the drawing.

make diagram of demultiplied body

or little model with
wires + rings.....

POINTS: The NINE SHOTS.

C03

C02

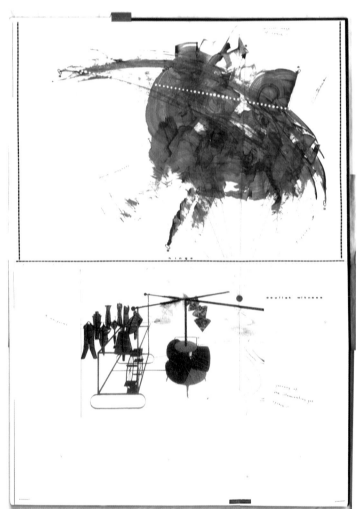

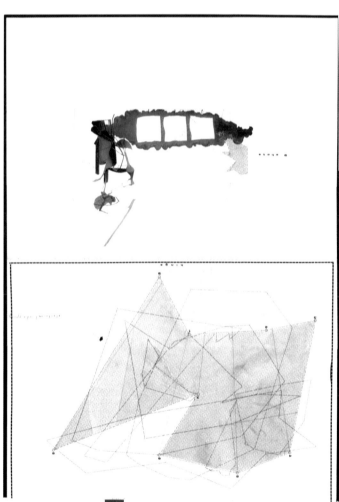

C04

51

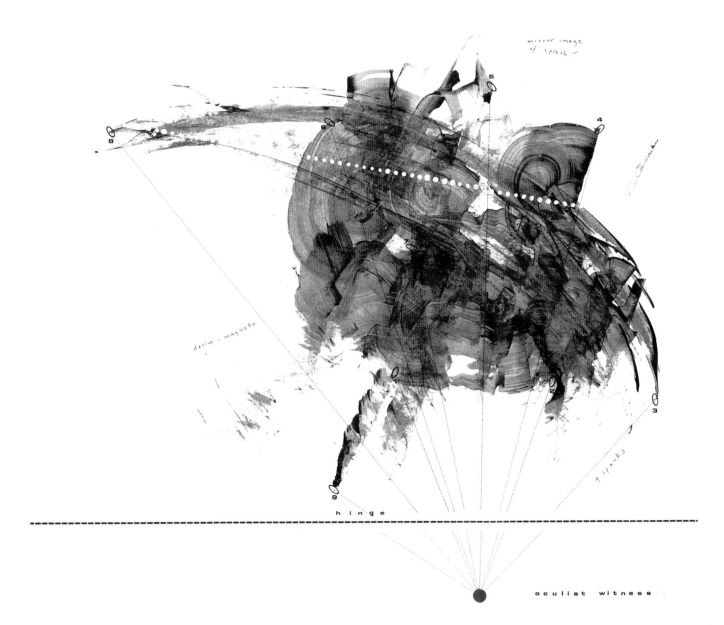

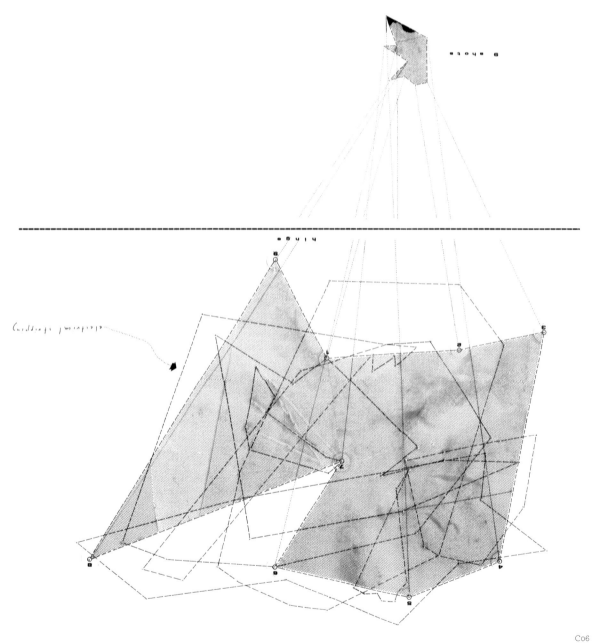

C06

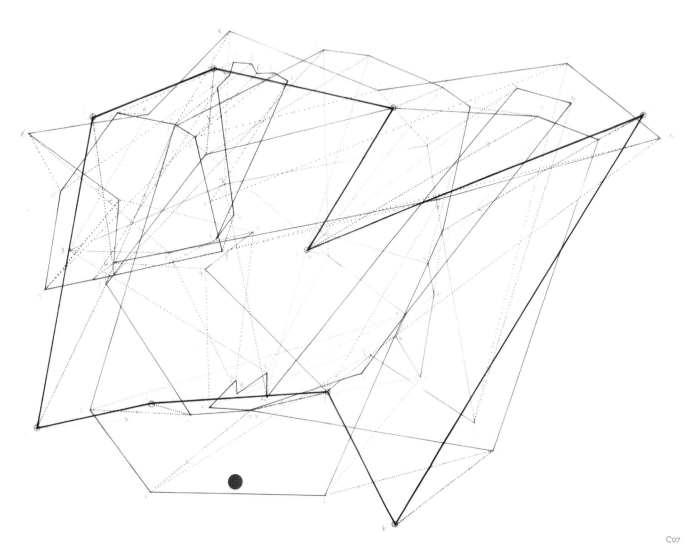

C07

C08

C08 The Milky Way represents the Bride's experience of 'cinematic blossoming' and is formed by the three air-blown nets of the Draft Pistons. For the Milky Way Duchamp originally used the French title *Voil lacteé* which, as Craig Adcock suggests, sounds like *voile acté*, meaning 'enacted veil'. Eadweard Muybridge's photographic work *Dancing Girl—A Pirouette* (1887) depicts a 'bride' pirouetting with a veil. Muybridge set up his cameras 'watching' from three different viewpoints while the observed woman-in-action would trip a sequence of wires, automatically releasing the shutters. In this manner three simultaneous but different views were captured on different plates. While Muybridge's isolated snapshots encouraged the viewer to imagine the missing fragments of the full action, the physiologist Étienne-Jules Marey, who was inspired by Muybridge, created chronophotographs to offer the viewer the entire movement from start to finish in one image. It is easy to see Marey's influence on Duchamp's figure of the *Nude Descending a Staircase* and Muybridge's influence on the triptych of the Milky Way for the *Large Glass*.

eyes + objects are moveable — we see a succession of different perspectives + from different points of view. Our position is rarely central, fixed etc — in fact it is always accidental in relationship to the surroundings.

A. deviations from a point
B. deviations from a line
C. deviations from a plane

— all things are spinning
the veil covers (an invisible motor) a probabilistic mechanism of chance.

→ the L.G.
a snapshot
a poincaré cut.

— Shearer: many pictures / perspectives from different points of view merged into one impossible perspective.

— Delay in Glass
Determine a succession of various facts in order to isolate the sign of the accordance between the State of Rest (all the innumerable eccentricities and a choice of possibilities)

7

A Poincaré cut or [snapshot] = L.G. = A poincaré cut is a window into a system of chance + complexity which captures emergent patterns of randomly-generated order.

poincaré technique:
to infer an invisible 3-nal object from only the cast shadows in 2 dims

Poincare: the idea as readymade= + intuition
pnof + elaboretation = logic
— a "readymade" idea that then one converifys by experiment + measurement +

Donald M. Davis:
"The nature + power of mathematics"

D + Poincare: both say that
"the unconscious" mind chores
"the intuition", not logic

• LG: a rd-nal slice of a fourth dim-nal university —
• small differences in "initial conditions" create indeterminat or chance results
 ex: roulette + weather
• motor space has as many dimension as we have muscles.
• many simultaneous perspectives at a given time → one chosen.

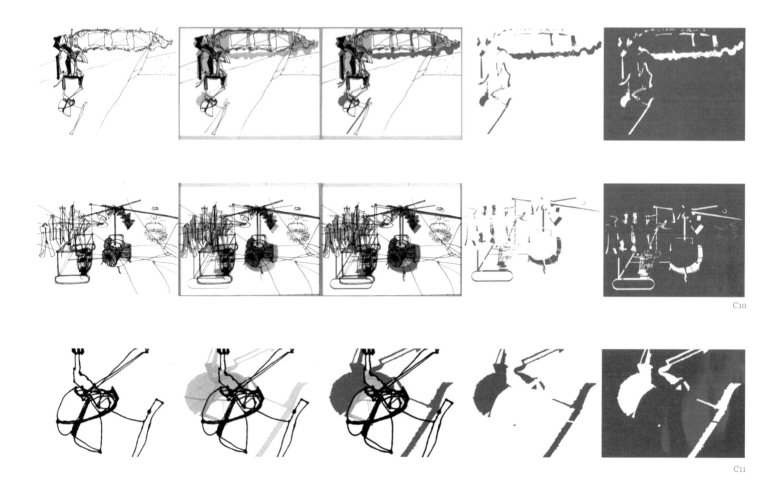

C10

C11

C09 Duchamp's and Poincaré's understandings of space had a triple form: visual, tactile and motor. But Duchamp's interest in representation expands beyond Poincaré's rationale to include questions of desire, emotion and play. Duchamp challenged, if not ridiculed, the dominance of scientific truth, pointing to its arbitrariness and limitations. His interrogations were more about the subjectivity of the individual and one's own fabrications of chance rather than any notion of universal chance.

C10 C11 These drafts for an animation represent the mismatch between the painting of the *Large Glass* as is and the painting as drawn from observation.

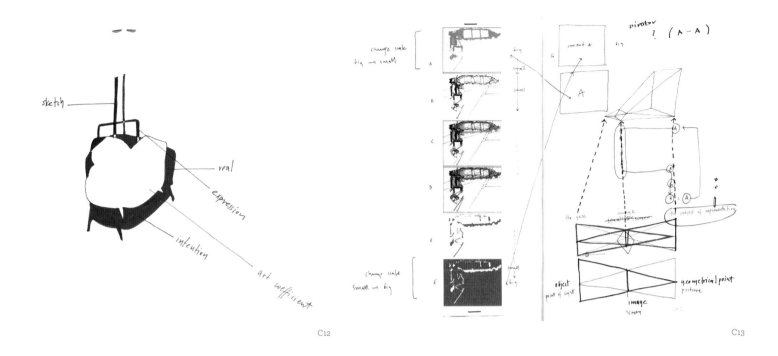

C12

C13

C12 C13 The aim of the animation would be to draw parallels between Duchamp's definition of the 'art coefficient' as 'the difference between intention and realisation' and Lacan's discussion about the structuring of the image as a screen that masks the real.

C14 C15 Study of the breakage of the *Large Glass* sketched from observation in the Philadelphia Museum of Art in 1999. Isolating the cracks from the figurative content of the work reveals the structural logic of the forces of the accident. Duchamp saw the cracks as a real 'canned' chance and a necessary addition to the piece.

C16 Due to its breakage and decay the *Large Glass* has become more remarkable over time. Positioned in front of a window in the Philadelphia Museum of Art, its impact on the viewer is incomparable to those of its intact replicas. Light exposes the disintegrating areas of the painting, giving it an extra plastic quality. It illuminates the cracks and makes the work sparkle.

Notes
1 Refer to Chapter 6 which is entirely devoted to Marcel Duchamp's experimental use of chance.

you see it

realist witness → when you see the
reflection of a body
on the silver lines

Ⓐ appearance & dissapearance

C15

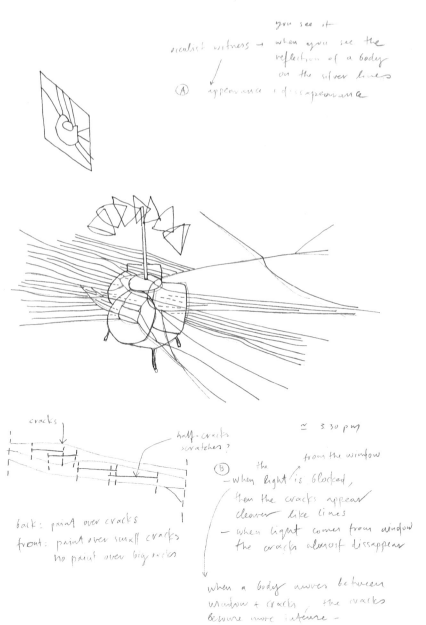

cracks

half-cracks
scratches?

≃ 3.30 pm

from the window

Ⓑ the
- when light is blocked,
then the cracks appear
clearer like lines
- when light comes from window
the cracks almost dissappear

back: paint over cracks
front: paint over small cracks
no paint over big cracks

when a body moves between
window + cracks the cracks
become more intense -

C14

C16

SHUTTERS
House F

There is a branch of architectural research that is particularly worth considering. It involves drawing and making that is not at first sight directly applicable, in the sense of logically solving building problems. This type of drawing and making would not routinely result in generally 'useful' products. Instead it constructs helpful mediating devices for the architect-researcher, standing somewhere between imagination and application, and helping her invent her own questions. These devices derive from the desire to play freely with an idea, without having to find deterministic solutions to situations. They help the designer, even if only temporarily, to enter the children's zone of 'unformed' toys: an enjoyable and independent world of interrogating ideas through indeterminate play.[1]

D01 *Shutters* explores relationality within the context of *House F*—a building design for a single-family house in Patras, Greece.[2] The piece attempts to capture the visual essence of an array of hinged panels that could intertwine the edge of the house. The panels would create a fugitive zone between the interior and the surrounding olive grove, a place sensitive to the changeable conditions of light, weather and inhabitation.

D02 Imagine openings, hinges, folds and breakages for an arrangement of flexible shutters. Lines, surfaces and shadows as ethereal as a three-dimensional drawing, perhaps resembling the infra-thin line structure of leaf veins. Make a flat template with adjustable parts that can be repeated to make a larger and more complex model with reconfigurable surfaces.

D03 Paint the planes of the model pale green on the front, silver on the back, recalling the flickering of olive leaves in the Mediterranean sun. Turn the hinged planes, some inward and some outward, splitting each one of the shutters into two or more parts. To fold or not; to position here or there; to show silver or green. What shadows will be cast?

D04 In addition the project describes a design mode that is useful beyond the limits of the particular house. As a reconfigurable model, always present in the studio, it can influence the making of other works.

D05 For example, it led to our design for the Visitor's Centre for the Brockholes Wetland and Woodland Nature Reserve in NW England.[3]

D02

D03

D04

Just as natural materials such as sand, water, bark and rock are ideal unformed toys for a child's imaginative play, *Shutters* is an unformed architectural object, an open-ended toy for design. Each time a part of *Shutters* is unfolded, a new motif appears. Reconfiguring the plasticity of this piece resembles playing chess or rearranging the words of a poem.

But is our strong desire to play with chance—as children, designers or creative adults in general—acquired empirically or inborn? Developmental psychologists Jean Piaget and Bärbel Inhelder investigated this question by asking whether the intuition of chance is as fundamental as, say, that of whole numbers (understanding 1, 2, 3 and so on). Through a number of experiments they demonstrated that in fact young children have no concept of chance at all.[4] This is because they have neither a concept of law nor a concept of design as an organized operation. Children before the age of seven make decisions about future occurrences in an entirely emotional manner. In an experiment with a spinning bar Piaget and Inhelder asked

'Do we know where the bar will stop? 'On the yellow', the child answered. When asked why, the child replied, 'because that's a wonderful yellow'. When the ball eventually stopped on the blue ball the child would come up with a justification, such as 'the bar got tired'![5] Children under seven years old fail to differentiate between the possible and the necessary. On the other hand seven- to eleven-year-olds discover the existence (and irreversibility) of chance but only through its antithesis: tangible organized operations that they can now perform. Finally, at eleven or twelve years of age children can deal with both tangible and hypothetical operations, construct a synthesis between chance and design, and gradually build their judgement of probability. Piaget and Inhelder's experiments prove that chance and order as fundamentally interdependent ideas begin to take shape in one's consciousness only after the age of seven.

The idea of chance is a 'secondary and derived reality' dependent on the search for order and its causes. It is through our understanding of the reversibility of order

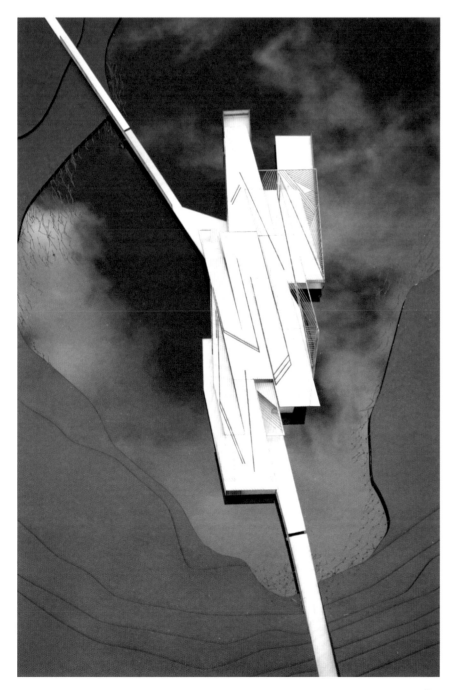

and rationality that we can recognize their opposites. And it is exactly this combination of causality and chance that satisfies the human mind in both art and design: we simultaneously seek order and difference, monotony and surprise. This is also the basis of play to which both adults and children are attracted. Neither intuition nor conscious logic can affect the result of the cast of a die but we are nonetheless tempted to guess the result and bet on it. This pleasure perhaps reflects a desire to overthrow our gradually acquired attachment to causality and return, at least temporarily, to that childhood period of ignorance when we understood neither causality nor chance.

Notes

1 For a definition of the 'unformed' in relation to architectural design, see Yeoryia Manolopoulou, 'Unformed Drawing: Notes, Sketches and Diagrams' (*The Journal of Architecture*, vol. 10, no. 5, 2005), pp. 517-25.

2 I have designed *House F* in collaboration with Anthony Boulanger through our studio AY Architects (www.ayarchitects. com), 2006.

3 Competition entry by AY Architects, 2008.

4 The definition of chance as the interaction of independent causal series is given by the mathematician and economist Antoine-Augustin Cournot (1801-77).

5 Jean Piaget and Bärbel Inhelder, *The Origin of the Idea of Chance in Children* (Routledge and Kegan Paul, 1975), p. 62. In another experiment, after the child repeated wrong predictions for the arbitrary positions of the coloured balls in a tipping box, the psychologist asked: 'And if we continue [tipping the box], can we know what will happen [with the positions of the balls]?'; the child answers: 'No, no one can be sure because we aren't balls.' Piaget and Inhelder, *The Origin of the Idea of Chance*, p. 7. For another discussion about play refer to Chapter 6.

D05

FIELDS
Drafting Pier 40

E01 Jutting into the Hudson River, Pier 40 opened in 1963 as the major single ship terminal in the US, to be used for embarking transatlantic passenger ships of the Holland America Line. The fifteen-acre pier, at the time the largest reinforced concrete structure in the world, would later change its use to accommodate warehouse and parking facilities. Today Pier 40 is a garage for more than 2,000 vehicles. Responding to the recreational needs of the local communities, an international architectural competition, set by Manhattan's Community Board 2 and the Van Alen Institute, invites new design visions to transform the pier into an open public space. *Drafting Pier 40* begins as a response to this call.

E02 The floors, ceilings and walls are demolished. Peeling off the majority of the pier's surfaces offers direct access to the river, clear views of the surroundings and an open field for public use.

E03 The central structural frame stays intact to preserve a single element: the garage's system of circulating rings as a characteristic icon of the pier's industrial history. The rings are now converted into pedestrian routes. Moving in rotation to view the surroundings means reconstructing the most memorable experience of the pier when it was used as a garage.

E04 The rings can also be used as balconies for panoramic vistas and for the observation of the events that happen on the pier beneath. The core area of the pier is intentionally left free and imagined as a public garden.

E05 Dots: Make nine drawings, each one with a different number of distributed dots at random.

E06 Lines: Make nine drawings, each one with six curves differentiated by thickness and texture.

E07 Horizon and Net: Make two more drawings, one with a straight line (the horizon) and one with a grid of squares (the net). Then randomly overlay transparent copies of all the Dot-, Line-, Horizon- and Net-drawings to create twelve new 'falling drawings' by chance. The Latin origin of the word accident, *accidere*, derives from *cadere* which means 'to fall'.

E02

E03

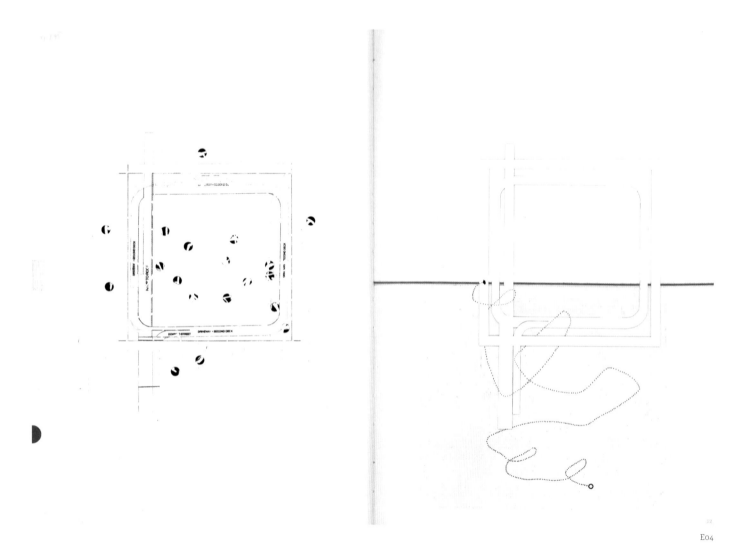

E04

sheet with 12 dots

sheet with 29 dots

E05

sheet with curves -6

sheet with curves - 7

E06

and Graph 2 is a blak-graph measuring (2 × 10) inches, marked into 1000 by 20 squares.

list of actions — —
excerpt from 'Water Walk':

0'43"- start fountain
(slow, faster, faster, fastest)
off at 55"

0'58"- start egg-cooking

1'39"- start washing machine

1'46"- start Radio #4 + coffee mak

48^ - slam lid coffee maker +
start tape loop- water s

2'15"- rubber duck sound in

2'24"- pour coffee in tub +
rubber duck again.

10 inches

2 inches

Graph-2

- Take a sheet with curving lines
- Place over it one of the transparencies containing points
- Over this, place Graph 2.
- Connect any point that is enclosed by Graph 2 to a point outside of Graph 2 by using Graph 1.
- Measurements horizontally on the top and bottom of the graph with respect to the straight line give a "time bracket" (time within which the event may take place.)
- Measurements vertically on the graph with respect to the intersections of the curved lines and the straight line may specify actions to be made.

E07

FONTANA MIX

E09

E08 Each of the falling drawings suggests the organization of a plant bed as a possible component of the park.

E09 Gradually the plant beds are imagined as flower islands that might embark from the pier to reach other parts of Manhattan's waterfront.

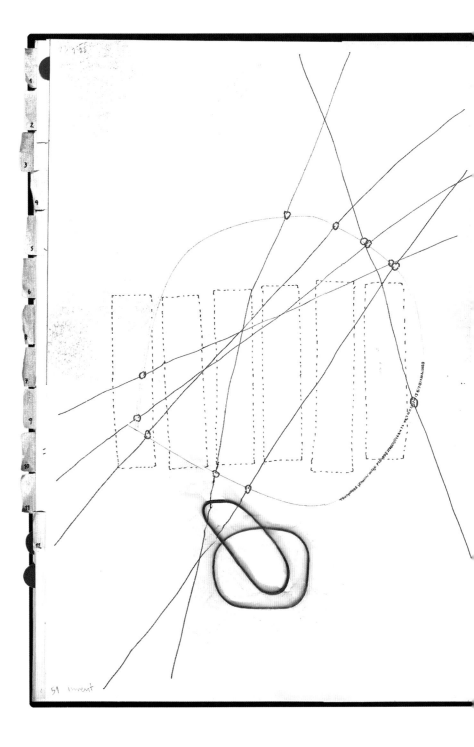

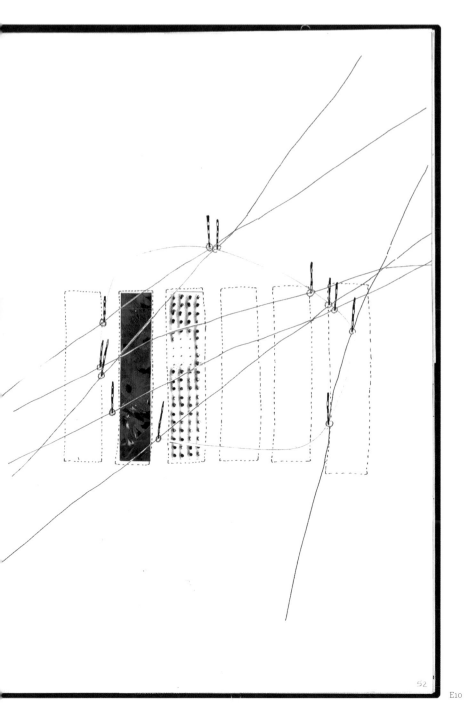

52

E10

E10 The flower islands could take up Pier 40's entire area and assemble a larger garden, set sail and leave the pier totally free, or compose other intermediate situations. *Drafting Pier 40* is a shifting landscape of parts, providing variety and an element of surprise in the city, depending on when and where the flower islands are located.

E11 While the floating islands wander off the pier, their plants grow and blossom. Improbable images can be formed if, through the islands' artificial and technologically managed micro-climates, the growth of plants is specifically regulated to be analogous to their distance from the pier.

E12 The further away a flower island is, the bigger its volume gets. As the island slowly shifts away from the pier, viewers see its volume as unchanging in size. This analogous correspondence between plant-growth and distance from the riverside upsets the viewers' habitual expectation of perspectival depth. The belief that an object appears to be smaller as it moves away from the observer is disturbed.

E13 Modelling starts with a found object, an unused skateboard salvaged from Brick Lane Market in London. The curved geometry of the skate-mould is introduced into the topography of the site so that the ends of Houston and Clarkson Streets to the east of the pier smoothly meet a new hollow floor.

E14 The pier's floor sinks under the water surface, forming an interior-like space below the horizon. The continuous concave ground allows one to stroll with ease until its edge.

E13

E14

E15

E16

E15 During the process of catalysing resin the model bends outward towards the opposite direction of the pier's cavity. This is a cast accident. 'Cast' means a throw of a die as well as an object that is made by pouring a liquid substance into a mould. The accidental form makes a key suggestion: the edge of the pier should not be a definite hard edge but a smooth slope that creates a shifting boundary of water.

E16 When the model is being made, its in-between stages are interpreted as 'found architectures' of the future life of the pier, influenced by the circumstances of weather, time and inhabitation. Seven chance images correspond to seven 'Imaginary Landscapes': hypothetical snapshots of the pier as it is imagined to change in time.

E17, E18 and E19

E20, E21 and E22

E17 Imaginary Landscape I: The mould of the pier.

E18 Imaginary Landscape II: The floor of the pier as transparent. Sun reflections in fair weather.

E19 Imaginary Landscape III: Bandaged pier. The pier as stage. During periods of transformation, cloths cover its entire surface.

E20 Imaginary Landscape IV: Possible layering of dust, pressed sand and gravel. Special floor coatings aid the layering of textures, unintentionally accumulated or purposefully deposited.

E21 Imaginary Landscape V: Pool or ice rink. The poles are used as vertical measuring sticks for water and ice levels. The rings function as measuring tools and carriers of park equipment and furniture.

E22 Imaginary Landscape VI: Flower garden in the summer.

E23

E23 Aquatic garden in winter. The trajectory of the floating flower islands.

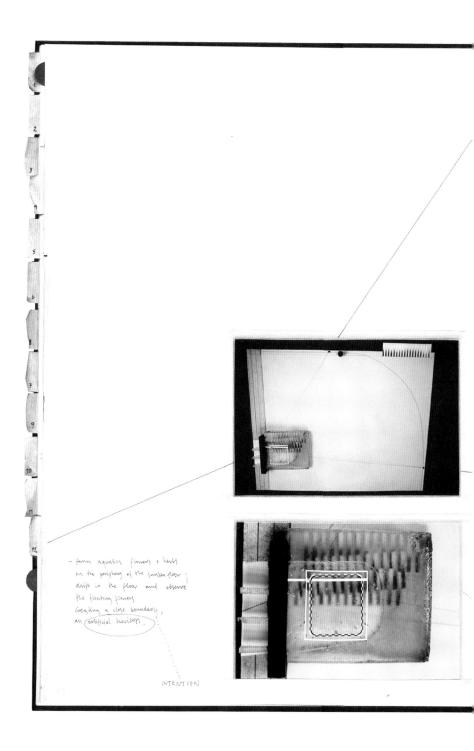

– farm aquatics flowers + herbs
on the periphery of the sunken floor;
drift in the floor and observe
the floating flowers
Creating a close boundary,
an (artificial horizon).

INTENTION

REALISATION

E24

E24 Aerial views of the pier: Water colour change and flower colour range.

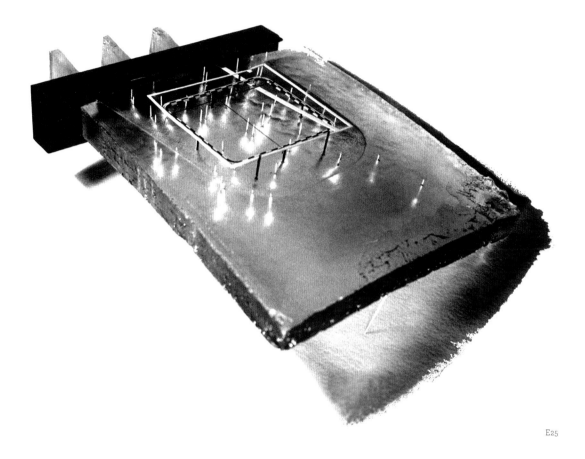

E25

E25 Poles: An assembly of poles is suggested. More random 'falling' overlays of the dot templates are repeated as many times as needed to create a dense net of points and define the floor plugs of the poles. The poles mark and measure the site vertically. Any number of poles can be plugged into any configuration depending on the choices of future occupants. Using a manual switching operation, visitors can make them glow to illuminate specific areas of the park if they choose.

E26 Rulers and Objects: The mid-height ring carries two intersecting rulers that scan the pier horizontally. The top ring works as a hanger and a sliding track for the transportation of objects like screens, windshields, rain collectors, shower sprinklers and shading covers. Rulers, hangers and tracks 'draw' operations in the pier, casting shadows, pausing or moving as needed. *Drafting Pier 40* is a live drawing apparatus continually changing itself within a set frame of minimal rules defined by the architect's chance operations.

E26

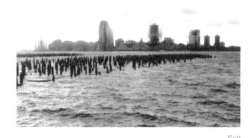

E28

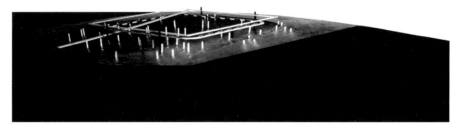

E27

E27 *Drafting Pier 40* is above all characterized by emptiness, attempting to prolong the design process to the inhabiting stages of architecture. The new pier is conceived as a nearly blank, three-dimensional 'drawing board' built at full scale. Readymade features of the site (like the circulating rings), the architect's chance (like her dot-drawings determining the locations of the poles) and a design strategy that incorporates further chance relations (between plants, water, objects, tools and people) all combine to make an aleatory landscape that can endlessly draw and change itself. Aleatory performance comes from *alea* (Latin for 'dice') and means the practice of not completely specifying

the end results of a piece. The composer or director designs only a part of it while the rest is completed by the performers' interpretations. Thus an aleatory piece has as many forms as performances. We can think of architecture in similar ways. A building produces as many spaces as it has occupied moments in time.

E28 Christmas 2001, New York. A visit to the site amazes me. Walking around, I discover the remains of the adjacent pier. *Drafting Pier 40* already 'exists': it has already come about without my intervention. Chance can be understood as nature, presiding over the ways in which architecture is planned.

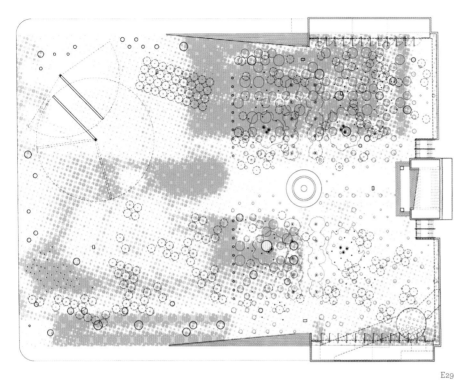

E29

E30

Notes

(a) *Drafting Pier 40* is a hostage to chance in the form of temporal occupation, weather and seasonal change, as well as the diachronic effects of time. The title 'Imaginary Landscape', used for each *found* architecture discovered at different stages of the model-making process, is the exact name used by John Cage for several of his chance-related pieces executed between 1939 and 1952. *Imaginary Landscape No. 4* (1951) in this series is his famous piece for twelve radios determined by whatever sounds happen to be on the air at the time of the performance. Overall *Drafting Pier 40* is set up dialogically with Cage's views on indeterminacy and his chance operations. Drawings 05–07 are direct adaptations of the instructions for *Fontana Mix* (1958). By superimposing drawings on different sheets of paper the performer of *Fontana Mix* creates different structures from which new music scores can be made. Similarly *Drafting Pier 40* can endlessly adapt itself to new spatial arrangements. For a detailed analysis of *Fontana Mix* see Chapter 7.

(b) Earlier versions of this work have been published in Manolopoulou, 'Drawing on Chance: *Drafting Pier 40*', *The Journal of Architecture* (vol. 11, no. 3, 2006), pp. 303–14; and '*Drafting Pier 40*: The Development of Chance as a Drawing Tool in the Process of Architectural Design', *Architectural Design Research RMIT* (vol. 1, no.1, 2005), pp. 19–38.

(c) In 1999 I worked with Anthony Boulanger, Penelope Haralambidou and Eduardo Rosa on a related project for the Syntagma Square International Competition, Athens. The proposal consists of hundreds of poles with light attachments ('floating hats' for shade, lights and flags for use in various celebrations and events). A half-tone typographic image, enlarged as an anamorphic projection to the size of the square, composes the architectural plan with a dense grid of pole foundations. All poles and hats are movable and can compose dense or sparse thickets and clearings, ordered or jumbled arrangements as desired. When the hats, adjustable at different heights, cast shadows in the day and pools of light at night, the image of the circular patterns of the floor shifts accordingly. Syntagma Square is a life-size indeterminate score continually changed according to its performative and varied use. Images E29, E30 and E31 ©Tessera.

E31

THE PRACTICE OF OBSERVATION

CHANCE IMAGE

The suggestion that architecture is part of the world and can be discovered rather than made may at first seem bizarre. But it is not. Star constellations can be thought to form drawings in the sky; rock and sand patterns can be interpreted as drawings made by nature over time. For the architecture to be detected, an intense and creative mode of seeing is required by the observer. Choosing where, when and for how long to observe is important. The observation must be patient, attentive and open to difference and change. It is an activity that requires practice to become skilled.

Accidental figurations, which have not or cannot be made by human intention but resemble recognizable shapes—such as the appearance of a face in a cloud formation—have particular value in art and are widely accepted as images made by chance, and referred to as *chance images*. The phenomenon is a manifestation of the primal human desire to find meaning in ambiguous figurations through pictorial association. Nineteenth century sculptor Adolf von Hildebrand's description of the 'enhanced perception' where the object's and the eye's accents coincide provides one of the best explanations of the chance image:

> In nature an appearance may be of such kind that the arrangement of its accents with respect to the functioning of the eye does not coincide with the accents which we need for the perception of spatial objects, and therefore the interests come into conflict. However, it may so happen that by chance an appearance may be such that both are discovered together and that the object, as a unified appearance, has an unexpected significance for the eye. This provides a strong visual image; for all interference is removed from the act of perception and the greatest resultant force is achieved. For it is not just a matter of a lack of interference, of the negative, as it were, but something positive, a matter of enhanced perception, of heightened force. Such moments in nature are artistic revelations, essentially artistic configurations.[1]

The 'heightened force' points to the beholder's imagination and the active power of perception. Acting between the observer and the world, chance is a silent mediator in this process, the agent that causes perceptions to coincide, clash or match, until the image is evoked. This process of acute, associative and imaginative observation is a foundational precondition for drawing and for architecture because it links the remembered, the observed and the imagined in a synthetic manner. In his book *A Scientific Autobiography*, based on notebooks from the 1970s, Aldo Rossi remarks on the creative value of observation in his work. He writes:

> Perhaps the observation of things has remained my most important formal education; for observation later becomes transformed into memory. Now I seem to see all the things I have observed arranged like tools in a neat row; they are aligned as in a botanical chart, or a catalogue, or a dictionary. But this catalogue lying somewhere between imagination and memory, is not neutral; it always reappears in several objects and constitutes their deformation, and in some way, their evolution.[2]

Some thirty years later, architects Jacques Herzog and Pierre de Meuron, for whom Rossi was an influential teacher, produced the exhibition *Archaeology of the Mind* and the book *Natural History* as a twofold project focusing on the creative

interplay between processes of observation and processes of design. In *Natural History* theoretical discussions about visual perception, the attentive and creative gaze of the beholder, and the ambiguity of natural phenomena observed on rocks and vortices are paralleled by illustration sequences of their architectural projects and processes. The book makes implicit correspondences between the creativity involved in seeing and in making architecture and art. It presents commonalities between the residues of observation and of design, many of which are centred on the idea of chance images as either found or evoked.

A DREAMER APART

Skies and rocks have been places for contemplation and exercising the imagination for as long as anyone can remember. A red pebble was found, carried from miles away, and preserved some three million years ago in a cave in Makapansgat in South Africa because it looked as though it had human faces on it; Pliny the Elder describes the image of Apollo and the nine muses suddenly 'rendered by nature' when a block of Parian marble was split open;[3] the Chinese cut veined marble in such ways as to reveal images of treasured mountains; Franciscus de Retza gives an incredible account of an animal body appearing on a cloud as vividly as though it were 'ready to drop from the sky';[4] James Abbott McNeill Whistler defines the artist as 'a dreamer apart' who perceives 'curious curvings, as faces are seen in the fire'.[5] The stories are many. In these and many other descriptions what is notable is the primary role that nature plays in the making of the chance image. The image is partly found in nature and partly elaborated by the human imagination.

Artists, from Leon Battista Alberti and El Greco to Pablo Picasso, Salvador Dalí and the contemporary Gerhard Richter, have used chance images as generative devices for their work. But there is a difference between image *encountered* and image *made*. An image encountered might be the discovery of the appearance of an anthropomorphic pattern on a rock, given its distinctive shape by complex environmental and geological phenomena. The image made, however, would be intentionally produced by the artist, like Andrea Mantegna's painting of the horseman on the clouds. Chance in the first case is fluid: it refers to people's inherent ability to make believe, and to shift between multiple pictorial associations impulsively and charismatically. The second case is a fixed presentation of the ambiguity principle on the surface of the painting: a hidden image is constructed as a visual pan, asking the viewer to see two images in the same figuration. While the encountered chance image is evoked and open to manipulation, the hidden image in the painting is a pictorial trick seeking a predetermined response.

The making of the image as an oscillating activity between various associative processes and experiences is the most spatial, and therefore most interesting for architecture. To understand this, we need to look at a different art mode practised in the nineteenth century. The great Romantic painters managed to represent the workings of the mind and of nature as two parallel and intertwined conditions on the surface of their paintings. James Abbot McNeill Whistler's *Nocturnes*, for example, are suggestive of a *felt reality* and intend to evoke images similar to those the painter encountered in

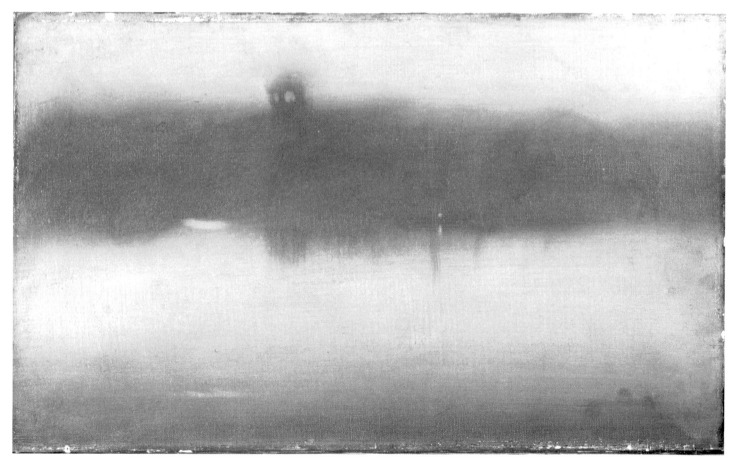

2.1 James Abbott McNeill Whistler, *Nocturne*, 31.1 × 51.8 cm, oil on canvas, 1875–80, Philadelphia Museum of Art (John G. Johnson Collection, 1917)

the city. Whistler used to take journeys on a boat on the Thames in order to observe places and events in the dusk. He would then go back to his studio and work from his dim impressions.

John Ruskin, on the other hand, recommended the observation of nature with the 'innocence of the eye', as a blind man who, suddenly gifted with sight, might see it for the first time. Accidental light and the complex and circumstantial environment were not transported onto the painting in a literally illustrational way. There was instead the desire to paint *in the manner of* nature, to enact the forces of the sky and the sea physically while painting. J. M. W. Turner 'began pouring paint onto the paper till it was saturated, he tore, he scratched, he scrubbed at it in a kind of frenzy and the whole thing was chaos'.[6] As a result, the painted scene requires an imaginative reconstruction by the viewer, an analogous patient and intense activity of observation until she can sense the chaos.

PERCEPTION AS HYPOTHESIS

Although different stories about chance images are sporadically documented across times and cultures, it was in the Italian Renaissance that the chance-image principle was coherently theorized in texts for the first time. In fact the role of chance as a creative agent was appreciated tremendously by Leonardo da Vinci and Leon Battista Alberti, who associated it with the origins of painting and sculpture respectively.

Leonardo acknowledged the creative power of chance in drawing and painting explicitly. His habit of staring at the sky, at crumbling walls and at moving liquids is well known: 'I have even seen shapes in clouds and on patchy walls which have roused me to beautiful inventions of various things, and even though such shapes totally lack finish in any part they were yet not devoid of perfection in their gestures or other movements.'[7] These 'gestures' of nature are characterized by instability, lack of finality and clarity. But for Leonardo confusion was a positive thing: 'confused things rouse the mind to new inventions'.[8]

The technique requires prolonged staring at the same optical stimulus until one becomes familiar with the different and numerous possible perceptions, and with the process of shifting between varying perceptions. This is a perceptual inquiry of doubt and play. The result is not a definitive and materially restricted figure, but a potential and malleable image surfacing dynamically in the mind. As psychologist R. L. Gregory suggests, what we see is only a creative hypothesis: 'perception is not determined simply by the stimulus patterns; rather it is a dynamic searching for the best interpretation of the available data'.[9] In this context I propose that

the architect should dare to observe and thereby discover. When practised observation becomes skilled, it is something more than a creative hypothesis, becoming a design and aesthetic process in its own right.

Philostratus believed that the difference between the artist who projects images onto his panel and the layman who projects appearances into the ambiguous shapes of rocks and clouds is a difference of manual skill determined by the ability to imitate. This was overturned by Renaissance thought which recognized the role of *fantasia* in art as superior to *mimesis*.[10] While Leonardo associated chance with drawing, Alberti argued that chance works best for the artist's *fantasia* during the tactile process of making objects. It is the ability to discover images in ambiguous tree trunks and clumps of earth while manipulating these forms, and it is the skilful adding or taking away of material when working with clay, that defines the artist, Alberti argued. This association of chance with the origin of sculpture presented in his *De statua* is different from the more passive role that chance takes in his *Della pittura*. For in *Della pittura* Alberti sees the images found in cracked marble as complete in themselves and therefore not needing further elaboration by the artist. This is a significant difference from Leonardo, who saw this type of chance images on stones and clouds as incomplete, and therefore actively generative for the artist's drawing.[11] However, Alberti's distinction between chance in drawing and chance in making can be especially understood in the context of the dominance of perspective and the tracing of shadows in the drawing practices of the Renaissance. Both of these are controlled processes of *mimesis* and, in their effort to imitate, resist the

2.1

2.2 Alexander
Cozens, Plates 1–16
('blot' landscapes)
for *A New Method
of Assisting the
Invention in
Drawing Original
Compositions of
Landscape*, Plate 9,
24 × 31.5 cm, aquatint
on paper, c. 1785,
© Tate, London 2011

creative potentiality of the accidental and the unformed.

BLOTSCAPES

In the eighteenth century the use of chance in art was revalued and put into practice by the British painter Alexander Cozens. His illustrated treatise *A New Method for Assisting the Invention in Drawing Original Compositions of Landscape* described how the making of casual accidental ink blots could be used methodically for the composition of landscapes. The resultant 'blot landscapes' were not entirely accidental—since the subject of landscape

representation was sought proactively—but, as Cozens argued, they were productions of chance 'with a small degree of design'.

Cozens used chance to creatively describe the forces of nature, and his liberating techniques of chance arguably influenced Constable, Turner and the great Romantic landscape painters of the nineteenth century.[12] In terms of his own inspirations, we should look to the Far East. The Chinese appreciation of the aesthetics of chance started to have an impact on the West during the late seventeenth and eighteenth centuries. Athanasius Kircher's *China Illustrata*, published

in 1667, presented Chinese iconography related to chance, including Chinese signs of writing which were understood as abstractions from natural phenomena. In addition, in the eighteenth century small marble paintings came to Europe from China, which may have also had an influence on Cozens. Between the eleventh and eighteenth centuries veined marble was studied thoroughly in China and cut in such ways as to reveal chance images. Marble pieces were skilfully sliced to reveal ambiguous figurations that could suggest landscapes, alluding to well-known mountain ranges and valleys. Each marble piece was then carefully framed, and an evocative inscription was added, thus preserving the chance image and elevating it to the status of art. Cozens's method can also be associated with the Chinese method *i-p'in*, or *untrammeled*, which was particularly open to spontaneity and chance.[13]

Many of the chance-related techniques used in the twentieth century avant-garde, such as surrealist automatism, nonfigurative abstraction and action painting, can in fact be linked with much earlier uses of chance in the history of art in early Chinese painting and calligraphy, and by Leonardo, Alberti, Cozens and the Romantic painters. The synergy between art, nature and *fortuna* (good luck) in the making of chance images has a long history and has been researched in detail from the points of view of ambiguity and indeterminacy by Dario Gamboni. Gamboni posits that although the importance of chance in modern and contemporary art has long been recognized both in practice and theory, little attention has been given to the history of the idea of chance and its use in the arts before then.[14] There are exceptions

and it is interesting to see direct links being made by the artists themselves. For example when Max Ernst explained his frottages, which incidentally have a similar quality with Cozens blotscapes, he openly referred to Leonardo:

> On August 10, 1925, I was seized with an unbearable visual need to discover the technical means whereby this theory of Leonardo's is clearly worked out in practice. It began with a childhood memory … I made a series of sketches on the floorboards by arbitrarily placing a few sheets of paper on them and then began to rub on them with a black pencil. When I closely scrutinized the sketches … I was amazed at the sudden intensification of my visionary capabilities and the hallucinatory result of the contrasting pictures.[15]

Rubbing the texture of various materials—floor, leather, stale bread, thread, wooden letter types and so forth—became Ernst's obsession, and a series of his rubbings composed his *Histoire Naturelle* (1925). This is essentially a collection of drawings made by chance but attributed, as the title suggests, to nature. Ernst believed that the frottage technique was the equivalent of literary automatism. He was particularly interested in the interpretation of the frottage drawing and its ability to evoke 'contrasting pictures' in the mind of the observer.

CLOUDS

The chance image is suspended in a state of visual confusion between being made in the world and being made in the mind. It oscillates and hovers in an intangible in-between space as a projected imagination merges with an interpreted image of what exists. Ambiguous and unstable, it cannot be confined by perspectival rules. This is why

2.3 Max Ernst, *Rasant les murs* (Shaving the walls), from *Histoire Naturelle*, introduction by Jean (Hans) Arp, 1926, Galerie Jeanne Bucher, Paris edition 306, 49.8 × 32.3 cm, one from a portfolio of thirty-four collotypes after frottage, 1925, © 2011 The Museum of Modern Art, New York (gift of James Thrall Soby) / Scala, Florence, © ADAGP, Paris and DACS London 2011

2.3

the majority of hidden images, which determine fixed viewing positions through anamorphosis, disappoint us as naïve pictorial tricks. The evoked chance image is not flat, singular or static; it is spatial, multiple and temporal. It makes associations with the unknown and the unformed. It is like a cloud.

Michel Serres has written that 'the name of chance is cloud' and Hubert Damisch has proposed a theory of /cloud/ which acknowledges the role of chance in perception and representation. Damisch holds the word cloud in slashes to remind the reader that his interest is not clouds per se but their meaning as signs in the representational order of painting. According to Damisch, linear perspective cannot encompass the visual experience in full and the cloud in art generates a counter situation with which perspective interacts dialectically. The cloud stands for all these parts of experience that are uncontrollable, fleeting, impossible to see, know or talk about fully. It stands for the accident. In Damisch's words:

> The cloud is this phenomenon—this phenomenon, not this object—which escapes both all intentional design and every essential position, and has no reality but the accidental and the transitory, for it is made of strictly external causes and conditions, all freedom also being left to the viewer to project his fantasies upon it.[16]

How is this phenomenon produced? What are the 'external causes and conditions' that Damisch refers to? Nature, the unconscious, the indeterminate, entropy, uncertainty, the accident. All of these are agencies, which I place under the bigger umbrella-concept of chance. This uncertain reality of experience, expressed as the semiotic operator of /cloud/, is produced and characterized by chance. Chance is its precondition and its manifestation. If the cloud is the transitory phenomenon seen, its cause and condition is chance. If the cloud is the oppositional means to perspective, chance is the oppositional means to design. Art and architecture, as practices concerned with form and structure, are inevitably caught in the heart of the intertwining interactions of these two pairs.

For centuries architects have indulged and agonized over the simultaneous presence of opposites, and particularly over the relations between heavy and light, earth and air. The Baroque painter and architect Andrea Pozzo in his famous frescoes of the ceiling of the church of Sant Ignazio in Rome used chance in the depiction of cloud formations in order to achieve the pictorial illusion of dematerialization and of greater distance towards an open sky.

But the chance condition, expressed as cloud and atmosphere impossible to fully determine, is a continuous concern in the history of architecture and is today as relevant as ever. It is the same interest in air and the building's dematerialization that led Diller+Scofidio in 2002 to produce the Blur Building. This mechanically driven project derives from different architectural sensibilities but aims to create 'an architecture of air', and therefore of chance, in the most literal sense. Architecture is 'an art of effects', Liz Diller says, so the cloud in the case of the Blur Building is, above all, an image; a fleeting but occupied image.[17] By forcefully turning this image into a temporary inhabitable space, Diller+Scofidio make a statement against the common perceptions of buildings as having to be solid, permanent and

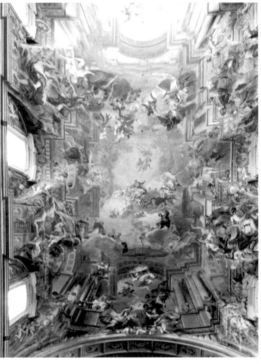

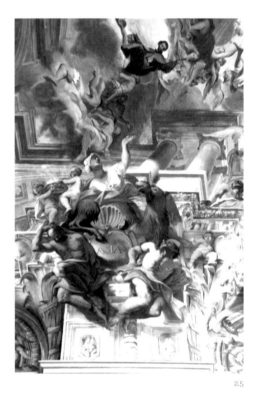

2.4

2.5

2.4 Andrea Pozzo,
St Ignazio, Rome
(1685), general
view of ceiling,
photograph courtesy
of Ro Spankie, 2011

2.5 Andrea Pozzo,
St Ignazio, Rome
(1685), detail view,
photograph courtesy
of Blair Osmer, 2011

clearly definable.

All buildings involve spectators, but Diller+Scofidio take this condition to the extreme, proposing a pop-up architecture of spectacle and effect. The perceptual change involved in the Blur Building is unusual, grabbing the spectator's attention at once. But there is another type of aesthetic pleasure implied, one which is based on extended contemplation rather than the shocking and sudden effects of transformation. For the aesthetic pleasure to be produced, the architecture must encourage a perception that is *prolonged*, and not speeded up. Buildings can provoke this kind of lengthening of perception as a creative activity in many ways, one of which is through ambiguity.

ROCKS

Chinese 'scholar's rocks' have been contemplated for centuries. They have been a source of inspiration for countless artists and poets because of their perplexing and ambiguously shaped forms and their capacity to evoke wonderful chance images. Material, surface texture, shape and colour are all significant factors in making these special stones look full of energy, as if they bring the animate and the inanimate into one and the same substance.

The scholar's rocks represent 'the natural state of things' and an appreciation of the indeterminacy found in natural phenomena. Black rocks and stones, particularly those looking equally interesting from many different angles, are the most sought after.

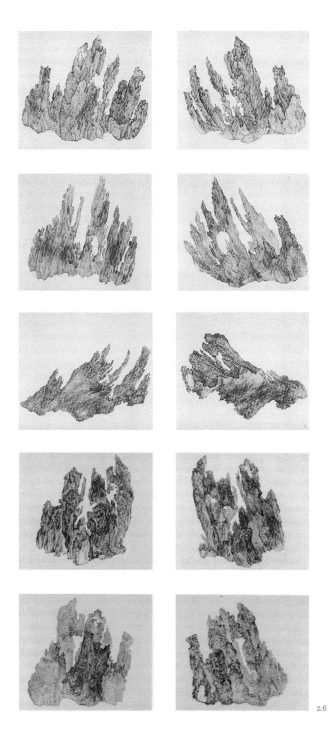

2.6 Wu Bin, *Ten Views of a Rock*, painted scroll, dated to 1610, sourced from Philip Ursprung, ed., *Herzog & de Meuron: Natural history*, Canadian Center for Architecture and Lars Müller, 2002

2.6

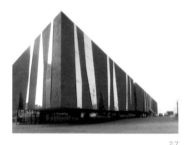

2.7

Their dramatic surfaces and extraordinary beauty can evoke ever-changing images in the mind of the observer. Since some parts of the rocks may be manipulated, it is not always clear what is authentically natural and what is not, which adds to the sense of ambiguity. This suspended condition between the natural and the man-made, the undifferentiated and the figurative, makes the scholar's rocks enigmatic and worthy of note for architects.

Herzog & de Meuron say that they look for the sensuality of ambiguity in their work, and use the scholar's rocks as examples of what they aspire to achieve. It is, they argue, the tension between the figurative and the abstract radiated in 'the effect of an *objet trouvé*' that is so appealing in these rocks.[18] They write:

> To us the scholar's rocks are a conceptual model for some of our current architectural projects, like the Forum Building in Barcelona, the harbour in Tenerife, or Prada Tokyo. In these projects a blend of natural and artificial elements results in configurations that clearly resemble certain natural forms and therefore often radiate great sensuality, while still eluding a fixed interpretation. You might compare it to cloud formations in which you can recognize various things, although the forms in isolation can never be mistakenly pinpointed and explained. This is an aspect of natural phenomena that interests us a great deal.[19]

The Forum Building in Barcelona is a floating mass, juxtaposing rough external surfaces and irregularly cut strips of glass with smooth and shimmering planes in its inner spaces. It has a strange blue monumental presence that may be said to imitate a lava-like geological mass. Herzog & de Meuron

wanted to give this building the ambiguous effects of a natural form but it is difficult to tell if the Forum manages to radiate the sensuality that they claim. In many areas the building evokes chance images, but the difficulty lies in the tension between fantasia and mimesis that the observer stumbles upon. At times it seems that the onlooker's imagination is being invaded by the building's conscious effort to imitate the natural and to directly enforce the idea of ambiguity rather than allude openly to its potential experience. The principle of ambiguity in architecture must be entirely unforced, and discovered unexpectedly, like Alberti's chance images found on tree trunks and clumps of earth.

Furthermore, the ambiguous element of architecture depends also on the historical and urban context of buildings. One example is Adolf Loos's entry for the 1922 Chicago Tribune competition, composed as a giant Doric column with an inhabitable empty core on top of a cubic building block. The proposal was what Manfredo Tafuri called the anticipation of a 'caustic and ambiguous Pop Architecture' that tried to grab the 'absent-minded' attention of the spectators. Its absurd style and epic size in contrast with its setting is remarkable. But what is further interesting in this project is the building's proposed materiality, being coated in polished black marble. The Chicago Tribune Tower was intended to evoke many different interpretations by being ambiguous in terms of its type, size and material aesthetic.[20]

Tafuri wrote that modern architecture can involve the spectator in two ways: by 'reducing every morphology to the invariance of *types*' and therefore 'cancelling the *object* in the repetitive process of the series' or by presenting the building

2.7 Herzog & de Meuron, Forum Building, Barcelona, completed 2004, exterior view, photograph courtesy of Ana Maria Ferreira, 2007

as 'a permanent *Total Theater*, as a new object able to make reality explode into an *espace indicible*'.[21] He associated the first with Mies's abstraction and the second with Le Corbusier's neo-symbolism, but insisted that these two ways of engaging the spectator are complementary. It is difficult to accept these categories as divided because they naturally mix and alternate. Moreover, there is a great degree of ambiguity implicated in the perception of buildings which is not only a matter of permanence and type. Ambiguity depends considerably on perception as a sensual experience, and can have an emotional significance for the spectator. Tafuri suggests that the city's ambiguity is sometimes difficult to bear, making the observer welcomed and refused at the same time. When he writes that the 'architecture continuously splits itself in an exhausting mirror game' and that the city is 'an elliptical presence of opposites', he refers to the experience of ambiguity as an intolerable situation. He states: 'In such a *mixture* the role of the observer becomes ambiguous. Involved and rejected at the same time, he takes part in the drama performed by architecture: but he is simultaneously launched outside architecture'.[22]

Robert Venturi in his *Complexity and Contradiction in Architecture* takes a more optimistic view, celebrating the presence of opposites in architecture and the city, and favouring richness of meaning over clarity. Notably Venturi's inspiration is poetry, where ambiguity and paradox are preferred over plain simplicity. Venturi writes:

> Architecture is form and substance—abstract *and* concrete— and its meaning derives from its interior characteristics and its particular context. An architectural element is perceived as form *and* structure, texture and material. These oscillating relationships, complex and contradictory, are the source of the ambiguity and tension characteristic to the medium of architecture.[23]

The views of Tafuri and Venturi are two sides of the same coin. On the one hand the ambiguous object confuses, on the other it liberates through opening multiple possibilities of meaning and placing emphasis on the aesthetic pleasure of ambivalence itself. As in poetry, ambiguity in architecture produces paradoxes in the reality of objects and in their interpretation, often evoking images that are difficult to pin down. But in breaking up our ease of understanding, and our general preference for clarity of meaning that is quickly reachable, it provokes a prolonged and creative mode of seeing. This prolonged mode of seeing is an aesthetic activity in itself close to the processes of *fantasia*. It is particularly evoked by architectural objects that are open to the poetics of chance.

NON-RECONCILIATION

Buildings often incorporate contradictions. This incorporation can be literal, where the components are directly juxtaposed in a collaged manner, or subliminal, where the contradiction is blurred and only suggested in the experience of space. Poets and playwrights incorporate contradiction, ambiguity and chance in their work not in order to unify the composition and offer a singular interpretation of it, but in order to offer richness of imagery and meaning. It is in this category of poetic making that I place the architecture of Jørn Utzon's Bagsværd Church in Copenhagen, completed in 1976.

Utzon saw observation as a significant part of his

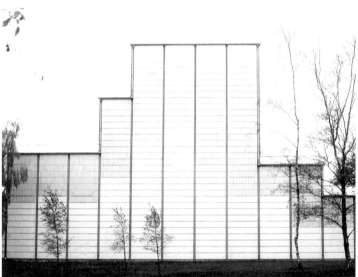
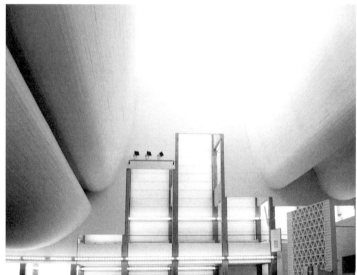

2.8

2.8 Jørn Utzon,
Bagsværd Church,
Copenhagen, 1976,
interior and exterior
views, photographs
by the author, 2010

practice and claimed that he conceived his design of the Bagsværd Church as a chance image. One of his early sketches shows a sequence of clouds, looking curiously parallel to each other, echoing the beach, the sea and the horizon below. A second sketch presents the interior of the Bagsværd Church shown to resemble the earlier sketch. Whether this is a fabricated association that Utzon has invented is not in itself terribly significant. What is important is the actual relation of the building with the sky *as experienced*. The church's vaults, built as thin concrete shells, constitute one of the most unusual interiors of the twentieth century. They look light and give the sensation of floating, although they are made from heavy reinforced concrete. They function like clouds, distributing the Danish sky softly in the interior space of the church. Utzon's early sketch is not to be seen as a picture that was literally translated into built form. The sketch

suggested an image of a spatial understanding of the world that could potentially be manifested in the architecture. According to Christian Norberg-Schulz, the building's aim was to possess the quality of this image and make its 'understood world' manifest:

> As a condensation and visualization of a world, the image unifies components of incompatible or even contradictory nature. Thus it cannot be understood in rational terms. To serve as an image it has to have a simple appearance, but its nature is complex. … Being simultaneously simple and complex, the image may be understood as a 'type' with infinite possibilities of variation.[24]

To understand the complex nature of this building we have to prolong our stay, and go in and out of it many times. The plain, standardized rectilinear exterior makes the church look like an industrial

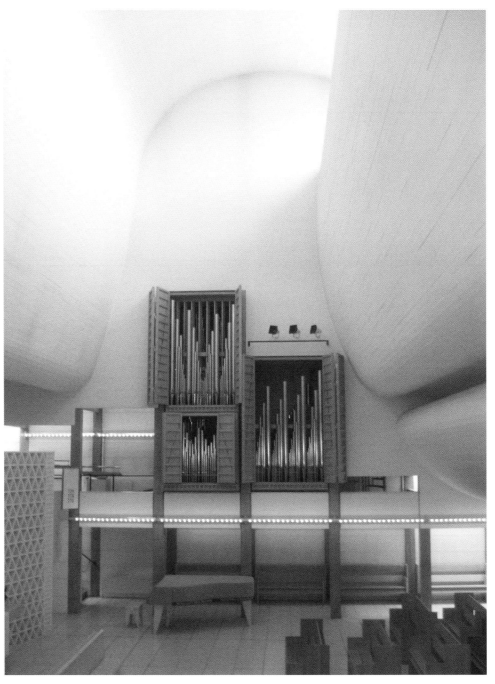

2.9 Jørn Utzon,
Bagsværd Church,
Copenhagen,
1976, central space
photograph by the
author, 2010

2.9

2.10 Jørn Utzon,
Bagsværd Church,
Copenhagen,
1976, detail view
of rectilinear and
curved ceilings,
photograph by the
author, 2010

2.10

storage unit, but its interior suggests another world, fluid and magical. The disjunction between interior and exterior is acute for the visitor, both beautiful and confusing. Utzon brings contradictory forms into close contact, folding and hiding incompatible choices in one another. The opposition of building types and spatial qualities creates effects which achieve a paradoxical unity. This experience of architecture is contradictory and at the same time united, perhaps recalling what Viktor Shklovsky wrote for art in 1917:

> the purpose of art is to impart the sensation of things as they are perceived and not as they are known. The technique of art is to make objects 'unfamiliar', to make forms difficult, to increase the difficulty and length of perception because the process of perception is an aesthetic end in itself and must be prolonged.[25]

It seems that it is this prolonged and aesthetic process of perception that Utzon sought. If the building presents a total image about the world, it is an image that expresses the difficulty in conciliating differences: earth and sky, exterior and interior, heavy and light, clear and ambiguous, the self and the other. In the Bagsværd Church these dilemmas are embodied in an intertwined spatial, material and symbolic dialogue to great poetic effect. The conflict between the finite and the indeterminate is manifested in the architecture, and this may well appeal to the visitor because it alludes to the human experience of being itself. The building encourages the visitor to prolong their stay in order to *see* and better understand, where this process of seeing is an aesthetic and reflective practice in its own right. It is perhaps

through the non-reconciliation of differences that the architect can make 'difficult forms' and, through these, successful analogies between the structure of the building, the structure of observation and the structure of the psyche. Non-reconciliation is a state of being, a mode of experiencing and thinking about the world, and should also be a mode of designing.

Notes

1 Hildebrand in Harry F. Mallgrave (ed.), *Empathy, Form, and Space: Problems in German Aesthetics, 1873–1893* (Getty Center, 1994).

2 Aldo Rossi, *A Scientific Autobiography* (MIT Press, 1984), p. 23.

3 Philip P. Wiener (ed.), *Dictionary of the History of Ideas* (Charles Scribner's Sons, 1968, 1973), p. 341.

4 This account was published in his *Defensorium inviolatae virginitatis Mariae* (c. 1400).

5 Dario Gamboni, *Potential Images, Ambiguity and Indeterminacy in Modern Art* (Reaktion, 2001), p. 67. Gamboni has researched the history of chance images extensively. See also his article 'Fabrication of Accidents' in *Anthroplology and Aesthetics* (no. 36, Autumn 1999).

6 This is an account from 1818. See Edith Mary Fawkes, typescript, 'Turner at Farnley' (London National Gallery, 1900).

7 Leonardo da Vinci, quoted in Ernst Gombrich, *Norm and Form: Studies in the Art of the Renaissance* (University of Chicago Press, 1966), p. 60.

8 Leonardo, quoted in Gombrich, *Norm and Form*, p. 62. The artist's fascination with 'half-guessed forms' is evident in many of his works and characterizes his invention of *sfumato*.

9 See R. L. Gregory, *Eye and Brain: The Psychology of Seeing* (Weidenfeld and Nicolson, 1990), pp. 9-14.

10 For more see Wiener, *Dictionary of the History of Ideas*, p. 342.

11 For more see H. J. Janson, '"The Image Made by Chance" in Renaissance Thought', in Millard Meiss (ed.), *De artibus opuscula XL: Essays in Honor of Erwin Panofsky* (New York University Press, 1961), pp. 254-66.

12 Philip P. Wiener (ed.), *Dictionary of the History of Ideas*, p. 350.

13 I will come back to these techniques in Chapter 3.

14 Gamboni, *Potential Images: Ambiguity and Indeterminacy in Modern Art* (Reaktion, 2001).

15 Max Ernst, quoted in Werner Spies, *Max Ernst Frottages*, trans. Joseph M. Bernstein (Thames and Hudson, 1986), pp. 6–7. Ernst also made compositions of more than one rubbed object which took the form of drawn collages.

16 Hubert Damisch, *A Theory of /Cloud/: Toward a History of Modern Painting* (Stanford University Press, 2002), p. 200.

17 See Diller•Scofidio, *Blur: The Making of Nothing* (Harry N. Abrams, 2002).

18 Herzog & de Meuron in Philip Ursprung (ed.), *Herzog & de Meuron: Natural History* (CCA and Lars Müller, 2002), p. 84.

19 Herzog & de Meuron in Ursprung (ed.), *Herzog & de Meuron*, p. 84.

20 The so-called 'ambiguous figures' alternate between object and ground or spontaneously change their position in depth. Two well-known examples are the figure of two black profiles alternating with a white urn (object-ground ambiguity) and the Necker cube (depth ambiguity).

21 Manfredo Tafuri, *Theories and History of Architecture* (Granada, 1980), p. 91.

22 Tafuri, *Theories and History of Architecture*, p. 97.

23 Robert Venturi, *Complexity and Contradiction in Architecture* (Architectural Press, 1977), p. 20.

24 Christian Norberg-Schulz in Utzon, Jørn, Yukio Futagawa and Norberg-Schulz, *Church at Bagsværd, near Copenhagen, Denmark, 1973-76* (Global Architecture 61, 1981).

25 Viktor Shklovsky, 'Art as Technique', in Lee T. Lemon and Marion J. Reis (eds), *Russian Formalist Criticism: Four Essays* (University of Nebraska Press, 1965), p. 12.

DRAWING AS EVENT

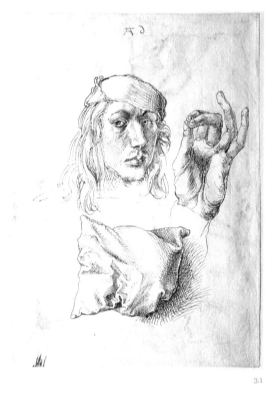

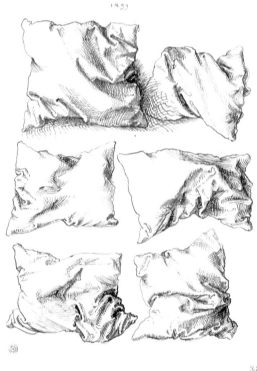

3.1

3.2

SELF PORTRAIT

Albrecht Dürer's ink drawing *Self-portrait at the Age of 22*, produced in 1493, is an arrangement of three parts: Dürer's face, his hand and his pillow. The parts are awkwardly positioned on the paper as if floating. There is a sense of fragmentation and incompleteness in the drawing that alludes to the idea of the fractured self. Dürer wants to draw his portrait but it is not easy. His hand draws his face, trying to present it as a picture to the world and to himself, but it looks like a mask that could cover his face. Curiously, the three parts of the drawing—hand, face and pillow—are drawn in similar sizes, which suggests that they could potentially screen each other. The face, the hand and the pillow can be located on the key positions of the Lacanian intersecting triangles of his eye and gaze theory, though it would be difficult to determine with certainty one-to-one correspondences between them, as Lacan's positions of the eye, the screen and the object tend to shift and interchange.[1]

Dürer points not only to the instability of self-consciousness involved in visual perception but also to the self-consciousness implicated in the act of drawing itself. *Pillows*, another work of his produced in the same year, has a similar subject matter. Six pillows drawn in pen with ambiguous folds and shades conceal the physiognomies of faces. The

3.3

3.4

drawing can be seen as an allegorical representation of the flow of dreams and the unconscious, metaphorically 'echoing' the instability of the self and representing change within the same face and dream. Dürer once more demonstrates a relativist understanding of the self and of the drawing where the boundaries between the two are blurred. As in the worlds of Lacan and Beckett, the Eye belongs in the Object and vice versa. Dürer presents the artist belonging *in* the drawing. People's creations—whether drawings, buildings or cities—are in some ways their own portraits. You are what you draw and make.

SOCIAL PORTRAIT

In his foreword for *Tre Città* Aldo Rossi writes: 'It is strange how I resemble myself.'[2] This enigmatic phrase alludes to how cities correspond to people's lives and the materialization of their deepest desires. The city is a live social drawing, uncontrollable and partly unconscious, an ongoing material portrait of its people.

It is strange how the city resembles its people. Madelon Vriesendorp's paintings presented in Rem

Koolhaas's *Delirious New York* capture this theme implicitly. In *Flagrant délit*, Manhattan is depicted as a city of faces. The buildings are human portraits, 'looking' through a large window at a bedroom interior where the Chrysler and Empire State Buildings are painted as strange anthropomorphic towers, lying in bed together. *Apres l'amour* shows the same scene with the bed clearly presented as the sea, while in other views the bed is Manhattan's grid with an infrastructure of urban and human vessels underneath it.

The meaning of these works is closely associated with Koolhaas's 'retroactive manifesto': the seemingly unrelated events which produced the architecture of Manhattan have a coherent logic and this logic is founded on the desires and the collective unconscious of its people. Referring to Salvador Dalí's famous invention in the late 1920s of the 'Paranoiac-Critical Method' (PCM), Koolhaas writes:

> Architecture = the imposition on the world of structures it never asked for and that existed previously only as clouds of conjectures in the minds of their creators. Architecture is

inevitably a form of PC [Paranoic Critical] activity.[3]

The PCM involved 'setting down an obsessional idea suggested by the unconscious and then elaborating and reinforcing it by a perverse association of ideas and a seemingly irrefutable logic until it took on the conviction of inescapable truth'.[4] In this way 'false' facts are created and placed among 'real' facts, and 'the reality of the external world is used for illustration and proof ... to serve the reality of our mind'.[5] Dalí's ambition was 'to materialize the images of concrete irrationality with the most imperialist fury of precision'.[6]

The PCM is not unlike the architect's vision, interweaving two processes in design, one paranoiac, the other critical. The paranoiac operation is a fantasy, the image of the building as dreamed. The critical operation is the materialization of the building, the objectification and affirmation of the fantasy as a real edifice inserted into the world. As Koolhaas says, Manhattan was built in order 'to live inside fantasy' and the plan was so ambitious that it could have never been openly stated. 'Manhattanism', the interpretation of the phenomenon of Manhattan, establishes the city as 'the product of an unformulated theory'.[7] Consequently it reverses conventional views that want architectural and urban practices to be controllable and predeterminable.

The practice of the city is a dream activity without a theoretical frame, a live aleatory and collective experiment. Our efforts to design rationally are in dialogue with our fantasies, oversights and unconscious desires. The city, like the self, is inevitably disturbed and fractured by the real. But the presence of chance is much more radical in the case of cities because there it generates infinite differences—material, social, aesthetic, emotional. The modern city, as an enormous matrix of built dreams and failures, is an enduring material expression of the architectural unconscious. If it is the physical sign of people's biography, it is primarily a sign of the tension between impulse and control.

IMPULSIVE CHANCE

In 1900 Sigmund Freud published *The Interpretation of Dreams*, which deeply opposed the Cartesian model of indivisible consciousness. Freud's thought and the meanings he assigned to symptoms of the unconscious—mistakes, jokes, dreams or slips of the tongue—instigated a strong interest in chance, both as subject and as technique, among the art circles of the first half of the twentieth century. This subjective notion of creative chance, which I will call *impulsive chance*, defined a large part of Surrealism and contributed significantly to its attack on objectivity and mimetic presentation. Chance was thought to be a creative device that could 'unlock' human impulse and the spontaneous development of ideas. It could assist plunges into indeterminacy, offering momentary glimpses of a subjective and a-causal world.

The creative relation between design and the unconscious is inevitable and evident in the history of cultural production across places and time. Yet the disciplinary divisions between architecture and psychoanalysis are still considerable. It is not until the latter part of the twentieth century that critical conversations about the two fields of thought have started to influence architectural theory. In addition to the writings of Beatriz Colomina

already mentioned in Chapter C, two recent books, Lorens Holm's *Brunelleschi, Lacan, Le Corbusier* and Michael Hays's *Architecture's Desire*, make important, yet very different, arguments about the relation of space and architecture to the psyche. Hays focuses on the avant-garde projects of the 1970s by Aldo Rossi, Peter Eisenman, John Hejduk and Bernard Tschumi, while Holm offers an in-depth analysis of the nature of subjectivity, space and representation since the Renaissance. I intend to complement these contributions by adding a designer's perspective and placing an emphasis on the function of chance in drawing production.

One of the bases of this book is the conviction that the drawing is a place where psychoanalysis and architecture can meet and influence one another, primarily because the study and representation of space is a shared concern. Because the historical distance between the two fields does not allow enough direct connections to be made, we will have to look sideways, diverting our attention to art. This is because art has the capacity to draw together spatial concepts relevant to both architecture and psychoanalysis, and also because art has a well-established connection with psychoanalytic chance. Automatism as we know it today, for example, appeared in the field of psychology before it appeared in art. In the late 1800s the psychologist Pierre Janet would focus the attention of his patients elsewhere, place a pencil in their hands, and discover in their writings aspects of their unconscious that were completely unthinkable by the patients.[8] Later on, and in parallel with Surrealism, Hans Prinzhorn created a remarkable collection of drawings made by patients in European psychiatric institutions, while the psychiatrist Hermann Rorschach used ink stains for psychological testing and as a tableau for note-taking. Psychoanalytic theory uses drawing to work out difficult intersubjective relations, and so can architecture.

Eventually architecture involves a broader and more unpredictable reality than the protected setting of drawing. For that reason a first question that arises is whether the more individualistic and impulsive modes of drawing used in art and psychoanalysis have any relevance to the social purposes of architecture. These spontaneous and impulsive methods can be expanded to use in architecture but cannot always be productive or meaningful. We need to choose why, when and how to enter into dialogue with chance, since it is both the possibilities *and* the limits of chance in design that should concern architecture.

Architecture is often caught in the gap between impersonal rationalized economic forces, and the localized desires of people. Complex external forces want the building to be this or the other; an emotional engagement with the project wants it to be something else. This gap is a difficulty for the architect. The oppositional impulses that drive the project can disrupt established habits and norms of the design process. This sense of disruption is what I call impulsive chance. Acknowledging the impulse, the symptomatic event or situation, means accepting our doubtful state of mind in its interaction with external realities.

BLIND AUTOMATISM

In spite of the dissemination of Freud's thought, the architects of the time did not accept impulsive chance entirely openly. Frederick John Kiesler, who associated himself with the Surrealists and Marcel

3.5

Duchamp, was inevitably attracted to it, but most architects ignored chance or engaged with it rather quietly. This is mainly because of the established views of the profession and society on the whole, which demanded (and still demand) that architects must think rationally and objectively, leaving no room for chance or impulse. It is broadly believed that architects are not supposed to act on impulse because their responsibility is to predict and control the implications of their decisions. The pressures on architects are certainly different from those on artists, but to say that it is possible to entirely separate the author's subjectivity and chance from the process of design is untrue. Decisions should not need to eliminate all aspects of impulsive chance in order to be 'right'. A world without chance would be unbearable, and an architecture not driven by impulse would be unimaginable.

The surrealist automatism was among the most influential art practices open to impulsive chance. Although it was a necessary stage for the development of the appreciation of chance in twentieth and twenty-first century art, it involved a paradox: the attempt to entirely separate unconscious from conscious work was pointless, in the sense that it is unachievable. An impossible *amnesia* was required by the Surrealists: 'Write quickly, without a preconceived subject, fast enough not to remember and not to be tempted to read over what you have written'.[9] This was a kind of blind and weak chance with minimal resistance, also practised in automatic drawing, the equivalent of automatic writing.

But some Surrealists saw automatism as a point of departure rather than a self-sufficient process. Joan Miró, for instance, would start painting from an accidental detail, such as a little thread out of the canvas, which he called a 'shock', and would intentionally prepare the canvas by rubbing it in order to welcome 'curious chance shapes', only later continuing to paint more rationally.[10] Many other automatic or semi-automatic techniques were used by the Surrealists and have further influenced art and design since then. Examples include:

- *Frottage*: using a pencil or other drawing tool to rub over a textured surface;
- *Fumage*: the passing of a sheet of paper over the flame of a candle;
- *Decalcomania*: spreading paint upon a canvas, covering it, and removing the cover while it is still wet;
- *Cut-up*: tearing and reassembling cut-up pieces of paper;
- *Grattage*: scraping dry paint off the canvas;
- *Froissage*: crumpling up a piece of paper and opening it up to create a drawing on the basis of the random patterns;
- *Coulage*: pouring a molten material into cold water in order to get an aleatory sculpted form.[11]

The Surrealists eventually exhausted automatism. As early as 1934, André Breton admits: 'the history of automatism would seem to be, I am not afraid to say so, that of a continual misfortune'.[12] It is impossible to define the gap between intention and outcome in the creative process and, in this sense, it is better to accept that there is no clear boundary between the two. By 1941 Breton has modified his view: 'the descent in the diving bell of automatism, the conquest of the irrational, patient coming and

going in the labyrinth of calculated probabilities are far from having been seen through to the end'.[13] Here Breton replaces blind automatism with a more selective and patient dialogue with chance through 'comings and goings'. As I will show, the surrealist *conquest of the irrational* and the *objective chance* were to become much more fulfilling practices because they embedded artistic intuition in the realm of social reality.

DEGREES OF INTUITION

When I use the word 'intuition' I do not mean a vague feeling of subjectivity. I refer to a Bergsonian understanding of the term, directly linked with experience. This is different from the more passive meanings of the word that denote automatic and responsive action. According to Bergson intuition is *knowledge in action*: the direct and willed perception of reality, and a method of doing and thinking in tune with the flow of events. This intuition resists abstract intellectual concepts which tend to simplify reality and fix reductive meanings about it. For Bergson, creativity is impossible without this element of willed and vital intuition.

The combination of intuitive and intellectual degrees of knowledge is productive for art and science as it is for architecture. The urge of the architect to draw intuitively is always there but not without criticism and therefore not always exposed. Architects from Alvar Aalto and Le Corbusier to Zaha Hadid have used painting as their 'other' private practice, in which spatial thought is expressed more freely, partly because it is independent of the pressures of the profession. The outcomes of these paintings range from the impressionistic and the symbolic to the entirely abstract but most reveal the underbelly of each architect's ideas that also affect their built work.

Hand sketches during the development of a project, on the other hand, press impulsivity into the service of design and many times lead to forms that are challenging to build. A high degree of vagueness in the sketch often requires an even higher degree of control in technical drawing and building technology. Moreover, the more complex the geometry, the more technological sophistication and computational control we are likely to use for its material realization. Today digital drawing and fabrication technologies make the transition from sketch to building easier.[14] In countless examples from Frank Gehry to EMBT the computer is used to demystify and rationalize complex sketched forms in order to make them possible and affordable. In this process, mathematical chance is used objectively and systematically for the purposes of economy, structural and formal optimization, and sometimes environmental efficiency.

The balance between degrees of technological systematization on the one hand and degrees of intuition on the other will continue to be a challenging question for architecture. Digital technology uses chance rationally, attempting to quantify it in terms of calculating probability and allowing no gap for human error. In principle it aims to *tame* the accidents and imperfections of human skill, but this can lead to deskilling in manual craft as an unavoidable consequence. If digital automatism is so popular, although not uncriticized, why is it that manual automatism is difficult to accept and usually eliminated from the design process? Human impulse is too private, lacking rational judgement,

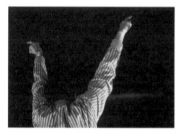

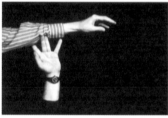

3.6

the critics will say. What may be a valuable sketch for the architect's subjective processes may not necessarily be noteworthy for the recipients of the proposal, and broader society. Digitally automated processes may be just as distant, or more, from social concerns, but their economic and practical effectiveness tends to mask the problem. Between these two extreme poles, a hybrid process of using different tools and understanding the gaps between them can be productive.

The basis of this suggestion involves acknowledging that human intuition is a critical part of the drawing process when the drawing is used as a research tool. It goes back to Bergson's proposal of the productive co-existence of intuition and intellect. Even Leonardo's technique of 'projecting' potential figures onto external incomplete forms when staring at crumbling walls, which seems arbitrary, was not disconnected from the pursuit of knowledge.[15] As Ernst Gombrich has argued, 'Leonardo knew that the fantasies he discovered in the indeterminate could only be made to spring to life by lucid knowledge.'[16] This play between intuition and intellect is to different degrees open to the use of chance as experiment: letting go and taking risks for the pursuit of novelty in order to discover something new. Henri Poincaré, the mathematician and philosopher who laid the foundations of modern chaos theory and instigated the systematic use of chance in twentieth century art through his influence on Duchamp, put it clearly as early as 1905:

We believe that in our reasonings we no longer appeal to intuition; the philosophers will tell us this is an illusion. Pure logic could never lead us to anything but tautologies; it could create nothing new; not from it alone can any science issue. In one sense these philosophers are right; to make arithmetic, as to make geometry, or to make any science, something else than pure logic is necessary. To designate this something else we have no word other than *intuition*.[17]

GESTURES

Spontaneous and incomplete paintings and drawings have caused curiosity and have been admired for their aesthetic quality for centuries. According to Pliny the Elder, chance through human skill could surpass nature's more automated powers. He refers to the famous painter Protogenes, who managed to paint the foam issuing from a dog's mouth successfully only after hurling a sponge at his panel, consequently achieving the image 'in just the way he wanted' when chance 'reproduced nature'.[18] In *Natural History*, written in first century Rome, Pliny explains that spontaneous and incomplete paintings can be worthy of more admiration than finished ones because they show the lines of the first sketch and so reveal 'the working of the artist's mind'.[19] Centuries later Wolf Prix and Helmut Swiczinsky demonstrated something similar in architecture when they challenged the conventions of architectural drawing through a very spontaneous mode of working. They used an unusual architectural method: no words or pencils, just gestures with their arms and hands, in order to design.

Subsequently they say that with eyes closed they created a kind of frantic sketch that they call a 'psychogram'. This sketch was to determine the design of their Open House project:

3.7

3.7 Coop
Himmelb(l)au, *The
Open House*, Malibu,
California, USA, plan
superimposed on
original sketch, 1983
/ 1988–89,
© COOP
HIMMELB(L)AU
2011

Created from an explosive-like sketch drawn with eyes closed. Undistracted concentration. The hand as a seismograph of those feelings created by space. It was not the details which were important at the moment, but the rays of light and shadow, brightness and darkness, height and width, whiteness and vaulting, the view and the air.[20]

According to Coop Himmelb(l)au, the arbitrary shapes produced were literally transformed into precisely defined line drawings, construction details and a three-dimensional model. There is a degree of myth-making in the description of this process but what matters most for our discussion about the role of chance in architecture is the suggestion that the speed and movement of drawing can reduce the architect's degree of reasoning and control.

The project remains unbuilt despite Coop Himmelb(l)au's intention to see it realized exactly in the form of the psychogram: as an 'open architecture' that would be completed by occupation. Built as a single large shell without interior specificity, the house would be intentionally *unfinished* in the sense that it would be complemented by the occupants' particular decisions.

The Open House solidifies an ambiguous chance figure into a building proposal that nobody asked for and perhaps nobody will ever want. But the promise of a building that is the pure incarnation

LONGITUDINAL SECTION

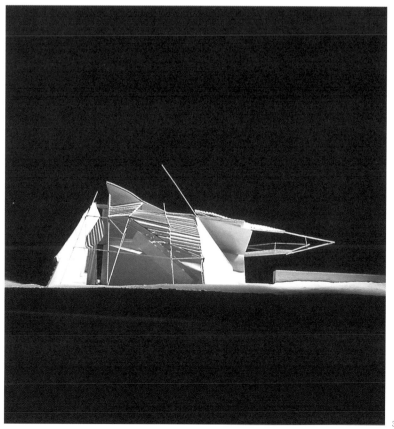

3.8 Coop
Himmelb(l)au, *The
Open House*, Malibu,
California, USA,
section and model
photograph, 1983 /
1988-89, © COOP
HIMMELB(L)AU
2011

3.8

of a biographical sketch acted on impulse, rather than dictated by reason, indicates that architecture can use a larger range of working tools, including impulsive chance. While Coop Himmelb(l)au claim that their Open House emerged like a feeling rather than a building form, most architects prefer to justify design choices with an objective reasoning that downplays the function of instinct. A large component of architectural theory and practice from Alberti to Le Corbusier has involved proportional systems based on Euclidean geometry. These attempt to limit the choice of shapes, dimensions and ratios which architects might choose from the theoretically infinite range open to them. In this sense, they reduce randomness to a very limited number of choices. The Open House, on the contrary, encourages an *increase* in randomness.

Yet there is a difficulty in accepting the Open House entirely positively. The stumbling block is architecture's general belief that pure automatism without any resistance from the realm of social reality is pointless in the production of buildings. To see the sketch literally as a formal expression of the architects' signature, imposing authority and style, is problematic for the recipients. It is also a reductive approach to the possibilities of drawing itself: the sketch should not simply illustrate reality, but research the complexity of thought about it.

Nevertheless, the Open House is above all an act of criticism of architecture's insistence on rationalization and control. It is a theoretical project inviting architecture to acknowledge the creative role of chance in design. It is, to be more precise, architecture's first official statement of 'canned chance', done some seventy years after Duchamp's 'Three Standard Stoppages'.[21] The Open House is a canned chance house.

DRAWING AS PLACE

I draw in order to sense. The history of performance and participation in drawing can be traced across cultures long before Jackson Pollock's action painting in the late 1940s. Centuries ago the ancient Chinese understood and practised performance-led drawings by making literal and direct connections between painting, calligraphy and the martial arts. What all these practices had in common was the painter/fighter's effort to enact the tension between impulse and control, the degrees of chance and certainty that merge in the present. The *i-p'in* or 'untrammelled' technique, used in pre-modern Chinese painting, is particularly famous in this regard. Many untrammelled painters performed before audiences and their works were to be appreciated more as performances than as objects. The extraordinary accounts of the untrammelled artists describe frenzied painters drawing on the floor by stamping, smearing and swashing their feet and hands in convulsion. Gesture, motion, pacing and momentum, turning, splashing and stretching were all important. What mattered was not so much *what* was painted but *how* it was painted. To be *in* the drawing, immersed and physically involved, was a kind of drama: playing and fighting with the work, experiencing and demonstrating the inevitable gap that exists between intention and outcome.

Gestural modes of drawing are inherently open to accidents. In architectural discourse this active notion of chance has frequently been associated with the complexity of cities. Manfredo Tafuri, in particular, has made connections between action

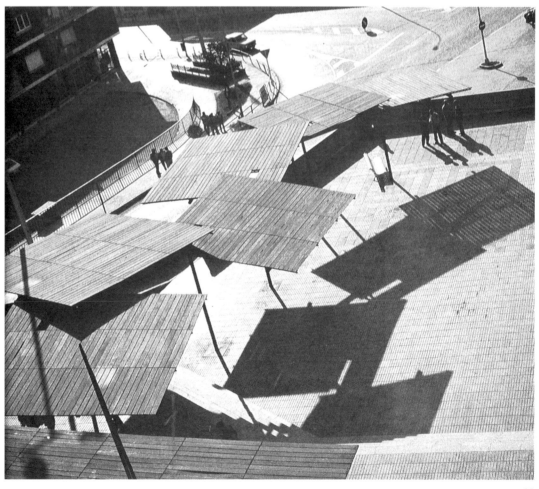

3.9 Miralles and
Pinos, Roofs for
Town Square in
Parets del Vallès,
reproduced with
permission from
estudio Carme Pinós
and El Croquis

painting and the city, arguing that the city is consumed as 'an unstable tank of images' and that the observer has a sense of participation in it similar to the observer of action painting:

> Action painting has tried to establish with the observer a sense of participation with the work, and just as the 'Total Theatre' of Gropius, or today, aleatory music, phonetic poetry and other neo-avant-garde forms, also architecture, drowning in the city, explode towards the user, involve him in its process, make him co-author of a formal event in fieri.[22]

What is notable in action painting and the untrammelled technique is not so much its extreme expressiveness but the idea that drawing, whether on the ground or on the paper, has its own reality

beyond the purpose of representation. Drawing as experience resembles the process of writing a poem or taking a walk. Through drawing the architect can make almost instinctive analogies between the space of the page as occupied by the body, the space of thought, and the place of situated experience as imagined. In his text 'Place' Enric Miralles writes:

> If place is one of those moments when thought is woven with reality ... the drawing, even the paper itself, is place for an instant. ... The rules that let us advance also appear in it. ... Shifts and turns make the paper lose its sheet nature. It is a working structure. ... On these planes there is no concern to represent ... it is a task of multiplying a single intuition: of seeing it appear in all its possible forms ... of aligning acrobatically, like a game, all the rays of lines that go in a direction ... of keeping all the aspects of one's project on paper. It is not a question of accumulating data, but of multiplying them; of enabling what you had not thought of to appear ... thus you advance through successive commencements.[23]

Drawing is place making. The Roofs for Town Square in Parets del Vallés in Barcelona (1985) by Miralles and Carme Pinós is an assemblage of roof planes which 'accompany the act of walking' (see fig. 3.9). The figure of the roof plan is like a collage drawing multiplying rectangulars. The roofs are simple but deliberately arranged randomly on a minimal number of slim columns. The result is a complex architectural volume, defined by the structure but also the space of the shadows cast by the roofs.

There are spatial correspondences that can be made between the space of the drawing, the space of writing and the space of walking and looking. Drawing, writing and walking are similar actions in that they accommodate and represent processes of thought and perception simultaneously and sequentially in time: unfolding stories, making journeys, encountering obstacles, going in circles.

POLYPHONY

I draw in order to understand. I draw in large notebooks in order to give my thoughts the space of the page to unfold. Page after page, my notebooks provide a seamless continuum in which the progression and iteration of thought can be expressed materially. Each drawing is provisional; it can be revisited, undone and redone. The outcome is an arrangement which can be reassessed and changed. It is important that a thought is immediately captured on the page as and when it occurs, because the more direct and honest the drawing is, the more constructively it will allude to critical reflection and further drawing. Doubt and contradiction are welcomed in this type of drawing because the action is non-illustrational and led by the principle of *aporia*. In Greek *aporia* means puzzlement, doubt and confusion. Research-led drawing is driven by questions. It expresses the difficulty of thought with all its fugitive qualities and backlashes, its uncertainty, multiplicities and stumbling blocks. This difficulty is productive in the joined making of drawing and thought. Perry Kulper's drawings for the David's Island ideas competition have some of this quality. Kulper writes:

> The Strategic Plot oscillates between concrete spatial proposals and notations for further development. Representational borders are opened with the hope of sustaining a more fluid ideological, critical and material

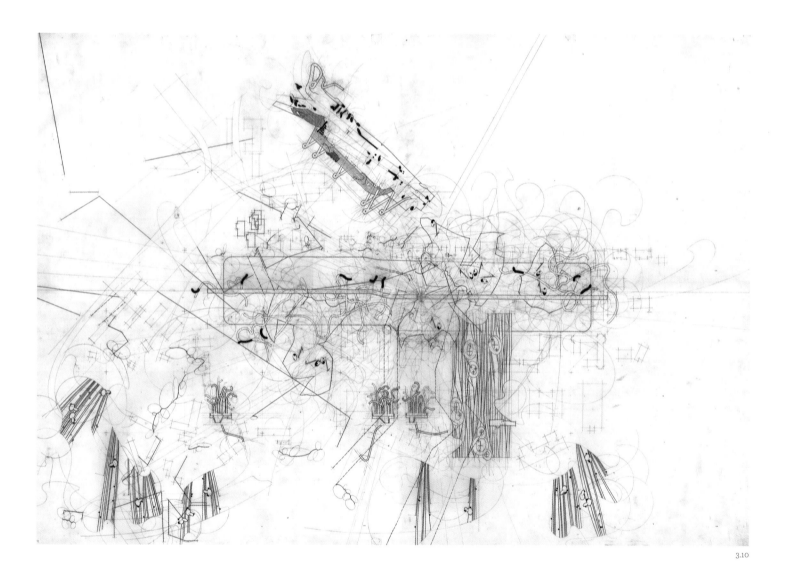

3.10

3.10 Perry Kulper,
David's Island,
strategic plot,
1997, published by
permission from the
author

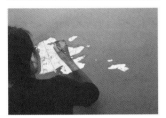

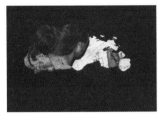

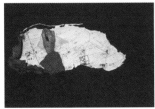

3.11

3.11 Michiko Sumi,
Robben Island,
video stills from the
process of drawing
a memory plan,
2008, published by
permission from the
author

amalgamation. … There are several relational characteristics that propagate the new and point toward the unforeseen. …. Here, quests for productive knowledge intermingle with imagination and illusory projection, loosening the authoritative grip of quantitative information and analytical domination.[24]

Hand-drawn sketches and quick collages may appear 'easy' but can express a kind of *sprezzatura*: looking effortless but interrogating something difficult.[25]

Rosalind Krauss has written that automatic hand drawing is ordinarily supported by the horizontal surface of the table, which she sees as 'the more culturally processed domain of the written sign'.[26] This is significantly different from the vertical picture plane, which is used to structure a perspectival notion of representation in the form of 'pictures'. My notebook drawings do not aim to construct views, pictures as such, but use the horizontal domain of the page to situate thoughts relationally. The surface of the paper meets *all thoughts falling*. As we saw in Chapter F, the origin of the word accident, *accidere*, derives from the Latin *cadere* which means to fall. Thoughts metaphorically fall on the page to contest and eventually shift meanings. The manner of spacing and intersecting the various diagrams, words and photo collages on the page is critical. Where things will go on the page can lead the project one way or another. Working in this way through chance and choice, positioning and combination, means *drawing together* multiple dialogues. In setting up imaginary dialogues with books, places, histories, other drawings and other voices, drawing gradually expands in scope and becomes inter-subjective. The thought is held on the page in tension with other thoughts and facts. By positioning myself among the work of others, and by making this positioning visible on the page I can better assess and communicate what I am producing.

There is always a history of drawings, objects and buildings within and against which an architectural work can be seen. The material integration of this history in the body of the work itself (whether a drawing or a building) may offer opportunities for what Mikhail Bakhtin calls the principle of *polyphony*.[27] Polyphony means many voices, a relational activity between different actions, conflicting or not. James Joyce used polyphony in *Ulysses*, as did John Soane in the making of his house in London.

As collectors and advocates of different 'voices', architects can use drawing to bring together different realities. Michiko Sumi's fifth-year student project in Unit 17, MArch Architecture at the Bartlett, is a characteristic example. Robben Island's history, its current state and Sumi's own journeys on it are collated into one palimpsest drawing surface which aims to trace everything that she can possibly know or remember about this site. Multiple and fractured lines, representing places, narratives and subjects—the pier, the arrival of tourists, the guides, the bus tour, bunkers, the prison, the well, penguins, are gradually drawn to build up the drawing. All rhythms, findings and doubts are equally active in a process-led drawing, which is recorded in real time by a video camera. All factors co-act simultaneously like a dream. What story and what building can she make through drawing in this way?

An impulsive mode of drawing is partly

3.12

3.12 Michiko
Sumi, *Robben
Island*, memory
plan drawn in full,
2008, published by
permission from the
author

autobiographical. Impulsive drawing draws on the self and on inter-subjectivity in order to include and communicate emotion in the interrogation of architecture and to eventually expand beyond the autobiographical. Bakhtin tells us that 'the self is an activity', an activity which is already a relation in action, that of the self and the other simultaneously. He also tells us that the novel is a 'live event', as is, I would argue, the architectural drawing when process-led, frank about its gaps, contradictions and the difficulty of reconciling differences.[28] In *the event of drawing* everything is active and exposed, and accidents are accepted as a natural part of it.

TRAP PICTURES

'I feel at home here in this chaos because chaos suggests images to me', Francis Bacon said when he described his small studio at Reece Mews, London.[29] The room where he painted for the last thirty years of his life was indeed a condensed universe of chaos. It contained material that Bacon accumulated for more than twenty-five years, completely covering the entire space: dozens of slashed canvases, hundreds of notes and drawings mixed with piles of books, catalogues, magazines and newspapers, hundreds of photographs and other illustrations, used and unused paint mixed with cups, brushes, everyday objects and fabrics.[30] Dust everywhere.

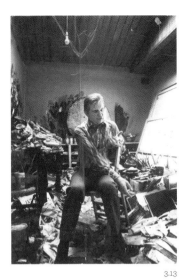

3.13

'I live in squalor. The woman who cleans is not allowed to touch the studio. Besides I like the dust—I set it like pastel,' Bacon said.[31] The photographs, photocopies, torn book pages and fragmented newspaper illustrations that lay messily on the floor constituted the artist's main source of inspiration. Bacon and his visitors walked on the floor, shifting heaps of material at random, crushing it repeatedly and irreparably to 'prepare' chance images for the artist's use later on.

The floor trapped accidents as living things. Bacon's painting practice was all about 'setting a trap' for the image to happen. He would start with arbitrary marks on the canvas until suddenly he would recognize an image and capture it: 'It's really a question in my case of being able to set a trap with which one would be able to catch the fact at its most living point.'[32] One accidental motif would provoke the next and the painting would have to be carried out quickly. For his *Painting*, 1946, he recalls:

> Well, one of the pictures I did in 1946, the one like a butcher's shop, came to me as an accident. I was attempting to make a bird alighting on a field. And it may have been bound up in some way with the three forms that had gone before, but suddenly the lines that I'd drawn suggested something totally different, and out of this suggestion arose this picture. I had no intention to do this picture; I never thought of it in that way. It was like one continuous accident mounting on top of another. … [the bird] suggested an opening-up into another area of feeling altogether. … I don't think the bird suggested the umbrella; it suddenly suggested this whole image. And I carried it out very quickly, in about three or four days.[33]

What is important in creative practices of chance is the author's critical ability to accept the accident—or not—and decide what exactly to do with it when he actually selects it. Bacon explains:

> It's really a continuous question of the fight between accident and criticism. Because what I call accident may give you some mark that seems to be more real, truer to the image than another one, but it's only your critical sense that can select it. So that your critical faculty is going on at the same time as the sort of half-unconscious manipulation—or very unconscious.[34]

But Bacon's ultimate interest in the accident was its *non-illustrational* function. He wanted to make something 'out of a thing which was non-illustrational', diminishing the gap between life and art, between the experience of painting and its outcome.[35] His canvas, positioned at the point of the Lacanian screen, is where the eye and the gaze meet in active friction. Trapping the image means trapping the painter's effort to reach the desired outcome. The gaze, in the form of the accident, captures a non-intended representation of the present moment. It is this quality of chance—of being entirely non-representable—that has fascinated artists and architects time and again. We are naturally attracted to the uncertain play of possibilities, fascinated by the fact that we don't know what might happen next.

The book *Anecdoted Topography of Chance* by Daniel Spoerri appeared in 1962 on the occasion of his first exhibition at the Galerie Lawrence in Paris. It was a kind of manifesto of Spoerri's idea of 'trap pictures', or 'snare-pictures', as he called them, which is similar to Bacon's idea of 'setting a trap' for the art work to happen. The two artists had different reasons

3.14

3.14 Daniel
Spoerri, drawing
from *Anecdoted
Topography of
Chance*, 1962,
reproduced with
permission from
Levi Gallery, ©
ADAGP, Paris and
DACS, London 2011

for welcoming the chance event: Bacon's concern was the accident as the non-representable reality of painting, whereas Spoerri's focus was everyday chance and the potential of participation in art. Despite the differences in interest and outcome, the concept of trapping chance is a common emphasis for both.

Spoerri describes the snare-picture as a way of fixing chance positions:

> objects found in chance positions, in order or disorder (on tables, in boxes, drawers, etc.) are fixed ('snared') as they are. Only the plane is changed: since the result is called a picture, what was horizontal becomes vertical. Example: remains of a meal are fixed to the table at which the meal was consumed and the table hung on the wall.[36]

The *Anecdoted Topography of Chance* describes all the objects that happened to lie on a kitchen table at a certain moment in time through a map with outlines of each object and a collection of annotations, which can be further annotated by others. The work suggests that the accidental and informal aspects of a situation are equally meaningful and perhaps more evocative than their carefully planned and formal counterparts. Spoerri's drawing on the everyday relates explicitly with the Fluxus group and his appreciation of informal creativity, but the act of freezing chance into a picture is closer to Duchamp's notion of canned chance.

Nat Chard's series of instruments for paint throws is a distinct experimental project in the field of architectural research that also deals with

3.15 Nat Chard,
Instrument Seven,
snapshots of
paint throws,
2011, published by
permission from the
author

3.15

3.16

trapping images of chance. Splashes of paint are thrown and captured on adjustable picture planes while photographic snapshots record the action of drawing. For his 'Instrument Seven' Chard writes:

> Instrument Seven has the same chassis as Instrument Five but has a new picture plane that sits adjacent to the flight of the paint. The folding picture plane has adjustments between each individual plate plus the whole picture plane can rotate slightly. The plane is set up so that the area closest to the drawing pieces forms a harbour to protect that part from a direct flight of paint. Some of the direct flight can catch the back end of the picture plane (or the front if the catapult is turned far enough).[37]

Chard's instruments engage with chance in order to highlight the uncertainty that is implicated in the production of drawing and architecture. It is intriguing that a miniature representation of the viewer is also present in many of his models, alluding perhaps to the crucial role that subjectivity plays in the representation and experience of architecture at large.

NEW BABYLON

Drawings can be instantaneous or take years to produce, but in both cases the drawing environment is paramount. The New Babylon project (1956–74) by Constant Nieuwenhuys developed intensively during a period of eighteen years. Through continual making and the prolonged interaction of many models and techniques, Constant tried to represent the life of this utopian city through *enacting* it. Similarly to Bacon's studio, his own studio became a kind of architectural theatre that could produce a polyphony of design languages.

Constant enacted again and again how the occupants of New Babylon would create different configurations of their environment. He orchestrated hundreds of scenes over the years, using models at various scales and combinations, different backgrounds, camera angles and lenses, and changeable filmic and lighting conditions in order to produce the desired views and potential ambiences of this city. Constant also created many other items—paintings, lithographs, etchings, drawings, films, manifestos, posters, maps and mixed-media assemblages. His process of playing freely with flat and three-dimensional components, hard and soft parts (like sand and coloured light), corresponds to representations of the social and spatial contingency of his utopian city. The mode through which New Babylon is produced expresses the mode through which the city would live: as a huge inhabitable drawing device of mythical proportions, drawn and redrawn by its inhabitants. New Babylon continuously changes following the actions of its inhabitants who draw perpetually in time and in three dimensions. As Mark Wigley comments, in New Babylon 'the experimental play' and 'the spontaneous physical act driven by unregulated desire, is accommodated rather than frozen'.[38]

Constant's means of production, I propose, is the means of enactive and prolonged architectural play. His vision dominated the conception and representation of New Babylon, but it is the unusually long period he spent on it that allowed him to work dialogically, playing different roles both as author and as potential inhabitant of his imagined world. Each scene he created is enigmatic in that it portrays no clear or complete picture of the whole

3.16 Nat Chard, *Instrument Seven*, view facing the picture plane, 2011, published by permission from the author

3.17

3.17 Constant
Nieuwenhuys in his
studio, 1967, © DACS
2011

city. The element of indeterminacy in this project is in the gaps and differences that exist between the pieces and between the various episodes of this prolonged play.

Constant's aim was to express the situationist idea of 'unitary urbanism' and grasp through architecture its ephemeral and nomadic character.

However, he was accused by the Situationist International of individualism and an unsuccessful effort to give form to misunderstood situationist ideas.[39] For the Situationist International, such individualist uses of play and chance were not critical or political enough.[40] I would argue, however, that chance and play are not necessarily

uncritical. It is exactly the combination of a dreamer's play with the concrete reality of a city that can lead to radical ideas about urbanism. Constant, as one of the founding members of CoBrA (1948–51), liked working spontaneously, expressively and often without a preconceived plan. Asger Jørn and the Danish CoBrA artists were particularly interested in mythology and were even known as *myth creating* artists. The creation of myth is common in children's play but also in architectural design. Whether critical or not, New Babylon has this quality of the creative force of a myth, resonating with architectural audiences ever since its making.

500 PEOPLE

The contemporary artist Francis Alÿs constructs 'live drawing' events, many of which enact myths in an effort to uncover the unconscious of a place. Extending Fluxus' scope by mixing politics with poetics, the artist integrates drawing and walking in a distinctive spatial poetic practice that is geographically, socially and politically charged. *The Green Line*, a walk through Jerusalem carrying a leaking can of paint and tracing the 'green line' drawn in 1948 as a ceasefire line, makes a one-to-one scale drawing on the surface of the city, provoking emotion and thought about the contested divide between Israel and Palestine. The walk looks informal but is a conscious counter-act to the authority of maps which control, distort or ignore realities, according to economic and political interests. The thin trembling line of green paint is a signal of social and personal difficulty, including the difficulty of one's own practice. 'This fortuitous encounter between a person, a place and a moment usually triggers an intellectual acceleration that at the same time makes you revise your own discourse'.[41] Alÿs adds:

> the cases where I feel that I have been successful in offering an answer to the local situations encountered, where the proposals did 'hit a nerve', in the local community, and sometimes abroad, these happy cases did not occur because one proposal was necessarily better than another. It is more because my own concerns at the time happen to coincide with the concerns of a certain place at a certain moment in history.[42]

For Alÿs direct observation, story-telling and personal engagement with the local situation are crucial processes for finding this 'happy' and critical coincidence of success. Alÿs looks at a place carefully in order to distil a kind of ideogram and see in the familiar an extraordinary but simple event to produce, an anecdote or myth to tell. If the story of the project is clear, it can travel on its own a long way.

When Faith Moves Mountains brought 500 people with shovels to form a line and shift a sand dune in Peru from its original position by a few millimetres. Everybody who participated in this project believed in it, in all its absurdity, and the dune did move. The impulse involved was both personal and social, and had a resonance on people beyond the particular situation. When the documentary film is seen in galleries, audiences connect with it emotionally, as if the work manifests a collective desire that is universally meaningful.

Although Alÿs's 'art in transit' is not permanent, it makes deep poetic and psychological connections between people and place which make it memorable.

3.18 Francis Alÿs,
*When Faith Moves
Mountains*, 2002,
photograph courtesy
of Francis Alÿs, 2011

3.18

His art resonates orally. He writes:

> When I decided to step out of the field of architecture, my first impulse was not to add to the city but more to absorb what was already there, to work with the residues, or with the negative spaces, the holes, the spaces in-between … What emerged was the idea to insert into the city a story rather than an object … It was my way of affecting a place at a very precise moment in history and for a very short period of time … Maybe you do not need to see the work, you just need to hear about it.[43]

Alÿs is an architect in training, not an artist. What kind of building would he design? How can architecture 'hit a nerve', be remembered emotionally or be heard like a story? There is an architectonic and archetypical quality in his work, which, in my view, recalls Rossi's writing about building types. While Rossi's interest in types alludes to the permanent, Alÿs's types are ephemeral ordinary actions. What both types of buildings and types of actions have in common is their power to survive in memory.

Alÿs's use of the phrase 'If Mohammed will not go to the mountain, the mountain must come to Mohammed', Rossi's lighthouse and the theatre, the dark as remembered, sitting at the table, making knots, playing under the tree, all evoke images of *felt experiences* with which each one of us can relate intuitively. These are occasions to be remembered with psychological and spatial significance. It is the continual combination of buildings and occasions that makes architecture. Moreover, it is the combined reality of places *and* stories that conditions the city and urban production.

My proposition to open architectural design to the possibilities of chance is not so much because of chance's capacity to generate physical form. It is rather because of the inexhaustible power of chance to bring into play coincidences, subjectivities, actions and desires, together in one story and one place, making a unique social occasion to be remembered in relation to architecture. Alÿs's work shows how the impulse of the individual can meet the impulse of others. When the architect's practice of observation is acute and 'hits the nerve', then his self-portrait becomes inter-subjective, a social portrait of his and of others. 'Drawing as event' means drawing on impulse and drawing together relations, drives and affects that are open to chance. Drawing the self into the real, the personal into the social.

Notes

1 Refer to Eyes a*nd Objects*.

2 Aldo Rossi, *Tre Città: Perugia, Milano, Mantova* (Electa, 1984), p. 7.

3 Rem Koolhaas, *Delirious New York: A Retroactive Manifesto for Manhattan* (010 Publishers, 1994), p. 246.

4 Carlton Lake, quoted in Meryle Secrest, *Salvador Dalí: The Surrealist Jester* (Paladin Grafton, 1986), p. 127.

5 Dalí, quoted in Koolhaas, *Delirious New York*, p. 10.

6 Dalí, quoted in Secrest, *Salvador Dalí*, p. 124.

7 Koolhaas, *Delirious New York*, p. 10.

8 Pierre Janet published his *L'Automatisme psychologique* in 1889.

9 André Breton, quoted in Edward Lucie-Smith, *Movements in Art since 1945: Issues and Concepts* (Thames and Hudson, 1995), p. 33.

10 Joan Miró, quoted in J. H. Matthews, *The Imagery of Surrealism* (Syracuse University Press, 1977), p. 146.

11 The list is indicative since the full range of adaptations of automatism is impossible to list.

12 Breton, quoted in Matthews, *The Imagery of Surrealism*, p. 135.

13 Breton, quoted in Matthews, *The Imagery of Surrealism*, p. 135.

14 The process is reversible with the use of 3D scanners where digital models of existing objects can be translated to drawings.

15 Refer to Chapter 2.

16 Ernst Gombrich, *Norm and Form: Studies in the Art of the Renaissance* (University of Chicago Press, 1966), p. 62.

17 Henri Poincaré, quoted in Craig E. Adcock, *Marcel Duchamp's Notes from the* Large Glass: *An N-Dimensional Analysis* (UMI Research Press, 1983), p. 144.

18 Pliny, quoted in Dario Gamboni's book *Potential Images: Ambiguity and Indeterminacy in Modern Art* (Reaktion, 2008), p. 25.

19 Pliny, quoted in Philip Wiener (ed.), *Dictionary of the History of Ideas* (Charles Scribner's Sons, 1968, 1973), p. 341.

20 Wolf Prix notes that weight was another important factor. Wolf D. Prix and Helmut Swiczinsky, *Blaubox* (Architectural Association, folio xiii, 1988), p. 67.

21 Refer to Chapter 6.

22 Manfredo Tafuri, *Theories and History of Architecture*, trans. Giorgio Verrecchia (Granada, 1980), p. 94.

23 Enric Miralles, 'Place', *El Crocquis, Miralles/Pinós 1983-1990*, p. 28.

24 Perry Kulper, *David's Island* (competition, 1996–97), unpublished correspondence with the author (January, 2012).

25 *The Oxford English Dictionary* defines *sprezzatura* as 'studied carelessness'. I have written about the unfinished and 'unformed' aspects of drawing as positive agents in the design process in Yeoryia Manolopoulou, 'Unformed Drawing: Notes, Sketches and Diagrams', *The Journal of Architecture* (vol. 10/5, 2005), pp. 517-25.

26 Rosalind Krauss, *Optical Unconscious* (MIT Press, 1993), p. 284.

27 Polyphony is one of the main concepts that underpin Mikhail Bakhtin's thought. See Bakhtin, *The Dialogic Imagination* (University of Texas Press, 1981).

28 For Bakhtin's dialogism see also Michael Holquist, *Dialogism: Bakhtin and his World* (Routledge, 1990).

29 Francis Bacon, quoted in Barbara Dawson and Margarita Cappock, *Francis Bacon's Studio at the Hugh Lane* (Hugh Lane Municipal Gallery of Modern Art, 2001), p. 27.

30 It is worth referring to the relocation of Bacon's London studio to the Hugh Lane Gallery in Dublin. The process involved the precise survey of his studio exactly as found after his death in 1992 as a catastrophic scene of multiple accidents. 7,500 items in total and all the surfaces and features of the room had to be removed to be reassembled with exact precision. Photographers, archaeologists, conservators and curators had to find order in chaos and carried out an elaborate archaeological survey of all layers of deposit from flimsy bits of paper and dust to actual canvases. The leader of the team, Ed O'Donovan, explained how the reconstruction was based on the principle of archaeological excavation: 'the removal of features one by one in reverse order to which they accumulated ... allowing sufficient evidence to be obtained to begin to understand the evolution of the site and to interpret its periods and structures'. Ed O'Donovan, quoted in Dawson and Cappock, *Francis Bacon's Studio*, pp. 22–23.

31 Bacon, quoted in Dawson and Cappock, *Francis Bacon's Studio*, p. 5. This phrase recalls Duchamp's *Dust Breeding* in which dust is used deliberately for the painting of the sieves in the lower part of the *Large Glass*.

32 Bacon, quoted in David Sylvester, *Interviews with Francis Bacon* (Thames and Hudson, 1975, 1993), pp. 53-54. Sylvester suggested that accidents would also happen because Bacon would freely scrub over something he didn't like, and paint impatiently and without attention, or while he was drunk. These comments are not dissimilar from some of the descriptions of the *untrammelled* techniques used in pre-modern Chinese painting. Moreover, Bacon was also renowned for his interest in chance through his gambling habits. Sylvester, p. 53.

33 Bacon, quoted in Sylvester, *Interviews with Francis Bacon*, p. 11.

34 Bacon, quoted in Sylvester, *Interviews with Francis Bacon*, pp. 121–22.

35 Bacon, quoted in Sylvester, *Interviews with Francis Bacon*, p. 53.

36 Danielle Spoerri, *Topographie anecdotée du hazard* (Editions Galerie Lawrence, 1962), p. 181.

37 Nat Chard, *Instrument Seven Drawings*, http://natchard.com/category/drawing-instruments/page/2/ (visited 7 December 2011).

38 Wigley, 'Papers, Scissors, Blur', in de Zegher and Wigley (eds), *The Activist Drawing*, p. 50.

39 The role of drawing during the creation of New Babylon was the subject of an exhibition held at the Drawing Center in New York in 1999 and an accompanying symposium and book. See Catherine de Zegher and Mark Wigley (eds), *The Activist Drawing: Retracing Situationist Architectures from Constant's New Babylon to Beyond* (MIT Press, 2001).

40 I am expanding on Guy Debord's views on spontaneity and chance in Chapter 7.

41 Francis Alÿs in Mark Godfrey (ed.), *Francis Alÿs: A Story of Deception* (Tate, 2010), p. 35.

42 Alÿs in Godfrey (ed.), *Francis Alÿs*, p. 35.

43 Alÿs in James Lingwood, 'Rumors: A Conversation Between Francis Alÿs and James Lingwood', in *Francis Alÿs: Seven Walks* (Artangel, 2005), p. 44.

ENCOUNTER
AND
ASSEMBLAGE

ENCOUNTER

Between 1982 and 1986 Louis Althusser developed a new philosophical understanding of the aleatory. Drawing upon the work of a variety of diverse philosophers, he defined a philosophy of the encounter which he associated with what he called 'aleatoric materialism'. Following Epicurus, Althusser argued that the origin of every reality and all meaning is due to absolute chance: a swerve for which there is neither reason, nor cause. According to Epicurus, before the formation of the world, an infinite number of atoms were moving in the same direction, parallel to one another. A tiny 'swerve' caused one of the atoms to encounter an adjacent atom: 'breaking the parallelism in an almost negligible way at one point, [it] induced *an encounter* with the atom next to it, and from encounter to encounter, a pile-up and the birth of the world'.[1]

For Epicurus and for Althusser the encounter is superior to the notion of being. Althusser expanded on Epicurus' 'swerve' and also Wittgenstein's famous proposal that 'the world is everything that is the case'. He explained: 'by *case*, let us understand *casus*: *at once occurrence and chance*, that which comes about in the mode of the unforeseeable, and yet of being'.[2] If we see the world as the unforeseeable falling together of things synchronically in the present, then the role of the building is ambivalent in this situation. Architecture as a relatively permanent built form resists chance; it is nearly set as an obstacle to chance. But on the level of experience this relation is reversed, and the building actually *attracts* chance. It is as if the avoidance of chance gives it actual force. Despite the design and control embedded in its spaces, the building will dialectically provoke 'a swerve'; it will produce a dynamic space of encounter around and within it. As a cultural object the building acts as an attractor of social encounter; as a material object exposed in the environment it constantly interacts with nature.

The Surrealists, too, valued the creative possibilities of encounters because they thought that they could help the artist escape rational causality to empower her imagination. Behind the encounter and the unexpectedly found object is the search for what André Breton called 'the Marvelous': an extraordinary aspect of life concealed in the everyday. In *Nadja*, one of the most celebrated novels using pictures next to text, Breton insists on the intense scrutiny of reality and the productive search for unusual objects. He writes:

> I go there often [the Saint-Ouen flea-market], searching for objects that can be found nowhere else: old fashioned, broken, useless, almost incomprehensible, even perverse—at least in the sense I give to the word and which I prefer—like, for example, that kind of irregular, white, shellacked half-cylinder covered with reliefs and depressions that are meaningless to me, streaked with horizontal and vertical reds and greens, preciously nestled in a case under a legend in Italian, which I brought home and which after careful examination I have finally identified as some kind of statistical device, operating three-dimensionally and recording the population of a city in such and such a year, though all this makes it no more comprehensible to me.[3]

The Marvelous is not restricted by the limits of the object as a thing. Instead it is associated with experience and the emotional encounter of situations. The collection of forty-four photographs

that structures *Nadja* is evocative of many and different chance meetings: places, poets, objects, signs, masks and seemingly worthless things. Chance, 'shock' and 'convulsive beauty' are all incorporated in the making of choices and in the making of the novel in order to negate the boundaries of logic and rationality and enter a zone of experiencing dreaminess within reality.

HE CHOSE IT

In some processes of collection the role of chance is paramount. The cabinets of curiosity of the sixteenth and seventeenth centuries, which worked as memory theatres, were called 'chance rooms' because they were open to variable juxtaposition and interpretation. The interrelation of things opens itself to chance naturally. Choice and collection, as aesthetic practices able to carry meaning, are inseparable from the history of architecture. This is because the collection can be treated as a microcosm of the self or the community, not a passive archive but a place for remembering and altering meaning by the very process of relating things. From the Sacred Way at Delphi, which was filled with treasury buildings and statues by the ancient Greeks for religious and political reasons to John Soane's House in London (1792–1824) filled with his collections of antiquities, we can think of numerous architectural examples that have incorporated originally unrelated building components.

Collecting is a design process in itself. For example, the archives of *L'Esprit Nouveau* in the Fondation Le Corbusier in Paris contain a large compilation of photographs from industrial catalogues and manufacturers' brochures that

Le Corbusier collected between 1920 and 1925. This comprised innovative industrial objects as well as everything that struck him visually, such as clippings from newspapers and magazines, postcards, notebook covers and everyday images, all juxtaposed to create interesting associations. This material strongly influenced Le Corbusier's design approach, and *L'Esprit Nouveau*'s 'machines to fly in' or 'machines to drive in' helped him produce the concept of 'machines to live in'.[4] Collecting information and all sorts of memoranda has continued to influence architectural practices today, but the excess of information available electronically means that more editing is required. Surfing the web is a kind of *dérive* that can assist findings by chance, but more than ever the architect needs to act as critical editor.

The architect editor makes critical choices and 'creates a new thought' for the piece that he has chosen. Defending his *Fountain* (1917) Marcel Duchamp famously said: 'Whether Mr Mutt with his own hands made the fountain or not has no importance. He CHOSE it. He took an ordinary article of life, placed it so that its useful significance disappeared under the new title and point of view—created a new thought for that object.'[5] Duchamp's art was often generated by irony and humour, non-intention and a kind of 'adoration' for chance as he characteristically said. His idea of the readymade exemplifies the ambiguity between non-art and high art and in that the tension between chance and choice. Duchamp did not 'design' the readymade; he simply chose it because of its 'beauty of indifference'. This aesthetic quality of indifference is achieved through the lack of intention to produce art. We can think of a similar kind of indifference

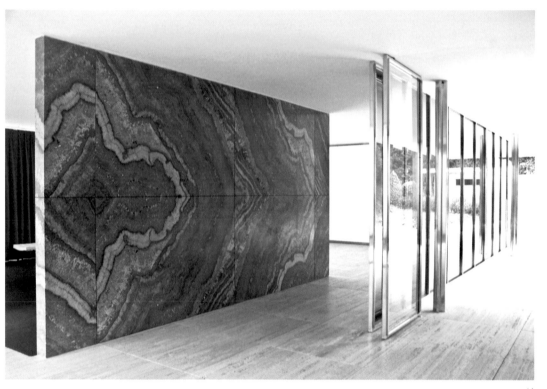

4.1

in the production of space, if we consider informal everyday spaces created by users and not by self-conscious architects.

ONYX BLOCK

> When I had the idea for this building I had to look around. There was not much time, very little time in fact. It was deep in winter, as you cannot move marble in from the quarry in winter because it is still wet inside and would easily freeze to pieces. So we had to find dry material. I looked round the huge marble depots, and in one I found an onyx block. This block had a certain size and, since I had only the possibility of taking this block I made the pavilion twice that height.[6]

In Mies van der Rohe's design for the Barcelona Pavilion (1929–30) the onyx wall played a pivotal role. It was indeed a key determinant of the building's composition, influencing its height and the symmetry of the pavilion along the horizontal axis.[7] But what at first glance seems a calculated choice turns out to have been a chance encounter. The golden onyx from the Atlas Mountains was chosen as a readymade for its color patterns and beauty. Mies adapted the height of the pavilion and the length of its central wall to the marble's exact proportions. In this way the accidentally found marble became the basis of a highly controlled design, much admired for its harmonic form and order.

4.1 Barcelona Pavilion, reconstruction 1986, photograph courtesy of James B. Janzer, 2011

Four different kinds of marble—Roman travertine, green Alpine marble, ancient green marble from Greece and golden onyx—are used in the Barcelona Pavilion, alluding to a particular Eastern sensibility about the representation of nature in buildings. The various stone patterns evoke landscape views. The onyx block in particular recalls the small marble paintings that were produced between the eleventh and eighteenth centuries in China.[8] As we have already seen, the Chinese studied marble blocks thoroughly and cut them in such ways as to reveal chance images resembling landscapes. The marble, once sliced, was carefully framed like a painting to suggest images of mountains or valleys, while an inscription was added. Just as the marble pieces were appreciated because of their suggestiveness and were elevated to the status of art, the onyx block in the Barcelona Pavilion can be seen to have a similar status. Encountered by chance, it now produces further temporal chance effects. The sense of weather and natural landscape arises subtly; marble patterns and reflections on water and glass produce an architectural experience which is intense but constantly in flux.

When chance is discussed in architecture it usually takes an unsatisfactory formalist role that focuses on how the use of the accident can result in distorted building forms. The case of the Barcelona Pavilion, however, is unique because it proves that the use of chance in architectural design does not necessarily need to result in complex shapes. Mies took advantage of the chance–design dialogue in two ways which were both *spatial*: in the process of architectural design as a situated activity (noticing and choosing the particular marble pieces) and in the production of experience for the visitor (evoking the constantly shifting, ethereal quality of the space). This second mode of chance is one of agency, action and potentiality, not one of static material or geometric form. The use of the accidental is in conflict with neither the designer's authority nor the viewer's desire to experience the space freely. In fact the author's wish for control interweaves with chance. The question is whether we, as architects, are alert and open enough to take advantage of this productive chance–design interrelation.[9]

DISPLACEMENT

'Objective chance' is perhaps the most critical and social practice of chance that was explored by the Surrealists. It is based on the idea that coincidences are meaningful and that the encountered chance event reveals a repressed aspect of reality, a hidden objective truth that suddenly becomes apparent. This openness to coincidence as revelation is close to psychoanalytic thought, where an accident is never simply an accident and any 'slip of the tongue' is meaningful. Objective chance demands skill in cultivating creative observation and noticing the chance event or object when it is meaningful. It is different from Duchamp's found readymades because of its emphasis on the relationship between experience and the unconscious (rather than art and non-art).

The surrealist use of chance involved taking unrelated objects from their original context and positioning them against each other to create unfamiliar juxtapositions. Max Ernst, the inventor of the collage novel who used to cut and paste nineteenth century engravings in absurd combinations, writes:

4.2

4.2 Hans Hollein, *Aircraft Carrier City in the Landscape*, 1964, The Museum of Modern Art, New York (Philip Johnson Fund 1967), reproduced with permission from Hans Hollein Architects

In the days when we were most keen on research and most excited by our first discoveries in the realm of collage, we would come by chance, or as it seemed by chance, on (for example) the pages of a catalogue containing plates for anatomical or physical demonstration and found that these provided contiguously figurative elements so mutually distant that the very absurdity of their collection produced in us a hallucinating succession of contradictory images, super-imposed one upon another with the persistence and rapidity proper to amorous recollections. These images themselves brought forth a new plane in order to meet in a new unknown (the plane of non-suitability).[10]

The surrealist collage used chance in the core of its operational logic in order to produce *contiguity*, the acausal meeting of things. Two or more unrelated images were brought next to each other in one 'plane' to produce a new reality with all kinds of contrasting effects. Ernst explains: 'I am tempted to see in collage the exploitation of the chance meeting of two distant realities on an unfamiliar plane, or, to use a shorter term, the culture of systematic displacement and its effects'.[11] It is through the logic of displacement and contiguity that the artist's imagination could be better stimulated. Chance would evoke a third plane of meaning which would be more than the meaning of the sum, an entirely new and 'non-suitable' reality in the context of the original parts.

While the surrealist use of chance was generally focused on the internal world of the artist, some Surrealists made considerable efforts to explore more collaborative notions of chance. The renowned '*exquisite corpse*' is a collaborative collage of either words or drawings in which each part is created by a different person who adds to the composition sequentially by only knowing the end of what the previous person contributed. Despite this expansion of chance from the individual to the group, most surrealist chance-related techniques remained quite introverted, focusing on the artist's unconscious. This was different from Dada's engagement with chance in poems and art manifestoes which was later to influence performance art, pop art, Fluxus and postmodernism on the whole. Rather than looking at art as an introverted and formal construct, Dada concentrated on society and sent a political message as an anti-war and anti-bourgeois practice. The Dadaist use of chance was essentially anarchist: anti-aesthetic, anti-rational, anti-art. More than a mere technique, it was an ideology.

In architecture many designers have used

collage and photomontage in ways comparable to those of Surrealism or Dada in order to evoke contiguity or construct polemical critique. Hans Hollein's visionary architectural drawings in his Transformations series, created between 1963 and 1968, show parts of everyday technological objects being inserted into landscapes with an eerie and infinite quality (see fig. 4.2). These objects are enlarged to a monumental scale in relation to the site, encouraging a stream of associations not unlike Ernst's collages. Hollein writes: 'The transformations and transpositions actually need no special explanation. They are charged with a multitude of meanings, there are many layers of a different significance as one's mind penetrates them, provoking a stream of associations'.[12]

A different architectural example is Ben Nicholson's Appliance House (1987). The project uses collage to critique the modernist functionalist home as a *machine for living in*. Nicholson's drawings were assembled from commercial catalogues in search for a new model of a suburban home that was also to house an imaginary kleptomaniac. In addition Nicholson used collage for his Loaf House (1989–96). Extremely distinct elements, such as a chocolate bar 'for mold and smell', a bread tag 'for plan-shape and iconography' and a B-52 wheel-well flap 'for technique and door' are brought together to create a series of changeable domestic configurations. He writes:

> The parts are encouraged to form a spatial collage between the empirical and propositional aspects of home life. … The Loaf House exists in a number of forms, each a slightly different version of the same … A series of drawings and collages work as multi-layered maps and, like all maps, suggest ways to locate the spaces in the house.[13]

The Loaf House is accompanied by text vignettes and is further developed as an interactive digital model. This virtual assemblage lets the viewer-participant 'surf' and 'edit' the house at will, proposing variety and transposition of authorship. Here the experience of chance is systematic and limited within a set of predetermined rules. This *systematic chance* is different from the function of Hollein's photomontages which, although static, evoke for the observer an open-ended stream of associations. In the first case the creative agency of chance is found in the Loaf House's flexibility; in the latter it is found in the effect of ambiguity that Hollein's image has on the observer.

MASONS AND BRICOLEURS

> One day something appeared in the studio which looked like a cross between a cylinder or a wooden barrel and a table-high tree stump with the bark run wild. It had evolved from a chaotic heap of various materials: wood, cardboard, scraps of iron, broken furniture, and picture frames. Soon, however, the objects lost all relationship to anything made by man or nature. Kurt called it a column.[14]

This Gothic-like architecture (column, tower, tree or house) was never imagined as a whole. It grew relationally as an assemblage. It spread to the adjoining rooms, cellar, balcony, second floor, attic, and eventually filled almost all Kurt Schwitters' house. Left unfinished, the legendary *Merzbau* (1917–43) was completely destroyed during an Allied bombing raid over Hanover in 1943.

Masons combine pieces following a systematic logic, but *bricoleurs* work with what they have accumulated or accidentally have at hand.

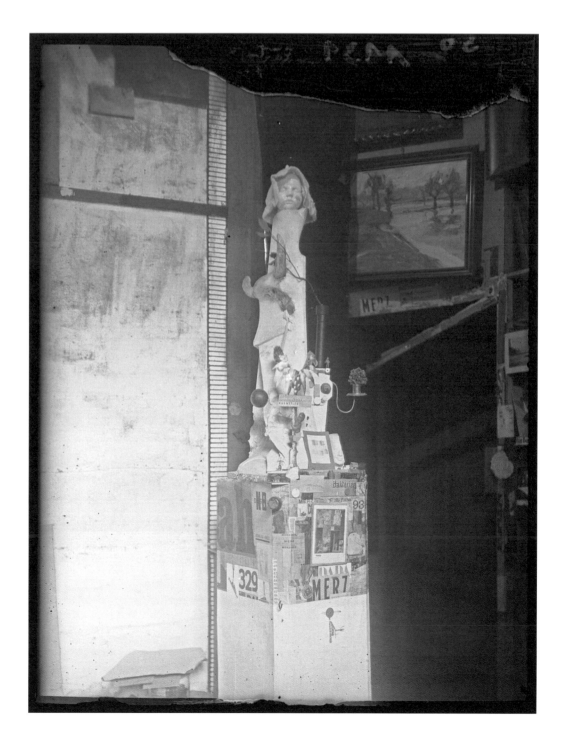

4.3 Kurt Schwitters, *Untitled (Merz Column)*, Installation, paper, cardboard, metal, plaster, wood, crocheted cloth, cow horn, laurel branch, sconce and several materials, 1923 / 1925 (destroyed 1943), photograph courtesy of Kurt Schwitters Archives, Sprengel Museum Hannover, reproduced courtesy of Michael Herling / Aline Gwose, Sprengel Museum Hannover, © DACS 2011

Combining precision and chance, architects take the roles of masons and bricoleurs in turn. Their buildings are unfinished assemblages which the users may extend to more complex assemblages, based on their habits and *ad hoc* design practices. 'Adhocism', a concept explained in Charles Jencks and Nathan Silver's book *Adhocism: The Case for Improvisation*, is based on the user's creative improvisation. As a design technique adhocism combines pre-existing elements to achieve new design results. The selected elements are not necessarily designed for the use to which the ad hoc designer puts them. Jencks and Silver write:

> Design is what everyone does all the time. Buildings are designed, as are 'consumer durables', disposables such as clothing, and anything else—including food—that has been shaped and packaged for a market. Adhocism deals with the fact that choice and combination are more central to design than novelty.[15]

A characteristic architectural example is Frank Gehry's remodelling of his own house in Santa Monica (1978), built deliberately as an unrefined collision of parts. Mundane materials, corrugated aluminium, plywood, glass and chain-link fencing were brought together to form a three-dimensional skin that wrapped the original house, largely stripped to its stud frame. William Curtis explains:

> confronted by the mess of the megalopolis, Gehry ... responded openly in a technique of bricolage abstracting bits and pieces of the confused urban environment. His buildings ... did not rely upon 'composition' but were rather assemblages of different fragments held together by lines of force. This was not the postmodernist indulgence in 'signs' but something more akin to Kurt Schwitters' or Robert Rauschenberg's earlier attempts at blending the rubbish and detritus of industrialism into a sublimated collage.[16]

This early use of collage by Gehry was a means of exploring the ambiguity of the built environment and the potentiality of bricolage in architectural production. To different extents all buildings are assemblages, but the Santa Monica House is representative of the avant-garde architectural tendencies of the late 1970s. The debate for processes of assemblage and fragmentation in architecture will become more evident in the 1980s through the deconstructivist movement. Deconstructivism played with the *image* of chance: juxtaposition and fracture were used to make building junctions *look* accidental when they were of course fully intentional. The deconstructivist image of chance was a deliberate fabrication.

ASSEMBLAGE

The word 'assemblage' in art refers to a stationary, three-dimensional arrangement of different and often unrelated components. Montage, on the other hand, alludes to cinematic compositions and is a term associated with time fragments. I am using the term *performative assemblage* to allude to a kind of gathering that has spatial, participatory and temporal dimensionality and is close to the social and political life of buildings. This is because assembly also means a gathering of people, and can imply accumulation of parts and activities gradually added over time. The building embodies physical and social components in space and time. Non-finality and the need for change make it contingent and always in the making. What happens to it after it is built is an unanswerable

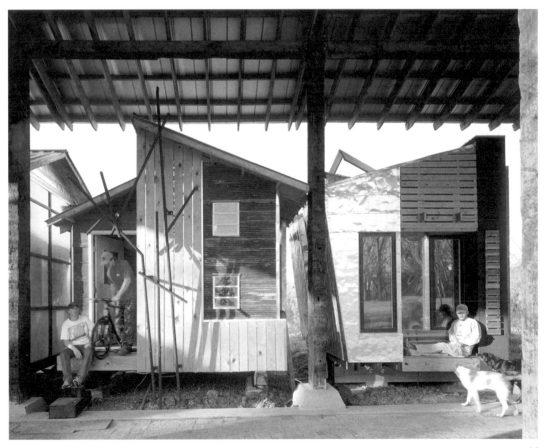

4.4

4.4 Auburn
University Rural
Studio, *Supershed
Thesis Project*, 1997,
Newbern, Alabama,
photographs
courtesy of Tim
Hursley

question. Yet Stewart Brand has devoted a whole book on this question through a catalogue of noteworthy examples of buildings affected by unpredictable courses of events. He refers, for instance, to the old building of the Architecture Department of the University of California, Berkeley (1906–79), known as the 'Ark', which was originally built as a temporary structure but over a period of about seventy years grew as an assemblage of many more buildings.[17] The most productive possibilities of the building as

a performative assemblage come from accumulated and participatory activity over time rather than the instantaneous and single vision of the architect-master who makes a composition in one go.

Since the mid-1990s this preoccupation with architecture as a time-related process with a social and participatory agenda has been strongly featured in the work of the Auburn University Rural Studio. Initially under the direction of Samuel Mockbee, Rural Studio designed and built

economic houses and small community schemes in deprived areas in western Alabama. Built by students through a participatory process and extremely low budgets, the buildings incorporate salvaged and donated materials of all kinds, from old roof beams and railway timbers to used carpets, windshields and car number plates. Each building is an assemblage, further activated, personalized and modified by the inhabitants. Mockbee was particularly interested in how the buildings were lived in and revisited them to write a book about them several years later. He published the new photographs taken by Timothy Hursley next to the original pictures of the new buildings, aiming to represent the two versions of the buildings as equally valued.[18]

The Paris-based architects Anne Lacaton and Philippe Vassal are also explicit about their interest in the social reality and non-finality of buildings. Their design approach is strategic and political, and aims to produce generous but economically built spaces for living. The architects intentionally choose ordinary standardized systems and everyday materials to create buildings that are stoical in terms of form but quite radical in terms of highlighting their social content. Their focus is the vacancy of space itself and the events that it can accommodate. The chance element in this case is not in the physical form of the building but in its extreme non-specificity, and in the capacity of this non-specificity to make social life forms particularly apparent.[19]

Buildings are unfinished, always in a process of active assembling, affected by time and the contingencies of life. People will change buildings as a matter of course. Walls will be taken down, new ones will be added; nature, weather and climate will play their role; time and decay will creep in; insects and plants will spread everywhere; renovations, extensions, and alterations will follow; who knows what will happen next. The building is an ongoing material and social assemblage.

EXPANSION

Lina Bo Bardi was particularly aware of the value of time in architecture and of the creative antagonism between building designed and building experienced. In 1957 she designed the MASP São Paolo Art Museum completely lifted up, creating a monumental void underneath it, and so she let the city 'breath' and gave it a generous space for gatherings. It is as if the building was raised and contracted in order to release space below for urban occasions to occur. When John Cage, the advocate of chance and indeterminacy in music, visited the MASP museum he exclaimed: 'It's the architecture of freedom!' He meant that it is an architecture beyond material bounds, an architecture that gives room to the city, rather than simply taking from it.[20]

The void of the MASP Museum is extraordinary in this respect because of the remarkably large public events it can accommodate. Lifted like a heavy cloud, it challenges architecture's conventional relation to earth and air and reverses the visitor's typical anticipation that the building will abide by the laws of gravity. But with this reversal and the building's amplified detachment from the ground, an extra free and generous space is dialectically released below. This is the social domain of the ground, naturally expansive, open to possibilities and the contingencies of urban inhabitation.

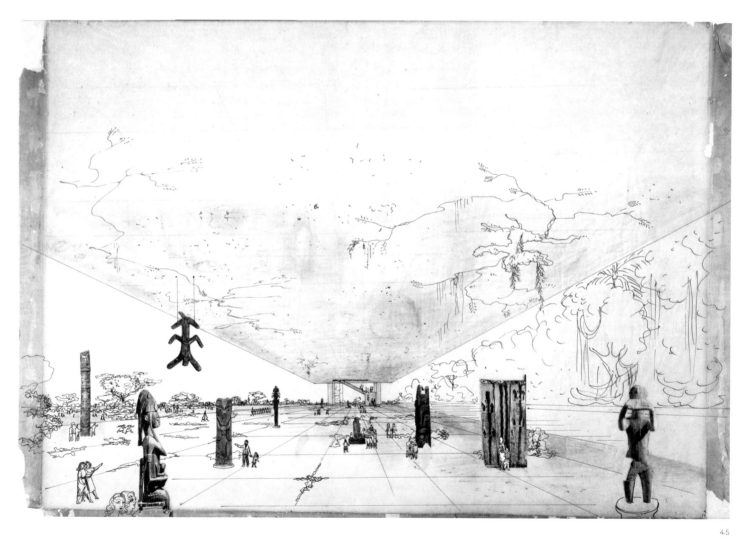

4.5

4.5 Lina bo Bardi,
*São Paolo Art
Museum (MASP),
void study*, 47.2 ×
69.8 cm, graphite,
Chinese ink and
collage on paper,
1963, © Instituto Lina
Bo e P.M. Bardi, São
Paolo, Brazil

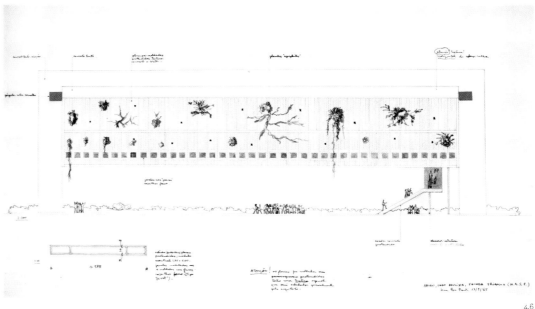

4.6

Bo Bardi studied the evolution of natural and social environments, and her architecture was in many respects open to expand in its context, to engage with people and plants and to be complemented by them as an assemblage in time. She wrote that architecture is remade and reinvented all the time, by each person who walks into it: 'until people enter the building, climb the steps and take possession of the space in a "human adventure" that develops in time, the architecture does *not* exist, it is an inhumane cold scheme.'[21] Her drawings are beautiful and a striking evidence of this thought, colourfully occupied by life: people, objects, animals and plants in non-hierarchical relations.

Bo Bardi's own house, the Glass House, completed in 1950, has a similar spatial quality through an exaggerated difference between contraction and release. In section the building lifts itself above the ground, hovering on pilotis and letting the landscape free (see fig. 4.8). In plan, the private parts of the house are tight cells, all contracted together, while the more public area of the house extends as a large airy space surrounded by glass. An amazing plant world pervades the building in an extraordinary manner and almost everywhere. Patios of tropical trees penetrate the building (see fig. 4.9) while an overgrown wild forest surrounds the whole house.

This dialogue between stillness and time, the permanence of the house and the complex and evolving forces of the environment, is evident throughout her projects. This is because Bo Bardi understood architecture as a reality much broader than the building. Her progressive and cross-disciplinary thinking defined architecture as an expanded spatial practice as early as 1957:

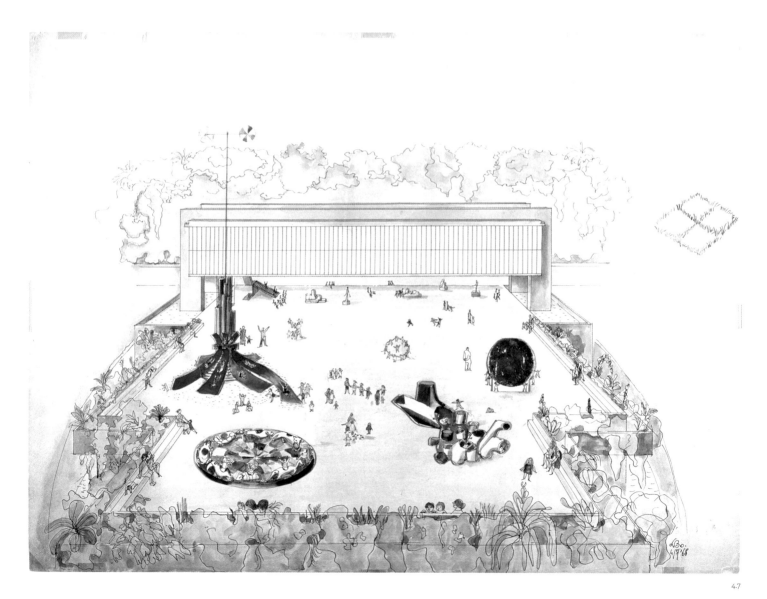

4.7 Lina bo Bardi,
*São Paolo Art
Museum (MASP),
Preliminary Study*,
56.2 × 76.5cm,
collage, ink and
watercolor on paper,
1968, © MASP, São
Paolo, Brazil

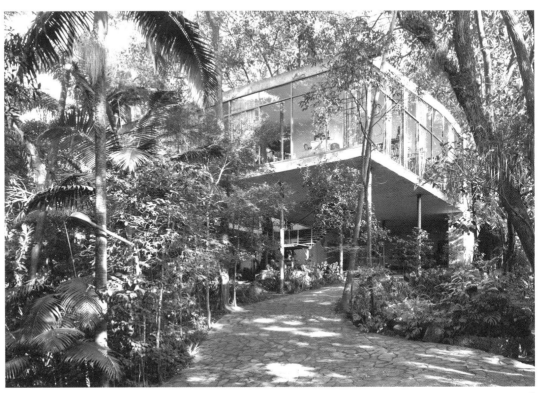

4.8

4.8 The Glass House, Sao Paolo, 1951, exterior view, photograph courtesy of Nelson Kon, 2011

What does the word Architecture intend to mean? At first, limiting it to the art of building could seem passive and, in an even more restricted way, concern just the house construction. But Architecture is almost implicitly everything which is structure and representation, from the rocks, the skeleton, from the structure of the atom up to the appearance of the spheres that are part of the planetary system. The man made efforts, using the elements that nature gave him, in order to modify and reorganize this same nature, created architectures that, by improving themselves, spread through the world, giving origin to new architectures, from the rock to the interplanetary satellite, from the cave to the sky-scraper, from the pendulous to the cathedral.[22]

Bo Bardi's interest in a spatial and social reality much broader than the building is not unique. In 1968, about ten years after Bo Bardi's statement that 'architecture is almost everything which is structure and representation', the architect Hans Hollein published his manifesto 'Everything is Architecture'. This document emerged from a very different design and cultural sensibility, but similarly intended to increase the scope of the architect and expand architecture towards interdisciplinarity. Hollein was in tune with the avant-garde of the late 1950s and 1960s, the Situationists, the Metabolists, Archizoom and generally architecture's emerging interest in participatory art. The pursuit of architecture as an

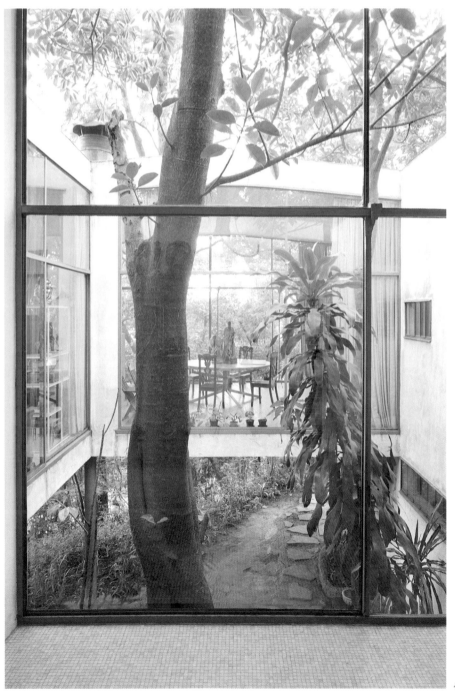

4.9 The Glass
House, Sao Paolo,
1951, view of atrium,
photograph courtesy
of Nelson Kon, 2011

4.9

expanded and interdisciplinary field was of course not unrelated to the art practices of the time. As Liaine Lefaivre has noted, 'at the same time Hollein was writing "Everything is Architecture", Joseph Beyus was claiming "Everything is Art", and John Cage "Everything we do is Music".'[23]

But the tendency to treat architecture as 'everything' is problematic because the building is an assemblage made *of* this everything and, at the same time, is *about* this everything. Robin Evans was concerned with something similar when he wrote that architecture is substantial yet representational, meaning that it is 'more equivocally of the world and, at the same time, *about* the world than any other art form'.[24] If, as Bo Bardi states, architecture is everything that is structure and representation in the world, the building inevitably has a troubled relation with the chance universe that contains it. How can architecture be structured like the world, and *like* chaos, be *in* this chaos, and *represent* it at the same time? How can it incorporate and represent chance simultaneously?

Firstly, architecture acknowledges chance by engaging with it dialectically. The building embodies and represents chance precisely because it tries to resist it. When you resist something, you make it apparent. The building, in its effort to tame chance, to defend itself against contingency, highlights what it represses, the very condition of chance. In its capacity to represent the world and itself in it, it manifests the tension between the necessary and the accidental as two oppositional and, at the same time, inseparable conditions.

Secondly, evolution and encounter are inherent in architecture, primarily because architecture is something beyond the building as a thing.

Architecture expands beyond the building as an object, spatially *and* temporally. When Bo Bardi says that architecture is about a greater whole than the building, I understand this to include the matrix of dialogues and clashes that architecture creates with places, people, histories and disciplines synchronically and diachronically. Architecture is an evolutionary device of thought and *a conversation* happening materially and conceptually in the world. It produces buildings, tells stories, creates encounters, makes different situations and poses questions *in, of* and *about* the world. The chance condition is manifested in the assemblage and antagonism of these differences.

Notes

1 Louis Althusser, *Philosophy of the Encounter: Later Writing, 1978-1987* (Verso, 2006), p. 169. Althusser's thought has influenced architectural theory, for example Jeremy Till's book *Architecture Depends* (MIT Press, 2009) which discusses the relations between architecture and contingency.

2 Althusser, *Philosophy of the Encounter*, p. 190. Althusser also created a two-page text titled 'Portrait of the Materialist Philosopher' for a 'quasi-professional' philosopher who is an 'aleatory materialist'. See Althusser, *Philosophy of the Encounter*, pp. 290–91.

3 André Breton, *Nadja* (Grove Press, 1960), p. 52.

4 Beatriz Colomina discusses many more layers about the relationship between the advertising industry and Le Corbusier's work in '*L'Esprit Nouveau*: Architecture and *Publicité*', in Michael K. Hays (ed.), *Architecture Theory since 1968* (MIT Press and Columbia Books of Architecture, 2000), pp. 626–37.

5 Marcel Duchamp, quoted in Anne d'Harnoncourt and Kynaston McShine (eds), *Marcel Duchamp* (Museum of Modern Art and Philadelphia Museum of Art, 1989), p. 283. Such activities of collection were common for both the architect Le Corbusier and the artist Duchamp. Colomina discusses their working manners in 'L'Esprit Nouveau: Architecture and Publicité', in Hays (ed.), *Architecture Theory*, pp. 626–37, and 'Le Corbusier and Duchamp: The Uneasy Status of the Object', in Taisto H. Mäkelä and Wallis Miller (eds), *Wars of Classification: Architecture and Modernity* (Princeton Architectural Press, 1991), pp. 36–61.

6 Mies, quoted in Robin Evans, *Translations from Drawing to Building and Other Essays* (Architectural Association, 1997), p. 257.

7 This condition is well discussed by Evans in his essay 'Mies van der Rohe's Paradoxical Symmetries', in *Translations from Drawing*, pp. 233-77.

8 Refer to Chapter 2.

9 The tension between design and chance experienced in the Barcelona Pavilion will also be discussed in Chapter 8.

10 Max Ernst, quoted in Harriett Ann Watts, *Chance: A Perspective on Dada* (UMI Research Press, 1980), p. 146.

11 Ernst, quoted in Watts, *Chance: A Perspective on Dada*, p. 145.

12 Hans Hollein, 'Transformations' (1966), http://www.hollein. com/index1.php?lang=en&l1ID=6&sID=13 (visited 17 October 2011).

13 Ben Nicholson, 'War and Peacefare at the Loaf House' in *Architectural Design* (no. 123, 1996), p. 39.

14 Kate Steinitz, quoted in Elizabeth Burns Gamard, Kurt Schwitters's *Merzbau: The Cathedral of Erotic Misery* (Princeton Architectural Press, 2000), p. 88.

15 Charles Jencks and Nathan Silver, *Adhocism: The Case of Improvisation* (Doubleday, 1972), p. 173.

16 William J. R. Curtis, *Modern Architecture since 1900* (Phaidon, 1996), pp. 662-63.

17 Stewart Brand, *How Buildings Learn: What Happens After They're Built* (Viking, 1994), p. 69.

18 See Andrea Oppenheimer Dean and Timothy Hursley, *Rural Studio: Samuel Mockbee and an Architecture of Decency* (Princeton Architectural Press, 2002). Since 2000 Andrew Freear has directed Rural Studio towards larger public buildings.

19 I am further discussing the work of Lacaton & Vassal in Chapter 7. See also Monica Gili (ed.), *Lacaton and Vassal* (2G Libros Books, 2007).

20 Lina Bo Bardi in Olivia de Oliveira, *Subtle Substances: The Architecture of Lina Bo Bardi* (Romano Guerra and Gustavo Gili, 2006), p. 295.

21 Bo Bardi in de Oliveira, *Subtle Substances*, p. 358.

22 Bo Bardi, *Contribuição Propedêutica ao Ensino da Teoria da Arquitetura*, 1957 (translation by the Instituto Lina Bo Bardi P.M. Bardi, http://www.institutobardi.com.br/eng/lina/depoimentos/ index.html, visited 13 October 2011).

23 Liane Lefaivre, 'Everything is Architecture: Multiple Hans Hollein and the Art of Crossing Over', *Harvard Design Magazine* (no. 18, Spring/Summer 2003).

24 Robin Evans, *The Projective Cast: Architecture and Its Three Geometries* (MIT Press, 1995), p. 65.

FRAGMENT, PART, WHOLE

TWO KINDS OF ORDER

The understanding of chance that underpins this book is influenced by Henri Bergson's definition of the *vital order*. Bergson insists that the modernist interest in relativism is in fact a confusion between two kinds of order: the 'vital order' on the one hand, the 'automatic order' on the other. The vital order is voluntary, willed and directed by human intention; the automatic order is geometrical, physical, observed in nature and somewhat inert. The vital order is essentially what we understand as creation. It is 'manifested to us less in its essence than in some of its accidents', Bergson writes.[1] These accidents are imagination in action: they can initiate, complement or interrupt, and totally alter our thinking behind a project.

For Bergson order is an 'agreement between subject and object. It is a mind finding itself against things':

> I enter a room and pronounce it to be in 'disorder', what do I mean? The position of each object is explained by the automatic movements of the person who has slept in the room, or by the efficient causes, whatever they may be, that have caused each article of furniture, clothing, etc., to be where it is: the order, in the second sense of the word, is perfect. But it is order of the first kind that I am expecting, the order that a methodical person consciously puts into life, the willed order and not the automatic: so I call the absence of this order 'disorder'.[2]

What chance really means is finding a different order from the one that was expected. Chance is essentially the relationship between an expected kind of order and an actual kind of order. It cannot arise without both vital and automatic order being present. Either vitality is expected in the mind, and the outcome delivers automatic order, or vice versa. But your mind, Bergson says, can go in two opposite ways:

> Sometimes it follows its natural direction: there is then progress in the form of tension, continuous creation, free activity—this is the vital order—and sometimes the mind inverts its way and leads to extension, to the necessary reciprocal determination of elements externalized each by relation to the others, in short, to geometrical mechanism.[3]

The mind sometimes expects vital order and sometimes expects automatic order. It always oscillates between the two with regard to the kind of order it is looking for:

> The mind swings to and fro, unable to rest, between the idea of an absence of final cause and that of an absence of efficient cause, each of these definitions sending it back to the other. The problem remains insoluble, in fact so long as the idea of chance is regarded as a pure idea, without mixture of feeling. But, in reality, chance merely objectifies the state of mind who, expecting one of the two kinds of order, finds himself confronted with the other.[4]

Our desire for vital order in design is expressed through experimentation in which chance as a pure and objectified idea plays a critical role. We take risks and experiment with our projects because we want to challenge the order that we are expecting and open up the possibility of chance outcomes. We like not to fully know in advance how ideas will turn out; we like to ask 'what if?' This is the vital will of the author who creates in order to pursue novelty and transcend finality. Fully predicting and knowing

would lead to finality but finality is too limiting for architecture and art, which are inherently open to experiment, continuously searching for the possibilities of human imagination. As Bergson says, finality is 'too narrow for life in its entirety'.

According to Bergson nature and the animal world invent variations of routines through automatic and relatively passive procedures. Even when these routines escape automatism it is in order to create a new automatism. To a certain extent this is also what computer processes of automation attempt to do. There is an element of inertia and passivity in their pursuit of the optimal. But human consciousness is different: it can break the chain of automatism towards a totally distinct sense of invention and freedom. This is because it is powered by the creative interplay of 'intelligence' and 'instinct'. Consciousness, according to Bergson, is freedom itself reached through the interplay of both orders: the vital order and the automatic activity, a double and simultaneous direction of the mind towards both intelligence and instinct. Human creativity is closer to the vital order because it is powered by the mind as it tends toward intelligence. The creativity of nature and animal life, on the other hand, is more automatic because it is powered by the mind as it tends toward instinct. There is, of course, an instinctive component to human life and intelligent creatures are not entirely removed from the order of the automatic, and so it is exactly this interplay between the automatic and the vital that is central for creative production and for architecture. The vital order alludes to intelligence; the automatic order alludes to mechanical processes. Combined they produce endless chance relations that affect design thinking, creative making and experience.

CUT-UPS

In the early twentieth century the Dada artists aimed to reject the prevailing order of art, rationality and the presuppositions of bourgeois society overall. Dadaist projects were often based on an initial choice of raw material and the subsequent introduction of a disordering process in order to generate an image of randomness. Tristan Tzara cut newspaper articles into small pieces, none longer than a word, put them in a bag and, after shaking them well, let them flutter onto a surface to make a poem. Similarly Hans Arp's *papiers collés* and *papiers déchirés* were produced by cutting pieces and letting them fall into place as randomly *self-arranged* works. Nevertheless the two extremes of order and disorder (as the deliberate disintegration of a particular order) are symptoms of the same design rationalization, showing a formalist preference towards minimal structures that is common to both processes. Rudolf Arnheim comments:

> In a crucial period of his life Arp found himself moving from the extreme of 'impersonal, severe structures', intended to eliminate the burden of personal experience, to the forsaking of defined form and the acceptance of dissolution. ... Clearly, the earliest insistence on minimal shapes of the utmost precision and the subsequent display of corrosion, seemingly at extreme opposites, were in fact symptoms of the same abandonment.[5]

While Tzara left the outcome of his creative self-arranging process completely intact and refused conscious involvement in the work, Arp tended to deliberately control the outcome and balance it with choice. The idea that chance should be married with control was also shared by Hans Richter who was

dissatisfied by the use of pure chance alone. Richter admitted that highly automatic processes of using chance gradually became frustrating for many of the Dada artists:

> We were all fated to live with the paradoxical necessity of entrusting ourselves to chance while at the same time remembering that we were conscious beings working towards conscious goals. This contradiction between rational and irrational opened a bottomless pit over which we had to walk. There was no turning back; gradually this became clear to each of us in his own secret way.[6]

Like Arp, Richter believed that chance plays only a complementary role in the creative process: 'Chance is not a thing of itself. ... An arrangement without cause is ... but it is still the individual, the author, who accepts this offering at the moment. So chance can be offered to you a hundred times, and you don't make anything out of it. And, then another time, it clicks.'[7] The author plays a critical role in triggering the chance process—here in the form of disordering—but also in noticing it and deciding when it is worthwhile to accept it in the work.

It was this realization that design and chance, reason and anti-reason, always coexist in the creative process that made the Dada movement so unique. While the Surrealists used chance impulsively and figuratively to expand the imagination of the individual artist, the Dada artists used it in highly automatic processes in order to loosen control of the work and pursue an expression of disorder that implied a political position. The Dada artists thought that Western notions of causality forced law and restrained humanity's creative freedom.

For them disorder was a critique of rationalism and institutional top-down rules. This use of disorder as the means to disturb the expected or accepted order has characterized avant-garde art and architecture throughout the twentieth century. For example, while John Cage used chance operations in order to disturb traditional tonal forms of music, Le Corbusier used random-looking positioning of windows, among other formal devices, to disembody the solidity of the concrete surface, allowing changeable rays of light to transform the interior of his Ronchamp Church.

But the tension between order and disorder has troubled architects of all times. This is because the question of order is inherent in any creative process. Aldo Rossi reflected on the possibilities and limits of disorder in his work in a way that describes a broader architectural view about the nature of design. While he embraced the importance of disorder in architecture as a condition that corresponds to experience and our state of mind, he rejected it as an arbitrary and complacent process or form:

> I felt that the disorder, if limited and somehow honest, might best correspond to our state of mind. But I detested the arbitrary disorder that is indifferent to order, a kind of moral obtuseness, complacent well-being, forgetfulness. To what, then, could I have aspired in my craft? Certainly to small things, having seen that the possibility of great ones was historically precluded.[8]

However, it is exactly around this period in the 1980s, when Rossi wrote this, that architects started using systematically disordering techniques in the design process. They explored random-looking folding, shifting and cutting to intentionally allude

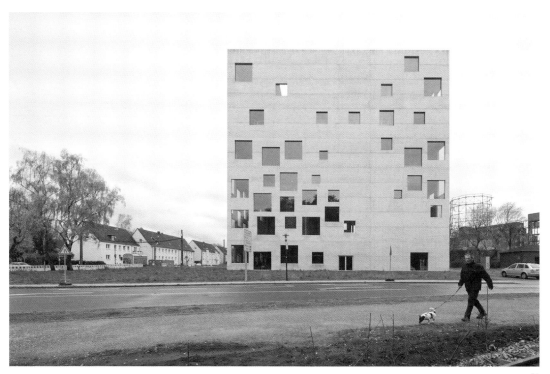

5.1

5.1 SANAA,
Zollverein School,
Essen, Germany,
photograph Iwan
Baan

to an image of chaos as part of a tendency soon to be coined deconstructivism. Frank Gehry's Vitra Design Museum (1989) in Weil am Rhein is an obvious early example that used deconstruction to critique the typical white cube modernist gallery. Two decades later in the same place Herzog & de Meuron's VitraHaus (2010) displays a different image of chance, where bars of an 'archetypal house' are stacked in an explicitly random manner. This idea of disorder is stoical, which is different from the more ambivalent image of deconstuctivist architecture pursued by Gehry, Coop Himmelb(l)au and others. It characterizes a number of new buildings in the early 2000s, showing a renewed interest in formalist randomness.

THE IMAGE OF RANDOMNESS

There is a noticeable visual similarity between Dadaist disordering works and some of the building surfaces by Kazuyo Sejima + Ryue Nishizawa (SANAA), built a century later. The Zollverein School in Essen, for example, has randomly positioned openings producing elevations which may be seen to be comparable with Arp's *Elementary Construction According to the Laws of Chance* (1916).

SANAA explain the irregular arrangement of the openings rationally on the basis of optimal light conditions and views. But, clearly, there is also a conscious interest in the aesthetics of chance insofar as the outcome of the methodical process defies

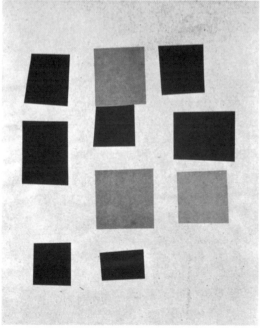

5.2

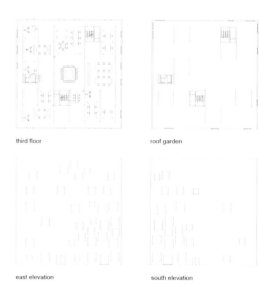

third floor roof garden

east elevation south elevation

5.3

5.2 Hans Arp,
*Construction
Elementaire
(Selon les Lois du
Hasard)*, collage,
40.4 × 32.2 cm, 1916,
Kunstmuseum Basel,
© DACS 2011

5.3 SANAA,
Zollverein School,
Essen, Germany,
third floor plan,
roof plan, east and
south elevations, ©
SANAA

our expectations of what it is to look rational. It is doubtful whether the Zollverein School enhances the experience of chance more than other buildings, but it clearly manifests the dialectic of architecture and chance as an image in the building. SANAA's architecture belongs to the modernist sensibility of abstract space but offers a slightly less familiar view: an intentional *image* of randomness, a simulacrum of chance.

The formal association with Dada, particularly Arp's chance compositions, can also be seen in the curved shapes of the roofs of SANAA's 2009 Serpentine Gallery Pavilion, the plans of the apartment building in Okurayama, designed by Kazuyo Sejima & Associates, and some of Sejima's seating designs. The apartment building in

Okurayama has a three-dimensional complexity, interweaving nine 50m² dwellings with garden spaces. Semi-Dadaist techniques of cutting, stacking and mixing up have produced geometric and spatial intersections that encourage in-betweenness and encounter (see fig. 5.5).

Sejima writes:

> The gardens cut through a rectilinear space, giving the plan a continuous strip-shape. By cutting this strip-shaped plan randomly, some spaces become interior terraces, while others become exterior terraces. We tried to create a condition where interiors and exteriors are intermingled comfortably and continuously. From windows opening in various directions, people can have different kinds of views, such as gardens with a closed and quiet atmosphere, softly

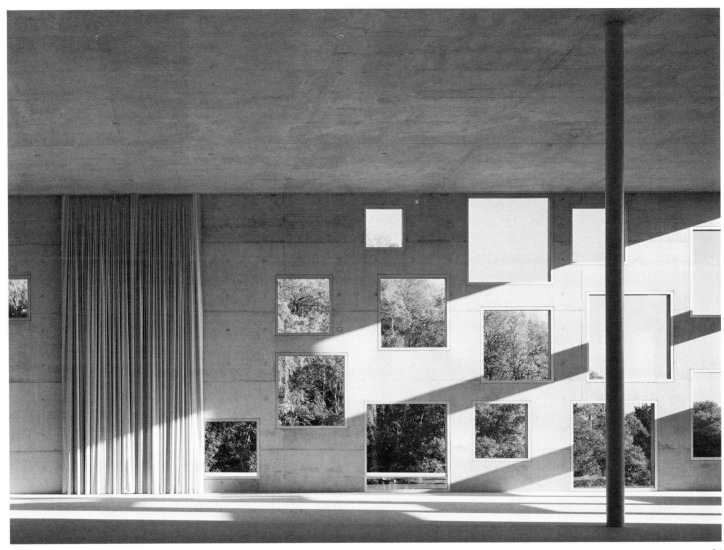

5.4

5.4 SANAA,
Zollverein School,
Essen, Germany,
photograph courtesy
of Christoph Engel

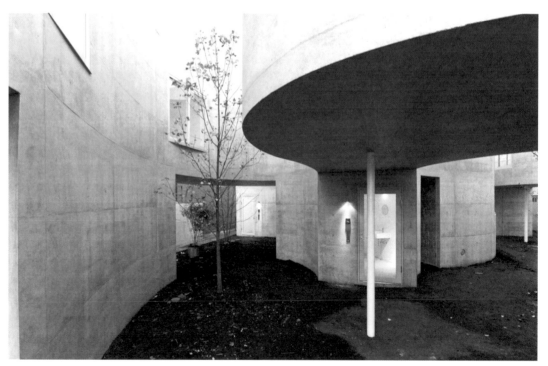

5.5

curved outside walls, or townscapes. ... different spaces can espouse various different life styles by spreading gardens, bathrooms, bedrooms, and living rooms all over the site, in a three-dimensional fashion.[9]

To different degrees the experience of all buildings is affected by various kinds of chance relationships: formal, material, social and atmospheric. The Okurayama apartments increase the spatial complexity of these kinds of relationships by means of contiguity. Contiguity is the spatial dimension of coincidence. In the apartment complex we see different types of space and human activity intentionally juxtaposed very close to each other in a matrix of interiors and exteriors that resembles

a complex miniature piece of city. Paths, terraces, bathrooms, living rooms, gardens and bedrooms are spread all over the site in a non-hierarchical manner in order to increase spatial opportunities for coincidences.

Quite differently SANAA's 21st Century Museum of Contemporary Art in Kanazawa is organized as a spacious arrangement of free-standing galleries within an open-plan circular building (see figs. 5.6 and 5.7). The building is characterized by polycentrism, a principle also explored by Van Eyck. What looks to be accidental is carefully designed to give the visitor a sense of wandering and of 'being lost' in a bright labyrinthine space. Varying light qualities, a random succession of interiors and

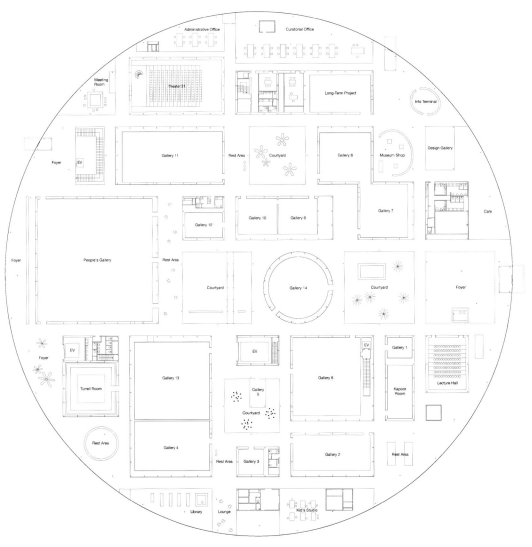

5.6

5.6 SANAA, 21st
Century Museum,
Kanazawa, Japan,
floor plan, © SANAA

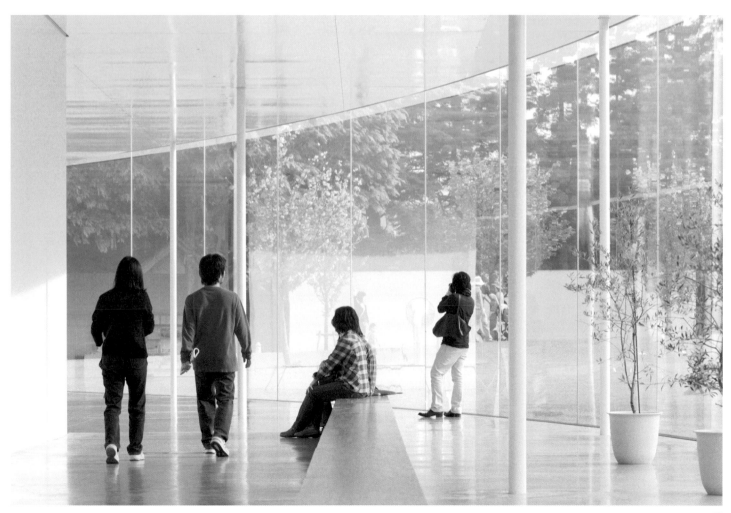

5.7 SANAA, 21st
Century Museum,
Kanazawa, Japan,
photograph Iwan
Baan

5.8

courtyards, the circular edge of the building with the panoramic views, the layering of glass surfaces, whiteness—all these contribute to an atmosphere of disorientation and ambivalence.

In addition the building expresses an economy of means that paradoxically generates spatial richness. Sejima and Nishizawa write: 'We are always fascinated by the ambivalence between something and nothing, by the insubstantial identity of material and space.'[10] This perception of ambivalence is further explored by the photographer Walter Niedermayr who regularly collaborates with SANAA. His photographs tend to be deliberately overexposed so that the depicted space can look whiter than normal, ambiguous and alluding to the infinite. People, plants and objects are shown 'floating' in the space of the photograph in vivid colours—just as in Sejima drawings accidental occupations complement an otherwise undifferentiated space. SANAA's drawings, photographs and buildings are deliberately constructed to evoke the ambivalence between the circumstantiality of lived space and the endlessness of abstract geometric space. We do not experience a stable and perfectly preserved designed environment, but rather transitory and dialectical relationships between the building and the phenomena that penetrate it.

Beyond SANAA there is a range of contemporary Japanese architects who are interested in the aesthetics of chance. For example, Sou Fujimoto, taught by Toyo Ito, forms multiple random-looking relations between rooms and openings. In 2008 the architect Junya Ishigami, having first worked with Sejima, realized the building KAIT Kobo for the Kanagawa Institute of Technology. A forest of slender columns, irregularly orientated and distributed in

a slightly distorted square bed of concrete, hold a thin, flat roof with parallel strips of openings. The plan of the building is like a Dada image of canned chance or like Cage's dot notations for *Fontana Mix*.[11] The building is experienced as a forest, a systematized but relatively unspecified space. Its minimalist airy quality is ideal for highlighting the contiguity of happenings, light, weather, people, objects and plants. All sorts of workshop activities happen in between the random clusters of columns; magnets hold various objects on the steel columns; larger constructions are hung from the beams. The space gets fuller through inhabitation and acquires a thicket-like quality.

The Zollverein School, the Okurayama apartments, the Kanazawa Museum and the Kanagawa Institute of Technology use chance in two ways: as form and as agency, meaning here the means by which chance relationships are active in time. On the one hand a kind of Duchampian canned chance is embedded in the building fabric, determining the location of windows, columns, and so on; on the other hand an unplanned, temporal and performative chance as agency is welcomed and diffused in the architecture.

TYPE FORMS

Many of the projects of Miralles and Pinós are worked out through layering many different plans and treating the ground as varied and animated rather than as homogeneous and static. William J. R. Curtis calls their more topographical works 'social landscapes'.[12] He sees the patchwork of building elements and walkways representing an interactive relationship between communities, buildings and nature. To construct these topographies Miralles

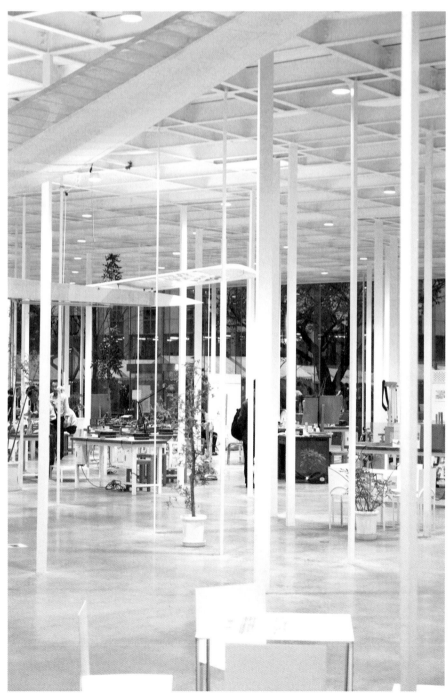

5.9 KAIT Kobo,
Kanagawa Institute
of Technology,
Japan, photograph
by the author, 2011

5.9

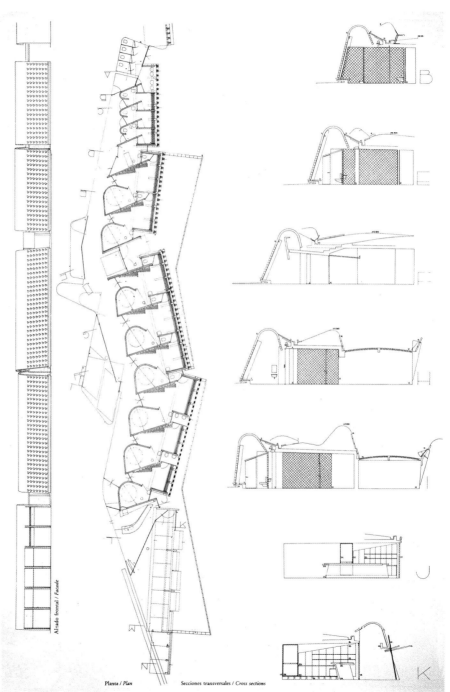

Altado frontal / *Facade*

Planta / *Plan* Secciones transversales / *Cross sections*

5.10 Miralles and
Pinós, Archery
Ranqe, 1990–92,
plan, sections
and elevation,
reproduced with
permission from
estudio Carme Pinos
and El Croquis

5.10

and Pinós create a language of architectural parts that they call 'type forms'. Consider for example the Archery Range in Barcelona: reinforced earth banks, prefabricated concrete units, metal grille doors, ramps, steps, windows, concrete gutters, ceramic lintels, benches and the rest are all explored relationally in a typological matrix of forms and materials.

There is both a systematic and an impulsive use of chance in this design methodology that aims to choreograph architecture as if it were dance. The result is a rhythmical composition: the type forms intertwine with the existing landscape, overlap or slip around each other but do not always join. If John Cage's music 'gets rid of the glue' between sounds, similarly Miralles and Pinós's type forms intentionally lack a tight joining, letting the parts create variable slippages between each other.[13] These different parts are not fragments but proper wholes in themselves, simultaneously autonomous and relative to each other.[14]

Archery Range is not only produced through serial variation, but the proposal itself is conceived in its entirety as one out of a series. This is typical of much of the work by Miralles and Pinós. Miralles explains:

> We have always presented our work not as the best and only possible solution, but as one of the multiple variations, which nevertheless seeks a similar degree of complexity to reality. … We would like to present our work within the context of this aspect: variations. A thousand and one projects, almost an ongoing narration of work that passes from one situation to another.[15]

The finished building incorporates many of its versions in its making. 'When one thinks about the construction of a wall … I am interested in thinking about all the possibilities that this element can or could contain', Miralles says.[16] Therefore the design of the wall is not conceived instantaneously but through a process of assembling its possible forms. These possible forms are eventually embodied in the wall as alternatives until they acquire material and structural coherence.

Characteristically, for Miralles a good way to start a project is 'to imagine a complex image of reality' which, of course, always embraces coincidences.[17] And this is exactly what he did in many of his projects with Pinós. Complex chance relations were rehearsed again and again in order to bring different coincidences of forms and materials together into one synthesized whole. The complex reality of the drawing is eventually built as an architecture of frozen randomness.

SELF AND FRAGMENT

The architect's urge to collect and make assemblages is combined with a parallel interest in the fragment as a thing in its own right. But where does this interest in the fragment come from which has dominated a large part of architectural thought, and what does it have to do with chance? In this passage Rossi has created a psychological link between the fragments of buildings and the fragments of ourselves:

> I have rediscovered Filarete's column in the Roman ruins at Budapest, in the transformation of certain amphitheaters, and above all as one possible fragment of a thousand of other buildings. Probably, too, I am fond of fragments for the same reason that I have always thought that it was good luck to meet a person with whom one has broken ties: it shows confidence in a fragment of ourselves.[18]

Just as personal memories give me comfort as fragments of myself, so the old building fragment reaffirms the passage of time and, therefore, the building's history, my history and the history of others. There is a strong psychological correlation between the object fragment and the psychic condition. The experience of the self is not entirely stable, ideal and whole, and will inevitably be interrupted. I *feel* myself as fragment, and so from time to time, I find comfort in the fact that other fragments and discontinuities exist around me.

If we accept that buildings are not always experienced as wholes, what is then architecture's relation to the fragment? Is it to represent the fractured conditions of experience, or is it to resist fragmentation through what Rossi has called a comprehensive and *unified project*? Rossi continues:

> But the question of fragment in architecture is very important since it may be that only ruins express a fact completely. Photographs of cities during war, sections of apartments, broken toys. Delphi and Olympia. This ability to use pieces of mechanisms whose overall sense is partly lost has always interested me, even in formal terms. I am thinking of a unity or a system, made solely of reassembled fragments. … I am convinced, however, that architecture as totality, as a comprehensive project, as an overall framework, is certainly more important and, in the final analysis, more beautiful. But it happens that historical obstacles—in every way parallel to psychological blocks or symptoms—hinder every reconstruction. As a result, I believe that there can be no true compensation, and that maybe the only thing possible is the addition that is somewhere between logic and biography.[19]

Architecture's effort to make a total and unified project is in tension with its historical circumstances. The fragment is an unavoidable symptom of this tension between architecture and history, which designers and writers have appreciated greatly over time. Yet, the degree to which the fragment dominated the architectural discourse of the twentieth century in particular is remarkable. During this period architects consciously and persistently moved beyond the found fragment to create new fragments and discontinuities themselves.

The architect's tendency to interrupt the geometric unification of form reflects an urge to break the idea of totality. The question is how this urge is eventually resolved in the designed object. In his text 'Persistent Breakage' Robin Evans explains how in the early twentieth century the architectural desire to break was influenced by the fracturing of pictorial space in cubist painting. The fractured simultaneity explored by Picasso found a literal equivalent in Kurt Schwitters' Merzbau and perhaps a sublimated one in the constructed views of Le Corbusier's Villa Savoye. A different motive for breakage was pursued by Alvar Aalto who tried to humanize modern architecture by finding connections between 'forms of social life' and 'forms of building' and who pursued spatial discontinuities in built form in order to echo the discontinuities of living. Evans writes: 'If buildings function as a perfect shell for people's lives, then diversified contours may be assumed to stand for diversified occupation, casual distribution for casual encounter, architectural monoliths for social monoliths, and so on.'[20] In this sense fractured form may correlate with the lack of continuity that characterizes the experience of space.

Evans continues and with reference to Colin

Rowe and Fred Koetter's *Collage City* (1978) writes:

> All the accidents, additions, revisions, and chance events arising from innumerable human impulses and encounters productive of the urban environment can then be concentrated—or counterfeited—in the simulacrum of the architect's collage. An uncoordinated procedure of thinking is presented as equivalent to the uncoordinated profusion of the multitudinous historical city.[21]

There are at least three links that Evans makes between the experience of chance in the everyday and its equivalent in the process of architectural design: a) the simultaneity of perception suggests the layering of multiple visual fields in the building (Villa Savoye); b) discontinuities of living find an equivalent formal interruption in the building (Paimio Sanatorium); c) contradictions in the experience of cities are simulated in the drawing process through collage (Collage City). These processes and the architect's desire to break the idea of totality reached a peak in the later part of the twentieth century with the movement of deconstruction. For Evans the deconstruction movement signals the effort to escape both humanism and modernism: war against totality; war against completeness and singularity. The fracture became the norm, and was the persistent characteristic of texts, films, poems, buildings and art works, as well as psychoanalytic and philosophical thought. Space was simultaneously fractured and dispersed. There was no single or permanent meaning. This interest in interruption was paralleled by a formalist appreciation of chance, associated with a revived attention to history and the conflation of styles; the popular acceptance of scientific concepts such as uncertainty and probability; and a continual interest in cinematic montage. It was also supported by philosophical thinkers such as Derrida, Lyotard, Deleuze and Guattari. Just as the reading of the world and of history was seen as complex and full of interruptions, so was architecture. In 'Persistent Breakage' Evans finally points to the formal irregularities of Hans Scharoun's Philharmonie in Berlin, arguing that this building covers all the historical phases of fragmentation of the twentieth century. Evans eventually comes to the conclusion that the use of fragmentation in architecture, especially in the most recent period of the late twentieth century, is 'an imaginary complement to the world that exists for us—the world experienced day after day'.[22]

Before the Enlightenment, architects used to produce buildings of symmetry and clear unity, perhaps in reaction against the experience of uncertainty. In contrast the architecture of the twentieth century is full of episodes of fragmentation in response to society's increasing ability to understand uncertainty and predict hazards. The more we know about indeterminacy, the more we are confident in representing it as form. A significant portion of twentieth century architecture and art might have well reacted to society's insistent efforts to control indeterminacy by producing dialectically opposite works which deliberately lack a sense of control. Many anti-order and de-centralized works, by Coop Himmelb(l)au for example, use fragmentation symbolically in order to represent the idea of indeterminacy as form.

In architecture fragment and whole are not antithetical. The fragment belongs in the whole and the whole is implied in the fragment. Yet

the realization of what Rossi calls the unified architectural project is difficult. Architecture as a unified totality is beautiful but hard to reach. If the total image of the self is an illusion, so is the total image of architecture. The place, the people, the environment, time and the historical moment will go against the ideal image of the building and hinder its realization.

Architecture's relation to the problem of the fragment is simply inevitable. Venturi wrote that architecture 'should be able to admit the paradox of the *whole fragment*: the building which is a whole at one level and a fragment of a greater whole at another level'.[23] He pointed to the complexity of the cityscape and proposed that its seemingly chaotic juxtapositions produce in fact an unexpected sense of unity. Consequently the presence of contradictory and circumstantial parts can give the building an inherent quality of unity, helping it to become an 'inclusive whole'. This whole, Venturi says, is a 'difficult whole' which 'maintains, but only maintains, a control over the clashing elements which compose it. Chaos is very near; its nearness, but its avoidance, gives … force.'[24] What makes the building a contingent object is this dynamic relation to chance. The building resists it but only just.

UNIFIED PICTURE

The photographer Jeff Wall, who has a particular interest in architecture and has closely collaborated with architects, sees the avant-garde insistence on the aesthetic of fragmentation as an orthodoxy of its time and argues that the experience of the work's unity as a total image is more vital:

The art of the past, which is defined as 'organically unified',
is art that does not want to recognize its own contingent character, its own fragile illusionism. It wants to revel in the illusionism for its own sake and for the sake of its own audience, and it wants to seem to be inevitable and complete, the creation of magicians. Tearing apart the organic work of art was the accomplishment of the avant-garde, which revealed the inner mechanics of traditional illusionistic art, the stagecraft of the masterpiece. To a great extent, I agree with that process, and I like a lot of avant-garde art very much; it's important for me. But, I feel it's an unfree way of relating to it to erect it as an absolute standard against the aspects of the unified work. *I like the idea of the unified work because I like pictures*, and there is always a sense in which a picture exists as such through unification.[25]

It is interesting to hear this argument from an artist who uses numerous digital fragments in his production process. While architectural drawing has limited means to understand the connection between design and lived experience, there is a lot that can be found in contemporary photography. Wall makes each of his photographs from hundreds of photographic fragments, all layered digitally in order to make a seamless continuum. The moment that we see captured in the photograph never existed as such: the portrayed events are recorded at different times over a period of many months and then assembled in order to construct the particular image. The photograph represents the complexity of the life of a place artificially condensed and unified. This aesthetic experience of unity seems to be a fundamental human need. One of the purposes of representation is to edit the contingencies of reality in order to produce a clear ideogram of it. This is true for painting as it is for photography and architecture. We like the space of an uninterrupted

room because it can be contained in our mind as a picture.

For many, the sustaining condition of architecture is its ability to provide stability against the indeterminacy and confusion of reality. The table, the room or the house, as unified and whole types of places, support all sorts of social practices, occasions and habits. We have confidence in them because they preserve their autonomy and help us 'anchor' and remember circumstantial and fleeting events that we would otherwise run the risk of forgetting. Rossi writes:

> architecture becomes the vehicle for an event we desire, whether or not it actually occurs; and in our desiring it, the event becomes something 'progressive' in the Hegelian sense. ... it is for this reason that the dimensions of a table or a house are very important—not as the functionalists thought, because they carry out a determined function, but because they permit other functions.[26]

Architectural design is not simply a matter of stylistic preference towards either unity or fragmentation but the vehicle through which buildings can support the continuities and discontinuities of life forms. We like uninterrupted and unified rooms because they welcome chance and 'permit', as Rossi says, 'everything that is unforeseeable in life'.[27] We like them because they are lived from within (rather than as 'icons'), enabling events and producing enduring experiences to be remembered as 'pictures'. I am talking about the sensation of buildings as they are inhabited again and again rather than as they are contemplated temporarily. These spaces are emotionally charged and so we picture them with affection.

PART AND WHOLE

Paul Virilio writes that 'each period of technical evolution, with its set of instruments and machines, involves the appearance of specific accidents, revealing in negative the growth of scientific thought'.[28] Our increased knowledge of uncertainty has produced a contrary effect across all facets of technological development: the desire to predict and control much more. Architecture is not unaffected by this tendency: increasingly buildings are expected to be controllable to a much greater extent, performing highly in terms of economy, function and energy efficiency, among other things. The problem that remains is that this technological understanding of optimal performance, achieved mainly through automated computational procedures, is very generalized, leaving out the qualities of contextual and less 'ideal' chance found in specific places.

Computer-aided design first invaded product design, automobile and aeronautical industries, and then architecture. At present, digital methods of modelling and fabrication have the growing capacity to play a critical role in the materialization of buildings, achieve better execution times and optimize the available resources. To this end computational processes can use chance constructively. However, these are likeable and small degrees of chance that are overarched by the ultimate aim to reach and control an 'ideal' formal outcome.[29] These processes overlook the everyday, social and contextual notions of chance.

As we saw, the architect's will to break forms characterized a good part of the twentieth century and reached its peak with the deconstruction movement. The question of the fragment was then

followed by two approaches: on the one hand a return to digitally unified forms made out of identical or modular building components, which now focuses on the problem of 'the whole part' (rather than the fragment); on the other a restrained, abstract and ironic use of disorder as expressed in the randomly arranged openings of buildings by many contemporary architects. Today's computational tendency towards wholeness relates to biomorphism and perhaps to a literal analogy between digital pixels and biological or other elemental particles. This can be seen in several examples of parametric design and patterned building forms being produced by star architects of the late twentieth and early twenty-first centuries. The part belongs in the whole, but is also an autonomous whole in its own right; the whole is made by the multiplication of parts but is also a part of a bigger whole. This new seamless and unfractured architecture made by the systematic repetition of particles alludes to mathematical infinity: 'digital continua' of surfaces made out of endless 'digits'.

At the turn of the twenty-first century most architects who use computational methods in design limit the notion of creative chance to mathematical applications. The numerical digit prevails: it is the building block of computer science and of digital architectural procedures. The pixel on the other hand is the smallest picture element of digital imaging: it can be easily copied, varied and multiplied in order to make a whole image or representation of a three-dimensional object. We can easily see direct analogies between the multipliable pixel in computation and the multipliable building component in digitally fabricated building surfaces.

Automated routines aiming to imitate the behaviour of natural systems often use emergent procedures to generate formal propositions without enough cultural specificity. The current interest in making analogies and mutations between buildings and biological systems brings us back to the tension between *mimesis* and *fantasia*. A new kind of digitally determined mimesis tends to prevail in the architecture of the post-digital age where the emphasis is on the structural and morphological mimesis of complex natural systems, and where the peculiarities of human subjectivity, history and culture are often marginalized. Structural, environmental and economic parameters alone will produce a rather predictable and homogeneous range of results. But, as Bergson says, the mind wishes to escape this expected and automated order to search for the vital order and something entirely novel outside the possibilities of the tools that it uses. This is the challenge of architectural design in the digital era: to incorporate both the systematic and the impulsive aspects of chance in order to escape the dead-end of an entirely predictable automatism that gives homogeneous results of buildings, thereby enriching digital architectural languages with cultural specificity.

Notes
1 Henri Bergson, *Creative Evolution* (Dover, 1988, first English translation 1911), p. 230.

2 Bergson, *Creative Evolution*, p. 232.

3 Bergson, *Creative Evolution*, p. 223.

4 Bergson, *Creative Evolution*, p. 234.

5 Rudolf Arnheim, quoted in Harriett Ann Watts, *Chance: A Perspective on Dada* (UMI Research Press, 1980), p. 74.

6 Hans Richter, quoted in Watts, *Chance: A Perspective on Dada*, p. 61.

7 Richter, quoted in Watts, *Chance: A Perspective on Dada*, p. 134.

8 Alsdo Rossi, *A Scientific Autobiography* (MIT Press, 1984), p. 23.

9 *El Croquis 155: SANAA Kazuyo Sejima+Ryue Nishizawa* (Madrid: 2008–11), pp. 90–105.

10 Kazuyo Sejima and Ryue Nishizawa in Moritz Küng, ed., *Walter Niedermayr / Kazuyo Sejima + Ryue Nishizawa / SANAA* (Hatje Cantz, 2007).

11 Refer to my discussion about *Fontana MIX* in Chapter 7.

12 William J. R. Curtis, 'Mental Maps and Social Landscapes', *El Croquis 30+49/50: Miralles/Pinós* (Madrid, 1983–90), pp. 9–21.

13 Alan Rich, 'John Cage', in Rich (ed.), *American Pioneers: Ives to Cage and Beyond* (Phaidon, 1995), pp. 168–69. For a further discussion on Cage's chance operations and techniques of indeterminacy see Chapter 7.

14 Rich, 'John Cage', in Rich (ed.), *American Pioneers*, pp. 168–69.

15 Enric Miralles, *El Croquis 100/10: Enric Miralles + Benedetta Tagliabue* (Madrid, 1995–2000), p. 21.

16 Miralles, *El Croquis 72[II]: Enric Miralles* (Madrid, 1990–94), p. 272.

17 Miralles, *El Croquis 72[II]: Enric Miralles*, p. 376.

18 Rossi, *A Scientific Autobiography*, pp. 7–8.

19 Rossi, *A Scientific Autobiography*, pp. 7–8.

20 Robin Evans, *The Projective Cast: Architecture and Its Three Geometries* (MIT Press, 1995), p. 74.

21 Evans, *The Projective Cast*, p. 79. See Colin Rowe and Fred Koetter, *Collage City* (MIT Press, 1978, 1998).

22 Evans, *The Projective Cast*, p. 105.

23 Venturi, *Complexity and Contradiction in Architecture* (Architectural Press, 1977), p. 103.

24 Venturi, *Complexity and Contradiction*, p. 104.

25 Jeff Wall (my italics), interview by David Shapiro, in *Museo Magazine*, http://www.museomagazine.com/938488/JEFF-WALL (visited 10 November 2011).

26 Rossi, *A Scientific Autobiography*, p. 3.

27 Rossi, *A Scientific Autobiography*, p. 3.

28 Paul Virilio, *A Landscape of Events* (MIT Press, 2000), p. 54. Virilio frequently argues for the necessary and unavoidable involvement of accidents in technology. Accidents lead to technological discoveries and developments in technology lead to the invention of accidents. He suggests that the twentieth century should be regarded as 'a museum of accidents'. See his interview with Andreas Ruby, 'Surfing the Accident: Interview with Paul Virilio', in Joke Brouwer (ed.), *The Art of the Accident* (NAi Publishers/V2 Organisatie, 1998), pp. 30–44.

29 Software innovation (rather than application) can potentially create more radical opportunities for the interaction of design and chance. When software is used as given by the commercial market it commonly ends up being a conservative force but there are exciting possibilities when the designer has also the knowledge to do programming. For various views on the emerging relationships between architecture, digital manufacturing technologies and computation see Branko Kolarevic (ed.), *Architecture in the Digital Age: Design and Manufacturing* (Taylor & Francis, 2003). For the use of software in particular see comments by Robert Aish and Bill Mitchell on p. 252 and p. 294.

IRONIC FABRICATION[1]

Two painted glass plates form a free-standing surface in a steel frame, 175.8cm wide by 272.5cm high. A horizontal band at mid-height. The Bride above, her Bachelors below. Above a cascade figure (the Bride herself), a hanging cloud with three frozen and distorted configurations (the Draft Pistons) and nine randomly located drilled holes (the 9 Shots). Below, a more architectonic composition with a central mechanical device (the Chocolate Grinder), a parallelepipedal frame (the Chariot together with the Water Mill), an arc of cones (the Sieves), nine chessmen figures (the Cemetery of Uniforms who are the Bachelors themselves), nine deformed lines (the Capillary Tubes), two long intersecting bars (the Large Scissors), one circle and three elliptical shapes in silver (the Oculist Witness and Charts). A painting machine in 'a state of rest' with the painting itself 'arrested' through a sequence of snapshots as a photograph (see fig. 6.1).

Marcel Duchamp's *The Bride Stripped Bare by Her Bachelors, Even* is an assemblage in one possible configuration out of many. To understand the wealth of ideas behind it we need to look at Duchamp's notes contained in the *Box of 1914*, the *Green Box* and the *White Box*. At a time when printing technology was not as advanced as now, Duchamp was determined to replicate his messy sketches as closely as possible by finding the paper and ink he had originally used and precisely recreating the random edges, uneven hand-writings, mistakes and crossings-out. The reproduction was elaborate, if not painstaking. It contradicts the spontaneity involved in making the notes but manifests visually Duchamp's difficulty of thought. The loose and unpaginated boxed notes are analogous to Duchamp's 'portable museums' in the sense that they leave viewers to create their own open-ended readings.

In Duchamp's *Large Glass* (*Glass* for short) the area where the Bachelors' desires meet the Bride was marked as a target (the vanishing point) framed by a rectangle (the picture plane) on the top plate. Duchamp stood at three different positions (viewing points) and from each location shot the *Glass* three times using a toy cannon with matches tipped with fresh paint. Each group of three matches had a different paint colour to indicate the different shooting locations. The coloured marks on the glass were then drilled through to create nine holes (see fig. 6.2).

If we knew the exact physical properties of each operation, such as the exact position of a matchstick's starting-point, its velocity and air friction, we could predict the results. But we don't. It is exactly this lack of knowledge that attracted Duchamp to the idea of chance:

> we don't know the results of chance, because we haven't got enough brains for that. ... We don't know because we are ignorant enough not to be able to detect what chance is going to bring. So, it's a kind of adoration for chance ... it's very interesting to have introduced it, to put it at the service of art production.[2]

Central to Duchamp's preoccupations was the problem of time and the impossibility of perspective to represent the complex dimensionalities of space. If we notionally join the nine sequential operations in one, we can imagine the 'demultiplied body' being formed by the accelerating journeys of the 'bullets'. This demultiplied body is a metaphor for vision itself, where the bullet trajectories represent visual

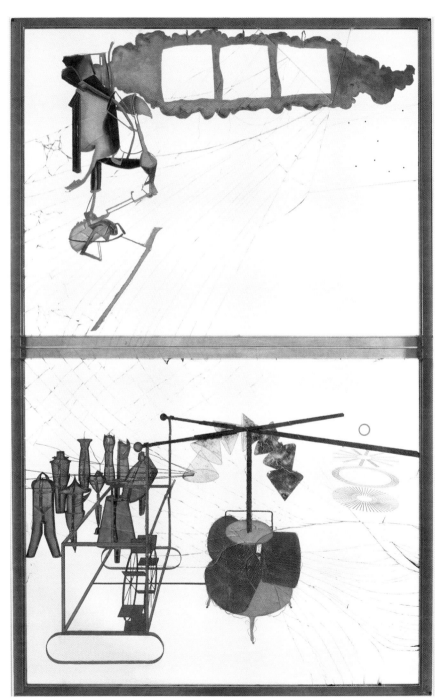

6.1 Marcel Duchamp, *The Bride Stripped Bare by Her Bachelors, Even (The Large Glass)*, 277.5 × 175.9 cm, oil, varnish, lead foil, lead wire, and dust on two glass panels, 1915–23, Philadelphia Museum of Art (Bequest of Katherine S. Dreier, 1952), © Succession Marcel Duchamp / ADAGP, Paris and DACS, London 2011

6.1

rays. Being fluid and in motion, the demultiplied body of vision went through the glass plate, but an instantaneous fraction of it was captured like a 'visible flattening'. The glass interrupted the velocity of vision, but preserved an accurate drawing, a momentary section of its form. The nine drilled holes signify the triumph of the experience of looking, multiplied and in action, traversing the picture plane.

Duchamp's interest in the limits of vision is evident in several works that he produced in order to provoke optical illusions. For example, his *Rotary Demisphere* (*Precision Optics*) (1925) and *Optical Disks* (1935) generate the illusion of depth through a rotating motion. In a different way, his last canvas, *Tu m'* (1918), is a synthesis of projections that plays with *trompe l'oeil*. It includes shadows of readymades anamorphically projected onto the canvas, real safety pins that close a painted tear of the canvas, a real bolt and a bottle brush that pass through it. From the front the bolt turns into a dot and the bottle brush into a shadow; from the side these elements appear as real objects in elevation while the rest of the painting seems almost to vanish.[3]

LINE

Held horizontally from a height of one metre, a metre-long length of thread was allowed to fall freely onto a canvas and make 'a new shape of the measure of length'. The process was repeated three times. Each curved thread was then fixed onto the canvas with varnish and a sheet of glass was placed over it. The curved lines obtained by chance were what the artist called 'canned chance' (*hasard en conserve*). To put chance in a can meant to recognize it as a creative act.

Duchamp claimed that to put chance in a can was also 'amusing'.[4] His 'idea of fabrication' started as a 'calculated nonsense', a joke about the metre and its authority as the standard unit of measurement: 'casting a pataphysical doubt on the concept of straight line as being the shortest route from one point to another'.[5] The curved threads were caught like snapshots of three spatio-temporal moments. Like the 9 Shots they represented a random slice from a continuum of possible configurations. Later on Duchamp cut three wooden rulers with profiles that precisely matched the accidental curves of the dropped threads and placed them in a wooden box as tools (see fig. 6.3). The *3 Standard Stoppages* marked the most significant turn in his work, liberating him from traditional art methods and leading him to devise, what I call, *fabricated chance*: chance as a kind of hidden and *critical* co-author, chance as a creative agency integrated with humour and irony. The three wooden rulers were then used to produce the last layer of his *Network of Stoppages* (1914), a palimpsest oil painting consisting of three superimposed layers made at different times.[6]

Subsequently this layer gave a plan view of the Nine Capillary Tubes, a pivotal piece for the Bachelors in the bottom panel of the *Glass*. The Nine Capillary Tubes describe the fluid movement of the illuminating gas which moves from the Malic Moulds towards the Sieves. In their journey through the Sieves', 'unequal spangles', 'lighter than air', form 'a sort of labyrinth of the 3 directions' and 'lose their awareness of position'. In the end 'they can no longer retain their individuality and they all join together'.[7] The gaseous molecules follow very complicated paths, constantly changing velocity, and their space can be estimated only through the

6.2

6.2 Marcel Duchamp, *The Bride Stripped Bare by Her Bachelors, Even (The Large Glass)*, detail of the nine holes

6.3

calculus of probabilities. So Duchamp's use of chance for the making of the rulers and, eventually, the lines representing gas movement was appropriate because a) it points to the invisibility and immeasurability of the movement of the gaseous molecules; and b) it estimates a potential image of it which is not absolute but probable and ironic.

PLANE

The Draft Pistons were painted on the *Glass* to represent the Bride's communication mechanism with her Bachelors. They comprise her Halo: three nets or 'alphabetical units' through which she would telegraph her commands. To create each net image, Duchamp staged an event: he hung a square piece of a dotted net above a radiator and photographed it three times. The three photographs depicted the net 'accepted or rejected by the draft' and the displaced dots revealed its exact topological deformation caused by the probabilistic behaviour of air currents.

Duchamp used the camera to capture three momentary and probabilistic configurations of a

6.4

constantly changing form, three canned chance images. The net itself can be seen as a critique of perspective's flat and unchangeable picture plane. It is perhaps the thinnest and most permeable solid that Duchamp could use in order to study small and almost indistinguishable changes that are difficult to see with unaided eyes. The randomly taken snapshots capture the shifts of the dots, and so their slight topological differences are arrested and compared.

Euclidean geometry is a 'convenient' geometry, studying states and movements of solid objects that are invariable and greatly simplified. But when an object is displaced and deformed, say because of a change in air temperature, this movement is non-Euclidean. According to the French mathematician and polymath Henri Poincaré, such properties of space and their consequences are neglected by the foundations of geometry 'for besides being but small they are irregular, and consequently appear to us as accidental'.[8] Duchamp read Poincaré, and some scholars, such as Rhonda Roland Shearer, believe that he explicitly practised his thought. With the aid of canned chance in the form of snapshot images, Duchamp 'saw' details that he could not have distinguished with naked eyes.

Not all scales and speeds of things are clearly apprehended by vision. Things can be invisible because they are macroscopic or microscopic, rapid or slow, or at light levels that are indistinguishable. They can be behind our back, in front of our eyes but hidden, or too far away to be perceptible. Things disappear when they are outside our visual range although they continue to exist and affect experience.

While photography can 'see' something happening extremely fast, it can also record very slow events and invisible or hardly noticeable changes over long periods of time. This was the case with Duchamp's and Man Ray's *Dust Breeding* (1920). The piece looks like an aerial photograph of a deserted landscape but is actually a photograph of a much smaller scene (see fig. 6.5). A thick layer of dust accumulated over six months on top of the lower plate of the *Glass* in Duchamp's studio. The dust was photographed and then glued down with varnish to form the Sieves while the rest was wiped away. Here Duchamp used a process of 'delay', a diametrically different action to that of the snapshots of the Draft Pistons. Slowness rather than speed. The spatial consequences of both could not be understood without the aid of photography.

According to Poincaré, to measure the dimensions of a gaseous or liquid matter we must first measure the limits of our instruments: 'we are not sure that behind the stars we see, there are not others we do not see; so that what we should measure in this way would not be the size of the milky way, it would be the range of our instruments.'[9] Unknown properties of such spaces can be imagined and approximately calculated with the use of chance in photography.[10] Multiple random apertures and shootings in contemporary photography can help us see and measure micro or macro scales of events.[11]

BODY

Duchamp's *Sculpture for Travelling* (1918) was a collapsible assemblage made out of rubber pieces without any special attention to regularity. It was held together by long strings, stretched from the four corners of a room: 'The length of the strings could be varied; the form was *ad libitum*. That's what

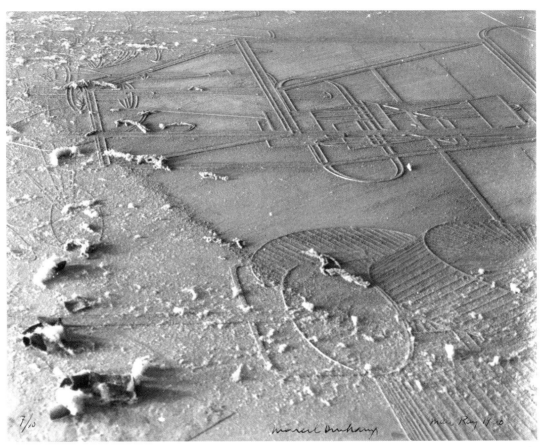

6.5

interested me. This game lasted three or four years, but the rubber rotted, and it disappeared.'[12]

Photographs show the piece as an ethereal and flexible apparatus, tethered and juxtaposed to the corners of a rigid cube-like interior. The shadows it 'drew' on the surrounding surfaces had a much stronger visual effect than the sculpture itself. One of the cast shadows resembles the figure of the Bride on the *Glass*. The Bride is imagined as a hanging 'Pendu', swinging 'at the pleasure of ventilation' and experiencing a 'cinematic blossoming'. Duchamp

created her entire domain absolutely flat without using any perspectival or other construction that would imply depth.[13] The Bride, he said, is the cast shadow of an imaginary fourth-dimensional world: 'my Bride is a two-dimensional representation of a three-dimensional Bride, who also would be a four-dimensional projection on a three-dimensional world of the Bride'.[14] Three-dimensional bodies cast two-dimensional shadows. By analogy, Duchamp proposes that three-dimensional bodies are shadows cast by four-dimensional entities.

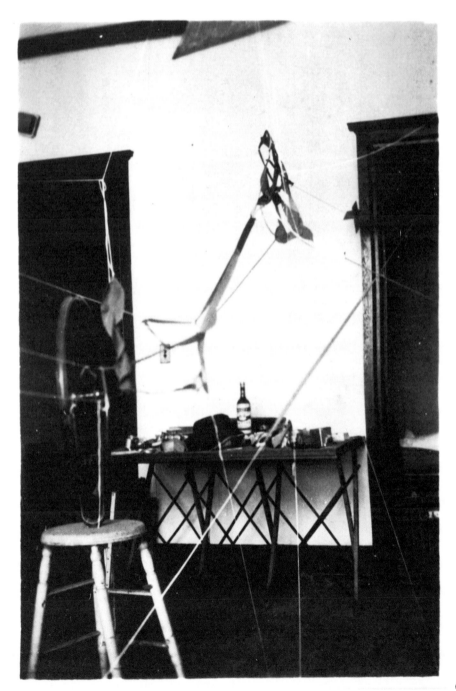

6.6 Marcel Duchamp, *Traveler's Folding Item (33 West 67th Street, New York, Henri-Pierre Roché)*, gelatin silver print, 1917-18, Philadelphia Museum of Art (Gift of Jacqueline, Paul and Peter Matisse in memory of their mother Alexina Duchamp), © Succession Marcel Duchamp / ADAGP, Paris and DACS London 2011

6.6

The installation principles of the *Sculpture for Travelling* can be seen as analogous to a brass and string model from the Poincaré Institute showing a flexible object hung on strings inside a frame. Poincaré's mathematical model attempts to visualize the four dimensions by showing how a regular three-dimensional body can be projected into four dimensions as a flexible object hung on strings in the interior of the three-dimensional body. On the whole, *Sculpture for Travelling* recalls Poincaré's thought on the definition of 'Analysis Situs', in other words topology, and its qualities of continuity, contiguity, closeness and neighbourhood: 'Topology is often loosely described as a rubber-sheet geometry, because if the figures were made of rubber, it would be possible to deform many figures into homeomorphic figures.'[15]

With *Sculpture for Travelling* we can imagine Duchamp's Bride, having variable dimensions and being affected by the irregularities of the sky as a chaotic system. The Bride's shadow in the *Glass* can be seen as a shadow inside a 'machine of chance'. Shearer writes:

> Duchamp describes, in text and image, a Poincaré machine of chance. ... his 'Pendu' mechanism is *'extremely sensitive* to differences' in 'meteorological' influences. ... The 'Pendu' ... is shaped like a 'double pendulum'. Like the weather, the double pendulum is always used as a key example of the marriage of irregularity and order in a chaotic system. Duchamp's sketch of his 'Pendu' is, in fact, identical to the double pendulum of chaos theory.[16]

Duchamp attempted to subvert the determinism of Euclidean geometry by welcoming and systematizing chance as an opposing force. His operations fabricated chance in various ways: shooting with a paint gun to define 'the point'; dropping threads and using gravity to draw 'the line'; employing thin nets and air movement to define 'the plane'; using the flexibility, ageing and chemical disintegration of rubber to draw 'the body'. None of these operations, deviating from the clarity and permanence of Euclidean geometry, is drawn with rulers and compasses.[17]

Duchamp's art was based on inventing and coordinating small events in an intentional dialogue with chance. His principal protagonists, the Bride and the Bachelors, play allegorical roles in that they represent two different ways of drawing and two corresponding ways of understanding space. The Bride is the instrument of chance that draws a topological space; her elements have no depth and are free forms.[18] The Bachelors, on the other hand, belong in a perspectival composition based on a plan and an elevation precisely mapped by Duchamp with rulers and compasses as the conventional instruments of Euclidean geometry.

STATE OF REST

Richard Hamilton helps us to imagine how the *Glass* can be activated:

> Water falls, the mill wheel begins to spin and starts the slow reciprocations of the chariot, we overhear its chanted litanies relieving the still silence of the cemetery of uniforms and liveries where the given gas is cast into malic forms. We become aware of the moulded gas seeping towards the elaborate conditioning which will prepare it for its final orgastic [sic] splashing and observe with wonder the beauty of its auras. The juices flow in the Bride, messages

are transmitted from pools of random possibilities, the throbbing energy of a robotic world strains to create. *The Bride stripped bare by her Bachelors, even* rumbles into its fantastic splendour.[19]

It is both looked at and looked through at the same time. The painted figures float in a sea of change: reflections, shadows, slow-moving images of visitors, variable colours, the window behind, my own reflection. The experience of looking at the *Glass* is entirely open-ended. The blank space of the transparent planes is filled by the imagination.

Duchamp wrote that *The Bride Stripped Bare by Her Bachelors, Even* is a 'delay in glass'. This delay expresses indecisiveness because a choice has to be made out of a matrix of possibilities in a succession of unpredictable facts 'capable of all the innumerable eccentricities'. According to Jean-François Lyotard, the *Glass* shows what the eyes see when making an image: an 'extra-rapid exposure' of the processing facts of perception. 'What the viewer sees on the *Glass* is the eye and even the brain in the process of composing its objects. … The *Glass*, being the film, lets us see the conditions of impression that reign on the inside of the optical box', he writes.[20] For Lyotard the *Glass* is the film but also 'the recording apparatus with all its implied settings'.[21] If the *Glass* represents image formations in the process of visual perception in the optical chamber, this coincides with Lacan's concept of the screen between the eye and the object. Duchamp ruptured the screen of the picture plane to search for the hidden, non-optical aspects of vision. Rosalind Krauss argues that this search for the anti-retinal indicates the invisibility of the unconscious:

If the mechanism of the *Large Glass* obeys Duchamp's dictum of 'going beyond' the retina, it does so not to achieve the condition of vision's transparency to itself—which is suggested by the model of classical perspective when applied to the *Glass*—but rather, quite obviously, to arrive at the threshold of desire-in-vision, which is to say to construct vision itself within the opacity of the organs and the invisibility of the unconscious.[22]

Duchamp's greater inquiry into the invisible was systematically pursued by employing chance. When he sought the psychological and physiological limitations of visibility—the unconscious of vision on the one hand and the practical limits of human sight on the other—he set his art to random mode. Behind this was also his desire for play and irony. He was also obsessively preoccupied with infinity, the precision of the architectural drawing, 'pataphysics' and, most of all, 'the possible'. Pataphysics was introduced in 1893 by the writer Alfred Jarry who opposed traditional positivism and attempted to create a 'science of imaginary solutions' instead. Duchamp was interested in pataphysics as the science of the particular, of exceptions and the occurrence of accidents. He not only appreciated the participation of chance in his work but, as he said, ended up loving it. This was not a love for random splashes of paint: 'I couldn't go into haphazard drawing or … the splashing of the paint. I wanted to go back to a completely *dry* drawing, a *dry* conception of art. I was beginning to appreciate the exactness of precision, and the importance of chance,' Duchamp said.[23] This conception of art acknowledges the limits of artistic intention and allows chance to become a complementary author in the making of the work.

INFRA-THIN

A point cuts a line (one-dimensional continuum); a line cuts a plane (two-dimensional continuum); a plane cuts a solid body (three-dimensional continuum); and a solid body cuts space (four-dimensional continuum). The *Glass* is an 'infinitely thin layer' of the third dimension embedded in a four-dimensional continuum. Its elements can indeed be conceived as 'cuts' or shadows of a hypothetical probabilistic world of *n* dimensions. Shearer argues that we can interpret the *Glass* as a 'Poincaré cut', which scientists call the snapshot of a chaos system.[24] She writes:

> Duchamp's 3-D window is a geometric 'snapshot' (Poincaré cut) of a 4-D probabilistic system of nature's whole, encompassing a mix of random and occasionally emergent ordered movements in vast times and space-movements that appear overwhelmingly complex and are, for the most part, and with the exception of limited slices, unseen.[25]

The *Glass* was intended to occupy a slice of space that cannot be physically inhabited but, in Duchamp's terms, may be seen as an *'inframince'* ('infra-thin'), the thinnest possible apparition of that space. The *Glass* is a 'possible':

> The possible implying
> the becoming—the passage from
> one to the other takes place
> in the infra thin.
> allegory on 'forgetting'[26]

The infra-thin is a veil-like space: a shadow, a reflection from mirror or glass and a paper-thin separation between two contacts or two very similar conditions of the same object as it evolves in the interval of a second. The infra-thin is an ethereal quality that characterises the thinnest possible slice of space, reaching sameness, and the shortest possible duration in time, reaching synchronicity. X-rays, light playing on surfaces, shadows, all belong in the infra-thin. The wind felt in a corridor or the warmth of a stone wall on a sunny day are, for example, manifestations of the infra-thin.[27] Such ordinary conditions quickly escape our attention. These 'suspensions of perception', as Jonathan Crary calls them, have often been described in literature but their visual representation has been puzzling.[28] When Duchamp writes 'allegory of forgetting' he is concerned with the persistent absence of the infra-thin from our visual representations. This absence reinforces its oblivion in a vicious circle and the problem of how to represent the infra-thin remains unresolved.[29] Duchamp fabricated experiments with chance in an effort to imagine and represent the infra-thin. He devised instruments and actions that might reach thinness rather than thickness, including polishing, sanding, sliding, skating, rubbing, steaming, scratching, melting and breaking. Importantly, his note on how to isolate the infra-thin starts with the word 'cutting' as noun and adjective. The cutting of the *Glass* arrested the 9 Shots, stopped the fall of the *3 Standard Stoppages* and momentarily captured the Draft Pistons' movement. The shadow cast by the four-dimensional Bride and the *Glass* as a whole all attempt to represent the invisible veil-like space of the infra-thin.

MEASURING TOOL

The treatment of chance as a tool for estimating the invisible has been in evidence throughout the

evolution of scientific thought from the seventeenth century on. A natural desire to predict the results of games and to minimise measurement mistakes in navigation, astronomy and geodesy encouraged the methodical use of chance as a measuring tool in the seventeenth and eighteenth centuries.[30] To tackle the problem of imperfect instruments and imperfect observing eyes, a theory of errors developed that was to influence our understanding of space at large.[31] If errors in measuring the position of a star were random, so were errors in measuring the position of a molecule. While the theory of errors was gradually adopted by physicists and biologists, statistics and random sampling were advanced by mathematicians. In short, by the early twentieth century a growing demand for large sets of random data encouraged the invention of processes that could now *create* chance. John von Neumann established the theory of games and experimented with probabilistic automata. His Monte Carlo method, initially used to simulate the behaviour of neutrons during nuclear experiments, was based on the principle of randomness as a vehicle to measure complex irregular surfaces.[32] Later the logician Kurt Gödel introduced the notion of incompleteness and Werner Heisenberg defined the uncertainty principle.[33] Uncertainty is a key concern in the twentieth century and was later to become a central concept in cybernetics. In 1961 Gordon Pask described how uncertainty means 'no information' and how, in this sense, design can be thought of as a process of removing uncertainty.[34]

In the nineteenth century chance was increasingly associated with the scientific understanding of indeterminism as opposed to causality and determinism, meaning in this case 'the

view that every event or state of affairs is brought about by antecedent events or states of affairs in accordance with universal causal laws that govern the world'.[35] It was also mainly in the latter part of the nineteenth century that chance started to become an interdisciplinary concern related to the problem of time and simultaneity, and the attention to movement and the cinematic image. It concerned diverse thinkers: from C. S. Peirce in philosophy to Stéphane Mallarmé in literature and, later in the turn of the twentieth century, C. G. Jung in psychology. Peirce argued that probability permeates all aspects of life and that 'tychism', which derives from *tyche* and means absolute chance, is *real*. He reasoned for an evolutionary cosmology in which all law and order develops out of chance. Moreover, Poincaré wrote that chance operates in similar ways, from the Milky Way to the function of the unconscious, and influenced artists like Duchamp.

BREAKAGE

- So here you are, Marcel, looking at your Large Glass.

- Yes, and the more I look at it the more I like it. I like the cracks the way they fall. You remember how it happened in 1926, in Brooklyn? They put the two panels on top of each other, not knowing what they were carrying, and bounced for sixty miles into Connecticut, and that's the result! But the more I look at it the more I like the cracks: they are not like shattered glass. They have a shape. There is symmetry in the cracking, the two crackings are symmetrically arranged and there is more, almost an intention there, an extra—a curious intention that I am not responsible for, a ready-made intention, in other words, that I respect and love.[36]

The damage was discovered several years later when the *Glass* was unpacked. Duchamp welcomed

and celebrated the accident and said that the *Glass* was finished only after an intention that was not his had altered his work. He painstakingly assembled the broken pieces and replaced two very shattered parts with new glass plates shaped to fit exactly. He was then surprised by a curious coincidence: the accidental cracks of the glass plates when assembled resembled the lines defined by his canned chance in the *Network of Stoppages*. Amused by the look of the breakage, he asked: 'Do you think I should have made it on glass if I had not expected it to break?'[37] He then showed a sketch he had drawn for his *Network of Stoppages*, adding ironically that he prophesied the shape of the cracks.

The *Glass* is an emblem of Lacan's theory of the eye and the gaze. It represents the screen between the viewer and the world. I/Eye can just about detect the Oculist Witnesses (who stand for the viewers of the *Glass*) when my figure is reflected on their silver lines. The Oculist Witnesses disappear when no one is reflected on them.[38] Similarly the cracks almost vanish when no one casts a shadow on the back of the glass, but show up intensely if light from the nearby window is blocked by a viewer.

The *Glass* is perhaps the art work of the modern world that has been most successful at trapping *the real*. It was deliberately made from fragile material, and Duchamp's fabricated chance operations were enriched by the punctum of the breakage as a genuine accident. The gaze eventually pierced Duchamp's *Glass* and, thereafter, pierces the viewers' experience of it. The shimmering radiation of the cracks, the unexpected reflections and backgrounds, will always confuse us. But it is in this ambivalence that a work of art is being made: 'a work of art is dependent on the explosion made by the onlookers', just as the production and experience of architectural space depends also on the occupants.[39]

PLAY

Duchamp said that when he made his 9 Shots he had the feeling of playing 'like a baby'.[40] Central to his use of chance was his appreciation of play as one of the main bases of creativity. You imagine and design through enacting and play. Play is in fact older than civilization and, according to Johan Huizinga, in certain ways, superior. Huizinga has argued that culture arises *in* and *as* play and that play is not a 'real' part of life but rather an 'interlude in life' that involves representation: 'the game "represents" a contest, or else becomes a contest for the best representation of something'.[41] This understanding of play as a contest is not far from the work of the *ultramelled* painters. Drawing, like play, is an immersive activity, a kind of drama in action that involves 'fighting' with possibilities and representations.[42] According to Gregory Bateson, fantasy and threat are inextricable parts of play. The player, the dreamer and the designer, because they are immersed in what they are doing, are not fully aware of *what exactly* they are doing. Bateson writes: 'within the dream the dreamer is usually unaware that he is dreaming, and within play he must often be reminded that "This is play"'.[43] Similarly, the designer, when immersed in the activity of designing, does not often realize that what he is doing is design.

It is no coincidence that Beckett, Cage and Duchamp, all of whom appreciated the role of chance in their work, enjoyed playing chess and even met as chess partners. Although chess is a game of strategy,

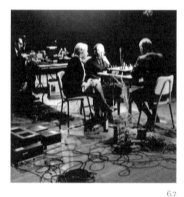

6.7

its relation to chance lies in the fact that it gives each player a wide possibility of moves so that the game on the whole is very alterable. The aesthetic dialogue between strategy and unpredictability (not knowing the opponent's plan) offers the satisfaction of design. Duchamp explains:

> Chess … is plastic so to speak. Each time I make a move of the pawns on the board I create a new form, a new pattern, and in this way I am satisfied by the always changing contour. Not to say that there is not logic in chess. Chess forces you to be logical. The logic is there, but you don't see it.[44]

While the game unfolds as a complex field of relationships, numerous possible 'patterns' can be shaped mentally to be projected onto the chessboard. Playing chess resembles writing a poem:

> Beauty in chess is much closer to the beauty of poetry; the chess pieces are the alphabet that shape the thoughts; and although these thoughts form a visual pattern on the chessboard, they express beauty in the abstract, like a poem. I really believe that every chess player experiences a mixture of two aesthetic pleasures; first the abstract image, which is closely related to the poetic idea in writing, and then the sensual pleasure involved in the ideographic representation of that image on the chessboards. Based on my own close contact with artists and chess players, I have come to the personal conclusion that although not all artists are chess players, all chess players are indeed artists.[45]

Duchamp's interest in chess is the contest for the construction of ideas: the visual patterns acted on the chessboard are representations of bigger 'abstract images'.

FABRICATION

'The consciousness of a living being may be defined as an arithmetical difference between potential and real activity. It measures the interval between representation and action.'[46] This passage by Henri Bergson in his *Creative Evolution* was published in French in 1907 and appeared in English in 1911. It presents remarkable similarities with 'The Creative Act', a short talk that Duchamp presented in a meeting of the American Federation of the Arts in 1957 and which very much reflects his position as artist since the early 1910s. In 'The Creative Act' Duchamp explains that in the process of creation, intention is an ambiguous factor which artists cannot express fully. Their pure intention remains unexpressed and invisible even upon completion of the work. Furthermore for Duchamp there is an 'arithmetic relation' that characterizes the difference between the intention and outcome of a project:

> The result of this [the artist's struggle] is a difference between the intention and its realisation, a difference which the artist is not aware of … in the chain of reactions accompanying the creative act, a link is missing. This gap which represents the inability of the artist to express fully his intention; this difference between what he intended to realise and did realise, is the personal coefficient contained in the work. In other words, the personal 'art coefficient' is like an arithmetic relation between the unexpressed but intended and the unintentionally expressed.[47]

Duchamp's 'art coefficient' indicates the difference between the intended idea and its possible realization which, according to Bergson, is a difference between representation and action. I am proposing, as Lucia Beier has also suggested,

that the *Glass* is primarily influenced by Bergson's thought. While the Bachelors can be read to represent Bergson's 'Intellect', the Bride can be seen as Bergson's 'Intuition'.[48] Duchamp is very likely to have read Bergson and, contrary to Shearer, I would say that what we see in the *Glass* is a construct influenced more by Bergson than by Poincaré. Duchamp knew he could not fully control 'the passage in the infra-thin', the passage from action to representation. So he used action open to chance to provoke deviations from his representational routines and aesthetic taste. When he said that 'the *possible* is only a *physical caustic* ... burning up all aesthetics or callistics', he meant that the possible is in fact 'the real', that which in Bergsonian terms is achieved through non-representable action and which in psychoanalytic terms we can't foresee. The real is encountered, not represented. We find it through obstacles, mistakes and accidents. It is impossible to represent it in advance.

Duchamp's practice of chance expresses this passage from the imagined to the actualized. It is based on fabricating chance-related events in order to question certainty and ridicule the accepted 'truths' of science and art. In his book *Duchamp and the Aesthetics of Chance* Herbert Molderings looks at the detailed history of the different manipulations and versions of the *3 Standard Stoppages* to prove the artificiality of the work and to argue that Duchamp's principal drive for his art was the idea of fabrication as a deliberately falsifying act. Molderings puts forward an original and exciting interpretation of Duchamp's work, providing evidence about the artist's main aim to distort and undermine the ideals of science. He, too, argues that Duchamp's philosophical influence was primarily Bergsonian:

Duchamp's stance on Poincaré's theories ... was in no way clear, but full of contradictions. A closer study of the philosophical discourse at the beginning of the twentieth century will show that, in the controversy between Henri Poincaré and the Bergsonian philosopher Édouard Le Roy over the value of science, Duchamp's art sides *against* the rationalism of Henri Poincaré and *with* the nominalistic theory of Édouard Le Roy, according to which all laws, axioms, and standard measures are the arbitrary constructs of scientists. From 1913 onward, the subversion of scientism became the main intent of Duchamp's art. ... Every single artistic work and action by Duchamp was aimed at undermining the primacy of science as the dominant model for explaining the world. The intellectual tools of his new parascientific aesthetic were humor and irony, his model the 'Pataphysics' of Alfred Jarry. ... Where science was no longer a valid explanatory model of the world or a substitute for religion, where there were no longer any absolute certainties or truths, the only remaining fixed point of reference was the individual himself.[49]

The individualist use of chance as a creative tool combined with humour and irony is closer to the category of 'the possible' and Bergson's 'vital order' than to mathematical automata and the calculus of probability. Duchamp's practice of chance was highly personal and fabricated, open to subjectivity and circumstance, and against mathematical definitions of chance as general or statistical. In fact his canned chance is essentially a critique of science, statistics and the use of cellular automata in art. Duchamp took scientific concepts and intentionally subverted them in order to show that they are arbitrary. He fabricated ironic outcomes of chance to call into question the problematic primacy of scientific reason,

rationality and generalization. For Duchamp it is the individual's will that can produce a truly new piece of work. 'Your chance is not the same as my chance', he claimed.

My reading of Duchamp's work reinforces Molderings's argument. Automatic chance leads to homogeneity, and brings us back to generalizations and inert propositions. It is the individual's will and her impulsive chance that can bring us forward and closer to true differences in creative production and experience.

Octavio Paz wrote that the *Glass* is 'a painting of Criticism and a criticism of Painting'.[50] This criticism was empowered by an intentionally ironic use of chance that was used to question Euclidean principles, the limits of seeing and of representation.

Duchamp engaged with this use of critical chance in a life-long experiment. His work is about non-finality and interdisciplinarity and, unsurprisingly, it has attracted many architects to study it and extend it through new projects.[51] Like the artist-researcher Duchamp, the architect-researcher should cross disciplines to seek new understandings of space and modes of representation, and to explore the creative possibilities of critique. If chance-related techniques in architecture can indeed be comparable to Duchamp's approach, we would need to think of Paz's observation about the relationship between creation and criticism: how can the welcoming of chance in architectural design produce *architectures of criticism* and *criticisms of architecture*? Perhaps in many similar ways: through appreciating the readymade qualities of existing environments and incorporating their beauty of indifference in the work and through enabling a broader co-authorship in the production

of architecture.

Fabricated chance is above all a tool for criticism. Drawing on irony and deliberate subjectivity, it aims to critique art and architecture's accepted conventions and to highlight the uncertainty and relativity involved in all those things that we consider to be known and valued.

Notes

1 I wrote this whole chapter led by the drawings presented in *Projections* and ideally these two parts of the book should be read in conjunction.

2 Marcel Duchamp, quoted in Francis Naumann, *Marcel Duchamp: The Art of Making Art in the Age of Mechanical Reproduction* (Ludion Press Ghent, 1999), p. 303.

3 For a discussion about anamorphosis see also Chapter 1.

4 'I keep the line and that gives me a deformed metre. It's a canned metre if you like, a piece of canned chance … It's amusing to put chance in a can.' Duchamp, quoted in Pierre Cabanne, *Duchamp & Co* (Finest SA/Editions Pierre Terrail, 1977), p. 89.

5 Duchamp, quoted in d'Harnoncourt and McShine, pp. 273–74.

6 The first layer is an unfinished version of *Young Man and Girl in Spring* (1911); the second a half-scale measured layout of the *Glass*, probably executed in late 1913. Duchamp also used the outlines of the three rulers on *Tu m'*.

7 Duchamp, *Bride Stripped Bare*, unpaginated.

8 Henri Poincaré, *Science and Hypothesis* (Dover Publications, 1952, 1905), pp. 66–67.

9 Poincaré, *The Foundations of Science: Science and Hypothesis; The Value of Science; Science and Method*, trans. George Bruce Halsted (Science Press, 1921), p. 525.

10 As Poincaré writes, 'the statistical methods founded upon the calculus of probabilities applicable to a gas are also applicable to [the milky way].' Poincaré, *The Foundations of Science*, p. 524.

11 For instance, today's stereoscopic cameras on space vehicles use multiple-pinhole optics. For the purposes of 'coded-aperture imaging' aperture plates have randomly selected and punched-out holes.

12 Duchamp, quoted in Craig Adcock, *Marcel Duchamp's Notes from the* Large Glass: *An N-Dimensional Analysis* (UMI Research Press, 1983), p. 128. From a strictly mathematical point of view the composition is not rigorously following topology's rules but nevertheless is representative of its qualities.

13 The flatness of the Bride's domain refers to world of four or more dimensions. Edwin A. Abbott's *Flatland*, written in the 1880s, comes to mind: the inhabitants of two-dimensional Flatland can see nothing but lines, luminous edges of shadow-like entities. Their difficulty comprehending three dimensions is analogous to ours, as the inhabitants of Spaceland who struggle to conceive four or more dimensions. The story is an allegorical reflection on the human mind and its attitude towards geometric and social limitations. See Edwin A. Abbott, *Flatland: A Romance of Many Dimensions* (HarperCollins, 1884, 1983).

14 Duchamp, quoted in Adcock, *Marcel Duchamp's Notes from the Large Glass*, p. 137.

15 Morris Kline, quoted in Adcock, *Marcel Duchamp's Notes from the Large Glass*, p. 127. It is also worth noticing that Lacan, who systematically used spatial metaphors to discuss psychological phenomena, was particularly interested in topology. He abandoned the use of Euclidean diagrams and in the 1960s and 1970s turned his attention to the figures of the Moebius strip, the torus and the topology of knots, especially the Borromean knot. This is a chain or rings linked in such a way that if any ring is cut, the whole chain falls apart. For more on Lacan's topological references see Dylan Evans, *An Introductory Dictionary of Lacanian Psychoanalysis*, pp. 18–20, 116, 188–90, 207–09.

16 Rhonda Roland Shearer, 'Marcel Duchamp's Impossible Bed and Other "Not" Readymade Objects: A Possible Route of Influence From Art To Science', http://www.marcelduchamp.net/marcelduchamp-Impossible-Bed.php (visited 13 December 2011).

17 A greater emphasis on non-Euclidean space through practices of chance can complement Euclidean geometry and enrich our methods of representation.

18 Jean-François Lyotard, *Duchamp's TRANS/formers* (Lapis Press, 1990), p. 103.

19 Richard Hamilton in Duchamp, *The Bride Stripped Bare by Her Bachelors, Even* (Hansjörg Mayer and Jaap Rietman, 1976), unpaginated.

20 Lyotard, *Duchamp's TRANS/formers*, pp. 169–70.

21 Lyotard, *Duchamp's TRANS/formers*, p. 180.

22 Rosalind Krauss, *The Optical Unconscious* (MIT Press, 1993), p. 125.

23 Duchamp in Duchamp, *The Writings of Marcel Duchamp*, eds. Michel Sanouillet and Elmer Peterson (Oxford University Press, 1973), p. 130.

24 Shearer, 'Marcel Duchamp's Impossible Bed and Other "Not" Readymade Objects: A Possible Route of Influence From Art To Science', http://www.marcelduchamp.net/marcelduchamp-Impossible-Bed.php (visited 13 December 2011). Weather and roulette are examples of non-linear systems.

25 Shearer, 'Marcel Duchamp's Impossible Bed and Other "Not" Readymade Objects: A Possible Route of Influence From Art To Science', http://www.marcelduchamp.net/marcelduchamp-Impossible-Bed.php (visited 13 December 2011).

26 Duchamp, *Notes*, unpaginated.

27 Duchamp writes similarly: 'The warmth of a seat (which has just been left) is infra-thin.' Duchamp, *Notes*, unpaginated.

28 Jonathan Crary's research on attention with regard to perception appears in his *Suspensions of Perception: Attention, Spectacle, and Modern Culture* (MIT Press, 1999).

29 This is an oblivion of optical appearances because we have the most intense memories of touch or smell experiences.

30 The first serious evidence of the mathematical study of chance was Girolamo Cardano's *The Book on Games of Chance* written around 1564 but not published until almost a hundred years later. Random sequences were also studied by Galileo who wrote his essay *Thoughts about Dice Games* between 1613 and 1623. Deborah J. Bennett, *Randomness* (Harvard University Press, 1999), pp. 61–2.

31 The theory of errors was initially discovered by Pierre-Simon Laplace in 1778. It was independently developed by Carl Friedrich Gauss in 1809. Bennett, *Randomness*, p. 97.

32 A simple geometric application of the Monte Carlo method, for instance, would involve generating and calculating many points at random positions.

33 Kurt Gödel argued that there is always some indecisive property that can be neither disproved nor invalidated within a system. Ivar Ekeland, *The Broken Dice, and Other Mathematical Tales* (University of Chicago Press, 1993), p. 54. Werner Heisenberg argued that 'for every physical event, there exists an uncertainty concerning the quantity of energy released during the event, and this uncertainty is directly related to the uncertainty about the exact moment in which the event occurred'. Claudio Rebbi, quoted in Paul Virilio, *The Lost Dimension* (Semiotext(e), 1991), p. 118.

34 Gordon Pask, *An Approach to Cybernetics* (Hutchinson & Co, 1961), p. 26.

35 This is the definition of 'determinism' in *The Cambridge Dictionary of Philosophy* (Cambridge University Press, 1999), p. 228.

36 Duchamp in Duchamp, *The Writings of Marcel Duchamp*, p. 127.

37 Duchamp in Charles Henri Ford (ed.), *View: Parade of the Avant-Garde: An Anthology of View Magazine 1940–1947* (Thunder's Mouth Press, 1977), p. 139.

38 De Duve discusses the relationship of the viewers with the *Glass* and its thematic representation with reference to Lacan in de Duve, *Kant after Duchamp* (MIT Press, 1998), pp. 401–13.

39 Duchamp, quoted in Adcock, *Marcel Duchamp's Notes from the Large Glass*, p. 8.

40 Duchamp, quoted in Naumann, *Marcel Duchamp: The Art of Making Art*, p. 303.

41 Johan Huizinga, *Homo Ludens: A Study of the Play-Element in Culture* (Beacon Press, 1955), p. 13.

42 Refer to Chapter 3.

43 Gregory Bateson, *Steps to an Ecology of Mind* (Jason Aronson, 1987), pp. 177–93. For a another discussion about play see the project 'Shutters'.

44 Duchamp in his interview 'I Propose to Strain the Laws of Physics' with Francis Roberts, *Art News* (no. 8, December 1968), p. 63.

45 Duchamp, quoted in Kornelia Von Berswordt-Wallrabe 'Fishing in the Stream of Function …' in Gehard Graulich, Herbert Molderings and Kornelia von Berswordt-Wallrabe, *Marcel Duchamp Respirateur* (Staatliches Museum Schwerin and Hatje Cantz, 1999), p. 22.

46 Henri Bergson, *Creative Evolution* (Dover, 1988, 1911), p. 145.

47 Duchamp, quoted in Harriett Ann Watts, *Chance: A Perspective on Dada* (UMI Research Press, 1980), pp. 40–41.

48 Lucia Beier, 'Time Machine: A Bergsonian Approach to *The Large Glass*', *Gazette des beaux-arts* (series 6, vol. 88, November 1976), pp. 194–200.

49 Molderings, *Duchamp and the Aesthetics of Chance* (Columbia University Press, 2010), p. xv.

50 Octavio Paz, *Marcel Duchamp: Appearance Stripped Bare* (Arcade Publishing, 1990), p. 76.

51 *The Rotary Notary and His Hot Plate or A Delay in Glass* (1986) by Diller + Scofidio is one example. See Diller + Scofidio, *Flesh: Architectural Probes* (Princeton Architectural Press and Triangle Architectural Publishing, 1994), pp. 103–35.

ALEATORIC FORM

OVER TO THE WEATHER

The composer and performance theorist John Cage was a famous advocate and creative user of, what I will call, *active chance*. This is not canned chance but chance as free agency. Active chance surpasses the author's control to produce changeable, pluralistic and performative configurations rather than fixed outcomes.

For Cage art should act in nature's manner of operation. He used the weather as a metaphor to represent his understanding of indeterminate systems whether spatial, sonic or social. Environment, human thought and experience, all interested Cage because he saw them as equally unstable systems. He said, 'I am willing to give myself over to the weather. I like to think of my music as weather, or part of the weather.'[1] This is the complex reality of the cosmos with all its uncertainty and intricate relationships between order and accident on both the human and the universal scales. For Cage art is made within chaos; it is part of it and affected by it. We could claim something similar for architecture, that it embodies chaos, because the process of design is exposed to multiple and complex factors generated by human thought and other external parameters, and because the outcome—the building itself—is not finite but continually in interaction with the indeterminacies of experience and the environment.

In the production of art and architecture indeterminacy means the practice of not completely specifying the end results of a project. Indeterminacy has a particular meaning in architecture, for it accepts and exploits the fact that design should take into account that the perception and use of buildings are never entirely controllable. Cage's work is open to the potential involvement of the audience and the sonic environment it is played in, and it is exactly this openness towards others that should interest architects too. Buildings *perform* in society and the environment and alter accordingly through time. Their life span is considerably different from the duration of a music performance but the issue of openness to change remains significant for both. In *The Open Work* Umberto Eco theorizes the role of openness in modern aesthetics, by focusing explicitly on what it means for the author to understand their work as unfinished and open to change and chance—a significant question for all creative practices, including music and architecture.[2]

In the 1930s Cage devised the first 'prepared piano' which had strings 'doctored' with everyday attachments such as screws, bolts, nuts and rubber strips. A prepared piano not only generates unfamiliar sounds but also gives the performer less control over the music that he or she produces. The material properties of the nuts and rubber strips are not explicitly specified and, since they are loosely attached to the strings, the piano does not give a precisely managed tone. This deficiency of control over the performance means that the sounds are not consistent and cannot be fully predicted. The prepared piano led Cage to 'the enjoyment of things as they come, as they happen, rather than as they are possessed or kept or forced to be'.[3] Gradually he developed more techniques of relinquishing full control of his performances, written and visual pieces. Cage's 'chance operations', as he called them, were produced by methods of random ordering such as tossing coins, consulting arbitrary numbers generated by the computer or using the

I Ching. These methods gradually produced an unprecedented experience in making and listening to music that was particularly open to the idea of indeterminacy.

The *I Ching* (*Book of Changes* in English), used by Cage, has been used in China as an oracle for more than three thousand years. Confucianism and Taoism have their roots in it and many of its aspects have influenced the development of Chinese thought as well as other philosophical ideas through the world. The *I Ching* is underpinned by an idea of chance that embraces three principles: 'change', 'image' and 'judgement'. It contains sixty-four hexagrams which are not representations of things as such but representations of 'tendencies towards change'. This is the first principle of the book. Just as all phenomena and relationships constantly change in the physical world, the hexagrams too continually undergo transformation. The second principle of the book is a theory of ideas: 'every event in the visible world is the effect of an "image", that is, of an idea in the unseen world. Accordingly, everything that happens is a reproduction, as it were, of an event beyond our sense perception.'[4] For the Chinese this invisible event beyond our sense perception may be glimpsed with the aid of chance. The third principle of the *I Ching* is that of judgement. The *I Ching* gives a list of possible actions, empowering the individual to freely chose an action and so to share responsibility in her shaping of chance. The fact that the individual is encouraged to interpret and influence the transient state of situations suggests a subjective notion of chance dependent on the individual mind.

For Carl Gustav Jung the *I Ching* represents something very different from the Western understanding of causality:

> What we call coincidence seems to be the chief concern of this peculiar [Chinese] mind, and what we worship as causality passes almost unnoticed. We must admit that there is something to be said for the immense importance of chance. An incalculable amount of human effort is directed at restricting the nuisance or danger represented by chance. Theoretical considerations of cause and effect often look pale and dusty in comparison to the practical results of chance. … The manner in which the *I Ching* tends to look upon reality seems to disfavor our causalistic procedures. … The matter of interest seems to be the configuration formed by chance events in the moment of observation, and not at all the hypothetical reasons that seemingly account for the coincidence. While the Western mind carefully sifts, weighs, selects, classifies, isolates, the Chinese picture of the moment encompasses everything down to the minutest nonsensical detail, because all of the ingredients make up the observed moment.[5]

Jung insists on the interdependence of psychological and physical circumstances in the making of the experienced moment and argues that the principle of *synchronicity* is as important as causality:

> It seems … necessary to introduce, alongside space, time and causality, a category which not only enables us to understand synchronistic phenomena as a special class of natural events, but also takes the contingent partly as a universal factor existing from all eternity, and partly as the sum of countless individual acts of creation occurring in time.[6]

Here chance is both universal and subjective, centred on the individual and the cosmos

simultaneously. This double agency of chance has been appreciated by many authors interested in the temporal and participatory experience of space and art, most notably by Cage.

FONTANA MIX

Cage aimed to diminish the gap between producing and experiencing works of art. He compiled highly detailed charts of ordinary actions, durations, found sounds and tones, including noise, from everyday audio environments. He used these charts to find new possibilities for the making of his work: 'by making moves on the charts I freed myself from what I had thought to be freedom, which was only [the] accretion of habits and taste'.[7] But Cage's bigger ambition was to further weaken his control over the end result and, through the pursuit of indeterminacy, to free himself from his own taste and beliefs as much as possible.

Imaginary Landscape No. 4 (1951) was Cage's first work that clearly employed chance for both the initial composition of the piece and its actual performance. The piece is scored through chance operations for twelve radios and two performers: one operating the radio-station tuner, the other controlling the amplitude and timbre. While the composition is described in a determinate notation, the sonic results produced by scanning radio stations at a particular moment in time cannot be fully determined. A year later Cage created his well-known *4'33"* (1952), also called *Silent Piece*. This piece has no sounds decided by Cage. Instead, its only property determined by the author is three time-frames within the piece which Cage defined with the aid of chance operations.

Beyond these time-frames *4'33"* is entirely

unpredictable: self-composed by the sounds which will occur incidentally in the performance space. In this way the piece is different each time. Art critic Calvin Tomkins describes the first performance:

> In the Woodstock hall, which was wide open to the woods at the back, attentive listeners could hear during the first movement the sound of wind in the trees; during the second, there was a patter of raindrops on the roof; during the third, the audience took over and added its own perplexed mutterings to the other 'sounds not intended' by the composer.[8]

The role of the audience is important in music and, of course, in architecture. The architects I discuss later on in this chapter, such as Cedric Price and Lacaton & Vassal, take the audience into consideration to a very great extent. They recognize that users can challenge and complement their own design intentions and welcome the spaces they produce.

In music, while a deterministic use of chance results in fixed final scores, like Duchamp's canned chance, indeterminate uses of chance require that the performers activate new chance procedures to make their own scores. A characteristic example of indeterminate notation is Cage's *Fontana Mix* (1958) made for the production of any number of tracks of tape, any number of players and kinds of instruments.[9] The notation includes: ten unnumbered transparent sheets where several points can be marked on them (7, 12, 13, 17, 18, 19, 22, 26, 29 and 30 points respectively); ten unnumbered opaque sheets on which drawings with different curved lines can be made (three unbroken and three dotted lines—thick, medium and thin, respectively); a transparent sheet with a graph

7.1 John Cage, *The first movement from 4'33"*, made for Irwin Kremen in 1953. © 2011 Henmar Press Inc., reproduced with permission of Peters Edition Limited

7.2

7.2 John Cage, *An example of Fontana Mix, showing a superimposition of score parts*, 1958, © 2011 Henmar Press Inc., reproduced with permission of Peters Edition Limited

of equally sized units (one hundred units horizontally and twenty vertically); and a transparent sheet with a straight line.[10]

The score's directions ask for the sheets to be overlaid randomly and for measurements to be taken between the various points, lines, and the graph as they have 'fallen' on the surface. The lines and measurements can be freely assigned to determine sound sources, actions and durations, volume, tone and pitch.[11] Eventually *Fontana Mix* comprises twenty-two drawings that can be reinvented and mixed differently each time by the performers who, in addition, determine freely the list of sound materials that they want to use. *Fontana Mix* is therefore indeterminate in terms of its notation, sound sources and performance.

Music Walk (1958) is a complex indeterminate score by Cage, even more multi-layered than *Fontana Mix* because it involves the interdependent performance of many individuals.[12] Performers respond individually to given instructions and also invent their own scores. Eventually the performance is a composite of simultaneous actions, resulting in multiple sound conflations and 'traffic jams'. It is possible to think of the process of architectural design as similarly collective and interdependent, although typically without quite the same degree of freedom and scope for improvisation possible within music.

We should note that although most of Cage's pieces admit an element of improvisation by the performers, Cage disliked the idea of total improvisation, on the grounds that improvisation depends too much on the author's own habits and tastes which tend to prevent him from interacting with pure chance.[13] Cage's dislike of total improvisation rejects individualistic intuition as the only creative force and in doing so it affirms Bergson's suggestion that the automatic order and the vital order must proceed together. Mixing structured and deterministic rules with elements of chance is paradoxical neither in music nor in architecture. It is exactly the combination of the structure of design with the uncertainty involved in experiencing design that makes architecture indeterminate during both its making and its reception.

QUESTIONING

An aleatoric work is a piece that does not completely specify its end results. The author controls only a part of it while the rest is left to be completed by the performers' interpretations. This may mean a strictly demarcated scheme where limited areas are intended for improvisation; a loose structure consisting of vague instructions; a request for reordering sections of the piece; or a combination of the above. An aleatoric work contains an element of chance, and as many versions as it has performances.

The aleatoric work is also critical: *a form of questioning*. In his letter to Kostas Axelos, 'What is Modernity?', Henri Lefebvre characteristically writes that the aleatory is the essential characteristic of modernity, which invades all consciousness 'in the form of questioning'. Modernity is defined by the aleatory, meaning here the calculation of probabilities and statistical information in general. Our increased knowledge of nature and the human desire to control it have made the world gradually more aware of the aleatory, even if not always in an entirely conscious way. With the aid of information technologies, theories of game and probability, we have integrated the aleatory in most areas of our consciousness of modernity. The more we know about chance, the more we want and are able to make it useful. Lefebvre makes us think about the everyday regulatory systems of modernity that organize social life, such as the operation of traffic lights. He states:

> The controlled sector is becoming wider. The amount of irrationality *per se* is diminishing. ... Paradoxically, this knowledge of the aleatory reduces the chances of error or failure by eliminating the need for actions to be overprudent and extracautious. Once it has been conceptualized and understood, the aleatory can become useful. But it cannot be controlled, like some kind of mechanical force, and it cannot be eliminated. Such is the message of the theory of strategies, games and decisions.[14]

The aleatory cannot be controlled and cannot be eradicated. Genuine spontaneity and freedom are found less in the use of digital and generative technologies for the pursuit of formal innovation, and more in the creative possibilities of social media and the participatory decision-making they facilitate. These possibilities should not be statistically generated, but driven by the circumstances of human intersubjectivity expressed through communication.

UNITIES OF AMBIANCES

Between the late 1950s and the early 1970s the movement of the Situationist International explored a variety of urban tactics which were naturally open to active chance. Many members of the Situationist International saw chance as a critique of the deterministic functionalist zoning of the modern city. The *dérive* was a technique of walking that enabled irrational encounters with the diverse and complex realities of the city. As a 'transient passage through varied ambiences' the *dérive* was practised playfully and collaboratively. As Guy Debord explained in 1956, 'the *dérive* entails playful-constructive behaviour and awareness of psychogeographical effects'.[15] Preferably a group of people, rather than an individual, had to drop their habitual urban behaviours and let themselves be drawn by what they encountered in the city. The 'psychogeographical' relief of the city with its microclimates and centres of attraction would encourage them to walk randomly in the flow of 'ocean currents'. As a technique of political critique the *dérive* aimed to awaken urban consciousness in order to reach new conclusions about the city. The role of chance in this process was paramount.

As Simon Sadler notes, 'most of the architecture and spaces that were endorsed by the situationists existed by chance rather than by design: back streets, urban fabric layered over time, ghettos'.[16] This social type of chance rejected all design processes that separated themselves from political life. It was different from the surrealist chance which was linked with the unconscious and which Debord criticized quite forcefully:

> the action of chance is naturally conservative and in a new setting tends to reduce everything to an alternation between a limited number of variants, and to habit. Progress is nothing other than breaking through a field where chance holds sway by creating new conditions more favourable to our purposes. … the first psychogeographical attractions discovered run the risk of fixating the dériving individual or group around new habitual axes, to which they will constantly be drawn back.[17]

Clearly, Debord was suspicious of the limitations of impulsive chance and of the tension that exists between habit and accident because the one can easily become the other. 'We know that the unconscious imagination is poor, that automatic writing is monotonous, and that the whole genre of ostentatious surrealist "weirdness" has ceased to be very surprising', he wrote.[18] Debord based this argument on an opposition to Freud: 'Everything conscious wears out. What is unconscious remains unaltered. But once it is set loose, does it fall into ruins in its turn?'[19] However, the problem is not mere chance as such but the danger entailed in someone becoming too accustomed to certain practices of chance. When chance turns into habit, when its techniques become abstract, methodological and

automatic, then we have no chance at all. True active chance must also implicate impulse in the Bergsonian sense. The emphasis should be on chance as a vital and performative force rather than as an abstract concept.

In one of his least known texts titled 'On Chance' Debord wrote:

> 1. One cannot reduce chance. One can [merely] know all of the limited possibilities of chance in the existing conditions (statistics).
>
> 2. In known conditions, the role of chance is conservative. Thus, games of chance do not give way to any novelty. Likewise, the readers of cards play upon the very small number of possibilities [de hasards] that might exist in someone's private life. They often 'foresee' events to the extent that an average individual's life is as impoverished as the classical variants of their own predictions.
>
> 3. All progress, all creation, is the organization of new conditions of chance.
>
> 4. At this superior level, chance is really unforeseeable—amusing—for a certain period of time, but the new field of chance sets other limits to its action, and these limits will come to be precisely studied and known.
>
> 5. Man does not desire chance as such. He desires more, and he expects from chance the encounter with what he desires. This is a passive and reactionary situation (cf. the surrealist mystification) if it isn't corrected by the invention of concrete conditions that determine the movement of desirable chances.[20]

In this passage chance is discussed dialectically with 'the invention of concrete conditions'. The invention of the concrete is the potential offered by design: the means to correct conservative and meaningless habits of chance which tend to lead to likeable and expected results. The concrete resists the circumstantial; it is architecture itself. Architecture operates within and against chance, which is nothing else than its *other*. As an autonomous creation, architecture encounters and, as Debord hints at, 'organizes new conditions of chance'.

7,000 OAKS

Many urban theorists have criticized the functionalist control imposed by modernism by showing how cities perform beyond the limits of built form to enable surprise, social encounter and the accidental happening of events. For example in the text 'Walking in the City' Michel de Certeau explains how everyday tactics counter-balance the strategic planning of the city as a unified whole and welcome the particular, the informal and the accidental.[21] This attention to the accidental is a matter of cultural and political critique, questioning top-down urban development and emphasizing instead the realm of inhabited space and lived experience with all the messiness and unpredictability that it implies. To welcome the accident in architecture is to express doubt about the development forces of modernity and to propose within and against these forces projects which engage with specific neighbourhoods and the localized desires of people.[22] For this type of ideological practice a very close connection with places and people is needed, so that the chance element is not abstract or anarchic for its own sake but humanistic and socially meaningful.

It was in this spirit that the members of Fluxus developed anti-formalist works of art drawing attention to the realm of lived experience. As precursors of performance art, the Fluxus artists initiated 'happenings' which aimed to diminish the

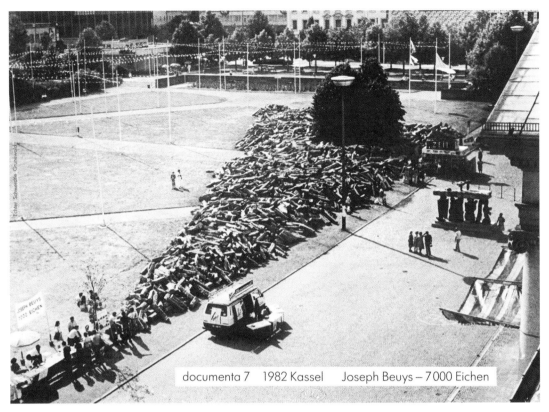

documenta 7 1982 Kassel Joseph Beuys – 7000 Eichen

7.3

distance between art and everyday life. Many Fluxus artists were particularly interested in the use of non-intentional compositional methods. George Brecht's book *Chance-Imagery* questioned rationalism, formalism and single authorship explicitly, while Brecht and George Maciunas were influenced by Robert Rauschenberg, Merce Cunningham and Cage, and generally by the experimental aleatoric work that was happening at the time at the Black Mountain College.[23] Likewise Yoko Ono and Nam June Paik created happenings that had a political tone. But the artist who engaged most explicitly with

performance on the scale of the city, stating that 'Everyone is an Artist', was Joseph Beuys.

Beuys radically expanded the definition of art through his concept of *social sculpture*. His *7,000 Oaks* proposed a 'city of forestation' instead of a 'city of administration' and involved the help of volunteers who over several years in the 1980s helped plant 7,000 trees in Kassel, each with an accompanying basalt stone. While it is difficult to see how the complex demands of architecture can permit minimal and polemical participatory strategies like this, it is not impossible.

The design strategies of the architects Lacaton & Vassal are worth noticing here because they explore the limits of architecture as a design discipline. Such is the architects' appreciation of the given and overlooked qualities of a place that they are prepared to accept it fully as a 'readymade architecture', negating the desire to design anew.[24] For example, in the case of the Plaza Léon Aucoc Burdeos in Bordeaux they decided that non-designing would contribute to the place much more than designing.[25] This strategic type of minimalism has a political dimension which defines many of their projects, particularly their housing proposals. For the housing blocks in Saint-Nazaire, La Chesnaie and Petit Maroc, originally built in the 1970s and planned to be demolished by the authorities in the early 2000s, Lacaton & Vassal proposed to avoid demolition and to look instead at the blocks 'attentively' and from the 'inside' in order to understand how spaces are inhabited and how people are emotionally rooted to their homes. Many apartments are appreciated for their given qualities and are preserved, enlarged with spacious rooms and prolonged balconies for winter gardens, whereas some new flats are also added. Addressing the economical and political concerns about increasing 'the value' of the districts, the architects write: 'To increase the number of apartments on the plot of land and to keep what exists are not contradictory. On the contrary, to make with what exists enables one to make more by using the potential of the situation.'[26] We can perhaps start seeing architecture as an active social practice, similar to Beuys's definition, and always in the making by architects and non-architects. Its permanent form is always in interaction with its social form and it is in this space of tension that meaningful chance meetings occur.

USELESSNESS

Since the 1970s Bernard Tschumi's writings advocate the role of the event in the experience of space and the city. For Tschumi the event is an encounter, an unplanned situation that surpasses the limits of form. The event is not designed; it simply occurs. While Cage pursued the wholesale absence of any intended content, constructing music with no music at all (as in 4'33"), Tschumi went to the other extreme and argued for the multiplicity of contents, the juxtaposition and dissociation of many and different programmes in architecture, including an appreciation of *uselessness*. His polemic against functionalism and the reductive nature of the architectural programme (as used by mainstream practice) was not entirely new but he explicitly articulated it.

Tschumi's concept of 'disjunction' describes a systematic act of disjoining and 'dissociation in space and time'.[27] It rejects the notion of synthesis, highlighting instead a state of heterogeneity and discontinuity that can be found between building elements, movements and programmes. For Tschumi disjunction is an instrument of urban critique but also a theoretical and practical tool that can be deliberately used in the process of design. He argues that there is no cause-and-effect link between form and function because the actions and events that take place in cities and buildings are unpredictable, contradictory, conjoined and disjoined simultaneously. In the mid-1970s he states: 'we inhabit a fractured space, made of accidents, where figures are disintegrated, *dis*-integrated.'[28] He attacks the purism of the modern movement and calls for a revaluation of the creative methods used

by Dada and Surrealism. He writes:

> Tzara's ironical contempt for order found few equivalents among
> architects too busy replacing the *système des Beaux-Arts* by
> the modern movement's own set of rules. In 1920—despite the
> contradictory presences of Tzara, Richter, Ball, Duchamp and
> Breton—Le Corbusier and his contemporaries chose the quiet
> and acceptable route of purism.[29]

Tschumi lists a number of 'types of derivation' which
can be used as design tools or critical instruments.
He continues:

> Contamination implies a progressive shift from one reality
> to another (vocabulary by Mallarmé, syntax by Proust; plan
> by Le Corbusier, walls and colums by Mies van der Rohe).
> ... An important category is that of disjunction, dissociation,
> rupture, dislocation and cut-ups ... just as particles of matter
> in space will occasionally concentrate and form new points
> of intensity, so the fragments of the dislocation can be
> reassembled in new and unexpected relations.[30]

In his book *Manhattan Transcripts* (1981) the trio
of movement, action and event is manifested as a
series of curved walls and corridors. If fluid action is
translated into solidified concrete form, Tschumi does
not achieve an architecture of event but a restricted
architecture of control. Yet the purpose of this project,
so much influenced by the cinematic montage, is
in its ideological polemic for the role of movement
in architecture rather than its literal interpretation
for the design of buildings. Like Cage, Tschumi is
interested not only in the relations between things but
also in the relations between actions. What he calls
'the combinative' refers to juxtapositions of building
elements as well as human activity, programmes and

performances. This is one step further than the formal
expression of deconstruction, evident in the early
architecture of Gehry or Coop Himmelb(l)au, say,
which only focuses on the juxtaposition of physical
fragments. In Tschumi's thought there is evidence of
a more sophisticated appreciation of chance as the
underlying order that dominates all facets of human,
artistic and scientific consciousness. By the 1980s he
writes:

> One must remember that initially, the sciences were about
> substance, about foundation: geology, physiology, physics,
> and gravity. And architecture was very much part of that
> concern, with its focus on solidity, firmness, structure
> and hierarchy. Those foundations began to crumble in
> the twentieth century. Relativity, quantum theory, the
> uncertainty principle: this shake up occurred not only
> in physics, as we know, but also in philosophy, the social
> sciences and economics.

> How then can architecture maintain some solidity, some
> degree of certainty? It seems impossible today—unless one
> decides that the accident or the explosion is to be called
> the rule, the new regulation, through a sort of philosophical
> inversion that considers the accident the norm and
> continuity the exception.[31]

Here Tschumi's acknowledgment of the role of the
accident in twentieth century philosophy, sciences
and economics as well as architecture is clear. It is,
however, through his readings of Michel Foucault
in the early 1990s that Tschumi more distinctly
defines architecture as an event-space open to
potentialities. For Foucault the event is also *an
event of thought*, and according to Tschumi the
moment of 'questioning, or problematization of

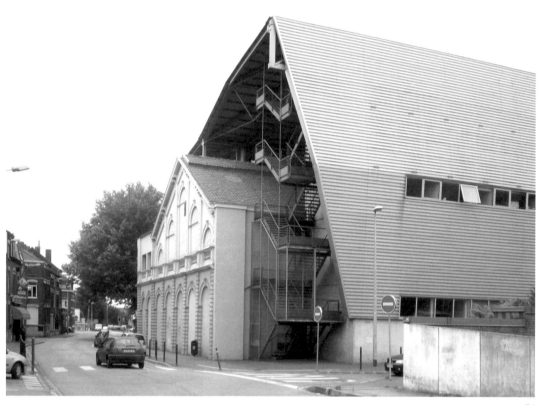

7.4

7.4 Le Fresnoy National Studio for Contemporary Arts, Tourcoing, France, 1997, exterior view, photograph courtesy of Christos Papastergiou, 2010

the very assumptions of the setting within which a drama may take place—occasioning the chance or possibility of another different setting'. And Tschumi continues: 'The event here is a *turning point*—not an origin or an end—as opposed to such propositions as form follows function. I would like to propose that the future of architecture lies in the construction of such events.'[32]

How exactly architecture can construct such events is not an easy question but Tschumi argues that he came close to answering it through his Le Fresnoy, the National Studio for Contemporary

Arts in Tourcoing (1997). For this building Tschumi proposes a purposefully 'ambiguous' space between a new large roof and the existing old building that the roof shadows below. The roof acts as a hangar and the space below it is intentionally left undetermined, in a sense useless. Tschumi explains:

what interested us most was the space generated between the logic of the new roof (which made it all possible) and the logic of what was underneath: an in-between, a place of the unexpected where unprogrammed events might occur, events that are not part of the curriculum.[33]

7.5

In Le Fresnoy the significance, according to Tschumi, lies in the in-between and the unexpected. Whether the building makes more or less room for chance is impossible to tell but what is important is the clarity of the argument in the architect's writings. Tschumi's desire for *unprogrammed* spaces represents an openness to the indeterminacy of life. The more the space becomes useless and liberated by the architectural programme, the more it can open to all kinds of events. But the space, for all it is useless, is not really unprogrammed. It has been simply programmed by the architect to represent the idea of an unprogrammed space notionally open to chance.

Architecture is often used politically to create an 'ideal' image of coherence by hiding the actual differences and contradictions of the cultural and economic factors that determine its production. Tschumi sought an alternative by questioning the role of the building as an expression of a single 'order' and collated instead different types of spaces into one place. Commenting on Tschumi's work, the architectural historian Adrian Forty notes that Tschumi's order 'was to be concerned neither with the pursuit of beauty, nor with the avoidance of chaos, but rather with defining what an architect could still do in the post-structuralist era without becoming an accomplice in the general reduction of all things to abstract models'.[34] He argues that for architects like Tschumi, Coop Himmelb(l)au and Morphosis, the idea of order is not entirely abandoned but creatively interrogated in order to find a more open-ended form of order. But he concludes that the subject of order is too difficult for architecture because it raises threatening questions for its own position:

If architecture does not create 'order', there would be no need to have architecture at all and the processes of environmental change can be left to get on with it on their own; but if architecture is in the business of producing 'order', it is involved in something far bigger than it can possibly handle, the process by which experience is filtered, transformed and fed back to us in reduced form, all in the name of 'culture'. In these circumstances, one can well understand why an architect might choose to remain silent on the question of 'order'.[35]

Perhaps this difficult question of 'order' in architecture explains partly Tschumi's silence on the relation between his earlier texts and his later buildings.

TWIN PHENOMENA

It was, however, much earlier that the concept of the *in-between* was brought to the attention of architects. From the early 1950s the prolific Aldo van Eyck critiqued architectural rationalism and functionalism, advocating a people-centred approach and promoting the intermediary quality of neglected or unplanned spaces in the city.[36] As a follower of Arp and Tzara, who also used chance in their work, Van Eyck favoured spaces that could enable 'occasions'. Against the abstract modernist continuity of space and time, he proposed the particularity of in-between places, such as those found in his several Amsterdam Playgrounds. He remarked: 'Whatever space and time mean, place and occasion mean more.'[37] Occasion is the juncture of circumstances from which architecture, as a situated practice, is inseparable: partly found and partly designed, constantly undone and redone by future inhabitations. This principle, which underpins

much of Van Eyck's work, suggests an architecture that is co-made by both design and circumstance. For his 'clearly defined' matrix of anti-hierarchical aggregate rooms and courtyards in the Amsterdam Orphanage (see figs. 7.6 and 7.7) he writes:

> The building was conceived as a configuration of intermediary places clearly defined. This does not imply continual transition or endless postponement with respect to place and occasion. On the contrary, it implies a break away from the contemporary concept (call it sickness) of spatial continuity and the tendency to erase every articulation between spaces, i.e., between outside and inside, between one space and another. Instead, I tried to articulate the transition by means of defined in-between places which induce simultaneous awareness of what is signified on either side.[38]

The simultaneity experienced in these in-between places also reflects Van Eyck's broader interest in what he called 'twin phenomena', meaning two simultaneous and corresponding realities, one being psycho-social, the other material. For Van Eyck the built environment is the material 'counterform' in reciprocal tension with the 'form', the social and mental realities of people inhabiting this environment. One example of twin phenomena is found in the experience of the house: a house can be a tiny city and a city can be a house, Van Eyck proposed. To admit that the building is partly described by the social events it embraces and partly by its material limits means to recognize architecture's performative nature. The role of chance in this performative understanding of architecture is not only the intuitive processes of the designer expressed in her drawing practice, nor the

systematic and aleatoric procedures of production, nor the ironic use of fabricated stories and artefacts, although it may include aspects of all these. It is predominantly *chance as performance* generated by a broader ecology: social activity, historical and political circumstances, weather patterns, environmental change, time and all impermanent forces that interact with buildings and cities.

ANTI-BUILDING

There is often a confusion between the terms flexibility and indeterminacy in architecture, because both are similarly associated with the negation of deterministic function, even though each word suggests different attitudes to it. A building's flexibility can be provided through spatial means, technical means, or both.[39] Large rooms whose purpose isn't explicitly determined suggest a freedom of use and therefore a good degree of spatial flexibility, as in the case of the spacious rooms of castles or baroque palaces or, more recently, the expanded and 'surplus' spaces proposed by Lina Bo Bardi and Lacaton & Vassal.[40] A building with adjustable components, on the other hand, provides flexibility because it offers a moveable system through which the occupants can make changes. Consider the light *shoji* screens in the traditional Japanese house or the modular and adaptable rooms of Cedric Price's Inter-Action Centre in Kentish Town (1971–2002). The first is an architecture capable of adapting to seasonal domestic routines; the second was never as flexible as it promised but nevertheless it inspired many British architects interested in interaction, and the image of interaction.[41]

Spaces with unspecified function suggest an

Ground floor
Departments:
1 Boys 14-18
2 Girls 14-18
3 Boys 10-14
4 Girls 10-14
5 Children 6-10
6 Children 4-6
7 Children 2-4
8 Babies
9 Infirmary
10 Festive hall
11 Theatre and gymnasium
12 Trustees, psychologist,
 team leader and staff
13 Administration and archive
14 Staffroom and library
15 Maintenance/service room
16 Garage
17 Main linen room
18 Main kitchen, director's
 residence
19 Team leader's residence
20 Entrance to cycle shed

7.6

7.6 Aldo Van Van
Eyck, Amsterdam
Orphanage, plan,
sourced from
Francis Strauven,
*Aldo van Eyck: The
Shape of Relativity*,
Architectura &
Natura Press, 1998

7.7

7.7 Aldo Van Van
Eyck, Amsterdam
Orphanage, interior
view, sourced from
Francis Strauven,
*Aldo van Eyck: The
Shape of Relativity*,
Architectura &
Natura Press, 1998

7.8 Cedric Price, *Aerial perspective from cockpit of Fun Palace for Joan Littlewood*, 22.2 × 26.7 cm, cut-and-pasted painted paper on gelatin silver print with gouache, 1959–61, © 2011 The Museum of Modern Art, New York (Gift of the Howard Gilman Foundation) / Scala, Florence

7.8

open-ended flexibility closer to total indeterminacy because anything can happen in a space entirely empty of content. On the other hand mechanically flexible buildings use prescribed rules to support an 'optimization' of use. The boundaries between these two approaches are not always distinct but what is worth clarifying is that the mechanical flexibility of buildings does not always mean more openness to chance. To the contrary it can be quite deterministic and suppressive, demanding particular kinds of change and forcing the users to generate and experience new versions of the building whether they want it or not.[42]

Price's interest in an architecture that is capable of accommodating constantly evolving needs has fascinated architects for more than four decades, leading to a number of visionary proposals for adaptable buildings. It was driven by a mixture of spatial and technological concerns and the particular historical and political moment of post-war Britain that reached an acute crisis of unemployment, among other unstable socio-economic conditions. Price wanted the 'machine aesthetic' and formal representation of technology that dominated Modern architecture to be replaced by a genuinely advanced technological society and architecture. Just as Cage aimed to develop an environment in which new sounds can occur, Price tried to develop architecture as an intelligent frame within which social happenings are free to play out at will. He was interested in interdisciplinary, democratic and anti-elitist design, an adaptable and performative architecture which could go beyond 'high art'. His Fun Palace was a proposal for a skeletal framework within which users would 'design' spaces at will as and when they need them by assembling and rearranging parts continuously. Characteristically, Price said that his Palace would be so flexible that it would be an 'anti-building'.

Price also proposed Potteries Thinkbelt, a participatory project that aimed to be 'open to all' (see fig. 7.9). It would occupy a vast wasteland of derelict industrial sites and railways in Staffordshire, England, as a new flexible infrastructure for housing, industry and educational facilities with mobile units for 20,000 students. This was a revolutionary project that critiqued the traditional university system to propose learning units on railway tracks. Price argued that Potteries Thinkbelt would offer a solution to local unemployment and the social collapse of the Potteries, promoting economic growth, new social organizations and inclusive educational reform.

Price's interest in indeterminate environments is perhaps best expressed through his concept of free space: 'an operational matrix' that can accommodate any kind of use at any point in time. This variable and self-determined space with no specified programmatic content recalls Cage's interest in unplanned sonic environments. If Cage determined time frames for capturing found audio material, Price tried to create space frames for supporting the unpredictability of events. Technological flexibility has been the most obvious vehicle through which Price's work has been discussed but, above all, there are strong political concerns that underpin his work. His engagement with systems, games, new communications and cybernetic theory has a social basis and should be seen within the broader interdisciplinary spectrum of the arts and politics of his time. For his 1995 Magnet project he writes:

7.9

Anticipatory Architecture is essential to equate its use and delight with contemporary social, economic and political items of the new. Thus, Anticipatory Architecture must only anticipate the nature and form of future human services that require architectural attention for them to function but also design future enclosures that through their sitting, form, life span and uniqueness enable activities hitherto impossible and therefore socially undefined Community and certainty, solitude and doubt must be welcomed equally.[43]

Price's Anticipatory Architecture accepts the ambiguity and contradictions that may exist between people's choices and activities in an undefined community as a positive architectural opportunity. The extremely flexible architecture of the Fun Palace and Potteries Thinkbelt recognizes the role of active chance through all stages of production, from conception and design to construction and inhabitation. These unbuilt but pioneering works of their time bring together areas of knowledge that are very different to each other: from the uncertainty theory of physicist Werner Heisenberg to cybernetics and situationism. Price synthesized these insights through a distinct design mode that attempted to link technology, theatre, space and society into one whole.

NON-SPECIFICITY

The building is one of the most paradoxical aleatoric objects: no matter how much it is designed and controlled, it tends to release a dialectically opposed space of chance. In this book I have tried to suggest that a crucial task of architecture is to be aware of this paradox and to explore it creatively. To consider chance during the design process does not mean to submit blindly to material forms that are randomly or accidentally generated but to produce building forms that are generous enough to accommodate the

contingencies of future inhabitations and events. To think about chance is to think about time. To think about the experience of time through architecture is to consider everything 'other' than the physical building, all those activities and phenomena that continuously qualify and complement its presence.

As already discussed, Anne Lacaton and Jean-Philippe Vassal are particularly aware of the productive dialogue between building and 'other', where other is the creative possibilities of inhabitation. Lacaton & Vassal aim for an intentionally laconic and self-evident architecture which at first sight seems to *resist* but in actual fact *highlights* chance. A characteristic example is their Social Housing in Mulhouse (2005). With the use of standardized building systems and materials they provide more living space within the budget limits of a project, therefore offering extra space for each apartment at no extra cost. Contrary to many architects who try to define their work through geometric inventiveness, Lacaton & Vassal avoid the idea of formal innovation and focus instead on the generation of a 'surplus space' that is purposefully unspecified in terms of programme, awaiting for the anticipated inventiveness of the users.[44] As Ilka and Andreas Ruby write 'the most important quality of the *surplus space* is not the *additional room* but rather the *extra potential*, the *added life and experience*.'[45] Lacaton & Vassal's architecture is remarkably rational but acts as a framing device for the unpredictability of this 'added life and experience' and in this it directly acknowledges the creative role of chance.

The architects' suppression of morphological expressiveness is underpinned by an intentional avoidance of over-specificity. Generous, simple and rational rooms, which do not point to functional specificity, are free to be experienced in many different ways. Lacaton & Vassal are aware that the less particular the building is in terms of form and function, the better it will embrace the occasion. And so they are not interested in inventing new materials and techniques but prefer to choose from what is available, particularly the ordinary building technologies found in common and economical building types such as greenhouses and car parks. The greenhouse typology is adopted for the design of residential units and the building type of a multiple-floor car park is adopted to become a school of architecture. The crossing of typologies is aesthetically and spatially expressed until the building takes a truly informal presence: as if it *is* a greenhouse, a car park or the everyday corner of a street.

This architectural informality may invite equally informal practices of inhabitation, which can be as creative and free as living outdoors. Lacaton & Vassal explain that they are inspired by the open-air unplanned architectures in Marrakech and the African desert. Of the Palais de Tokyo they write: 'To consider the space as a place to inhabit. The spot must resemble a town square. To us, the Place Djemaa-el-Fnaa in Marrakech, which we've proposed as a reference, seemed to perfectly represent this idea of a place of passage and of meeting, of spatial freedom and usage.'[46] This spatial freedom seems to welcome both the ethics and aesthetics of chance.

The buildings designed by Lacaton & Vassal may seem rather monotonous in terms of form but are characterized by specific temporal qualities: particular temperatures and light ambiences so

7.10 Social
Housing, Mulhouse,
France, exterior
view © 2011 Philippe
Ruault

that the occupants can migrate from one area to another according to season and time of day. This spatial variety and freedom of movement given to the occupants is further enhanced by an attention to seasonal gardens. For example, the flowers incorporated in the design of the Grenoble University of Arts and Human Sciences and the Bordeaux University of Management Sciences highlight the dialogue between the temporal beauty of plant life and the permanence of the building.

Rather than letting go of their creations once they are built, Lacaton & Vassal express a particular fondness for what happens to their buildings over time. They systematically revisit them to see and record how their interiors are transformed by specific occupants (see figs. 7.12 and 7.13).[47] While they are uninterested in chance as form, their architecture frames and emphasizes chance as performance. The avoidance of formalist chance in the design stage of their projects is counter-balanced by an actual affection towards chance as a social and spatial

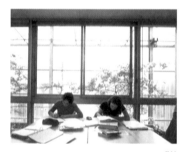

7.11

agency in the life of their buildings when inhabited. The building form is purposefully kept rational, minimalist and rather 'empty', perhaps analogous to Cage's empty piece of music. Each time *4'33"* is played, it is remade by all kinds of sounds happening in the present and each time the architectural space is used, it is reproduced by the inhabitants' actions. The building is autonomous, pointing to its *other*, that is the space of chance.

Lacaton & Vassal's appreciation of chance happens on two levels: by enhancing the given and by non-specifying the possible. The given is found in the creative understanding of the existing: the place as already formed, as in the Plaza Léon Aucoc; or the standardized building systems and everyday materials we see in the Trignac Apartments. The possible is characterized by the unforeseeable creativity of time, weather and the inhabitants. While maximum effort is expended on the consideration of the given in terms of observation and research analysis, no particular effort is being made in order to describe the possible because this is recognized as truly indeterminable. For a straw matting hut in Niamey, they write: 'Searching for and deciding upon the site took six months, the building work two days. The wind took two years to destroy it.'[48] Overall there is an intentional abandonment of the architecture to the consequences of time, and this abandonment is considered positive.

RESISTANT FORM

Architecture is naturally both attracted and indifferent to chance. I am proposing that designers, like artists and poets, need to cultivate their capacity for play with chance because it is through playing with chance that we can participate in the real. Robert Venturi's 'whole fragment' must be recognized and architecture should admit its paradox of being 'a whole at one level and a fragment of a greater whole at another level'.[49] Situated in a whole universe of chance the building happens to be here or there, and in one way or the other, for a number of contingent reasons. It marks the time it was built. With all its solidity and weight the building's main effort is to 'fight' indeterminacy and repress the accidental. But paradoxically as part of the chance-design space to which it belongs, the building reveals chance as much as it suppresses it.

And yet the architects' avoidance of chance, their very different attitudes to it and the degrees to which they have tried to regulate it, have determined consciously or unconsciously a large part of the history of architecture. All styles, theories and movements of the twentieth century indirectly represent an either intentional or unintentional position towards time, and therefore towards chance. Mies van der Rohe's architecture, for example, which at first sight appears to be distant from any consideration of the idea of chance *is* in fact conceived by Mies and experienced by us fundamentally in relation to it. While the process of design is rational and purposefully set up to negate chance, the experience of many of Mies's buildings draws attention to chance by enhancing the temporal and a deliberate sense of perceptual ambiguity for the observer-participant. I call this *resistant chance*: a restrained control of chance in design choreographs and releases dialectically chance as agency in the experience of the building.[50] Detlef Mertins writes about the Barcelona Pavilion:

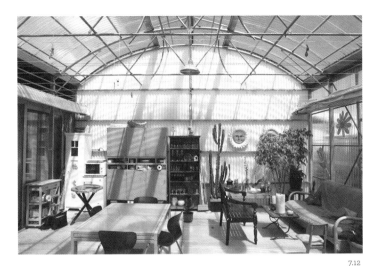

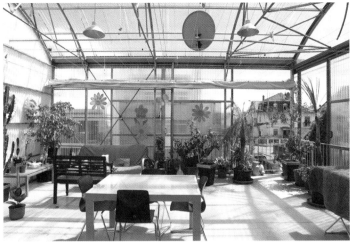

7.12

7.13

7.12 and 7.13 Social
Housing, Mulhouse,
France, 2005, interior
view of the 'surplus
space' in a four-
bedroom apartment,
© 2011 Lacaton &
Vassal.

As in Richter's films, the elements and spaces assume coherence and unity through the rhythm with which they move the observer through and around them. Yet at the same time, something of van Doesburg's simultaneity also remains in effect—combining synchronic and diachronic conceptions of rhythm and unity. Reflections on the marble, glass, and water intensify the ambiguity between inside and out, up and down, reinforcing the cohesion of the whole by folding the parts onto themselves—establishing identity while precluding any stable image. … Again and again from different vantage points, the statue is multiplied and dislocated, a symbol and symptom of the ongoing fracturing and recombination of identity feared in Expressionism and then celebrated in Dada and Surrealism. … It places the observer in a state of suspended animation and reverie that is nonetheless marked by movement, and by a combination of self-estrangement and self-integration.[11]

As observers we experience slippages of spaces and meanings, a continual fracturing of any sense of order. Mies was not uninterested in philosophical theories of order. He had strong connections with Hans Richter and Theo van Doesburg, whose concerns of space and time were related to notions of counter-order, rhythm and change, and had read Henri Bergson's *Creative Evolution*. Mies knew that the value of chance in architecture is to be found less in its formal possibilities and more in its vital capacity to influence the perception of space synchronically and diachronically. His interest was in the faculty of chance to disturb autonomous architectural structures and in its active agency to generate *counter-arrangements* to buildings. This interest has nothing to do with playful drawing tactics or the subjectivity of the designer. For Mies the more controlled the design method is, the more the coherence and autonomy of the built form will emphasize chance dialectically. Resistant chance is the perpetual but varying aesthetic condition that qualifies the experience of every building, but the Barcelona Pavilion manifests this explicitly. Behind and within the Pavilion's 'ideal order'

exists a revelation of chance in the potentialities of space as experienced. The negation of chance in geometric terms is combined with an open-minded and positive acceptance of chance in perception. The reverie and beauty is in the interplay of the temporal element with the permanent element, in the contingency of experience within and against the stability of the building.[51]

THE BEAUTY OF INDIFFERENCE

'In my city everything is temporary' Francis Alÿs writes for his Zócalo project (1999).[52] The twelve-hour documentary film records the progression of the shadow of the flagpole in the Zócalo Square in Mexico City during the course of a day. People inhabit the shadow as it moves, producing a beautiful, yet indifferent, architecture in transit (see figs. 7.14 and 7.15).

Charles Baudelaire in 'The Painter of Modern Life' insisted that beauty needs a temporal and circumstantial element in its making. Characteristically he argued that beauty is made up of two components: 'beauty consists of an eternal, invariable element, whose quantity is excessively difficult to determine, and of a relative, circumstantial element, which will be, if you like, by turns or all together, the era, its fashion, its morals, its passions'.[53] Without the temporal and fugitive qualities beauty would be solely composed of the permanent element and would simply be impossible to sense. Without chance and circumstance, architecture would be lifeless. Solely composed of permanence and rationality, it would be disconnected from time and therefore impossible to comprehend, let alone enjoy.

Like Cage who questioned the generally accepted norm of making more and more music,

Lacaton & Vassal have questioned the broad expectations of most societies to create new buildings and public spaces all the time. Rather than asking 'what kind of building is needed?', Lacaton & Vassal sometimes ask if a new building is really needed at all. They reached an extreme position in the case of the Plaza Léon Aucoc in Bordeaux when they decided that *doing nothing* was the best design proposition that they could make. Lacaton & Vassal eventually proposed to only replace the gravel of the square and simply clean it more often. Creative preservation as a minimum form of architectural intervention means an economy of effort that can have multiple benefits. Appreciating and maintaining the place as found is acknowledging the beauty and history of the place as formed socially over time. If there is a beauty in the negation of design, this is the beauty of chance as found, an antidote to the limitations of architecture as a design discipline. They write: 'this square is already very beautiful because it's authentic, lacking in sophistication. It possesses the beauty of what is obvious, necessary, right. Its meaning emerges directly.'[54] The square possesses a found 'beauty of indifference', recalling Duchamp's value of the non-artistic intention as the main criterion for choosing the readymades.[55]

Like Duchamp, the architect should dare to observe and thereby discover. Acknowledging that architecture is *co-produced* by both design and chance requires us to learn how to better observe in order to critically decide where and when to design and where and when to stop. When the chance situation is given as a positive 'found environment', then non-designing, or designing

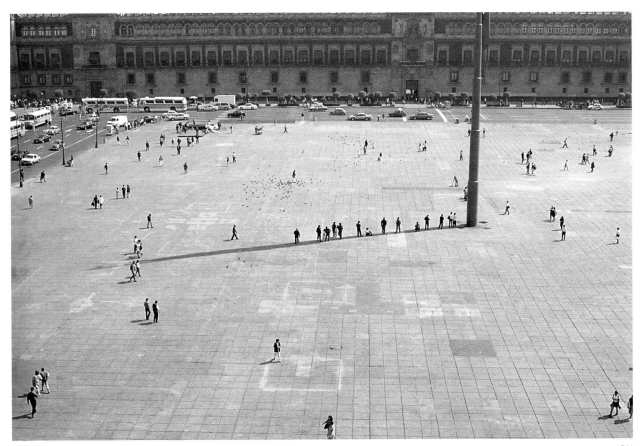

7.14

7.14 Francis Alÿs,
Zocalo (collaboration
with Rafael Ortega),
Mexico City, film
extract, 1999,
photograph courtesy
of Francis Alÿs, 2011.

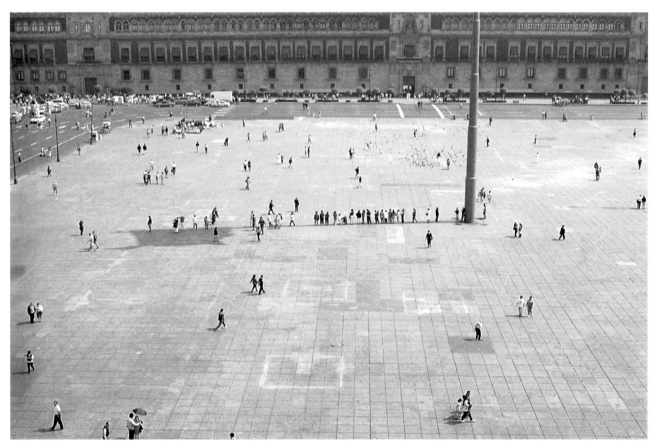

7.15

7.15 Francis Alÿs,
Zocalo (collaboration
with Rafael Ortega),
Mexico City, film
extract, 1999,
photograph courtesy
of Francis Alÿs, 2011.

less, are valuable design tactics. Recognizing the beauty of indifference found in buildings and places that are made without particular design intention is important: architecture must have some of this beauty of indifference in order to be less dominating, otherwise it risks being too precious to inhabit.

Notes

1 John Cage in conversation with Joan Retallack, quoted in Retallack, *The Poethical Wager* (University of California Press, 2003), p. 198.

2 See Umberto Eco, *The Open Work*, Anna Cancogni (trans.), Harvard University Press, 1989.

3 Cage quoted in Daniel Charles, 'About John Cage's "Prepared Piano" (1990)', in Richard Kostelanetz (ed.), *Writings about John Cage* (UMI Press, 1999), p. 49. In the twentieth century the first chance-generated musical piece was Duchamp's *Musical Erratum* (1913). This joy of chance in music was also explored much earlier by Mozart who experimented with the rolling of the dice in his *Musikalisches Würfelspiel* in 1787.

4 This theory is expressed in Lao Tse's and Confucius' teachings. Richard Wilhelm and Cary F. Baynes (trans), *The I Ching or Book of Changes* (Bollingen Foundation and Princeton University Press, 1977), p. lvii.

5 Carl Gustav Jung, quoted in Wilhelm and Baynes (trans), *The I Ching or Book of Changes*, pp. xxii–xxiii.

6 Jung, *Synchronicity: An Acausal Connecting Principle* (Ark, 1991), p. 143.

7 Cage, quoted in Jill Johnston, 'Cage and Modern Dance (1965)', in Kostelanetz (ed.), *Writings about John Cage*, p. 344.

8 Calvin Tomkins, quoted in William Fetterman, *John Cage's Theatre Pieces: Notations and Performances* (Harwood Academic Publishers, 1996), p. 75.

9 *Sounds of Venice* and *Water Walk* are very distinct works. Their notations are determinate but derive from *Fontana Mix*, a score in clearly indeterminate notation.

10 My project 'Fields' uses this set of instructions to generate the drawings for a proposal for Pier 40 in New York. Another designer who has worked with *Fontana Mix* is Yago Conde. See Conde, Bea Goller (ed.), Paul Hammond (trans.), *Architecture of Indeterminacy* (Actar, 2000).

11 According to the instructions 'sound sources, their mechanical alteration, changes of amplitude, frequency, overtone structure, the use of loops, special types of splicing, etc. may be determined'. Cage, *Fontana Mix, 1958* (Henmar Press, 1960), unpaginated.

12 To define and differentiate Cage's indeterminate scores and complex indeterminate scores see Fetterman's categorization of Cage's notations in his book *John Cage's Theatre Pieces: Notations and Performances* (Harwood Academic Publishers, 1996).

13 He explains: 'improvisation depends not on the work you have to do, but depends more on your likes and dislikes. It doesn't lead you to a new experience, but into something with which you're already familiar, whereas if you have work to do which is suggested but not determined by a notation, if it's indeterminate this simply means that you are to supply the determination of certain things that the composer has not determined'. Cage, quoted in Fetterman, *John Cage's Theatre Pieces*, p. 124.

14 Henri Lefebvre, *Introduction to Modernity* (Les Editions de Minuit, 1962; Verso, 1995), p. 204.

15 Guy Debord, 'Theory of the *Dérive*', in Ken Knabb (ed.), *Situationist International Anthology* (Bureau of Public Secrets, 1995), p. 50.

16 Simon Sadler, *The Situationist City* (MIT Press, 1998), p. 159.

17 Debord, 'Theory of the *Dérive*', p. 51.

18 Debord, 'Report on the Construction of Situations and on the International Situationist Tendency's Conditions of Organization and Action', in Ken Knabb (ed.), *Situationist International Anthology* (Bureau of Public Secrets, 1995), p. 19.

19 Debord, 'Report on the Construction of Situations', p. 19.

20 Guy Debord, 'On Chance', written in 1957 but never published during his lifetime, translated from the French in http://www.notbored.org/chance.html (visited 18 December 2011).

21 Michel de Certeau, *The Practice of Everyday Life* (University of California Press, 1988).

22 Jonathan Hill has discussed extensively the creative role of the user in architecture in his book *Actions of Architecture: Architects and Creative Users* (Routledge, 2003).

23 George Brecht, *Chance-Imagery* (Something Else Press, 1966).

24 This is like a *trap architecture*, recalling Spoerri's 'snare pictures'. Refer to Chapter 3.

25 Lacaton & Vassal in Mónica Gili (ed.), *Lacaton and Vassal* (2G Libros Books, 2007), p. 74.

26 Anne Lacaton & Jean-Philippe Vassal with David Pradel (architect collaborator) for their project Housing, Saint-Nazaire, Petit Maroc (2004), http://www.lacatonvassal.com/index.php?idp=40# (visited 12 December 2011).

27 He writes: 'The concept of disjunction is incompatible with a static, autonomous, structural view of architecture. But it is not anti-autonomy or anti-structure; it simply implies constant, mechanical operations that systematically produce dissociation in space and time, where an architectural element only functions by colliding with a programmatic element, with the movement of bodies, or whatever. In this manner, disjunction becomes a systematic and theoretical tool for the making of architecture.' Bernard Tschumi, *Architecture and Disjunction* (MIT Press, 1994), pp. 212–13.

28 Tschumi, *Architecture and Disjunction*, p. 217.

29 Tschumi, *Architecture and Disjunction*, pp. 83–84.

30 Tschumi, *Architecture and Disjunction*, p. 188.

31 Tschumi, *Architecture and Disjunction*, pp. 218–19.

32 Tschumi, *Architecture and Disjunction*, p. 256.

33 Tschumi, *Event-Cities (Praxis)* (MIT Press, 1994), p. 399.

34 Adrian Forty, *Words and Buildings: A Vocabulary of Modern Architecture* (Thames and Hudson, 2000), p. 247.

35 Forty, *Words and Buildings*, p. 248.

36 For similar reasons Herman Hertzberger criticized functionalism through his strategy of 'polyvalence'.

37 Aldo Van Eyck, quoted in Francis Strauven, *Aldo van Eyck: The Shape of Relativity* (Architectura & Natura, 1998), p. 359. See also Liaine Lefaivre and Alexander Tzonis, *Aldo Van Eyck: Humanist Rebel* (010 Publishers, 1999), p. 103. Today public art is increasingly devoted to the creative understanding of a similar concept: *situations* as time- and site-specific social constructs. The recent book by Claire Doherty determines 'situation' as a key concept of twenty-first century art. See Doherty (ed.), *Situation* (Whitechapel Gallery and MIT Press, 2009).

38 Van Eyck, quoted in Udo Kultermann, *Architecture in the 20th Century* (John Wiley & Sons, 1993), p. 138.

39 See Forty's chapter 'Flexibility' in *Words and Buildings*.

40 Refer to Chapter 4.

41 Such as Richard Rogers.

42 A similar point is made by Hill. For a discussion about flexibility and the role of the user see Hill, *Actions of Architecture*, pp. 32–50.

43 Cedric Price, quoted in Stanley Mathews, *From Agit-Prop to Free Space: The Architecture of Cedric Price* (Black Dog, 2007), p. 246.

44 This surplus space is not that dissimilar from Lina Bo Bardi's attitude towards expansion like in the MASP, as already discussed in Chapter 4.

45 Ilka and Andreas Ruby in Gili (ed.), *Lacaton and Vassal*, p. 15.

46 Lacaton & Vassal in Gili (ed.), *Lacaton and Vassal*, p. 101.

47 This approach is similar to Rural Studio's described in Chapter 4.

48 Lacaton & Vassal in Gili (ed.), *Lacaton and Vassal*, p. 24.

49 Robert Venturi, *Complexity and Contradiction* (Architectural Press, 1977), p, 103. Refer also to Chapters 2 and 5.

50 This intercation between resistance and release perhaps brings to mind Damisch's definition of the /cloud/ in relation to perspective. See Chapter 2.

51 Something similar can be said for the Farnsworth House.

52 Francis Alÿs in Mark Godfrey (ed.), *Francis Alÿs: A Story of Deception* (TATE Publishing, 2010), p. 35. For more on Alÿs's work refer also to Chapter 3.

53 Charles Baudelaire, *The Painter of Modern Life and Other Essays* (Phaidon Press, 1964), p. 3.

54 Lacaton & Vassal in Gili (ed.), *Lacaton and Vassal*, p. 74.

55 Refer to Chapter 6.

Double Passage

CHANCE AS EXPERIENCE

It is recognized across disciplines that design is inherently weak, and bound to be transcended by time. Virginia Woolf communicates this observation very evocatively in *The Waves*. She writes:

> How tired I am of stories, how tired I am of phrases that come down so beautifully with all their feet on the ground! Also, how I distrust neat designs of life that are drawn upon half-sheets of note-paper. I begin to long for some little language such as lovers use, broken words, inarticulate words, like the shuffling of feet on the pavement. I begin to seek some design more in accordance with those moments of humiliation and triumph that come now and then undeniably. Lying in a ditch on a stormy day, when it has been raining, then enormous clouds come marching over the sky, tattered clouds, wisps of cloud. What delights me then is the confusion, the height, the indifference and the fury. Great clouds always changing, and movement; something sulphurous and sinister, bowled up, helter-skelter; towering, trailing, broken off, lost, and I forgotten, minute, in a ditch. Of story, of design I do not see a trace then.[1]

In *The Poethical Wager* Joan Retallack uses this extraordinary paragraph by Woolf in order to argue for the creative role of chance in poetry. Through discussing Epicurus' swerve, John Dewey's *Art as Experience*, D. W. Winnicott's theory of play and Cage's chance operations in music, she explores the poetics and ethics of chance, which she combines to create 'the poethics of chance'.[2] I propose that Retallack's poethics of chance are as important for the making of poetry as they are for the making of architecture. Just as poetry must make its way through 'the mess' to create itself, so architecture must make its way through the chance circumstances that influence design and later on the lives of its buildings in order to produce itself.

Since the origins of architecture, buildings have had an autonomous and resilient presence towards the messiness of the surrounding environment and a distinct representational and communicative purpose which has given them relative authority among other human creations. This authority of buildings is counter-balanced by the circumstantial element of experience, by meanings and events that appear to us as if by chance. The tension between the autonomy of architecture and the constantly changing life forms that surround it has been the exact subject of much of this book. Whether pleasurable or critical, I have tried to show that this tension is productive.

Architecture typically strengthens its autonomy by intentionally repressing chance, denying chaos during the process of design. This is in the nature of the discipline: architects design, they do not leave things to chance. But, as psychoanalytic thought tells us, this very repression may emerge for the subject elsewhere. Architecture's suppression of chance is neither total nor finite. Its designed resilience to embracing chance happenings during the drawing phase is inevitably followed by a kind of entropy towards chance during the life of the building. This entropy towards chance can enrich architecture and

spatial experience. In many ways the value of chance in architecture is in its inexhaustible capacity to disturb otherwise planned and coherent structures, generating counter-tactics to design, and counter-arrangements to buildings.

It is interesting to note that in the beginning of the twenty-first century the topic of chance is re-emerging as a creative agency worthy of attention across many different disciplines. Art historians Dario Gamboni, Herbert Molderings and Margaret Iversen—in addition to Retallack—are paying critical attention to the ethics and aesthetics of chance in art, while the social, urban and architectural aspects of indeterminacy continue to preoccupy authors like Claire Doherty, Stanley Matthews and Nat Chard among others.[3] What will architecture's new histories be, if chance consolidates its status as a valid concept for architectural thought, particularly strengthened by its active use in practice? A practice of chance in architecture should encompass both the poetics and criticality of chance. It should be directed towards the use of aleatoric techniques in the production and experience of drawing but also towards a better understanding of the critical questions raised by the contingencies of society and the environment.

Architects, like poets, must cultivate their capacity to imagine realities beyond the limits of deterministic design. They must start seeing chance as a creative agency that can allow architecture to be structured like a dream. As Woolf's passage suggests, the gap between design and chance may be difficult to pin down in the everyday experience of space but eventually it pierces and 'delights' the self because of its 'confusion', 'height', 'indifference' and 'fury'. This dream element of experience is perhaps another way of speaking about the role of Roland Barthes's punctum or Jacques Lacan's 'the real' in the structuring of the visual.[4] Separating architectural thought from the idea of chance would mean distancing architecture from the temporal and from the dream element that is naturally embedded in experience, whatever that may be—delightful, traumatic or both.

CHANCE AS TECHNIQUE

During the twentieth and early twenty-first centuries flexibility and appropriation have been addressed in architecture through interactive and participatory design and situational urbanism, but the idea of chance as a creative agency in its entirety has barely been acknowledged in architectural history and theory, let alone in practice. Characteristically most architects refer to chance in negative or superficial terms, alluding to accidents as 'obstacles' to their overall intentions, or to 'happy accidents'. I have addressed this gap by focusing on how and why chance has been explored positively in art, psychology and philosophical thought, and by showing the potential influence that these interdisciplinary examples may bring to bear on architecture. But I have also acknowledged that a small part of the architectural world has in fact welcomed chance in its own ways. In different ways the architects Bo Bardi, Venturi, Price, Coop Himmelb(l)au, Tschumi, Sejima and Lacaton & Vassal, for example, have engaged with chance quietly, and in doing so have profoundly reconsidered issues of order, co-authorship and the creative potential of inhabitation and the environment.

When I suggest that architecture should

proactively include chance in its practice, I propose an architectural approach that sees the design process continuing after the drawing stage, accepting the indeterminate and questioning the degrees of control demanded from and exercised by most architects.[1] I also propose a fondness for *the given* and for designing and building *less*. This acceptance of chance in architecture would not contradict its tendency to create autonomous and resilient forms but simply counterpart it.

I will now return to the minimal and permeable typology of the varieties of chance that I mentioned in the beginning of this book and have discussed in the various chapters in an interspersed manner. I am proposing that there are at least five types of chance that are important for architecture: *impulsive*, *systematic*, *fabricated*, *active* and *resistant*.

Impulsive chance is driven by intuition, subjectivity and the imagination. We can find it in Leonardo's 'chance images' seen on clouds and Alberti's use of clay; in the paintings of Turner and Whistler and in surrealist automatism; in Coop Himmelb(l)au's gestural drawings or Scharoun's formal irregularities in the Philharmonie in Berlin. Although impulsive action is generally initiated by the individual, it can transcend the self to reach the collective for the making of architecture and the city. For instance this is evident in Rossi's discussions of architecture as ritual or Koolhaas's definition of Manhattanism, both of which are open to impulse, although in different ways.

Systematic chance is structured, methodical, and even mathematical. It aims for generative variation within clearly determined parameters. For most of the architecture of the twentieth century this meant the physical and mechanical flexibility and adaptability of buildings, associated with industrial standardization and modularity. Price proposed flexible and adaptable structures that challenged the physical limits of buildings and opened architecture to pioneering ideas about new social and infrastructural possibilities. Since the 1990s systematic chance has increasingly been welcomed by digital technologies through the use of the algorithm, and a new affection for repeated variability in architecture. But today's computational methods, focusing mainly on material form-finding through serial geometric routines, are often too abstract, making it difficult to see enough differences in the types and forms of buildings produced.

Fabricated chance aims to communicate ironic messages. Through play and humour it makes up fictions to purposefully ridicule rationalism, functionalism, statistics and scientific, political or aesthetic doctrines. Postmodernism used this notion of chance to question the purity of modern architecture. In different ways Duchamp's *Large Glass*, Jencks's adhocism, Venturi's attention to contradiction and Gehry's early collage-like buildings operate within this realm of fabrication through caustic chance.

Active chance, on the other hand, accepts the aleatory as a critical part of *all* architecture, irrespective of place, period and style. It asks how buildings and places *perform* in time and society, rather than how they *are* as objects. This is a social kind of chance, underlined by non-finality and the possibilities of co-making. It values the inhabitants of architecture as co-designers and generally accepts all performative expressions of everyday chance. Van Eyck's thought, the Situationist International and Fluxus, Price's anticipatory architecture, Bo

Bardi's sense of expansion, Tschumi's event-space, Hill's creative user and attention to the weather and Till's contingency—all implicate an appreciation of the design-chance dialogue where architecture is understood to be co-produced by both architects and non-architects, both design and agency.

Finally, I propose that there is a fifth approach to chance which is hidden, but very common among architects and perhaps the most significant. It is based on the autonomy of architectural form and the actual negation of chance. Repressing chance can be productive because, in fact, it acknowledges the inevitable dialogue that occurs between the building and the indeterminacy that surrounds it. **Resistant chance** highlights indeterminacy as an oppositional condition to design and to the presence of resilient and autonomous buildings. The more rational and restrained the design method, the more it seems to release a form of openness towards chance. Lacaton & Vassal have confidence in architecture's capacity to welcome accidental environments as they are bound to happen and to positively enhance non-designable events. Their conscious indifference towards chance as material form is counter-balanced by their interest in the potentialities of chance as performance. I am interrogating both the possibilities and limits of chance, and therefore it should be no surprise that I also discuss works which deny chance. We choose when, why and how to enter into dialogue with chance. This element of choice is a critical skill that requires a deep understanding of chance as both subject and method on the architect's behalf.

These five techniques are not hermetic but mix with each other and further interact with concepts and media beyond them. They are fundamentally inter-subjective, either starting from the personal and eventually reaching the public or starting from the group but ultimately addressing the self. As design tactics and strategies, they can overlap within the same project and so the boundaries between the chance-related processes that are at play at any given time of a project are constantly shifting.

DOUBLE PASSAGE

One of the aims of this book has been to emphasize the experience of design rather than solely its outcome. Architectural design is sometimes wrongly discussed as a logical instrument of regulation, reacting to external demands and finding solutions for anticipated future needs. These discussions typically lack a consideration of the pleasures and agonies of design practice as experienced here and now. Design is inherently open to accidents, continuously oscillating between expectations, oversights, doubt and desire. It is a live activity in its own right, not simply the representation of solutions, and not hermetically isolated from life. Design as *experience in action* is an experiment, an event in the making which implicates the psychological complexities of the self. This experience of design must be enriched and prolonged because it is an aesthetic activity in itself, and it is to this end that the study and practice of chance in architecture can also contribute.

Considering the role and potential of architectural drawing, Robin Evans notes the Western prejudice of favouring 'neatness as a sign of civilisation' and its counter-prejudice, a reaction to neatness which favours 'the unpremeditated and unregulated as signs of art and feeling'.[6] He

disapproves of both but insists that the manner in which drawings emerge is significant, and suggests a study of architectural history that concentrates on the gap between drawing and building. Such a study might well illuminate with precision the role of chance in the production of architecture. The area where chance takes over design and control is often the area of transition from one stage of architectural production to the next. As Evans explains, the gap between drawing and building is a 'blind spot':

> because we can never be quite certain, before the event, how things will travel and what will happen to them on the way. We may, though … try to take advantage of the situation by extending their journey … so that more remote destinations may be reached. … These destinations are … merely potentialities that might be brought into existence through a given medium.[7]

By specifically studying the gap between drawing and building one would most likely show the insufficiency of design to fully determine its passage towards 'the real'. Digital fabrication has narrowed the gap between drawing and making and in doing so, some believe that it has challenged the Albertian significance of drawing in architecture.[8] Whatever the case may be, in the context of chance digital technologies allow for new aleatoric and interactive approaches to design that encourage variability and co-authorship. Yet the engaging questions of architecture's relation to built form, whether digital or not, mostly occur in the creative failure of architecture to control its passage from design to the actual production of space as socially experienced.

Architectural design takes the infinite range of possibilities available to it in order to produce a singularity. It negates the totality of chance in order to release a design. As a thing-in-itself, the architectural product (drawing or building) is a sole creation out of an infinite number of possibilities, a restriction of the universe of *tyche*. In this sense architecture is a passage from chance to design. But the building, despite its precise nature and intention to stand as a restricted and resilient edifice, will never put an end to chance. Chance will eventually conquer design. Time and again the building will produce entropies towards non-design, manifesting an inevitable overall inclination towards chaos. In this way architecture is also a passage from design to chance.

In bringing together the last and first lines of Mallarmé's famous poem, we can say for architecture as for poetry that 'all thought emits a throw of the dice … [but] a throw of the dice will never abolish chance'.[9] During the drawing process architecture is the passage from chance to design; during its manifestation in built form it is the passage from design to chance. This never-ending cyclical passage moving in two directions is the aesthetically and socially felt practice of architecture as experiment, involving many different agents and authors in endless chance relationships.

Notes

1 Virginia Woolf, *The Waves* (first published by The Hogarth press in 1931, Oxford University Press, 2008), pp. 199–200.

2 Joan Retallack, *The Poethical Wager* (University of California Press, 2003).

3 In addition to the books that I have already referred to, see Margaret Iversen (ed.), *Chance* (MIT Press and Whitechapel Gallery, 2010) and Jonathan Hughes and Simon Sadler (eds), *Non-Plan: Essays on Freedom Participation and Change in Modern Architecture and Urbanism* (Architectural Press, 2000).

4 Refer to Chapter 1.

5 For related discussions which have been incorporated in this book see Yeoryia Manolopoulou, 'The Practice of Chance', *OASE 85: Productive Uncertainty* (NAi Publishers, 2011), pp. 44–56, and Manolopoulou, 'The Active Voice of Architecture: An Introduction to the Idea of Chance', *Field:* (vol. 1, no. 1, 2008), pp. 62–72.

6 Robin Evans, *Translations from Drawing to Building and Other Essays* (Architectural Association, 1997), p. 185.

7 Evans, *Translations from Drawing to Building*, p. 182.

8 For example this position is taken by the historian Mario Carpo. See Mario Carpo, *The Alphabet and the Algorithm* (MIT Press, 2011), pp. 44–48.

9 Stéphane Mallarmé, *Un coup de dés, Collected Poems*, trans. Henry Weinfield (University of California Press, 1994), unpaginated.

Bibliography

Abbott, Edwin A. *Flatland: A Romance of Many Dimensions*. New York: HarperCollins, 1983. First published in 1884.

Adcock, Craig E. *Marcel Duchamp's Notes from the 'Large Glass': An N-Dimensional Analysis*. Ann Arbor: UMI Research Press, 1983.

Althusser, Luis. *Philosophy of the Encounter: Later Writings, 1978–1987*. Ed. François Matheron and Oliver Corpet; trans. G. M. Goshgarian. London and New York: Verso, 2006.

Alÿs, Francis, Robert Harbison, James Lingwood and David Toop. *Francis Alÿs: Seven Walks*. London: Artangel, 2005.

Aumont, Jacques. *The Image*, trans. Claire Pajackowska. London: British Film Institute, 1997.

Awan, Nishat, Tatjana Schneider and Jeremy Till. *Spatial Agency: Other Ways of Doing Architecture*. London: Routledge, 2011.

Bair, Deirdre. *Samuel Beckett: A Biography*. New York: Harcourt Brace Jovanovich, 1978.

Bakhtin, Mikhail M. *The Dialogic Imagination: Four Essays*. Trans. Caryl Emerson and Michael Holquist. Austin: University of Texas Press, 2006.

Baltrušaitis, Jurgis. *Anamorphic Art*. Trans. W. J. Strachan. New York: Harry N. Abrams, 1977.

Barthes, Roland. *Camera Lucida: Reflections on Photography*. Trans. Richard Howard. London: Vintage, 2000.

Bateson, Gregory. *Steps to an Ecology of Mind*. Northvale, New Jersey, London: Jason Aronson, 1987.

Baudelaire, Charles. *The Painter of Modern Life and Other Essays*. Trans. Jonathan Mayne. London and New York: Phaidon Press, 1995.

Beckett, Samuel. *The Complete Dramatic Works*. London: Faber and Faber, 1986.

Beckett, Samuel. *Film: Complete Scenario/Illustrations/Production Shots*. London: Faber and Faber, 1972.

Beckett's Archive, Reading University, MS 1525/1: 'Photocopy of Typescript of *Film* with Manuscript Corrections and Additions by S. B, Dated in Type May 1963'.

Beckett's Archive, Reading University, MS 1227/7/6/1: 'Manuscript Notebook for *Film*'.

Beckett's Archive, Reading University, MS 1227/7/6/2: 'Stencilled Typescript Shooting Scenario for *Film*, Project 1, Evergreen Theatre (USA), with Typescript Sheet of Author's Comments, Dated 20 July 1964'.

Beier, Lucia. 'Time Machine: A Bergsonian Approach to The Large Glass'. *Gazette des beaux-arts*, series 6, vol. 88, 1976.

Benjamin, Walter. *Illuminations*. Ed. Hannah Arendt, trans. Harry Zohn. London: Fontana Press, 1992.

Benjamin, Walter. *Charles Baudelaire: A Lyric Poet in the Era of High Capitalism*. Trans. Harry Zohn. London and New York: Verso, 1997.

Bennett, Deborah J. *Randomness*. Cambridge: Harvard University Press, 1999.

Bergson, Henri. *Matter and Memory*. Trans. W. S. Palmer and N. M. Paul. New York: Zone Books, 1988. First published in 1896.

Bergson, Henri. *Creative Evolution*. Trans. Arthur Mitchell. New York: Dover, 1988. First English translation published in 1911.

Bignel, Jonathan. 'Questions of Authorship: Samuel Beckett and *Film*'. In Jonathan Bignel, ed., *Writing and Cinema*. London: Longman, 1999.

Bois, Yve-Alain. 'Metamorphosis of Architecture'. *Daidalos*, September 1981.

Bouchrad, Norma. Film *in Context(s)*. In Marius Buning, Danièle de Ruyter and Sjef Houppermans, eds, *1 Samuel Beckett 1970–1989: Samuel Beckett Today/Aujourd'hui 1*. Amsterdam: Rodopi, 1992.

Brand, Stewart. *How Buildings Learn: What Happens After They're Built*. New York: Viking, 1994.

Brater, Enoch. 'The Thinking Eye in Beckett's *Film*'. *Modern Language Quarterly*, vol. 36, no. 2, June 1975.

Brecht, George. *Chance-Imagery*. New York: Great Bear Pamphlet by Something Else Press, 1966.

Brederoo, Nico J. 'Beckett's *Film*: An Essay', trans. Onno Kosters. In Marius Buning, Danièle de Ruyter and Sjef Houppermans, eds, *1 Samuel Beckett 1970–1989: Samuel Beckett Today/Aujourd'hui 1*. Amsterdam: Rodopi, 1992.

Breton, André. *Nadja*, trans. Richard Howard. New York: Grove Press, 1960. First published in 1928.

Brivic, Sheldon. *The Veil of Signs: Joyce, Lacan, and Perception*. Urbana and Chicago: University of Illinois Press, 1991.

Brotchie, Alastair and Mel Gooding, eds. *A Book of Surrealist Games*. Trans. Alexis Lykiard and Jennifer Batchelor. Boston and London: Shambhala Redstone Editions, 1995.

Brouwer, Joke, ed. *The Art of the Accident*. Rotterdam: NAi Publishers/V2 Organisatie, 1998.

Bryson, Norman. 'The Gaze in the Expanded Field'. In Hal Foster, ed., *Vision and Visuality*, Dia Art Foundation, Discussions in Contemporary Culture, no. 2. New York: New Press, 1988.

Buning, Marius, Danièle de Ruyter, Matthijs Engelberts and Sjef Houppermans, eds *Beckett Versus Beckett: Samuel Beckett Today/Aujourd'hui 7*. Amsterdam: Rodopi, 1998.

Cabanne, Pierre. *Duchamp & Co*. Ed. Jean-Claude Dubost, trans. Peter Snowdon. Paris: Finest SA/Editions Pierre Terrail, 1977.

Cage, John. *A Year from Monday: New Lectures and Writings*. London and New York: Marion Boyars, 1976.

The Cambridge Dictionary of Philosophy. 2nd Edition. Cambridge: Cambridge University Press, 1999.

Carpo, Mario. *The Alphabet and the Algorithm*. Cambridge: MIT Press, 2011.

Charles, Daniel. 'About John Cage's "Prepared Piano" (1990)'. In Richard Kostelanetz, ed., *Writings about John Cage*. Ann Arbor: UMI Press, 1999.

Clair, Jean. *Sur Marcel Duchamp et la fin de l'art*. Paris: Gallimard, 2000.

Coles, Alex and Alexia Defert, eds. *The Anxiety of Interdisciplinarity: De-, Dis-, Ex-*. vol. 2. London: Backless Books and Black Dog Publishing, 1998.

Colomina, Beatriz. '*L'Esprit Nouveau*: Architecture and *Publicité*'. In Michael Hays, ed., *Architecture Theory since 1968*. Cambridge: MIT Press, New York: Columbia Books of Architecture, 2000.

Colomina, Beatriz. 'Le Corbusier and Duchamp: The Uneasy Status of the Object'. In Taisto H. Mäkelä and Wallis Miller, eds, *Wars of Classification: Architecture and Modernity*. New York: Princeton Architectural Press, 1991.

Colomina, Beatriz. *Privacy and Publicity: Modern Architecture as Mass Media*. Cambridge: MIT Press, 1994.

Conde, Yago. *Architecture of Indeterminacy*. Ed. Bea Goller, trans. Paul Hammond. Barcelona: Actar, 2000.

Coolidge, Clark. 'Perhaps Takes On Some Beckett Teleplays Not to Settle Out What Won't Go Away At Any Rate There Are No Secrets There'. In Stan Douglas, Linda Ben-Zvi and Coolidge, *Samuel Beckett Teleplays*. Vancouver: Vancouver Art Gallery, 1988.

Crary, Jonathan. *Techniques of the Observer: On Vision and Modernity in the Nineteenth Century*. Cambridge: MIT Press, 1992.

Crary, Jonathan. *Suspensions of Perception: Attention, Spectacle, and Modern Culture*. Cambridge: MIT Press, 1999.

Csikszentmihalyi, Mihaly and Eugene Rochberg-Halton. *The Meaning of Things: Domestic Symbols and the Self*. Cambridge: Cambridge University Press, 1981.

Curtis, William J. R. *Modern Architecture Since 1900*. London: Phaidon, 1996.

d'Harnoncourt, Anne and Kynaston McShine, eds. *Marcel Duchamp*. New York: Museum of Modern Art and Philadelphia Museum of Art, 1989.

Damisch, Hubert. *A Theory of /Cloud/: Toward a History of Painting*. Trans. Janet Lloyd. Palo Alto: Stanford University Press, 2002.

Dagognet, François. *Étienne-Jules Marey: A Passion for the Trace*. New York: Zone Books, 1992.

Dawson, Barbara and Margarita Cappock. *Francis Bacon's Studio at the Hugh Lane*. Dublin: Hugh Lane Municipal Gallery of Modern Art, 2001.

de Certeau, Michel. *The Practice of Everyday Life*. Trans. Steven Rendall. Berkeley and Los Angeles: University of California Press, 1988.

de Duve, Thierry, ed. *The Definitively Unfinished Marcel Duchamp*. Cambridge: MIT Press, 1991.

de Oliveira, Olivia. *Subtle Substances: The Architecture of Lina Bo Bardi*. Sao Paulo: Romano Guerra; Barcelona: Gustavo Gili, 2006.

de Zegher, Catherine and Mark Wigley, eds. *The Activist Drawing: Retracing Situationist Architectures from Constant's New Babylon to Beyond*. New York: The Drawing Center; Cambridge: MIT Press, 2001.

Debevec Henning, Sylvie. '*Film*: A Dialogue Between Beckett and Berkeley'. *Journal of Beckett Studies*, no. 7, Spring 1982.

Deleuze, Gilles. *Cinema 1: The Movement-Image*. Trans. Hugh Tomlinson and Barbara Habberjam. London: Athlone Press, 1992.

Deleuze, Gilles. *Cinema 2: The Time-Image*. Trans. Hugh Tomlinson and Robert Galeta. London: Athlone Press, 1989.

Deleuze, Gilles. '*Film* by Samuel Beckett'. *Film West*, Spring 1995.

Diller, Elizabeth and Ricardo Scofidio. 'A Delay in *Glass*'. *Daidalos*, December 1987.

Diller+Scofidio, *Flesh: Architectural Probes*. New York: Princeton Architectural Press; London: Triangle Architectural Publishing, 1994.

Diller+Scofidio, *Blur: The Making of Nothing*. New York: Harry N. Abrams, 2002.

Dodsworth, Martin. '*Film* and the Religion of Art'. In Katharine Worth, ed., *Beckett the Shape Changer*. London: Routledge and Kegan Paul, 1975.

Doherty, Claire, ed. *Situation*. Cambridge: MIT Press; London: Whitechapel Gallery, 2009.

Driver, Tom. 'Interview with Samuel Beckett'. Columbia University Forum, Summer 1961. In L. Graver and R. Federman, eds, *Samuel Beckett: The Critical Heritage*. London: Routledge, 1999.

Dubery, Fred and John Willats. *Perspective and Other Drawing Systems*. New York: Van Nostrand Reinhold, 1983.

Duchamp, Marcel. À *l'infinitif*. A typotranslation by Richard Hamilton and Ecke Bonk of Marcel Duchamp's *White Box*, trans. Jackie Matisse, Richard Hamilton and Ecke Bonk. Paris: Typosophic Society, 1999.

Duchamp, Marcel. *The Bride Stripped Bare by Her Bachelors, Even*. A typographical version by Richard Hamilton of Marcel Duchamp's *Green Box*, trans. George Heard Hamilton. Stuttgart: Edition Hansjörg Mayer; New York: Jaap Rietman, 1976.

Duchamp, Marcel. *Notes*. Trans. Paul Matisse. Paris: Centre National d'Art et de Culture Georges Pompidou, 1980.

Duchamp, Marcel. *The Writings of Marcel Duchamp*. Ed. Michel Sanouillet and Elmer Peterson. New York: Oxford University Press, 1973.

Eco, Umberto. *The Open Work*. Trans. Anna Cancogni. Cambridge: Harvard University Press, 1989.

Edelman, Gerald M. and Giulio Tononi. *Consciousness: How Matter Becomes Imagination*. London: Penguin, 2001.

Ekeland, Ivar. *The Broken Dice, and Other Mathematical Tales*. Trans. Carol Volk. Chicago: University of Chicago Press, 1993.

Evans, Dylan. *An Introductory Dictionary of Lacanian Psychoanalysis*. London: Routledge, 1996.

Evans, Robin. *The Projective Cast: Architecture and Its Three Geometries*. Cambridge: MIT Press, 1995.

Evans, Robin. *Translations from Drawing to Building and Other Essays*. London: Architectural Association, 1997.

Fawkes, Edith Mary. 'Turner at Farnley'. London: typescript in National Gallery, 1900.

Feshbach, Sidney. 'Unswamping a Backwater: On Samuel Beckett's *Film*'. In Lois Oppenheim, ed., *Samuel Beckett and the Arts: Music, Visual Arts, and Non-Print Media*. New York: Garland Publishing, 1999.

Fetterman, William. *John Cage's Theatre Pieces: Notations and Performances*. Amsterdam: Harwood Academic Publishers, 1996.

Flam, Jack, ed. *Robert Smithson: The Collected Writings*. Berkeley and Los Angeles: University of California Press, 1996.

Fletcher, Banister. *A History of Architecture*. London: Athlone Press, 1975.

Ford, Charles Henri, ed. *View: Parade of the Avant-Garde: An Anthology of View Magazine 1940-1947*. New York: Thunder's Mouth Press, 1977.

Forty, Adrian. *Words and Buildings: A Vocabulary of Modern Architecture*. London: Thames and Hudson, 2000.

Foster, Hal. *Compulsive Beauty*. Cambridge: MIT Press, 1995.

Foster, Hal. *The Return of the Real: The Avant-garde at the End of the Century*. Cambridge: MIT Press, 1996.

Gamard, Elizabeth Burns. *Kurt Schwitters' Merzbau: The Cathedral of Erotic Misery*. New York: Princeton Architectural Press, 2000.

Gamboni, Dario. *Potential Images: Ambiguity and Indeterminacy in Modern Art*. London: Reaktion, 2002.

Gamboni, Dario. 'Fabrication of Accidents'. *Anthropology and Aesthetics*, no. 36, Autumn 1999.

Gavard-Perret, Jean-Paul. 'Beckett et le cinéma: L'Oeil du cyclope et l'image impossible'. *Ralentir Travaux*, no. 4, 1996.

Gavard-Perret, Jean-Paul. 'L'Oeil du cyclope: Beckett et la vidéo'. *Turbulances Vidéo: Culture Contemporaine– Arts Vidéo & Nouvelles Technologies*, no. 14, 1997.

Gibson, James J. *The Ecological Approach to Visual Perception*. New Jersey: Lawrence Erlbaum, 1986.

Gili, Mónica, ed. *Lacaton & Vassal*. Barcelona: 2G Libros, 2007.

Godfrey, Mark, ed. *Francis Alÿs: A Story of Deception*. London: TATE Publishing, 2010.

Gombrich, E. H. *Norm and Form: Studies in the Art of the Renaissance*. Chicago: University of Chicago Press, 1966.

Gontarski, S. E. '*Film* and Formal Integrity'. In Gontarski, *The Intent of Undoing in Samuel Beckett's Dramatic Texts*. Bloomington: Indiana University Press, 1985.

Graulich, Gehard, Herbert Molderings and Kornelia von Berswordt-Wallrabe. *Marcel Duchamp Respirateur*. Ostfildern: Hatje Cantz, 1999.

Gravagnuolo, Benedetto. *Adolf Loos: Theory and Works*. London: Art Data, 1995.

Gregory, R. L. *Eye and Brain: The Psychology of Seeing*. London: Weidenfeld and Nicolson, 1990.

Grosz, Elizabeth. *Chaos, Territory, Art: Deleuze and the Framing of the Earth*. New York: Columbia University Press, 2008.

Hacking, Ian. *The Taming of Chance*. Cambridge: Cambridge University Press: 1990.

Harmon, Maurice, ed. *No Author Better Served: The Correspondence of Samuel Beckett and Alan Schneider*. Cambridge: Harvard University Press, 1998.

Hays, Michael, ed. *Architecture Theory since 1968*. Cambridge: MIT Press; New York: Columbia Books of Architecture, 2000.

Hays, Michael. *Architecture's Desire*. Cambridge: MIT Press, 2010.

Henderson, Linda Dalrymple. *Duchamp in Context: Science and Technology in the 'Large Glass' and Related Works*. New York: Princeton University Press, 1998.

Hertzberger, Herman. *Lessons for Students in Architecture*. Rotterdam: 010 Publishers, 1991.

Hill, Jonathan. *Actions of Architecture: Architects and Creative Users*. London: Routledge: 2003.

Holm, Lorens. *Brunelleschi, Lacan, Le Corbusier: Architecture, Space and the Construction of Subjectivity*. London: Routledge, 2010.

Holquist, Michael. *Dialogism: Bakhtin and his World*. London: Routledge, 1990.

Hughes, Jonathan. 'The Indeterminate Building'. In Jonathan Hughes and Simon Sadler, eds, *Non-Plan: Essays on Freedom Participation and Change in Modern Architecture and Urbanism*. Oxford: Architectural Press, 2000.

Huizinga, Johan. *Homo Ludens: A Study of the Play-Element in Culture*. Boston: Beacon Press, 1955.

Iversen, Margaret, ed. *Chance*. Cambridge: MIT Press; London: Whitechapel Gallery, 2010.

Janet, Pierre. *L'Automatisme psychologique: essai de psychologie expérimentale sur les formes inférieures de l'activité humaine*. Paris: F. Alcan, 1930.

Jay, Martin. *Downcast Eyes: The Denigration of Vision in Twentieth-Century French Thought*. Berkeley and Los Angeles: University of California Press, 1994.

Jencks, Charles and Nathan Silver. *Adhocism: The Case of Improvisation*. New York: Doubleday, 1972.

Judovitz, Dalia. *Unpacking Duchamp: Art in Transit*. Berkeley and Los Angeles: University of California Press, 1995.

Jung, C. G. *Synchronicity: An Acausal Connecting Principle*. Trans. R. F. C. Hull. London: Ark, 1991.

Knabb, Ken, ed., and trans. *Situationist International Anthology*. Berkeley: Bureau of Public Secrets, 1995.

Knowlson, James. *Damned to Fame: The Life of Samuel Beckett*. New York: Simon & Schuster, 1996.

Kofman, Eleonore and Elizabeth Lebas. 'Recovery and Reappropriation in Lefebvre and Constant'. In Hughes, Jonathan and Simon Sadler, eds, *Non-Plan: Essays on Freedom Participation and Change in Modern Architecture and Urbanism*. Oxford: Architectural Press, 2000.

Kolarevic, Branko, ed. *Architecture in the Digital Age: Design and Manufacturing*. New York and London: Taylor & Francis, 2003.

Koolhaas, Rem. *Delirious New York: A Retroactive Manifesto for Manhattan*. Rotterdam: 010 Publishers, 1994.

Krauss, Rosalind E. *The Optical Unconscious*. Cambridge: MIT Press, 1993.

Krauss, Rosalind E. 'Where's Poppa?' In de Duve, Thierry, *Kant After Duchamp*. Cambridge: MIT Press, 1998.

Kuenzli, Rudolf E. and Francis Naumann, eds. *Marcel Duchamp: Artist of the Century*. Cambridge: MIT Press, 1996.

Kultermann, Udo. *Architecture in the 20th Century*. New York: John Wiley & Sons, 1993.

Kundert-Gibbs, John. 'Continued Perception: Chaos Theory, the Camera, and Samuel Beckett's *Film* and Television Work'. In Lois Oppenheim, ed., *Samuel Beckett and the Arts: Music, Visual Arts, and Non-Print Media*. New York: Garland Publishing, 1999.

Küng, Moritz, ed. *Walter Niedermayr/Kazuyo Sejima + Ryue Nishizawa/SANAA*. Munich: Hatje Cantz, 2007.

Kwinter, Sanford. *Architectures of Time: Toward a Theory of the Event in Modernist Culture*. Cambridge: MIT Press, 2002.

Lacan, Jacques. *Écrits: A Selection*. Trans. Alan Sheridan. London: Routledge, 2001.

Lacan, Jacques. *The Four Fundamental Concepts of Psycho-Analysis*. Ed. Jacques-Alain Miller. Trans. Alan Sheridan. London: Vintage, 1998.

Lefaivre, Liane. 'Everything is Architecture: Multiple Hans Hollein and the Art of Crossing Over'. *Harvard Design Magazine*, no. 18, Spring/Summer, 2003.

Lefaivre, Liane and Alexander Tzonis, *Aldo Van Eyck: Humanist Rebel*. Rotterdam: 010 Publishers, 1999.

Lefebvre, Henri. *Introduction to Modernity*. Trans. John Moore. London and New York: Verso, 1995. First published in 1962.

Lefebvre, Henri. *Rhythmanalysis: Space, Time and Everyday Life*. New York: Continuum, 2004.

Levy, Shimon. 'Spirit Made Light: Eyes and Other I's in Beckett's TV Plays'. In Catharina Wulf, ed., *The Savage Eye/L'Oeil fauve: New Essays on Samuel Beckett's Television Plays: Samuel Beckett Today/ Aujourd'hui 4*. Amsterdam: Rodopi, 1995.

Lichtenstein, Therese. *Behind Closed Doors: The Art of Hans Bellmer*. Berkeley and Los Angeles: University of California Press, 2001.

Lyotard, Jean-François. *Duchamp's TRANS/formers*. Trans. Ian McLeod. Venice, CA: Lapis Press, 1990.

Mallarmé, Stéphane. *Collected Poems*. Trans. Henry Weinfield. Berkeley and Los Angeles: University of California Press, 1994.

Mallgrave, Harry F., ed. *Empathy, Form, and Space: Problems in German Aesthetics, 1873–1893*. Santa Monica: Getty Center for the History of Art and Humanities, 1994.

Malone, Meredith, ed. *Chance Aesthetics*. St. Louis: Mildred Lane Kemper Art Museum, 2009

Manolopoulou, Yeoryia. 'The Interior of Vision: Beckett's *Film* and *Viewing Instrument I*'. *The Journal of Architecture*, vol. 9, no. 3, 2004.

Manolopoulou, Yeoryia. 'Unformed Drawing: Notes, Sketches and Diagrams'. *The Journal of Architecture*, vol. 10, no. 5, 2005.

Manolopoulou, Yeoryia. '*Drafting Pier 40*: The Development of Chance as a Drawing Tool in the Process of Architectural Design'. *Architectural Design Research RMIT*, vol. 1, no. 1, 2005.

Manolopoulou, Yeoryia. 'The Active Voice of Architecture: An Introduction to the Idea of Chance'. *Field:*, vol. 1, no. 1, 2008.

Manolopoulou, Yeoryia. 'The Practice of Chance'. *OASE 85: Productive Uncertainty*. Rotterdam: NAi Publishers, 2011.

Marr, David. Vision: *A Computational Investigation into the Human Representation and Processing of Information*. New York: W. H. Freeman, 1982.

Mathews, Stanley. *From Agit-Prop to Free Space: The Architecture of Cedric Price*. London: Blackdog Publishing, 2007.

Matthews, J. H. *The Imagery of Surrealism*. New York: Syracuse University Press, 1977.

Mavor, Carol. '*Odor di femina:* Though You May Not See Her, You Can Certainly Smell Her'. *Cultural Studies*, vol. 12, no. 1, January 1998.

Meiss, Millard, ed. *De artibus opuscula XL: Essays in Honor of Erwin Panofsky*, New York: New York University Press, 1961.

Merleau-Ponty, Maurice. *Phenomenology of Perception*. Trans. Colin Smith. London: Routledge, 1962.

Merleau-Ponty, Maurice. *The Visible and the Invisible; Followed by Working Notes*. ed., Claude Lefort. Trans. Alphonso Lingis. Evanston: Northwestern University Press, 1968.

Mertins, Detlef. *The Presence of Mies*. New York: Princeton Architectural Press, 1996.

Miralles, Enric. El Croquis 72[II]. Madrid, 1990–94.

Miralles, Enric and Benedetta Tagliabue, El Croquis 100/10. Madrid, 1995–2000.

Miralles/Pinós: El Croquis 30+49/50. Madrid: 1983–90.

Molderings, Herbert. *Duchamp and the Aesthetics of Chance: Art as Experiment*. Trans. John Brogden. New York: Columbia University Press, 2010.

Mostafavi, Mohsen and David Leatherbarrow. *On Weathering: The Life of Buildings in Time*. Cambridge: MIT Press, 1993.

Naumann, Francis M. *Marcel Duchamp: The Art of Making Art in the Age of Mechanical Reproduction*. Ghent: Ludion Press, 1999.

Nicholson, Ben. 'War and Peacefare at the Loaf House'. *Architectural Design*, no. 123, 1996.

Noever, Peter, ed. *Architecture and Transition: Between Deconstruction and New Modernism*. Munich: Prestel, 1991.

Oliva, Achille Bonito, ed. *La delicata scacchiera. Marcel Duchamp: 1902/1968*. Florence: Centro Di, 1973.

Palmer, Stephen. E. *Vision Science: Photons to Phenomenology*. Cambridge: MIT Press, 1999.

Pask, Gordon. *An Approach to Cybernetics*. London: Hutchinson & Co, 1961.

Paz, Octavio. *Marcel Duchamp: Appearance Stripped Bare*. Trans. Rachel Phillips and Donald Gardner. New York: Arcade Publishing, 1990.

Péréz-Gómez, Alberto and Louise Pelletier. 'Tu M' Harcelles: The Reversibility of Projective Representation'. *Scroope Seven*, Cambridge University School of Architecture, 1995.

Petersen, Steen Estvad. 'Jumbo-Architecture'. In Kirsten Degel, ed., *The Architect's Studio: Frank O. Gehry*. Luisiana: Luisiana Museum of Modern Art, 1998.

Piaget, Jean and Bärbel Inhelder. *The Origin of the Idea of Chance in Children*. Trans. Lowell Leake, Paul Burrell and Harold D. Fishbein. London: Routledge and Kegan Paul, 1975.

Poe, Edgar Allan. *The Works of Edgar Allan Poe*, vol. iv. London: Lawrence & Bullen, 1895.

Poincaré, Henri. *The Foundations of Science: Science and Hypothesis, The Value of Science, Science and Method*. Trans. George Bruce Halsted. New York: Science Press, 1921.

Poincaré, Henri. *Science and Hypothesis*. New York: Dover Publications, 1952. First published in English in 1905.

Popham, A. E., ed. *The Drawings of Leonardo da Vinci*. London: Reprint Society, 1952.

Pountney, Rosemary. 'Beckett and the Camera'. In Catharina Wulf, ed., *The Savage Eye/L'Oeil fauve: New Essays on Samuel Beckett's Television Plays: Samuel Beckett Today/Aujourd'hui 4*. Amsterdam: Rodopi, 1995.

Pountney, Rosemary. *Theatre of Shadows: Samuel Beckett's Drama 1956-76: From All That Fall to Footfalls with Commentaries on the Latest Plays*. New Jersey: Barnes and Noble, 1988.

Prix, Wolf D. 'On the Edge'. In Peter Noever, ed., *Architecture and Transition: Between Deconstruction and New Modernism*. Munich: Prestel, 1991.

Prix, Wolf and Helmut Swiczinsky. *Blaubox*. London: Architectural Association, folio xiii, 1988.

Ramírez, Juan Antonio. *Duchamp: Love and Death, Even*. Trans. Alexander R. Tulloch. London: Reaktion, 1998.

Rendell, Jane. *Art and Architecture: A Place Between*. London and New York: I.B. Tauris, 2006.

Retallack Joan. *The Poethical Wager*. Berkeley, Los Angeles and London: University of California Press, 2003.

Rich, Alan. *American Pioneers: Ives to Cage and Beyond*. London: Phaidon, 1995.

Richter, Hans. DADA: *Art and Anti-Art*. London: Thames and Hudson, 1965.

Roberts, Francis. 'I Propose to Strain the Laws of Physics'. Interview with Marcel Duchamp. *Art News*, no. 8, December 1968.

Ross, Ciaran. 'The Face in the Mirror: A Comparison Between *Waiting for Godot* and *Film*'. In Catharina Wulf, ed., *The Savage Eye/L'Oeil fauve: New Essays on Samuel Beckett's Television Plays: Samuel Beckett Today/Aujourd'hui 4*. Amsterdam: Rodopi, 1995.

Rossi, Also. *A Scientific Autobiography*. Trans. Lawrence Venuti. Cambridge: MIT Press, 1981.

Roth, Moira and Jonathan D. Katz. *Difference/Indifference: Musings on Postmodernism, Marcel Duchamp and John Cage*. Netherlands: G+B Arts International, 1998.

Rowe, Colin and Fred Koetter. *Collage City*. Cambridge: MIT Press, 1978, 1998.

Rural Studio: Samuel Mockbee and an Architecture of Decency. Text by Andrea Oppenheimer Dean and photographs by Timothy Hursley. New York: Princeton Architectural Press, 2002.

Sadler, Simon. 'Open Ends: The Social Visions of 1960s Non-Planning'. In Jonathan Hughes and Simon Sadler, eds, *Non-Plan: Essays on Freedom Participation and Change in Modern Architecture and Urbanism*. Oxford: Architectural Press, 2000.

Sadler, Simon. *The Situationist City*. Cambridge: MIT Press, 1998.

Sakamoto, Tomoko, ed. *From Control to Design: Parametric/Algorithmic Architecture*. Barcelona: Actar, 2008.

SANAA Kazuyo Sejima+Ryue Nishizawa: El Croquis 155. Madrid, 2008–11.

Schneider, Bernhard. 'Perspective Refers to the Viewer, Axonometry Refers to the Object'. *Daidalos*, September 1981.

Schwarz, Arturo. *The Complete Works of Marcel Duchamp*. New York: Harry N. Abrams, 1970.

Secrest, Meryle. *Salvador Dalí: The Surrealist Jester*. London: Paladin Grafton, 1986.

Shklovsky, Viktor. 'Art as Technique'. In *Russian Formalist Criticism: Four Essays*, trans. Lee T. Lemon and Marion J. Reis. Lincoln: University of Nebraska Press, 1965. First published in 1917.

Simons, Katrin. *El Lissitzky Proun 23 N*. Frankfurt: Insel Verlag, 1993.

Sontag, Susan. *Against Interpretation*. London: Vintage, 1994.

Spies, Werner. *Max Ernst Frottages*. Trans. Joseph M. Bernstein. London: Thames and Hudson, 1986.

Spoerri, Danielle. *Topographie anecdotée du hazard*. Paris: Editions Galerie Lawrence, 1962.

Strauven, Francis. *Aldo van Eyck: The Shape of Relativity*. Amsterdam: Architectura & Natura, 1998.

Sylvester, David. *Interviews with Francis Bacon*. London: Thames and Hudson, 1993.

Tafuri, Manfredo. *Theories and History of Architecture*. Trans. Giorgio Verrecchia. London: Granada, 1980.

Taylor, Sue. *Hans Bellmer: The Anatomy of Anxiety*. Cambridge: MIT Press, 2000.

Teyssot, Georges. 'Boredom and Bedroom: The Suppression of the Habitual'. *Assemblage*, no. 30, 1996.

Thierolf, Corinna. 'Sudden Images: The Ryoanji Drawings of John Cage'. In Joachim Kaak and Corinna Thierolf, eds, Melissa Thorson Hause trans., *Hanne Darboven/John Cage: A Dialogue of Artworks*. Munich: Hatje Cantz Publishers, 2000.

Till, Jeremy. *Architecture Depends*. Cambridge: MIT Press, 2009.

Tomkins, Calvin. *Duchamp: A Biography*. London: Pimlico, 1998.

Tschumi, Bernard. *Architecture and Disjunction*. Cambridge: MIT Press, 1994.

Tschumi, Bernard. *Event-Cities* (*Praxis*). Cambridge: MIT Press, 1994.

Tschumi, Bernard. *Le Fresnoy: Architecture In/Between*. New York: Monacelli Press, 1999.

Tschumi, Bernard. *The Manhattan Transcripts*. London: Academy, 1994.

Uhlmann, Anthony. 'Image and Intuition in Beckett's *Film*'. *Substance*, issue 104, vol. 33, no 2, 2004.

Ursprung, Philip, ed. *Herzog & de Meuron: Natural History*. Montréal: CCA; Rotterdam: Lars Muller, 2002.

Utzon, Jørn, Yukio Futagawa and Christian Norberg-Schulz. *Church at Bagsværd, near Copenhagen, Denmark, 1973–76': Global Architecture 61*. Tokyo, 1981.

Venturi, Robert. *Complexity and Contradiction*. London: Architectural Press, 1966.

Vidler, Anthony. 'Diagrams of Utopia'. In Catherine de Zegher and Mark Wigley, eds. *The Activist Drawing: Retracing Situationist Architectures from Constant's New Babylon to Beyond*. New York: The Drawing Center and Cambridge: MIT Press, 2001.

Virilio, Paul. *A Landscape of Events*. Trans. Julie Rose. Cambridge: MIT Press, 2000.

Virilio, Paul. *The Lost Dimension*. Trans. Daniel Moshenberg. New York: Semiotext(e), 1991.

Vitruvius. 'The Origin of the Dwelling House', *The Ten Books on Architecture*. Trans. Morris Hicky Morgan. New York: Dover, 1960. First published as *De architectura* in the first century BC. Wade, Nicholas J. *A Natural History of Vision*. Cambridge: MIT Press, 1998.

Watts, Harriett Ann. *Chance: A Perspective on Dada*. Ann Arbor: UMI Research Press, 1980.

Wiener, Philip P., ed. *Dictionary of the History of Ideas*. New York: Charles Scribner's Sons, 1968, 1973.

Wilhelm, Richard and Cary F. Baynes, trans. *The I Ching or Book of Changes*. New Jersey: Bollingen Foundation and Princeton University Press, 1977.

Woolf, Virginia. *The Waves*. London: Penguin Classics, 2000. First published in 1931.

Wulf, Catharina, ed. *The Savage Eye/L'Oeil fauve: New Essays on Samuel Beckett's Television Plays: Samuel Beckett Today/Aujourd'hui, vol. 4*. Amsterdam: Rodopi, 1995.

Zeizek, Slavoj, ed. *Everything You Always Wanted to Know about Lacan (But Were Afraid to Ask Hitchcock)* London: Verso, 1992.

FILMS

Film, 1964, Dir. Alan Schneider, Pr. Barney Rosset and Evergreen Theatre (British Film Institute, 16mm, and Applause, VHS).

Film, 1979, Dir. David Rayner Clark, Pr. British Film Institute (British Film Institute, 16mm).

Index

442187